THE BLACK IMAGINATION

BLACK STUDIES
& critical thinking

Rochelle Brock and Richard Greggory Johnson III
Executive Editors

Vol. 14

PETER LANG
New York • Washington, D.C./Baltimore • Bern
Frankfurt • Berlin • Brussels • Vienna • Oxford

THE BLACK IMAGINATION

SCIENCE FICTION, FUTURISM AND THE SPECULATIVE

Edited by Sandra Jackson
and Julie E. Moody-Freeman

PETER LANG
New York • Washington, D.C./Baltimore • Bern
Frankfurt • Berlin • Brussels • Vienna • Oxford

Library of Congress Cataloging-in-Publication Data

The black imagination, science fiction, futurism and the speculative /
edited by Sandra Jackson, Julie E. Moody-Freeman.
p. cm. — (Black studies and critical thinking; v. 14)
Includes bibliographical references.
1. American fiction—African American authors—History and criticism.
2. Blacks in literature. 3. Blacks in motion pictures. 4. Blacks—Race identity.
5. Futurism (Literary movement) 6. Science fiction—History and criticism.
7. African Americans—Intellectual life.
I. Jackson, Sandra. II. Moody-Freeman, Julie E.
PS153.N5B5545 813'.509896073—dc22 2011002728
ISBN 978-1-4331-1242-3 (hardcover)
ISBN 978-1-4331-1241-6 (paperback)
ISSN 1947-5985

Bibliographic information published by **Die Deutsche Nationalbibliothek.**
Die Deutsche Nationalbibliothek lists this publication in the "Deutsche
Nationalbibliografie"; detailed bibliographic data is available
on the Internet at http://dnb.d-nb.de/.

"'Explorers'—*Star Trek: Deep Space Nine*", Michael Charles Pounds, *African Identities*,
May 2009, Taylor & Francis, reprinted by permission of the publisher
(Taylor & Francis Group, http://www.informaworld.com).

"Brave black worlds: black superheroes as science fiction ciphers", Adilifu Nama,
African Identities, May 2009, Taylor & Francis, reprinted by permission of the publisher
(Taylor & Francis Group, http://www.informaworld.com).

Cover image © 2011 JupiterImages Corporation

© 2011 Peter Lang Publishing, Inc., New York
29 Broadway, 18th floor, New York, NY 10006
www.peterlang.com

Printed in the United States of America

Contents

The Black Imagination and the Genres

Science Fiction, Futurism and the Speculative

SANDRA JACKSON & JULIE MOODY-FREEMAN

SCIENCE FICTION AS A GENRE, INCLUSIVE OF FUTURIST WORKS, SPECULATIVE fiction written by Black authors and films by Black directors or cinema in which Black characters are the lead protagonists, and other works in literature, film, television, and popular culture, has begun to come into its own. It is no longer an anomaly. It is no longer seen as errant star gazing about future realities or things not of this world, in a context in which excavation of the past—the unearthing and construction of counternarratives to restore the humanity of African descendant populations in the wake of erasures, omissions and silences as a consequence of imperial incursions and domination and slavery, has been the preoccupation of most Black writers and scholars in the U.S. Exploration of future possibilities and the fantastic, and speculation about alternative possibilities to the world we inhabit now, we (the editors) think have been viewed as iconoclastic, trivial pursuits in the face of the harsh realities of the here and now, shaped by colonialism, slavery, servitude, underdevelopment, Jim Crow terror, segregation, violence and repression and a host of inequalities as a consequence of structural inequalities and their legacies of difference, notions of inferiority, and Otherness. However, works in the traditional disciplines of history, political science, and sociology and education, for example, as well as those produced by scholars in interdisciplinary fields like African American Studies, Africana Studies, African and Black Diaspora Studies, Atlantic Studies, Black and Women's Studies have set the record straight regarding the histories of Black experiences, nationally, globally and transnationally and have documented Black contributions to humanity in terms of invention, the arts, culture, science and technology. Considering fictional accounts of Black experiences set in the future

and/or alternative pasts is no longer an aberrant pastime. We wonder about space and time travel, parallel universes, fantastic machines, encounters with other sentient beings, and worlds and galaxies in which Black people are actors, alive and well, indeed thriving in realities very different from the ones in which we live. Under the rubric of Science Fiction (Sci Fi), mainstream media and popular culture, literature, film, and television programming engage us in thinking about "imagined futures in which African descendant people as well as other people of color are neither conspicuously absent nor marginalized as background or expendable characters, but…instead not only present but rather active agents—protagonists and heroes— in events which take place here on the planet Earth or elsewhere in the universe, set in the past, alternative pasts, distant and near future times" (Jackson and Moody-Freeman, 2009, p. 127).

Broadly defined, Science Fiction, a term first used by Robert Heinlein, in his essay, "On Writing of Speculative Fiction," in 1948 (Lilly, 2002, p.1), as a genre is subsumed under the umbrella of speculative fiction, that which includes science fiction, fantastic fiction, horror, supernatural fiction, magical realism, alternative history, apocalyptic and postapocalyptic fiction, utopian and dystopian. According to Shade (2009), in speculative fiction the "action of the story can take place in a [society or] culture that never existed, on a world we know nothing of, or an earth that might have been or might be" (p. 2). The primary question posed by writers of speculative fiction is, what if? Furthermore, there are additional defining characteristics (Shade, p. 2, alluding to Orson Scott Card (1990, p. 17) which include the following: stories that take place in a setting contrary to known reality; are set in the future; are set in the historical past that contradict known facts of history or present alternative scenarios; are set on other worlds; are supposedly set on Earth but contradict known records—stories about ancient aliens and their visits, ancient civilizations, lost kingdoms; contradict known or supposed laws of nature, i.e., time travel; generally take place on worlds that have never existed or are not yet known. David Wyatt (2007, pp. 1–2) adds,

> Speculative fiction is a term which includes all literature that takes place in a universe slightly different from our own. In all its forms it gives authors the ability to ask relevant questions about one's own society in a way that would prove provocative in more mainstream forms.…In all its forms, it is a literature of freedom, freedom for the author to lose the chains of conventional thought, and freedom for the reader to lose themselves in discovery.

Speculative fiction broadly includes science fiction, science fiction mystery and suspense, horror, superhero fiction, utopian and dystopian, apocalyptic and postapocalyptic, and alternative history.

Futurism is a related sub-genre which is future oriented, often involving science, technology and change. The narrative is set in the future, and the conditions that exist are presented as outcomes of current realities and are therefore plausible

in the suspension of disbelief. (Leiss, 1994, pp. 61–71). Afro-futurism, also a sub-genre of science fiction, is a literary and cultural aesthetic which encompasses historical fiction, fantasy and myth, magical realism and draws upon non-Western cosmologies to interrogate and critique current conditions of Black and other people of color to examine the past and envision different futures. More specifically Afro-futurism considers issues of time, technology, culture and race, focusing on Black speculations about the future, foregrounding Black agency and creativity, explored through literature, film, art and music.

Literary Science Fiction has a long history of social commentary and critique about the order of things and social relations, speculation about other possibilities, "growing out of Western experiences, geo-politics and conflicts between nation-states as well as those between governments and their citizens, and responses to social, cultural, [scientific] and technological changes."(Jackson and Moody-Freeman, 2009, p. 128). The beginnings of Science Fiction are reflected in the works of Mary Shelley, *Frankenstein* (1818) and Jules Verne, *Voyage au Centre de la Terre* (1864), and *20,000 Lieues sous les Mers* (1872) and H.G. Wells, *War of the Worlds* (1896). These works explore issues related to science, playing God, poverty and body parts, the monster killing its creator, venturing to the core of the Earth to find a lost and hidden civilization and an environment filled with prehistoric animals, journeying to the bottom of the sea to encounter sea creatures—bizarre, hideously monstrous, dangerous and destructive of gigantic proportions—and an Earth in which Earthlings are besieged by aliens with superior technology bent on eradication of the human race. In these and other works, the focus is on science and transgression of a moral code and ethics, human arrogance, humankind's relationship with nature and imagined past civilizations, as well as virtual war with aliens as symbols of imperialism and militarism in an age of empire. These early works were set in late 19th century England and France and addressed social conditions and issues of the times. Other titles include Samuel Butler's *Erewhon* (1972), Edward Bellamy's *Looking Backward* (1888), and William Morris's, *News from Nowhere* (1890). These texts were written during the early stages of industrialism and explored the issues of tension between the rural and the urban, changing social relations and a nostalgia for halcyon days of uncomplicated life and living. The protagonists were white males and issues of race and gender were not considered nor were they part of the story-line. Racism and sexism were silent and invisible. However, class, social hierarchy, power and privilege were addressed in the works of Huxley, *Brave New World* (1969), and Orwell, *1984* (1948). While Callenbach's *Ecotopia*, (1975) an eco-friendly, egalitarian, non-violent, democratic society, which has seceded from the U.S., led by a woman president, set in the 21st century, does address the issue of race, it is treated in a peculiar manner, drawing upon stereotypes of inner city Blacks. Most Black people do not live in the major centers of the country; instead they have chosen to live in their own part of the country. Written in the 1970s, this book draws

upon notions of the Republic of New Africa, a social movement of the time that called for land in several southern states to be given to Black people to form a separate country.

It is a common assumption that Black Science Fiction writers only emerged in the mid-twentieth century. But Sheree Thomas's *Dark Matter: A Century of Speculative Fiction from the African Diaspora* (2000) and her *Dark Matter: Reading the Bones* (2005) challenge this belief and demonstrate that Black writers produced what we call proto-science fiction works as well as contemporary literature. We say this because such works were written by Black authors who did not self-identify as Science Fiction or Speculative Fiction writers, let alone Futurist. Yet, the conventions that they employed and adapted as well as social commentary, particularly regarding the state of the race, clearly indicate that they were writing works that posited different realities for Black people, with political, social, cultural dynamics contrary to what Black people have experienced historically. Here W.E.B. Du Bois's "The Comet," (1920), Charles W. Chesnutt's "The Goopered Grapevine" (1887), George Schuyler's *Black No More* (1931) come to mind. During the 1920s and 1930s Black writers began to explicitly appropriate Science Fiction conventions and idioms to create works about imagined futures in which Blacks and other people of color were not only present but also agents in their own communities, locally, nationally and globally. Here one can consider *Dark Princess* (1928) by Du Bois and *Black Empire* by George Schuyler (1991). In these works, Black men and women defy stereotypes, are intellectually gifted, and politically savvy. They are subjects. In *Black Princess*, the protagonist engages in Pan-African and culturally diverse global politics and works to bring about change for Black and Brown people around the world. *Black Empire*, which is considered as satire and sarcasm, presents a Black leader one loves to hate, who unifies Black people around the world, fights to liberate Africa, uses advanced technology, draws upon the talents of Black men and women, creates a religious and spiritual community, and rules with a steel fist. Woe to those who challenge him or attempt to defect.

Later, explicitly science and speculative fiction by Black writers include Samuel Delany's "Aye Gomorrah" (2003) and Derrick Bell's "The Space Traders" (1992). These works were followed by numerous books and short stories by Black writers, Octavia Butler, Nalo Hopkinson, Tananarive Due, Steven Barnes, Jewelle Gomez, and Nnedi Okorafor to name a few. Michael Pounds (1999) *Race in Space: the Representation of Ethnicity in* Star Trek *and* Star Trek: The Next Generation, and Adilifu Nama, *Black Space: Imagining Race in Science Fiction Films* (2008) have written insightful critical commentary regarding Black Science Fiction, race and representation in Science Fiction films and television. Marleen Barr's *Afro-Future Females: Black Writers cCart Science Fiction's Newest New Wave Trajectory* (2008) includes essays and interviews by Black Science Fiction writers that discuss sex and gender, real and imagined women. Brooks Landon's *Science Fiction After 1990: From the Steam Man to the Stars* (1995) provides critical commentary about the genre

produced in the late 20th century but only comments on two Black sci fi authors, Butler and Delany much like most sci fi handbooks and readers. *Women of Wonder, the Contemporary Years: Science Fiction by Women from the 1970s to the 1990s* (1995) by Paula Sargent does not discuss works by Black female writers of the genre. *Dark Horizons: Science Fiction and the Dystopian Imagination* (2003) by Rafaella Baccolini and Tom Moylan discusses three white female sci fi writers but no Black writers. Thaler's *Black Atlantic Speculative Fictions* (2010) explores literary and theoretical works in the genre by writers of the Black Diaspora, focusing on the works of three Black women writers, Octavia Butler, Jewelle Gomez, and Nalo Hopkinson. There are numerous other books examining science fiction as a genre, again some of which include commentary about the work of Black writers of science fiction, but most marginalize them, and some do not include any references to them at all, except perhaps in a chapter on race or gender. In this regard, see the following: *Great Themes of Science Fiction: A Study in Imagination and Evolution* (1987) by J. J. Pierce; *A Companion to Science Fiction* (2005) by D. Seed; *The Cambridge Companion to Science Fiction* (2003) by E. James and F. Mendelsohn; *Critical Theory and Science Fiction* (2000) by Carl Freedman; *Speculations on Speculation* by James Gunn and Matthew Candelaria (2004); *Science Fiction, Canonization, Marginalization and the Academy* (2002) by Gary Westfahl and George Slusser; *Reading Science Fiction* by Gunn, Barr, and Candelaria (2008); *Science Fiction: A New Critical Idiom*, second edition (2006) by Robert Adams; *The History of Science Fiction* (2007) by Adam Roberts; *Visions and Revisions (Re) constructing Science Fiction* by Robert M. Philmus (2006); *Archaeologies of the Future: The Desire called Utopia and Other Science Fictions* (2007) by Fredric Jameson; *Battle of the Sexes in Science Fiction* (2002) by Justine Larbalestier; *Worlds Apart: Dualism and Transgression in Contemporary Dystopias* by D. Mohr, D. Palumbo, and C. Sullivan (2005); *Science Fiction* by Roger Luckhurst (2005); *Science Fiction: Its Criticism and Teaching* (2005) by P. Parrinder; *Science Fiction and Empire* (2007) by Patricia Kerslake; *Science Fiction Films* (2001) by J. Tellote and Barry Grant; *Science Fiction and Fantasy Cinema: Classic Films of Horror, Science Fiction and the Supernatural* (2007) by John Howard Reid; *Colonialism and the Emergence of Science Fiction* (2008) by John Rieder; *Science Fiction Handbook* (2009) by M. Booker and Anne-Marie Thomas; *Science Fiction: Classic Stories from the Golden Age of Science Fiction* (2010) by Isaac Asimov.

BLACKS, SCIENCE FICTION, CINEMA AND TELEVISION

Science Fiction films have generally reflected the same proclivities as has Science Fiction literature. In most of the films, the heroes are white males, often in the character of an explorer, scientist or gladiator type who prevails in spite of perceived human limitations and frailty in the face of a powerful and technologically advanced alien intruder or technological threat (e.g., *War of the Worlds, Mission to Mars, The*

Time Machine, The Body Snatchers, Millennium, The Abyss, The Fifth Element, Dark City, The X-Files, Starship Troopers, The Astronaut's Wife, Alien, Species, and *Predator*).

Female lead characters have also been predominantly white, often playing the role of damsel in distress, a love interest, and more recently a warrior, at times with a kick-ass attitude. Regarding the latter, as notable exceptions, consider Sigourney Weaver's role as Lt. Ellen Ripley in the Alien franchise. In the first films, at the end, she saves a child and a cat, and goes one-on-one with an Alien queen and wins; she remains the only survivor of a starship crew who landed on a desolate planet in response to what they thought was a distress call but which was in fact a warning. In one film in the series, she sacrifices herself by leaping into a cauldron of molten flamed steel to kill the Alien fetus within her. Later, in *Alien Resurrection*, through a series of experiments, she is cloned to live and fight for humanity again. There is also Sarah Connor, the mother of the young man destined to be the future leader of humanity, in the Terminator series. She is petite, physically fit and attractive, wears tight tee-shirts, dark jeans, and knows how to use a high powered rifle. In *Terminator 2*, she tracks down the scientist, Miles Dyson, played by Joe Morton, who invented a prototype part for the Terminator series of robots and almost kills him. *Eve of Destruction* (1991) stars Gregory Hines and features a white woman in the lead role as a deadly female cyborg, who does not observe the first law of robotics, the "do not harm humans" override that Arnold Schwarzenegger develops as the male lead in the Terminator film series. She is a new improved, more deadly prototype.

Black women protagonists cast in heroic roles are much more recent, yet rare as in the case of Sanaa Lathan's character, Alexa Woods, in *AVP* (*Alien vs. Predator*, 2004). Of an archeological expedition party of around 20, that gets caught between a war game of Aliens and Predators, she is the last woman standing. Halle Berry plays the character, Storm, in the *X-Men* films (*X-Men*, 2000; *X-Men United*, 2003; and *X-Men the Last Stand*, 2006). While Zoe Saldana is a main character in Cameron's *Avatar* (2010), she is not cast as heroic in that she is more a love interest (a kind of Pocahontas), with the focus on the white male lead and a leader of her race who join forces. In considering films which address women's issues—inequality and patriarchy—there are two which are the most salient: *The Stepford Wives* (2004) and *The Handmaid's Tale* (1999). The former presents a critique of the planned suburban community in which men relegate their wives to the domestic sphere and leaves viewers with the idea that they are indeed replaced by supplicant robots who willingly fulfill their husbands' every desire. When a Black couple joins the community, we see her introduced as an intelligent, independent woman—a writer—who is also slated to be changed. *The Handmaid's Tale* set in a near future postapocalyptic world in which morality has been restored in a society ruled by men, militant Christian theocrats, most humans are sterile, and the responsibility for reproducing the race is delegated to Handmaids who are members of a highly stratified female servant caste. In this film, there are no Black people (or any people of color for that matter) in the film, except seen in fleeting images of unwanted peo-

ple and immigrants presented in blurred images being trucked to who knows where across the border of Gilead.

Regarding Black males as sci fi film protagonists, one of the earliest Black men to be cast in a leading role is Joe Morton in *Brother from Another Planet* (1984), a contemporary allegory about slavery, and a runaway slave chased by inter-galactic slave hunters. Currently, Morton is a member of the core ensemble of actors on the popular television science fiction program *Eureka*, in which he plays a talented scientist, upon whom the community relies heavily for his knowledge and skills. Prior to this in 1980, Billy Dee Williams was cast as Lando Calrissian in *Star Wars: The Empire Strikes Back* and in 1983 he played the same character in *Return of the Jedi*. Earlier in 1977, James Earl Jones "starred" as the voice of Darth Vader in *Star Wars: Episode IV: A New Hope*. In 1999 Ahmed Best was cast as Jar Jar Binks in *Star Wars: Episode I the Phantom Menace*. Samuel Jackson, starred as Mace Windu in *Star Wars: Episode III: Revenge of the Sith* in 2005 and in 2008, he "starred" as the voice of Mace Windu in *Star Wars: the Clone Wars*. Robert Townsend played the lead role in *The Meteor Man* (1993), as a superhero with two Black co-stars, Marla Gibbs and Eddie Griffin. Quite a rare phenomenon. Danny Glover was cast as a police lieutenant who contends with the Predator in *Predator 2* (1990). He is not killed off early and he survives as the victor. Wesley Snipes (*Blade*) plays the role of a vampire who can walk in the sunshine and successfully prevails over other vampires who feed on humans. Laurence Fishburne has played the role of Morpheus in *The Matrix* trilogy (*The Matrix*, 1999, *The Matrix Reloaded*, 2003, and *The Matrix Revolutions*, 2003) and while a lead character, he is in a supportive role to the main character played by Keanu Reeves, a white male who is the *one* to save humanity from the machines in cyberspace. Jada Pinkett, a Black actress, plays an important role in the third installment of *The Matrix* series as a heroic and savvy battle ship captain. However, she is not a main protagonist. The Oracle, who gives cryptic advice to the resistance, is played by Gloria Foster, a Black woman. Here, we note that the author of the *Matrix* story-line is a Black woman who has recently won a suit with a large monetary judgment against the Wachowski brothers. However, for some reason, this has not been widely publicized. Another Black actress, Angela Bassett, starred as a medical officer in *Supernova* (2001).

Other Black actors/actresses have played lead roles in various *Star Trek* Movies: LaVar Burton as Lt. Commander Geordi LaForge in *Star Trek Generations* and *Nemesis*; Micheal Dorn as Lt. Worf, a Klingon in *Star Trek: The Next Generation*; Whoopi Goldberg as Guinan, a bartender and confident of the crew and staff, in *The Next Generation*, and Tim Russ cast as a Vulcan, and a tactical officer in *Star Trek VI: The Undiscovered Country*. Samuel Jackson has played a lead supporting role in *Star Wars: The Clone Wars*. And there is Will Smith who has starred in several science fiction films (the *Wild Wild West*, *I Robot*, *Independence Day*, and *Hancock*—as a superhero who has to regain his mojo) and *Men in Black I* and *Men in Black II*), both as the main character and protagonist and as a main character in a buddy role

to a white co-lead character played by Tommy Lee Jones, in the latter two films. Denzel Washington starred as the protagonist, a time traveler in *Déjà vu*, who returns to the past to prevent a brutal murder. Washington also starred in the recent postapocalyptic film, *The Book of Eli*, a near future narrative, bleak and anarchistically violent with a glimmer of hope. There are a few other science fiction films in which Black characters have been in visible roles; however, in most when they are part of a group, they are either killed off early, or killed off at the end, after having saved the white lead and then sacrificing their own lives voluntarily or involuntarily for others, usually white people. Rarely are they among the last men standing. Never *the* last man standing. Absolutely not the last man standing with a white woman survivor.

Early science fiction television programs prior to the late 20th century, like sci fi cinema, did not focus on issues of race, nor did they include Black characters. During the mid 1900s, few programs began to include Black characters, who were usually in the background and/or in supportive roles. Notable exceptions are the very popular and long running *Star Trek* series and its various iterations, one of which, *Deep Space Nine*, featured Avery Brooks, in the role of Sisko, a Black male starship captain with story-lines not only about encounters with alien races but also about his private life, regarding relationships with his son, and his father, as well as an occasional love interest. In *Star Trek: Voyager*, which features a white woman starship captain, a Black man, Tim Russ, is cast in the role of a high ranking tactical officer, as a Vulcan, a person of a highly rational, scientifically trained race who hold their emotions in check and make decisions usually based on pure logic. Whoopi Goldberg and Micheal Dorn are also featured as core ensemble characters in the series. In *V* (for *Visitors*), there are three Black characters who are part of the resistance against aliens (reptilians clad in humanoid bodies) who purportedly come in peace, but engage in a genodical plot against humanity. Another more recent popular program, *Star Gate 1*(SG-1), includes a Black male character, Teal'c, played by Christopher Judge, who regularly appears. He also directed some of the episodes. *Serenity*, another series, features three Black main characters: two males played by Ron Glass and Chiwetel Ejiofor, and one female. Another popular program, *Lost*, a story about a plane crash and survivors on an otherworldly island on Earth did include Black characters—male and female, but none of them in leading roles. *Eureka*, now in its third season features Joe Morton, as mentioned previously, and in *Warehouse 13*, a Black woman, Carol Christine Hilaria Pounder (C.C. Pounder), plays Mrs. Irene Frederick, the director of the secret organization that houses supernatural artifacts. No current science fiction program has a Black lead protagonist around whom the episodes center .

This book intends to further the conversation and promote dialogue and critical examination about science fiction literature and film, particularly about how imagined futures and the ways in which Black people, issues of representation, issues

of social commentary, and Black agency are portrayed and the treatment of these issues and ideas. Science Fiction by Black writers and films featuring Black characters in leading roles, Futurist and Speculative works add new dimensions about imagined futures, other worlds, alternative histories, and complicate the notions of identity, considering intersectionality regarding race, gender, sexual orientation, otherness, humanness, across time and space. These works decenter whiteness, Eurocentrism, and Western cosmologies and offer new visions of what could come to be. A broad spectrum of perspectives is presented, and different voices comment on the "what if" Black people and their perspectives are central to the narratives about the future, and alternative realities about possibilities for humanity. Topics addressed in this book include the following: AfroFuturist fiction and the future of race; Black superheroes; Octavia Butler's work—feminism and eco-feminist vegan theory; American politics, genocide and possibility of a transformed humanity; the *Star Trek: Deep Space Nine* television series and issues of race and Black masculinity; vampires and motherhood in Jewelle Gomez's "Louisiana 1850"; a techno-utopia, the films of Will Smith; Audre Lorde and a Queer Black Futurism; Nalo Hopkinson's *Midnight Robber,* storytelling technology and connection to community; science fiction in the Caribbean Diaspora.

CHAPTER HIGHLIGHTS

In "The Future of Race in Afro-Futurist Fiction," Madhu Dubey examines how Walter Mosley's *Futureland* (2001) and Andrea Hairston's *Mindscape* (2006) attempt to challenge prior futurist fictions that imagined a "raceless future" yet remain constrained by the indelible force of U.S. racial paradigms. According to Dubey, Mosley and Hairston use obvious markers of race or narrative commentary in their Afrofuturist novels to note some of the obvious ways society racially discriminates. Hairston creates a utopian future society in *Mindscape* that reflects an "ethnic cultural pluralism" that, Dubey argues, uses "ethnicity" and ethnic diversity to replace the "racial essentialists and mono-culturalists" in power. Mosley, on the other hand, depicts a dystopian future with racial binaries intact.

In "Brave Black Worlds: Black Superheroes as Science Fiction Ciphers," Adilifu Nama examines the black superhero in comic books as Afrofuturist characters that challenge our traditional constructions of black identity. Nama's analysis of "T'Challa, the Black Panther superhero of Marvel," for example, reveals how a comic book delves into racial and anticolonial geopolitics in Africa and depicts T'Challa, "the ethical, incorruptible, super-scientist, superb warrior king," who wins "political independence" for the fictive African country Wakanda. He concludes that even though Black superheroes like Storm, Nick Fury, Steel, and T'Challa remain positioned on the margins of the mainstream comic fiction genre, analysis of these char-

acters remains a viable source for representations that produce visions of technologically advanced Black characters who challenge U.S. and European racial and sexual hierarchy.

"'Explorers' *Star Trek: Deep Space Nine*" by Micheal Charles Pounds uses reception, film and television studies as well as semiology to study "Explorers," an episode from *Star Trek: Deep Space Nine*. Pounds argues that this episode and the series itself challenge the original *Star Trek* series and its prior representations of conventional European history and experiences. In this chapter, he illustrates how the inclusion of Sisko, the series' black Starfleet captain in *Deep Space Nine* for the first time provided a venue for the introduction of African Diasporic history. Analyzing "Explorers," an episode in which Sisko re-enacts the first voyage of the Bajorans to Cardassia, Pounds argues that this fictive voyage by the descendant of Africans introduced viewers to an alternative history of exploration and discovery that privileges actual African voyages to the pre-Columbian Americas. He concludes that in doing this, this episode imagines an African origin that went unacknowledged in prior iterations of the *Star Trek* franchise.

Alisa Braithwaite's chapter "Connecting to a Future Community: Storytelling, the Database, and Nalo Hopkinson's *Midnight Robber*" considers the implications of technology and the database on narrative voice, agency, Black human subjectivity as well as on Hopkinson's literary and editorial contributions to constructing a Caribbean/African Diasporic Speculative Fiction database. Reading the speculative novel through the lens of Brent Hayes Edwards' concept of the Diaspora as *décalage*, Braithwaite argues that Hopkinson's depiction of Toussaint and the Marryshevites does not attempt to create a utopic homeland. Instead Granny Nanny, the computer interface, connects, like the Caribbean region itself does, Caribbean people who speak varying dialects as well as communities that extend into outer space. Analyzing Hopkinson's *Midnight Robber*, Braithwaite thus focuses on the oral/aural aspect of the database in *Midnight Robber* and examines the emphasis Hopkinson places on the "human element" in her novel, even as she constructs a narrative narrated by a computer database, Grande Nanotech Sentient Interface (aka Granny Nanny). As well, she argues that in light of slavery, colonization, and Caribbean literary struggles to record the histories and voices of Caribbean people, Hopkinson's novel's "digital storyteller," (i.e., her computer generated Caribbean database) expands the Speculative Fiction genre by re-imagining who and what narrators might be or sound like. For Braithwaite, Hopkinson's novel, therefore, imagines how symbiosis between humans and technology might benefit humanity.

"Science Fiction, Feminism, and Blackness: The Multifaceted Import of Octavia Butler's Work" by Shannon Gibney examines Butler and her writings through three paradigms: as a Black writer, a science fiction writer, and as a feminist science fiction writer. Gibney argues that Butler's characters challenge prescriptive racial categories of the Black Arts Movement. In addition, her work is distinct

from Black American literature for Butler's fiction focuses on representations of the human species' desire for "hierarchy and power" irregardless of race. Furthermore, Butler's science fiction works challenge mainstream Science Fiction groups and SF feminists to address issues of race, class, gender, and sexuality in their works, which has in turn given weight to cultural issues more than to just technology. As a result, Gibney argues, although Butler disliked labeling, when Butler's writings are examined in the contexts of other literary groups, one can clearly see how they have "[...] forced many communities to radically revise their understanding of art, ideology, and identity."

In "The Absence of Meat in Oankali Dietary Philosophy: An Eco-Feminist-Vegan Analysis of Octavia Butler's *Dawn*," Amie Breeze Harper argues that Butler's sci-fi novel links the consumption of meat to the violent sexual consumption of women's bodies in the West. Examining *Dawn* using ecofeminist vegan theory, Harper contextualizes the novel through 1980s social and political history and argues that the novel published in 1987 not only signifies upon the decade's obsession with beef eating but sees a cause and effect relationship between meat consumption and the dominant militarism of the eighties as the U.S. and USSR competed in a nuclear race to position themselves for global domination. For Harper, Butler's depiction of Lilith—a Black woman who adopts Oankali, an alien races, vegan practices and symbiotic ways of living—provided an alternative vision of the stereotypical images of blackness and black womanhood as an avid consumer of chicken, as solely heterosexual, as subservient and partnering only with Black men. Instead, Lilith, partners with a Chinese male, and she is depicted as a leader that will lead a "new species" of humans who follow vegan nonviolent practices and create an interspecies community. Harper posits that this novel's ecofeminist vegan focus revolutionizes the science fiction and speculative fiction genre to move beyond binaries, Westernized polemical thinking, and to think about the interrelationship among gender, food consumption, healing practices, and social justice.

In "Speculative Poetics: Audre Lorde as Prologue for Queer Black Futurism," Alexis Pauline Gumbs' rereading of Lorde's "Prologue" reveals the "speculative poetics" that shape the vampire subject who has not only "haunted" Jewelle Gomez *The Gilda Stories* but also Octavia Butler's vampire novel *Fledgling*. She offers up Lorde's "Prologue" as evidence of how speculative fiction can be utilized to disrupt other limiting dominant forms of fiction and movements. Gumbs argues that Lorde's vampiric poetic subject offers a narrative vision of a utopic Black future that refuses to replicate the heteropatriarchy of the Black Arts Movement, of which she was not only a member but also an active writer for their publication, Broadside Press. Using "black maternity," "queer intergenerationality," and the vampire figure, Gumbs illustrates how Lorde produces a Black futurist work that uses the contradictory figure of undead black vampire womanhood as lens to imagine a future that affirms Blackness without the violence, oppression, and limiting subjectivities affirmed in the past.

If, as Alexis Pauline Gumbs asserts, Audre Lorde's introduction of the specu-lative genres of utopia and horror into her poetry affirmed a new vision of "vam-pire subjectivity as a Black feminist futurist" that made possible "Black feminist speculative and fantasy authors to *speculate* on spectral meanings of life," Marie Luise-Loeffler illustrates the implications of this "queer intergerationality" through her analysis of the "maternal vampire" in Jewelle Gomez's *The Gilda Stories*. In, "'Why white people feel they got to mark us?'—Bodily Inscription, Healing, and Maternal 'Plots of Power' in Jewelle Gomez's 'Louisiana 1850'," Loeffler classifies Gomez's short story under the category of "plots of power" precisely because the writer's depiction of women as vampires produces a story in which Black women gain control over their lives, particularly in the context of slavery, a white patriar-chal institution that violently restricted the body of their lives. Furthermore, Loeffler in, "Louisiana 1850" "rewrite[s] conventional (white, male) speculative fiction in gen-eral and vampire fiction" by focusing her plot solely around Bird and the Girl who share an interracial mother-daughter relationship and exchange life-giving blood that allows them the autonomy to "transgress *any* spatial (and even temporal) boundaries held in place within a white hegemonic society."

Brandon Kempner provides a critical analysis of Walter Mosley's Afrofuturist novel *The Wave* in the context of his philosophical works *What Next* (2003) and *Life out of Context* (2006) on post-9/11 racial geopolitics. In his analysis of the novel, about a harmless alien race violently persecuted by the United States government, Kempner argues that Mosley forces readers to consider the parallels between "the patriotic American context of "destroy the invader" in the novel and "America's irre-sponsible, violent, and indefensible actions since the 9/11 attacks." According to Kempner, Mosley's depiction of Errol, a Black man, who defies the U.S. government in order to prevent their extermination of the aliens, becomes the writer's symbol-ic act to use the science fiction genre as a vehicle to force readers to imagine "new contexts" and a different "America ideology." For Kempner, Mosley's central focus in the novel on Errol's defiance of the U.S. government's militarism is important to note, for Mosley's non-fiction writing articulates his views that "the unique social, economic, and historical experiences" of Blacks in the United States positions them to potentially offer alternative ideologies that counter American unilateral-ism and its us and them philosophy.

Debbie Olson's "Techno- Utopia and The Search for Saaraba (1989)" exam-ines Amadou Saalam Seck's film *Saaraba*. Olson argues that *Saaraba*'s representa-tion of technology in Africa challenges Western films that present technology as the path to utopia. For Olson, this African film distinguishes between "the isola-tion and distraction of modernity" and "family-centered, traditional society." *Saaraba* tries to negotiate a "healthy balance" between tradition and modernity. She argues that in the film, tradition is not always the substitute for technolog,y and "It is the lack of access to those technologies that the film criticizes." Olson concludes that

Amadou Saalam Seck's representation of Africa refutes the belief that modernity can only be achieved through Western technology and instead depicts an Africa that privileges "a cultural balance [...] between science/technology and humanity/community."

Stephanie Larrieux's "Towards a Black Science Fiction Cinema: The Slippery Signifier of Race and the Films of Will Smith" addresses the contradictory Black subjectivity in Will Smith's films. Larrieux examines the paradox of Will Smith's science fiction film repertoire by arguing that Will Smith's clearly articulated mission to depict positive Black images produces "race neutral" colorblind characters. The chapter studies Smith's sci-fi films and his characterizations of Hancock, Robert Neville, Del Spooner, Jim West, Agent J, and Steven Hiller. Larrieux argues that to enact his "race consciousness" mission, Smith's performances produce his "brand of Black subjectivity" in the trope of the Black hero as "savior of the world" and reproduce Hollywood representations of the blackness as the archetypal "cool guy persona." Given the blockbuster success of these sci-fi films with a Black lead character, Larrieux concludes that Smith's films have contributed to the science fiction genre and to Black science fiction film, yet to an extent these representations of colorblind characters maintain Hollywood's non-threatening representations of Black subjectivity.

REFERENCES

Asimov, I. (2010). *Science fiction: Classic stories from the golden age of science fiction.* Aptos, CA: Galahad.

Baccolini, R., & Moylan, T. (2003). *Dark horizons: Science fiction and the dystopian imagination.* New York: Routledge.

Barr, M. (2008). *Afro-future females: Black writers chart science fiction's newest new wave trajectory.* Columbus, OH: Ohio State University Press.

Bell, D. (1992). *The space traders. Faces at the bottom of the well: The permanence of racism.* New York: Basic.

Booker, M. K., & Thomas, A. -M. (2009). *Science fiction handbook.* Hoboken, NJ: Wiley-Blackwell.

Card, O. S. (1990). *How to write science fiction and fantasy.* Cincinnati: Writer's Digest.

Delany, S. (2003). *Aye, and Gomorrah: And other stories.* New York: Vintage.

Freedman, C. (2000). *Critical theory and science fiction.* Middletown, CT: Wesleyan University Press.

Gunn, J., & Candelaria, M. (2004). *Speculations on speculation.* Lanham, MD: Scarecrow.

Gunn, J., Barr, M. S., & Candelaria, M. (Eds.). (2008). *Reading science fiction.* Hampshire, UK: Palgrave Macmillan.

Jackson, S., & Moody-Freeman, J. (Guest Eds.). (2009, May). Editorial Note. *African Identities: The Black Imagination and Science Fiction.* Special Issue. 7(2). 127–132.

James, E., & Mendlesohn, F. (2003). *The Cambridge companion to science fiction.* Cambridge: Cambridge University Press.

Jameson, F. (2007). *Archaeologies of the future: The desire called Utopia and other science fictions.* New York: Verso.

Kerslake, P. (2007). *Science fiction and empire.* Liverpool, UK: Liverpool University Press.

Landon, B. (1995). *Science fiction after 1900: From the steam man to the stars* (Genres in Context). New York: Routledge.

Larbalestier, J. (2002). *Battle of the sexes in science fiction*. Middletown, CT: Wesleyan University Press.

Leiss, W. (1994). *Of the domination of nature*, (Chapter 3, pp. 61–71). Montreal, QC: McGill Queen University.

Lilly, N. E. (2002, March). What is speculative fiction? Green tentacles. (pp. 1–6). Retrieved from http://www.greententacles.com/articles/5/26.

Luckhurst, R. (2005). *Science fiction*. Malden, MA: Polity.

Mohr, D., Palumbo D., & Sullivan, C.W. III. (2005). *Worlds apart: Dualism and transgression in contemporary dystopias*. Jefferson, NC: McFarland.

Nama, A. (2008). *Black space: Imagining race in science fiction films*. Austin, TX: University of Texas Press.

Parrinder, P. (2005). *Science fiction: Its criticism and teaching*. New York: Routledge.

Philmus, R. M. (2006). *Visions and revisions (re) constructing science fiction*. Liverpool, UK: Liverpool University Press.

Pierce, J. J. (1987). *Great themes of science fiction: A study in imagination and evolution (contributions to the study of science fiction and fantasy)*. Santa Barbara, CA: Greenwood.

Pounds, M. (1999). *Race in space: The representation of ethnicity in* Star Trek *and* Star Trek: The next generation. Lanham, MD: Scarecrow.

Reid H. J. (2007). Science fiction and fantasy cinema: Classic films of horror, science fiction and the supernatural. Lulu.com

Rieder, J. (2008). *Colonialism and the emergence of science fiction*. Middletown, CT: Wesleyan University.

Roberts, Adam. (2007). *History of science fiction*. New York: Palgrave.

Roberts, Adam. (2006). *Science fiction (the new critical idiom)*. New York: Routledge.

Sargent, P. (1995). *Women of wonder, the contemporary years: Science fiction by women from the 1970s to the 1990s*. New York: Mariner.

Seed, D. (2005). *A companion to science fiction*. Hoboken, NJ: Wiley-Blackwell.

Shade, D.D. *What is Speculative Fiction?* (2009). Lost Books Archives, 1–8. Retrieved from http://www.lostbooks.org/speculative-fiction.html

Telotte, J. P., & Grant, B. (2001). *Science fiction film*. Cambridge, UK: Cambridge University Press.

Thaler, I. (2010). *Black Atlantic speculative fictions: Octavia E. Butler, Jewelle Gomez, and Nalo Hopkinson*. New York: Routledge.

Thomas, S.R. (2000). *Dark matter: A century of speculative fiction from the African diaspora*. New York: Warner Books.

Thomas. S.R. (2005) *Dark matter: reading the bones*. New York: Warner Books.

Westfahl, G., & Slusser, G. (2002). *Science fiction, canonization, marginalization and the academy*. Santa Barbara, CA: Greenwood.

Wyatt, D. (2007, December 10). Speculative fiction, in context science fiction. Retrieved from http://contextsf.org/blog/207/12/speculative-fiction.html

The Future of Race in Afro-Futurist Fiction

MADHU DUBEY

DURING THE 1990S, "BLACK TO THE FUTURE" APPEARED AS THE TITLE PHRASE of two pieces of writing concerned, ironically, with the question of why blackness (in the sense of a racial designation) has been so antithetical to the futurist imagination in the United States. Cultural critic Mark Dery's "Black to the Future: Interviews with Samuel R. Delany, Greg Tate, and Tricia Rose," originally published in 1993, and Walter Mosley's short essay "Black to the Future," published in *The New York Times Magazine* in 1998, puzzle over the shortage of African American writers of science fiction. Dery cites a speech Samuel Delany, the most prolific African American writer of science fiction, gave at the Studio Museum of Harlem in which he said, "We need images of tomorrow, and our people need them more than most" (Dery, 1994: 190). However, Delany explains to Dery, the futuristic imagination has historically been "so impoverished" among African American writers "because, until fairly recently, as a people we were systematically forbidden any images of our past" (190–191). The "massive cultural destruction" caused by slavery (191) goes a long way toward explaining the historical rather than speculative bent of the African American literary imagination.

Walter Mosley as well takes slavery as the point of departure for his essay: "Black people have been cut off from their African ancestry by the scythe of slavery and from an American heritage by being excluded from history." But for Mosley, such violent historical dislocation should in fact draw African American

writers to science fiction, a genre that "allows history to be rewritten or ignored" and "promises a future full of possibility" (Mosley, 1998: 32). One reason speculative or futuristic impulses have been inhibited among African American writers is that they have been obliged to approach literature as a realist medium of racial protest: "So if Black writers wanted to branch out past the realism of racism and race, they were curtailed by their own desire to document the crimes of America. A further deterrent was the white literary establishment's desire for Blacks to write about being black in a white world, a limitation imposed upon a limitation" (34). If we follow Mosley's logic here, race has doubly constrained the African American literary imagination. The first limitation is the imputed reality of race as an axis of social stratification, which is compounded by the expectation that African American literature should centrally address this reality. The task of cataloguing the horrors of actually existing racism has confined African American writers to realist literary genres and discouraged them from envisioning alternative futures.

Mosley's contention that race operates as a brake on the speculative imagination applies not only to African American literature but also to mainstream American strains of futurism, helping to account for the racially unmarked futures projected in so much twentieth-century U.S. science fiction. If the problem of the twentieth century is the problem of the color line, as W. E. B. Du Bois famously asserted, this problem seemed so intractable that racial difference had to be banished altogether from fictive visions of desirable future societies. Some critics have regarded the raceless futures of U.S. science fiction as evidence of the socially progressive tendencies of the genre. For example, Robert Scholes remarks that the genre has been "advanced in its treatment of race and race relations. Because of their orientation toward the future, science fiction writers frequently assumed that America's major problem in this area—black/white relations—would improve or even wither away" (Scholes and Rabkin, 1977: 187–188). In response to Scholes, Sandra Govan, one of the earliest critics to write on science fiction by African American authors, astutely points out that the erasure of racial distinctions in science-fictional images of future societies might be indicative of an evasion of the race problem rather than a solution (Govan, 1984: 44). Racial distinctions in science fiction are often eclipsed by human-alien encounters that provoke the solidarity of humanity in response to the threat of alien others. In her ironic sketch of this stock science-fiction scenario, Octavia Butler writes that the "affront" to human essence posed by alien species serves to "bring us together, all human, all much more alike than different....Humanity, *E pluribus unum* at last" (Butler, 2000: 416). Aside from the fact that human-alien encounters in U.S. science fiction often work as narrative mechanisms for displacing racial difference,[1] the humanism shored up against alien others in science fiction is not so much raceless as racially unmarked or, in other words, covertly racialized as white.

The "blanching of the future," in Gregory Rutledge's phrase (Rutledge, 2001: 239), has functioned in various ways to discourage African American writers from laying claim to the futuristic imagination. The most daunting problem has been lack of access to the cultural industries that manufacture and distribute futurist fantasies. The "unreal estate of the future," as Mark Dery points out, is "owned by the technocrats, futurologists, streamliners, and set designers" who have been "white to a man" (Dery, 1994: 180). The problem of access has been exacerbated in the genre of hard science fiction, in which the future is actualized by means of advanced (albeit often fanciful) technologies. In his interview with Dery, Samuel Delany remarks that it is easy to understand the relative scarcity of African American readers and writers of science fiction: "The flashing lights, the dials, and the rest of the imagistic paraphernalia of science fiction functioned as social signs—signs people learned to read very quickly. They signaled technology. And technology was like a placard on the door saying, 'Boys Club! Girls, keep out. Blacks and Hispanics and the poor in general, go away!'" (Dery, 1994: 188). Delany's remarks clearly indicate the semiotic as well as material dimensions of the problem of technological access. Until very recently, African Americans in particular were racially coded as the primitive others of scientific rationality and technological progress.[2] Focusing on late twentieth-century discourses on digital technology, Alondra Nelson identifies two prominent trends that symbolically bar African Americans from the turf of cyber-futurism: utopian visions that are coded as raceless and dystopian models of a racialized 'digital divide.'[3] In spite of their apparent differences, both share the tacit assumption "that race is a liability in the twentieth century" (Nelson, 2002: 1). Left behind or belated, blackness gets configured as "always oppositional to technologically driven chronicles of progress" (Nelson, 2002: 1), as the "primitiveness or outmodedness" that throws into bold relief the technological cutting edge of the future (Nelson, 2002: 6).

Afrofuturism emerged at the turn of the twenty-first century in reaction against precisely this sort of conception of blackness as the residual remnant of the past. Mark Dery coined the term 'Afrofuturism' in 1993 to refer to African American artists (musicians, filmmakers, writers, visual artists, among others) who "have other stories to tell about culture, technology, and things to come" (Dery, 1994: 182). Dery wrote that "Speculative fiction that treats African-American themes and addresses African-American concerns in the context of twentieth-century techno-culture—and, more generally, African-American signification that appropriates images of technology and a prosthetically enhanced future—might, for want of a better term, be called 'Afrofuturism'" (180). In 1998, Alondra Nelson founded an online community under the umbrella term AfroFuturism to initiate and sustain discussions of "sci-fi imagery, futurist themes, and technological innovation in the African diaspora" (Nelson, 2002: 9). Flashes of Afrofuturism are visible in early-

twentieth century works such as Edward Jones's *Light Ahead for the Negro* (1904), W.E.B. Du Bois's short story "The Comet" (1920), and George Schuyler's satirical novels *Black No More* (1931) and *Black Empire* (serialized between 1936 and 1938), which imagine various resolutions to America's race problem by means of science or technology. During the 1960s and '70s, the two most critically acclaimed African American writers of science fiction, Octavia Butler and Samuel Delany, began to publish novels, set in the future, that explore the utopian promise as well as the dangers of technology. But the phenomenon of Afrofuturism began to gain critical mass only in the last decade of the twentieth century, which witnessed an explosion of futuristic works by writers and artists including Stephen Barnes, LeVar Burton, Kodwo Eshun, Nalo Hopkinson, and Paul D. Miller.

In this chapter, I will focus on two recent novels, Walter Mosley's *Futureland* (2001) and Andrea Hairston's *Mindscape* (2006), which explicitly engage with the racial dimensions of technological futurism. Inventing worlds in which accelerated leaps in technology are radically refashioning human corporeality and identity, Hairston and Mosley pose a cluster of perplexing questions about the future trajectory of race: Are the historically calcified meanings of race being dislodged or reinforced by recent developments in cyber and bio-technology? Does the fraught history of race in the United States block the desire to imagine utopian future societies? Which concepts of race are best relegated to the past and which, if any, are worth carrying into the future? Such questions about the past and future of race are especially pertinent and pressing at the turn of the twenty-first century, which marks a crucial moment of transition in U.S. racial history. Hairston and Mosley critically engage with contentious late-twentieth century discourses about race by displacing them to an unfamiliar future. While their novels project sharply different visions of future societies—a utopian world of multiracial cooperation in *Mindscape* and a dystopian scenario of race war in *Futureland*—both writers militate against the facile assumption that credible new worlds are best imagined by simply wishing away the historical legacy of race.

Hairston and Mosley explicitly take on the paradigm of the raceless future through their representations of future societies that mark progress as a measure of their transcendence of race. Set in a distant future, *Mindscape* depicts a world divided into three warring zones by an epi-dimensional Barrier that functions as a psychic as well as material boundary. One of these three zones or social orders, named Paradigma, is a technocratic, capitalist society driven by the values of "Civilization, democracy, free market, and science" (Hairston, 2006: 190). An obvious symbol of a modern liberal state, Paradigma has outlawed "petty ethnicities" and racially specific vernaculars and cultural traditions, which are deemed to be "obsolete" (185). Mosley's *Futureland*, a collection of stories set mostly in New York City in the near future, similarly depicts a society in which race-blindness is vaunted as

the official state policy. In Mosley's rendering of the United States in the future, "It's a punishable offense to slander race" in the media and "racial image profiling had been a broadcast offense for more than two decades" (Mosley, 2001: 374, 345). Hairston briefly alludes to Paradigma's commitment to "liberal justice" (284), a putatively race-blind ideal that Mosley's novel fleshes out through its futuristic construct of an automated justice system made up of electronic judges and juries. By means of automation, justice is said to have "become an objective reality for the first time in the history of courts" (226). Universal fairness is guaranteed by the fact that the justice system is a technological artifact that supersedes the embodied particularities of race and gender. In the automated court, Justice appears as a digital image of a human being "whose color and features defied racial identification" (240). Although the Judge is gendered as masculine, he claims to be "superior to flesh and blood" (232); his indifference to "race or sex" (229) presumably enables him to consider nothing but the facts of each case. Because it is presented as a futuristic technology, Mosley's construct of an automated court defamiliarizes and thereby exhibits all the more sharply the racialized operations of the justice system in the present-day United States. Although the digitized, deracialized Judge supposedly actualizes the egalitarian principles underlying liberal justice, the prisoners in Mosley's future society (as in our present) are disproportionately Black.

The target of Mosley's critique here is not only the spuriously universalist claims that have masked the racialized workings of liberal justice but also a broader tendency within futurist fiction to identify the raced body as a thing of the past. The digital court seemingly perfects a disembodied ideal common to many varieties of techno-futurism, perhaps none more so than cyberpunk fiction, which typically devalues the body as a hindrance to be discarded with the aid of digital technologies. Several stories in *Futureland* acknowledge the advantages of cyberpunk's disembodying drive: digital literacy affords Mosley's disempowered characters their only sense of mobility and control in a material world that is rigidly stratified by race and class divisions. Most of the characters in *Futureland* who heroically subvert the seemingly absolute power of multinational corporations are African American hackers, including Bits, the "hijacker" who uses a virus program to hijack a prison database and free the prisoners although he himself survives only as a disembodied spirit trapped in cyberspace. The most inventive hacker hero in Mosley's text is Ptolemy Bent, who uses his technological expertise to 'save' Africa and avert global Black genocide. But, as revealed in the opening story of the collection, the cost of Ptolemy's genius and success in the cyber-sphere is the literal dismemberment of his uncle, who had to sell his limbs and organs to pay for Ptolemy's education in computer literacy. The mutilation and sale of Black body parts occur with alarming frequency in the future worlds of Afro-diasporic speculative fiction, notably LeVar Burton's *Aftermath* (1996) and Nalo Hopkinson's *Brown Girl in the Ring*

(1998), which, along with Mosley's text, suggest that corporeal transcendence is not so easily available to people of African descent, whose value has historically been reduced to the price of their bodies.

In *Mindscape* as well, Hairston exposes the racial subtext of those versions of technological futurism that entail a disembodying logic, although in this case it is biological rather than cyber technologies that project the promise of overcoming corporeal limitations. In the world of Hairston's novel, genetic modification allows human beings to reinvent their bodies, thereby reconstituting race and gender as matters of consumer choice. A striking example is film director Aaron, described as a "post-op transracial" who transformed himself from a poor Black woman into a pale man with blue eyes (121). Considering that it takes pale skin and blue eyes to become trans-racial, the novel shows that paradigms of the raceless future enabled by technology insidiously promote whiteness as the measure of humanity. Although advances in genetic engineering make it possible for individuals in *Mindscape* to select any skin color, few trans-racials choose to "go black" (122), ensuring that the "default settin' for humanity" remains "white" (153). Under this dispensation, people of other races are perceived either as inhuman aberrations—"aliens" or "freaks of nature" (153)—or as regressive holdovers from the past. Not coincidentally, an African American character such as Lawanda Kitt, who refuses to de-racialize herself, is associated with the "dark ages," the "past we left behind" (108), reprising long-familiar narratives of Western progress that relegate people of African descent to a primitivized past.

In Hairston's fictive world of Paradigma, which has officially eradicated racial difference, those who choose to retain the cultural practices specific to their racial groups are derided as "Ethnic Throwbacks," including not only African Americans who still like to sing the blues or speak in the Black urban vernacular of the late-twentieth century but also other racial and ethnic groups who betray any attachment to the past, such as the Born-Again Sioux, whose ceremonies in remembrance of bygone ancestors are dismissed as a "retro death cult" (55). Hairston's term, Ethnic Throwback, precisely captures the residual logic assigned to race in techno-futuristic conceptions of progress. While in *Mindscape*, such conceptions are aligned with the liberal democracy of Paradigma, Mosley provides an example from an entirely different point of the political spectrum. The International Socialist Party, commonly known as Itsies, excludes Jews from party membership because Jewish people cling to "primitive notions of how the world should be organized," based on the "deep symbolic knowledge [they] have hoarded over the last six thousand years" (142). Once again, racialized forms of knowledge and culture are construed as stubborn remnants of an ancient history that must be left behind in the name of progress. The Itsies conceptualize the future of the human race through scientific models of social evolution, models they insist on describing as "not racist" but simply progres-

sive: their disqualification of Jews is necessitated by the demands of being "modernists in a modern world" (142).

By inventing a fictive world in which Jewish people are identified as the counter-progressive element and in which the promise of the future is exemplified by a techno-vanguard group dominated by African American hackers, Mosley playfully subverts the more common tendency to identify blackness as the polar opposite of futurity. Alondra Nelson argues that Afrofuturism "looks backward *and* forward" at once, "asks what was *and* what is" (4) in the service of alternative notions of futurity that are not defined in contrast to a racialized past. Hairston's novel takes exactly this kind of Afrofuturist approach as it reveals the importance of history to any credible vision of future transformation. Lawanda Kitt proudly claims the label of Ethnic Throwback, resignifying it to express her "intense relation to history" (128) as well as her ambition to "turn the tides of history" (37). Lawanda values history not out of a nostalgic impulse to sanctify a dead past but rather as a vital resource for imagining and realizing a new future. Refusing to situate past and progress, race and futurity in categorically antithetical terms, Hairston presents Ethnic Throwbacks such as Lawanda Kitt and the Born-Again Sioux as active agents of social and political change, as the bearers of a vision of futurity that is informed by history.

In disputing the paradigm of the raceless future, Hairston and Mosley are, of course, conducting an oblique quarrel with the present—more specifically, with the racial common sense of American public discourse at the end of the twentieth century. In keeping with the distinctive temporality of science fiction, which heightens critical understanding of contemporaneous social reality by disfiguring it as a possible future, Hairston and Mosley invent future social orders—ostensibly race-neutral but in fact deeply stratified by race—that render, with some "significant distortion," the U.S. racial order of the post-Civil Rights era.[4] As numerous scholars have observed, the end of the Civil Rights movement was widely hailed as the successful completion of a long history of struggle against racial inequality and as the dawn of a new, post-racial future. The claim that Civil Rights legislations of the mid-1960s had eliminated racial discrimination was used to discredit all further talk of racism and to justify a widespread "retreat from race" across the political spectrum (Steinberg, 2000: 37). Any race-specific policies, especially those (such as affirmative action) designed to rectify historically sedimented patterns of racial discrimination, were construed as evidence of racism, which was systematically reframed by the 1980s to refer to any institutional consideration of race. Angela Davis's remark that "many of us who persist in raising charges of racism…are regarded as relics from the past" (Davis, 1996: 44) captures the willful historical amnesia of post-racial discourses in the decades following the Civil Rights movement.

Concluding their influential discussion of the reaction against race that set in during the 1980s, Michael Omi and Howard Winant insist on two interrelated points: that despite significant progress, "it is implausible to believe that racism is a thing of the past" (1994: 157) and that "opposing racism requires that we notice race" (159). One of the most immediate ways in which Hairston and Mosley contend with the rhetoric of race-blindness (whether situated in the real-world present or the speculative future) is by pointedly introducing all significant characters with racial markers, thereby forcing readers to notice race. In addition to this simple but effective device, both writers also persistently highlight the continuing reality of racism in their fictive future worlds. Mosley intersperses his text with racial statistics—such as, for example, about the proportion of black people in prisons—delivered in the authoritative and neutral voice of third-person omniscient narration. Hairston takes a more explicit approach, as characters often seem to break out of the narrative flow to refute spurious claims of race-blindness. For instance, when confronted with Lawanda Kitt's talk about racism, a military officer of Paradigma at first voices his skepticism about "petty racial politics" that involve playing "the old race card" (130). But the Major, who has thus far been characterized as an exemplary citizen and representative of the liberal state that takes pride in its indifference to race, then goes on to say that "we should never underestimate 'the persistence of the old regime.'…We may no longer believe in 'race' as a significant human category, nevertheless we continue with our racist practices" (130–131). The repeated emphasis on the long afterlife of the "old" racial regime challenges both the historical amnesia and the dichotomous relation between racist past and raceless present that characterized U.S. public discourse about race in the late twentieth century.

The fact that the term *race* appears in scare quotes in the passage cited above attests to the confusion surrounding the category in the post-Civil Rights decades. Establishing the continuing significance of race as a socio-political construct rather than a biological reality (which is the meaning generally intended by the use of scare quotes) still leaves open the question of how exactly race continues to matter. Writing in the aftermath of the Civil Rights movement, which legally brought an end to the Jim Crow era in which all African Americans were subject to state-sanctioned racial discrimination, authors such as Hairston and Mosley can no longer confidently identify race as the primary axis of inequality. If the U.S. concept of race went through a "paradigm shift" during and immediately after the Civil Rights movement, as Omi and Winant claim (1994: 95), Hairston betrays some uncertainty in her effort to grasp this shift. The workings of race in relation to political and economic inequality appear to be locally variable in the fictive world of the novel, so that while the "distribution of wealth and power in Paradigma is still mildly correlated with color" (131), this is not so clear in Los Santos, a different zone dominated by Latino gang-lords. Perhaps the most grimly memorable invention in

Hairston's novel is a besieged population known as Extras, a surplus group subject to gruesome bodily assaults that include gang-rape, organ trading, and film snuff takes. Given that Extras are the most vulnerable group in the novel, readers might be disappointed by Hairston's deliberate vagueness about the group's demographic profile. The novel includes but refuses to adjudicate between two conflicting accounts of the correlation between race and Extra status. According to hearsay and local knowledge, "dusky" people are over-represented among Extras, but official narratives describe the process of becoming an Extra as a purely random phenomenon: "ANYBODY could end up" as an Extra, regardless of wealth, race, gender, and heredity (122). Based on information reserves maintained by the state of Paradigma, "it would be impossible to analyze the relationship of an individual's 'color' to frequency on Death Percent List" (130), or a list of Extras condemned to being snuffed out. Suggesting that the causal or correlative significance of race is often hard to prove or quantify, Hairston's equivocal portrayal of Extras reveals the difficulty of establishing racial injury within the color-blind parameters of post-Civil Rights era racial ideology.

Taking a different approach, Mosley obviates the question of causal primacy by showing that racial differences crucially serve to rationalize and reproduce the inequitable social order of global capitalism. In *Futureland*, the group most closely akin to Extras is called White Noise, a surplus population consigned by the state to permanent unemployment and forced to live in Common Ground, an underground public homestead. Unlike Hairston, Mosley is quite clear about the importance of race to the distribution of inequality: "The weight of poverty, the failure of justice, came down on the heads of dark people around the globe. Capitalism along with technology had assured a perpetual white upper class" (75). In the U.S. national context of Mosley's novel, these "dark people" who bear the brunt of poverty are disproportionately black, although this picture gets more complicated at the global scale. Along with White Noise, a group strikingly reminiscent of the category of the Black urban 'underclass' that was manufactured by social scientists, public policy makers, and the media during the 1980s, the other brutally oppressed population in Mosley's novel consists of prods, a class of people subject to forms of labor exploitation akin to slavery. As indentured servants and debt slaves to multinational corporations, prods sell their labor in exchange for room, board, and medicine. With labor camps established in the U.S. as well as in strategic locations around the 'Third World,' the racial category of "dark people" gets rearticulated to include Peruvians and Middle Easterners along with Ugandans and African Americans. By likening corporate practices of neo-slavery to American chattel slavery, Mosley reveals the resilient and historically variable processes of racialization that legitimize capitalist exploitation of certain populations. Highlighting the instrumentality of race to capitalist social stratification, Mosley bypasses misguid-

ed arguments about the relative causal primacy of race or class, arguments often meant to demonstrate the "declining significance of race" in the post-Civil Rights period (Wilson, 1978).[5]

While it is important to recognize that, under the guise of imagining the future, Mosley and Hairston engage in a vigorous critique of the present as they dispute various influential racial discourses of their time, equally important is the fact that both writers are also deeply interested in imagining possible or unlikely futures. If we attend closely to this speculative dimension of their texts, the important question then becomes: If the raceless future is implausible (even in the context of a genre such as speculative fiction that is meant to exceed the horizon of realist possibility), what notions of race, if any, may survive in the future? This question is quite easy to answer in the case of Hairston's novel, which concludes with the achievement of a utopian new world. The cast of characters who help to bring about the new world order consists of "colored folk" (153), a category that includes African American, Latino, Native American and Middle Eastern people, but there is no place for racial distinctions in this order except insofar as they can be translated into cultural differences. Significantly, the Throwbacks who thrive in the future world of the novel are described as ethnic rather than racial, with the category of ethnicity enabling Hairston to shed the concept of race, with all its attendant baggage of biological determinism and social ascription, in favor of group identity understood as a matter of cultural choice. Lawanda, the character who most often serves as the author's mouthpiece, describes the identity of Ethnic Throwbacks as a matter of volition rather than social imposition: "Throwbacks all the time choosin' who we wanna be" (63). The displacement of race by ethnicity is critical to this gesture of redefinition and self-determination, as Lawanda asserts that Ethnic Throwbacks like herself "do culture....We don't put stock in color. Race is how the world see you, ethnicity is how you see yourself" (121).

The ethnic cultural pluralism affirmed in *Mindscape* is identical in every significant respect to the brand of multiculturalism that gained momentum in the U.S. during the 1980s. As Christopher Newfield and Avery Gordon, among others, point out, the 1980s witnessed a "culturalization of race" that was intended to displace biological and essentialist notions of racial difference (Gordon and Newfield, 1996: 78), which is exactly the work done by the category of ethnicity in Hairston's novel. Tending towards a politics of recognition and inclusion rather than redistribution, the 1980s discourse of multiculturalism "was pro-diversity and it defined diversity not in racial or political but in cultural terms" (Gordon and Newfield, 1996: 86). In *Mindscape*, multiculturalism is shown to be a hard-won political achievement, given that the world of the novel is peopled with racial essentialists and mono-culturalists. The Prime Minister of Paradigma, who comes from a family that "led the crusade for monopoly, not diversity," is opposed to "mak[ing] a fetish of diversity"

and is particularly averse to the "multi-kulti affectations" of Ethnic Throwbacks (185–186). In such passages, Hairston is obviously indexing the real-world crusade against diversity and multiculturalism led by political conservatives in the U.S. during the 1990s, evident in the 'culture wars' and fraught debates about 'political correctness,' but what is more interesting here is that Hairston aligns the anti-diversity backlash with the liberal state of Paradigma. Allowing Hairston to position multiculturalism in opposition to the reigning political order, this move obscures the fact that cultural diversity not only can be perfectly congruent with liberal democracy but also that it in fact became the official ideology of the neoliberal U.S. state by the 1990s.

Among the numerous critiques of multiculturalism that have been launched from the political left as well as the right, the one most relevant to this discussion is the charge that its emphasis on culture mystifies the harsh realities of political-economic stratification by race. If we agree that these realities must be eradicated in any notion of a desirable future society, Hairston's turn to multiculturalism as the defining element of her fictive new world begins to make some sense. To briefly retrace the career of race in the present and future worlds of *Mindscape*, the novel's point of departure is a dystopian social order that has ostensibly obliterated race. To expose the hollowness of these claims to race-blindness, Hairston reveals the persistence of the "old regime" of racism. Hairston's own effort to move beyond this old regime and to imagine a new future also entails critical distance from the category of race insofar as it is laden with the baggage of biological and social determinism. As a term that bears the crushing weight of socially ascribed identity—"how the world see you," in Lawanda Kitt's phrase—race must necessarily be left behind in a future world where individuals are free to choose who they want to be.

In *Futureland*, Mosley ultimately reaches a similar conclusion about the future of race, although he gets there from a very different direction. If *Mindscape* suggests that the old racial regime should not be carried into any utopian vision of the good society, Mosley's text concludes with a dystopian picture of a future held hostage by the racial logic of the past. Mosley identifies the old racial order with the binary and biological conception of race that was institutionalized by U.S. chattel slavery. This racial history is shown to be an immovable obstacle to political change in the short story "Dr. Kismet," in which Pan-Africanist leader Fayez Akwande decides to escape to Mars when he realizes that he cannot change the world. Akwande has to displace his hope for a "new world" to Mars (87) because "*this* world was set when they dragged the first African into a slave ship" (85, emphasis mine). Throughout *Futureland*, Mosley shows that the dualistic racial ideology of slavery, notwithstanding its lingering grip on the present and future, is utterly inadequate for understanding or transforming the multiplex racial order of global capitalism.[6]

The successful agents of change in *Futureland* are those who can overcome the divisive force of racial differences in the interests of class solidarity. One such agent is Bits, "a worldwide revolutionary" who "defined himself as a class warrior, and though he suffered the pain of racism he did not exclude other races from his side" (115). In order to liberate the prisoners held in a multinational penitentiary, Bits assembles a multiracial "resistance panel" comprised of six African Americans, three Latinos, one Caucasian, and two people "of other races." The biggest challenge to Bits' vision of unity across racial differences comes from the one white man on his team, Stiles, a white supremacist beholden to the black-white racial dualism of slavery, but eventually Bits manages to convince Stiles of their "common cause" (116), and only with the participation of Stiles does the prison break become possible. Aside from Bits, the other conspicuous agent of social transformation in *Futureland* is the hacker Ptolemy Bent, whose purpose in the story "En Masse" is to hijack the very concept of change away from its monopoly ownership by capitalists. To this end, Ptolemy trains a "renegade production unit" made up of prods, whose bodies are merely "fuel for systems of production" (332). Ptolemy is quite far along in his enterprise "to create revolutionaries, people who aren't satisfied with being prods" (333), when his anti-capitalist mission is derailed by the resurgent logic of race, as the renegade production unit suddenly has to be diverted to dealing with a genetically engineered virus targeted at people of African descent.

Focusing on the race plague that ensues, the last story in *Futureland* stages the horrific revival of the reductive concept of binary racial difference that Mosley has tried to exceed over the course of the text. The success of the virus depends on its ability to recognize race, because it is designed by the fascist International Socialist party to infect only those people who have at least "12.5 % African Negro DNA" (377). But the virus mutates and it ends up killing all those who do not meet this minimal genetic definition of blackness, lending credibility to the idea of race as a biological fact. To protect themselves from the race plague, so-called white people decide to claim and publicize their hidden black ancestry by wearing signs reading "THE NIG IN ME: 12.5%" (377). Mosley's inversion of the one-drop rule exposes the absurdity of racial definition in the United States and suggests that the racial apocalypse that closes the text should be read as a grim farce rather than a political allegory. When a character in the story tries to read the race virus allegorically, wondering if the plague should be seen as punishment of white people for their long history of anti-black racism, another character responds that this interpretation would not account for the fact that "all the Chinese and Aborigines and Indians down in Peru" were also killed off by the virus (377). As the complex dynamics of racialization on a global scale are reduced to Black-white racial polarity, those who are neither white nor Black become the collateral damage of this dualistic logic.

Once the race plague subsides, a radical Black nationalist ideologue proclaims that "the day of the white man is over" (379) and calls on those who remain to embrace "the new world order" (380) in which, presumably, race will no longer pose a problem since the virus has eliminated racial difference by killing off all those who are not minimally Black. But immediately thereafter, battles over scarce resources break out among four sub-groups of people of African descent: "Two Spanish black armies, a white—or so-called—group, and then there's the American blacks....Fightin' over control of the utilities and right of way in the streets" (381). This "new" racial order almost exactly replicates the old order, in which "mobs of black and white ruffians were battling in the streets" (377). As racial conflict reasserts itself even after it has been eradicated as a signifier of biological difference, Mosley projects the durable future life of race as a divisive, although baseless, category. *Futureland* ends with Harold, who obviously must have at least 12.5% African DNA because he has survived the race plague, being hailed as "Hey, Nig" and shot at by three "swarthy-looking," "so-called white men." Following this reductio ad absurdum of racial logic, the last line of the novel, "The world had started over" (382), cannot possibly be seen as anything but ironic.

In stark contrast, when Lawanda Kitt says "this be the Promised Land" at the end of *Mindscape* (443), we are meant to take her seriously. From the perspective of Hairston's novel, a work of the futurist imagination that ends in racial apocalypse takes a predictable and easy way out. *Mindscape* is sprinkled with self-reflexive observations about the limitations of "realism," which can "gut the imagination" (32), and the unique power of the speculative imagination to breach the limits of reality and create unlikely or even impossible futures. Several chapters of the novel open with epigraphs from futuristic texts written by visionary characters that read as briefs for speculative fiction. "People be past masters at imaginin' the end of the world," writes one such character, "but folks're hard put to imagine a new day where we can get on with each other" (385). Another character exhorts her readers to "imagine the impossible," because "if you can't imagine it, it won't happen for you" (158). Through her distinctive blend of the genres of science fiction and "magic realism" (254), Hairston invents a new species—the Vermittler, or go-betweens—that embody the transformative potential of speculative fiction. Because they are able to phase-shift between different levels of (mystical and mundane) reality and to modulate "spacetime perception" (76), go-betweens can guide human beings from the past to the future by "forc[ing] us to feel beyond our time" (98). More specifically, due to their extra-human capacity to access the Barrier that fractures the world of *Mindscape* into warring zones, go-betweens help bring about a new future of interzonal and multiracial cooperation.

The most noteworthy aspect of the go-betweens is that they are a new breed created by means of "symbiogenesis," an experimental procedure of "genetic recombination and co-evolution" (154).[7] In Mosley's *Futureland*, as we have already seen, genetic technology is easily amenable to the evolutionary social science of the fascist International Socialists, who deploy it to resurrect biological concepts of racial difference. Hairston is not unwarily optimistic about the racial implications of genetic science as is obvious from her sardonic treatment of the white trans-racials fashioned by gene art. But through the go-betweens, Hairston tries to imagine possible future uses of genetic technology that will override biological notions of race. The disparate approaches to genetics taken in *Futureland* and *Mindscape* index the charged field of contemporary debate about race and genetics. On the one hand, DNA analysis indicates that there is far greater variation within so-called racial groups than between them and consequently disproves the scientific racism of the eighteenth and nineteenth centuries, which classified human populations into distinct racial categories. But on the other hand, the recent consideration of race as a scientifically coherent category in genomic medicine risks the dangerous revival of biological notions of race. That the specter of scientific racism continues to haunt the American public imagination is readily apparent in the fact that, as late as 1998, the American Anthropological Association found it necessary to issue a statement discrediting biological constructions of race: "we conclude that present-day inequalities between so-called 'racial' groups are not consequences of their biological inheritance but products of historical and contemporary social, economic, educational, and political circumstances." In this statement, every mention of the word *race* is accompanied by scare quotes, a strategy Hairston follows as well to underscore the fictive status of the category.

Not surprisingly, when Hairston invokes the utopian potential of genetic science, she carefully positions the emergent species of go-betweens in opposition to biological definitions of race. The most vehement objections to symbiogenesis come from the racial fundamentalist, Femi, who regards go-betweens as mongrel cross-breeds and alien abominations. Countering Femi's commitment to racial essentialism, Hairston celebrates go-betweens as epitomes of "bio-diversity" (370). The prominent go-between characters in the novel, Elleni and Sidi, belong to a hybrid new species, which eludes clear racial classification because it is not quite human, but Hairston markedly notes their proud retention of the African-derived cultural practices of one line of their ancestral human heritage.

As should be clear from the treatment of go-betweens as well as Ethnic Throwbacks in *Mindscape*, Hairston wants to abolish pseudo-scientific concepts of race while preserving the discrete cultural traditions developed in response to long histories of political and economic marginalization. This kind of approach to race is extremely hard to sustain, as biological difference continues to lurk behind cul-

turalist understandings of race.[8] In the face of this dilemma, some African American writers of speculative fiction have felt compelled to neutralize the cultural as well as biological meanings of race in their novels of the future. Cultural critic Greg Tate writes of his discomfort with the "racially defused futures" presented in Samuel Delany's early science fiction: "they seem to deny the possibility that the affirmative aspects of Black American culture and experience could survive assimilation" (Tate, 1992: 165). In response to Tate's complaint that even when his fiction contains black or other protagonists of color, "the race of these characters is not at the core of their cultural identity" (Tate, 166), Delany says:

> part of what, from my marginal position, I see as the problem is the idea of *anybody's* having to fight the fragmentation and multicultural diversity of the world, not to mention outright oppression, by constructing something so rigid as an identity, an identity in which there has to be a fixed and immobile core, a core that is structured to hold inviolate such a complete biological fantasy as race—whether white or black (Dery, 1994: 190).

Delany's remarks point to the difficulty of affirming the cultural differences associated with minoritized racial groups without implicitly lending credence to the "biological fantasy" of race. For this very reason, neither Hairston nor Mosley can imagine, even within the expansive genre of speculative fiction, any usage of the term *race* that should last into the future. This is why Hairston can imagine a utopian future for her Throwback characters, who wish to salvage the cultural dimensions of their history as oppressed groups, only by disavowing the category of race and replacing it with ethnicity. Mosley suggests that the destructive legacy of race is not so easily consigned to the dustbin of history; the race virus hyperbolically stages the return of the past by revalidating the one-drop rule, dispelling any hope of a future free of the biological baggage of race. Belying Mosley's own hope that speculative fiction will allow "history to be rewritten or ignored" (1998: 32), novels such as *Futureland* and *Mindscape* attest to the obstructive force still exerted by U.S. racial history on the Afrofuturist literary imagination.

NOTES

1. Fredric Jameson observes that human-alien encounters in Octavia Butler's science fiction are unique in that they serve to allegorize rather than neutralize racial differences (2005: 140).
2. This is not uniformly the case, as Kevorkian shows with regard to 1990s Hollywood films, which often incorporate technologically savvy African American characters. Kevorkian argues that a "compensatory mechanism" may be at work "in placing blacks in technologically skilled roles, a sort of reassuring virtual affirmative action" (2006: 14).
3. The term *digital divide* was widely used during the 1990s to refer to various kinds of demographic disparities in access to advanced electronic technologies.

4. I allude here to Samuel R. Delany's proposition that science fiction generally presents a "significant distortion of the present" rather than a plausible image of the future (Delany, 1994: 171).

5. The quoted phrase is the title of William Julius Wilson's influential book, *The Declining Significance of Race*, first published in 1978, which played an important contributing role in the 1980s liberal retreat from race. For a critical analysis of race versus class debates, see Adolph Reed, Jr. (2002).

6. This is not to suggest that the bipolar (black/white) definition of race was ever adequate for understanding the dynamics of racialization in the U.S., even during the era of slavery. But its reductiveness became particularly apparent in the decades following the Civil Rights movement, when Asian Americans and Latinos gained public visibility as racialized minority groups in American cultural and political life.

7. Hairston's term *symbiogenesis* strongly recalls Octavia Butler's Xenogenesis trilogy, consisting of *Dawn* (1987), *Adulthood Rites* (1988), and *Imago* (1989), which has recently been reprinted under the title *Lillith's Brood*. As used by Butler, the term *xenogenesis* refers to reproduction between human beings and alien species. Both terms—symbiogenesis and xenogenesis—are meant to counter essentialist conceptions of human species identity. Hairston may also be evoking the term *symbiont*, used in Butler's last published novel, *Fledgling* (2005), to refer to human characters who have relations of biological interdependence with vampires.

8. As noted earlier, another high cost of a culturalist conception of race is that it deflects attention away from the workings of race as a systemic determinant of socio-economic inequality. For this reason, it is difficult to interpret the multiculturalism affirmed in *Mindscape* as the "Revolution solution" that many of the novel's characters perceive it to be (433).

REFERENCES

American Anthropological Association. (1998). *Statement on 'Race.'* Retrieved from http://www.aaanet.org/stmts/racepp.htm

Butler, O. (2000). The monophobic response. In Sheree R. Thomas, (Ed.), *Dark matter: A century of speculative fiction from the African diaspora.* (pp. 415–416). New York: Warner.

Davis, A. (1996). Gender, class, and multiculturalism: Rethinking 'race' politics. In A. F. Gordon & C. Newfield (Eds.), *Mapping multiculturalism* (pp. 40–48). Minneapolis, MN: University of Minnesota Press.

Delany, S. R. (1994). *Silent interviews.* Hanover, NH: Wesleyan University Press.

Dery, M. (1994). Black to the future: Interviews with Samuel R. Delany, Greg Tate and Tricia Rose. In M. Dery (Ed.), *Flame wars: The discourse of cyberculture* (pp. 179–222). Durham, NC: Duke University Press.

Gordon, A., & Newfield, C. (1996). Multiculturalism's unfinished business. In A. Gordon & C. Newfield (Eds.), *Mapping multiculturalism* (pp. 76–115). Minneapolis, MN: University of Minnesota Press.

Govan, S. Y. (1984). The insistent presence of black folk in the novels of Samuel R. Delany. *Black American Literature Forum, 18*(2), 43–48.

Hairston, A. (2006). *Mindscape.* Seattle, WA: Aqueduct.

Jameson, F. (2005). *Archaeologies of the future: The desire called Utopia and other science fictions.* London and New York: Verso.

Kevorkian, M. (2006). *Color monitors: The Black face of technology in America.* Ithaca, NY: Cornell

University Press.

Mosley, W. (1998). Black to the future. *The New York Times Magazine*, November 1, 1988, pp. 32, 34.

Mosley, W. (2001). *Futureland: Nine stories of an imminent future*. New York: Warner.

Nelson, A. (2002). Introduction: Future texts. *Social Text, 20*(2), 1–15.

Omi, M., & Winant, H. (1994). *Racial formation in the United States: From the 1960s to the 1990s* (2nd ed.). New York: Routledge.

Reed, Jr., A. (2002). Unraveling the relation of race and class in American politics. *Political Power and Social Theory, 15*, 265–274.

Rutledge, G. E. (2001). Futurist fiction and fantasy: The racial establishment. *Callaloo, 24*(1), 236–252.

Scholes, R., & Rabkin, E. S. (1977). *Science fiction, history, vision*. New York: Oxford University Press.

Steinberg, S. (2000). The liberal retreat from race. In S. Steinberg (Ed.), *Race and ethnicity in the United States* (pp. 37–54). Malden, MA: Blackwell.

Tate, G. (1992). *Flyboy in the buttermilk: Essays on contemporary America*. New York: Simon & Schuster.

Wilson, W. J. (1978). *The declining significance of race*. Chicago, IL: University of Chicago Press.

Brave Black Worlds

Black Superheroes as Science Fiction Ciphers

ADILIFU NAMA

Black identity is not simply a social and political category to be used or abandoned according to the extent to which the rhetoric that supports and legitimizes it is persuasive or institutionally powerful.

PAUL GILROY, *THE BLACK ATLANTIC*

As you know I'm quite keen on comic books, especially the ones about superheroes. I find the whole mythology surrounding superheroes fascinating.

BILL, *KILL BILL: VOLUME 2*

WITH JULES VERNE'S VISIONARY TALES OF CAPTAIN NEMO IN *20,000 LEAGUES Under the Sea* (1870), Georges Méliès's bullet-shaped rocket ship in *A Voyage to the Moon* (1902) and the opening notes and narration of Rod Serling's *The Twilight Zone* (1959–1964), science fiction (SF) literature, cinema and television have for quite some time captured our collective attention and provided wide-eyed enjoyment for readers, movie-going audiences and television viewers alike. Despite the widespread popularity and wonderfully imaginative scope of the SF idiom across much of the genre, black folk and people of colour were absent. With, however, the notable contributions of Octavia Butler, Samuel Delaney, Walter Mosley, Will Smith and, my personal favorite, Sun Ra, these black SF luminaries have increasingly made the rarified world of science fiction a more multicultural and diverse realm of futuristic speculation and alternative worlds.

Certainly my scholarship around black representation and SF cinema speaks to this shifting dynamic in the field (Nama 2008). Yet, there is another science fictionesque genre that is often overlooked and under-analysed for including black folk in imaginative futuristic and alternative visions of society that present a progressive and sometimes daring depiction of Afrofuturistic images of and ideas about the American superhero comic book. For decades the superhero comic book functioned as a psychological sandbox for scores of readers. Superheroes have fulfilled the desire to escape from the humdrum world of gravity, swing through the Big Apple with the greatest of ease or stalk the dark terrain of the city to avenge various injustices. Without a doubt, superheroes have played a significant role in presenting often idealised projections of ourselves as physically powerful, amazing and fantastic. But superhero comic books also function as more than a roadway to escapist fantasy or funhouse mirror reflections of our desires to create bigger-than-life personas that can exert our will and power in the world. Superhero comics also invite readers to imagine a world where advanced science, UFOs, aliens, space exploration, time travel and hi-tech gadgets are common occurrences. Accordingly, superhero comics draw significantly from the SF idiom and for that reason what is drawn and written across a multitude of superhero comics is extremely significant as an expression of SF along with what is communicated about American culture, politics and social desires. Often lost in the intersection between superheroes and SF is the place race occupies in the genre, and when it is addressed, the discussion frequently turns to framing the genre as racially biased.

For example, Frantz Fanon (1959) in his psychoanalytical manifesto on race, *Black Skin, White Masks*, mentions how the superhero figure of Tarzan the Ape-man and various other comics functions to reinforce real racial hierarchies in the world in which whites repetitively imagine victory over the forces of evil, often represented by blacks and other racial minorities. Given Fanon's observation, the image of a virtually indestructible white man flying around the world in the name of 'truth, justice and the American way' easily opens up a Pandora's box of racial issues. Symbolically speaking, Superman easily functions as a strident representation of American imperialism and racial superiority. A straightforward ideological critique of white superheroes is also reflected in the race-conscious work of Black Nationalist poet and activist, Gil Scott-Heron in his declaration *Ain't no such thing as Superman* (1975) on the spoken-word track of the same title. On the recording Scott-Heron chides black people to abandon the idea that whites will save blacks from ghetto poverty and alienation. Moreover, Gil Scott-Heron, like Fanon, clearly comments on how the superhero motif and cultural politics of race are intertwined and suggests white superheroes pose a problematic incongruity for blacks who as victims of white racism are further victimised by reading and identifying with white heroic figures in comic books.

This fear of blacks overly identifying with whiteness, whether based in social fact or psychological conjecture, is not some form of racial paranoia. Rather the debate over black identification with white superheroes is similar to Kenneth Clark's doll experiments, where he concluded that black children in segregated schools who rejected the black doll for a white doll demonstrated internalised feelings of racial inferiority, a symptomatic effect of Jim Crow segregation. Against this theoretical backdrop the drive for positive black images was ratcheted up, and the race of superheroes became increasingly important along with the need to create black superheroes for black children to identify with rather than white ones (Brown 2001). On the one hand, such an analysis makes for a compelling argument concerning the likelihood that superhero comics are a form of white racial propaganda. On the other hand, such a severe indictment is, in my mind, overly simplistic. For example Junot Diaz, the author of the Pulitzer Prize-winning novel, *The Brief Wondrous Life of Oscar Wao*, in his youth identified with the white mutant superhero team the X-Men. Because the group were labeled mutants and treated as social outcasts, as a young black man Diaz felt he shared an affinity with the comic book superhero characters because of his own racial status that stigmatised him as an outsider to mainstream America (Danticat 2007). Consequently, a strict racial reading of the negative impact white superheroes have on black or even white readers is, for me, too simplistic and reductive. But more importantly, rather than castigating the limitations of a genre admittedly dominated by white guys and gals clad in spandex and tights, there remain significant areas of analysis concerning the black superheroes that have existed in the comic book universe for just over 40 years. Their presence marks a range of transformations and symbolic expressions that not only offer a sci-fi version of blackness but also challenge conventional notions of black racial identity while engaging the thorny topic of race and racism in America. In particular, the black superheroes that are ensconced in a SF motif function not only as counter-hegemonic symbols of black racial pride and racial progress but possibly even as *Afrofuturistic* metaphors for imagining race and black racial identity in new and provocative ways.

Although there has been some analysis of black superheroes such as in Richard Reynolds' (1994) *Superheroes: A Modern Mythology*, the discussion of black superheroes is, for the most part, a marginal one. Bradford W. Wright's (2003) *Comic Book Nation: The Transformation of Youth Culture in America* presents the most depth and breadth concerning the importance of black superhero comic books to American culture. He, however, situates black superheroes in the interplay between broad social and cultural themes of a period and emergent trends in the superhero comic book genre in general. Even the most definitive text to date on black superheroes, Jeffrey A. Brown's (2001) *Black Superheroes, Milestone Comics and Their Fans* invests virtually all his analytic efforts in covering the place and significance of a black comic

book company, Milestone Comics, in negotiating the fickle terrain of a predomi-
nantly white comic book culture and industry. Other than his examination of the
intersection of hyper-masculinity and black superheroes, scant attention and analy-
sis are given to what black superheroes signify concerning their cultural work as a
form of black science fiction representation.

The lack of recognition given to black superheroes as sci-fi objects is not all that
surprising given that many black comic book images easily fall into the uncompli-
mentary category of racial caricature, and therefore the focus of analysis and inter-
ests has revolved around exposing and interrogating this dubious history of black
representation in the comic book genre (Stromberg 2003). The purpose of this chap-
ter, however, is not in any way similar in scope or goal, nor is it attempting to restate
the obvious in a novel manner. Instead the chapter self-consciously adopts what I
call a critically celebratory perspective of the symbolic power and allegorical impact
of black superheroes as sci-fi figures in the American imagination. Rather than
examining black superhero representations in terms of how they are inadequate,
underdeveloped or inauthentic figures conjured up by white writers and artists, I
view them as significant (even if problematic) expressions of a science fiction
(re)imagining of black racial being that reflects and reveals a myriad of racial
assumptions, expectations, perceptions and possibilities.

As Roland Barthes (1972), Umberto Eco (1979) and Dick Hebdige (1981) have
superbly revealed in their respective works concerning cultural production, that
which appears the most mundane, innocuous and everyday offers some of the most
provocative and telling cultural and ideological information and insights about a
society. Accordingly, within the universe of DC and Marvel comic books various
black superheroes are more than marginal figures constricted to the panels and imag-
ination of the reader. They also are social symbols that represent the intersection of
race, science, speculative fiction, black culture, African tradition and technology and
as such stand as ideological place-holders for variegated expressions of black racial
identity and black futurism. Admittedly, a science fiction motif does not negate
problematic character elements that work to essentialise black racial identity, such
as the clumsy use of black jargon and affected speech patterns to signify black racial
identity. Instead, I propose that the significance of black superhero characters is not
rooted in how authentically black they are, but in terms of the alternative possibil-
ities a SF sensibility or motif offers for a more complex and unique expression of
black racial identity. Admittedly, the presence of black superheroes in the predom-
inantly white comic book universe of DC and Marvel comics drew their *raison d'être*
directly from the heightened racial politics of the 1960s and 1970s. But below the
surface of such reflectionist explanations, these dark figures not only introduced race
into superhero comics, but they also provided a portal for readers to (re)imagine
black folk singing the body electric as science fiction spectacles of technological

achievement and scientific mutation. Thus, culturally and ideologically, black super-heroes and the comic book pages they occupy are not merely disposable pop prod-ucts; rather they are SF signifiers that attack essentialist notions of racial subjectivity, draw attention to racial inequality and racial diversity, and contain a considerable amount of commentary about the broader cultural politics of race in America and the world.

Black superhero comic book figures are in many ways progressive representa-tions when compared with the representation of black people in early Hollywood cinema and American SF. Much of the history of Hollywood cinema is marked by black representation confined to comedic performances or limited to historical events (e.g., the Civil War), a particular geographical setting (the jungle forests of Africa or the antebellum South) or social class status (maids, chauffeurs and but-lers) (Bernardi 1996, Bogle 1998, Snead 1994), whereas except for superhero comics the presence of black people on alternative worlds, travelling in space, shooting ray-guns, inventing and commanding futuristic technology or experiencing time trav-el was until quite recently non-existent across various SF genres. This is not to say superhero comics were automatically more progressive or racially ahead of the curve in comparison to more traditional sites of SF expressions such as literature, television and film. In the wake of the Black Freedom movement of the 1950s and 1960s, virtually all mainstream media idioms made a self-conscious effort to address the dramatic racial shift in American society (Gray 1995, Guerrero 1993). By the late 1960s the age of innocence for America's youth was fast coming to a close and even superhero comic books were incorporating the grand social anxieties of the period: the Vietnam War, racial inequality and a burgeoning Women's Movement (Omi and Winant 1994, Steinberg 1995, Wright 2003, O'Neal and Adams 2004). But what the superhero comic book genre lacked in spontaneity compared with American film and television it made up for in originality. Although the emergence of the first wave of black superheroes symbolised the growing presence of black folk in public and professional settings to which they were previously denied access, they dramatically marked the emergence of black SF figures. If ever there was a black superhero that appeared directly drawn from the political moment yet presented an Afrofuturist sensibility, T'Challa, the Black Panther superhero of Marvel comics is such a compelling character.

In 1966 the Lowndes County Freedom Organization created the image of a black panther to symbolise black political independence and self-determination in opposition to the Alabama Democratic Party's white rooster. In October of the same year, the Black Panther Party for Self-Defense was created which adopted the identical black panther emblem as the namesake and symbol of their black militant political organisation. Fascinatingly, only a few months earlier a superhero called The Black Panther appeared in Marvel comic's *Fantastic Four* no. 52–53 series, begin-

ning in July of 1966. Although the Black Panther Party and the Lowndes County Freedom Organization's black panther emblem are not inspired by the Black Panther comic book figure, all three manifestations of the Black Panther are a consequence of the politics of the period in which 'Black' became a defining adjective to express the political and cultural shift in the civil rights movement. In 1966 Stokely Carmichael's call for 'Black Power' set in motion a sociocultural tsunami that swept over America. Negroes were now identified as blacks. Black radicals advocated the need for 'black' institutions. Black was beautiful. Indeed, 'black' not only became the appropriate term for designating a new type of political consciousness, but it also provided a synchronous template for the creation of a regal, super-intelligent and highly skilled hunter-fighter black superhero from the fictional African nation of Wakanda.

In America there is a dubious history of presenting Africa as a primitive and backward nation in books, television and film, a racial caricature readily available in virtually any garden-variety Tarzan film released over the last 70 years. Against this backdrop, the Black Panther character and comic book series is compelling because it stands in stark contrast to the historical and symbolic constructions of Africans as simple tribal people and Africa as primitive. The character and comic series challenge these common tropes by melding science fiction iconography with African imagery. T'Challa, the African prince-king, is Black Panther, a descendant of an ancient African fighting clan from the fictional Kingdom of Wakanda and a super-genius whose scientific prowess appears to rival Reed Richards aka Mr. Fantastic, a white superhero who is virtually peerless as an inventor and scientist in the Marvel Comic Universe. But most importantly, Wakanda is a scientific wonderland where African tradition and advanced scientific technology are fused together to create a hi-tech African Shangri-La nation-state which is the source of T'Challa's futuristic flying machines, weapons and power (Kirby 2005). The use of a third-world country as a high-tech base of operation for Black Panther is a pioneering representation given that New York City, a recurring symbol of Western modernity with its towering skyscrapers and bright lights, has for decades occupied our collective imagination as 'the city that never sleeps' and played a central role as the urban terrain of choice for a multitude of superheroes. Moreover, the speculative construction of a SF version of an African nation is not divorced from the real geopolitics of colonialism that has plagued Africa's development and dependence on the West (Rodney 1974). For Wakanda, black social agency is the fulcrum for their technological advancement.

In his debut, Black Panther prepares for and defends against an invasion of Wakanda headed by a villainous white character called Klaw who is determined to gain control over Wakanda in order to acquire vibranium, a precious sound-absorbing mineral only found there. The Black Panther, however, is able to defeat Klaw's

mercenary military forces and halt his plans for the exploitation of Wakanda's most precious of raw resources. Clearly an origin narrative that has an African nation successfully defending their borders from incursion and exploitation of their natural resources from white men obsessed with controlling the country and dominating their economy is easily read as a critique of the historical reality of colonialism that has accounted for much of the underdevelopment of far too many African nations. Moreover, symbolically speaking, T'Challa arguably works as a composite and idealised representation of the black revolutionaries of the anti-colonialst movement that took root in the 1950s. A significant part of the cresting wave of black racial pride and assertiveness in America was informed by the successful anti-colonialist struggle waged by African nations against their European colonisers. African leaders such as Jomo Kenyatta, Patrice Lumumba and Kwame Nkruma were the black princes of the African anti-colonialist movement. They captured the imagination of the people and hopes of the anti-colonialist movement with their charisma and promise to free Africa from European imperialism. Many of the real-world African leaders that spearheaded the freedom of their countries from colonialism were unable to make good on their mission to make their peoples' lives fundamentally better due to a combination of dubious internal and external forces and political deceit. As a result they often found themselves disposed, in exile or even assassinated. In contrast, T'Challa the ethical, incorruptible, super-scientist, superb warrior king, Black Panther superhero and leader of the fictional African nation of Wakanda succeeds in achieving economic and political independence for his people where many African nation-states have failed. Wakanda, however, is an African nation that compels not only geopolitical respect but reverence from the rest of the world.

At the centre of the geopolitical anti-colonialism metaphor of Wakandan independence rests a bold SF explanation and expression of blackness embodied by Black Panther and his Wakanda homeland. The Black Panther comic (re)imagined fixed concepts of black identity and history by having an African nation written as the source of technological wonders far advanced in comparison to any other Western nation. Steeped in mysterious African lore yet cloaked in the signature features of modernism, science and progress, the Black Panther stood out as completely different from previous attempts to represent black Africans. Yet the super-science that is a signature feature of Wakanda is also fused with the supernatural. The Black Panther as the leader of the Panther clan is granted the tribute of ingesting a special herb that enhances his senses and physical abilities along with linking him to their Panther god. In this sense, Black Panther embodies a syncretic impulse, and although syncreticism has been a cultural calling-card for black folk in America (where various cultural traditions and historical experiences are combined to express a unique form of black cultural expression and way of performing black racial identity), Black Panther expresses this impulse as the convergence of African tradition

with advanced science and technology. In doing so, Black Panther presents a politically provocative and wildly imaginative representation of blackness with a science fiction flare. As a result, the Black Panther character and comic book series is made more significant and compelling as one of the most mainstream yet radical (re)imaginations and representations of blackness. Both the character and the comic book work as a grand vision of Afrofuturist blackness where black folk are no longer over-determined by racism and colonialism.

Despite incorporating many of the stock-and-trade elements of SF sleek rockets, out of-this-world gizmos and super-science inventiveness this does not make the Black Panther character perfect or always progressive. A point of irritation is the poorly titled series, *Jungle Action* (1973–1976), in which the narrative arcs of these stories had the Black Panther spending his time fighting a slew of jungle nemeses while consolidating his power and establishing his reign in Wakanda. It was not until the late 1970s that Jack Kirby (2005) took over the title and brought Black Panther (1977–1979) back to SF in a series of Philip K. Dick-inspired adventures. For example, in 'The Six-Million Year Man,' T'Challa battles various parties for possession of a brass frog that unexpectedly opens a portal to the far future where an alien from 6 million years into the future materialises in front of them and threatens to destroy the world (Kirby 2005). Like Jason and the Argonauts' quest for the Golden Fleece, the Black Panther sets out on a mission to retrieve a hidden artifact that opens a time portal to the future that will enable him to return this overwhelmingly powerful being to his time. Such a storyline can easily be critiqued as an example of how the Black Panther, a symbol of black politics and pride, was depoliticised by placing him in these sci-fi otherworldly environments. However, I view the placement of Black Panther in these various sci-fi fantasy-scapes as politically progressive given that the history of black representation has exceedingly relied on clichéd notions of black figures narrowly tied to the geography of the black ghetto as their exclusive domain. Black superheroes like Black Lightning, The Falcon and Luke Cage took many of their narrative cues from the formulaic blaxploitation film craze of the period and employed ghetto-eccentric clichés as the 'black experience' in order to court black audiences and turn a profit on the racial and political discontent of the time (Guerrero 1993). In contrast, Kirby's Black Panther is speculative, Afrofuturistic and sci-fi-ish in the way that technology, ancient tradition, robots, time travel, space aliens, mythical beasts and samurai warriors are all rendered in an amusing mash-up of images, ideas and plot twists.

In subsequent issues, T'Challa was placed in an urban milieu, an arguably more culturally relevant environment. Most notably, writer Christopher Priest's and penciller Mark Texeira's graphic novels *Black Panther: The Client* (2001a) and *Black Panther: Enemy of the State* (2001b) put an urban spin on T'Challa, setting his adventures almost exclusively in New York City. Even though the hi-tech gadgetry

remained under Priest's direction, the Black Panther narrative was less about expressing some form of black futurism and more of an introspective psychological exploration of the character in which he seemed to be channelling the defiant cool of Miles Davis, the otherworld mysteriousness of Sun Ra and the internal contradictions of Jack Johnson. Nevertheless, the Black Panther series remained overtly political, with T'Challa playing geopolitical gamesmanship with the U.S. State Department as he tries to chart an independent course for his African homeland. This trend was further amplified when Marvel re-launched the Black Panther as a stand-alone title under the direction of Reginald Hudlin, part of the successful sibling directing duo, the Hudlin Brothers. The pair share co-directing credits for the films *House Party* (1990), *Boomerang* (1992), *The Great White Hype* (1996), *The Ladies Man* (2000) and *Serving Sara* (2002). Although the bulk of the Hudlins' films have not met the same type of box office success as *House Party,* subsequent films were culturally savvy when it came to expressing black sensibilities.

Coursing underneath many of Hudlin's comic misfires were critiques, commentary and satirical flourishes addressing race in America. Moreover, his sense of racial awareness became part and parcel of the next incarnation of the Black Panther as Hudlin appeared to work overtime in stressing the 'black' in Black Panther. Under Reginald Hudlin's (2006, 2007) direction, Black Panther was presented as a deeply racially aware figure navigating the highways, byways and backstreets of a contemporary black urban America like a cultural *flâneur.* T'Challa is also presented as fiercely protective of his homeland from prying Western eyes, almost to the point of imbuing Black Panther with a xenophobic sensibility. An exchange between Black Panther and Victor Von Doom, alchemist *par excellence* and super-scientist supreme in the *Civil War* series, exemplifies how Black Panther is a symbolic place-holder for broader racial issues under Hudlin's direction. As a newly-wed couple Black Panther and Storm travel to Latveria to confront Dr. Doom. What is interesting about their stand-off is the degree to which the verbal sparring that customarily takes place between all superheroes and their super-villain nemesis is racialised.

> Doom: I've always said the African is a superior physical specimen. Storm: Finish the sentence Doom '…which compensates for his lack of intellect.' Doom: Generally true. Yes, but clearly the Wakandan is exceptional! Perhaps a low-grade mutant strain in your people's DNA. Black Panther: Or perhaps because we had the military might to maintain our cultural integrity and out technological superiority over Europeans such as yourself. When you were in caves we were charting the stars.

This bit of racial banter invokes epic themes concerning European colonialism, racial eugenics, biological racism and white supremacy as a commonsense belief. On one hand, such an overtly racist proposition by Doom appears somewhat out of place in a superhero comic book. But on the other hand, if Doom is the anti-human villain he has been written as for nearly 50 years, how could it surprise anyone that

he also holds racist sentiments? Indeed, the maniacal nature of Dr. Doom's mission to control the world is based on a deep-seated belief that he is superior to all of humankind. Thus Doom's anti-humanism would certainly contain a racial bias. In this sense, Hudlin's use of racial rhetoric is not merely an interesting element to include, but a logical one in the representation of Doom's evil genius. Unfortunately, Black Panther's knee-jerk response smacks of the same type of retrograde racial equation as his racist nemesis, only the places of whites and blacks are switched. Nonetheless, the Black Panther is significant because it uses SF to establish a biting sociopolitical mythology for black people to move themselves outside of the crippling impact of colonialism and underdevelopment experienced by real African folk by painting an elaborate and grand picture of Wakanda as a technologically advanced and self-sustaining African country. Another black super-scientist, however, would crop up in DC comics that would bring the SF aesthetic to the Black Atlantic in a reimagining of the cornerstone of all superhero characters—Superman.

The Superman character that Jerry Siegel and Joel Schuster began in 1938 with Action Comics is now a multi-medium franchise found across a variety of media and media-related outlets such as video games, films, toys, television shows, cartoons and of course comic books. In addition there have been a number of related spin-off characters such as Superwoman, Superboy, Supergirl, Krypto the Superdog, and let's not forget to include Beppo the Super-monkey. However, it was not until *The Death of Superman* (1992) that a space for a black 'Man of Steel' to hold centre court was created. With Superman apparently deceased, several would-be replacements jockeyed for Superman's mission to protect the good people of Metropolis. John Henry Irons, a black weapons engineer, is one of the four stand-ins that come forward to replace Superman, becoming Steel. As a former weapons engineer, he is able to design and build an armoured suit which enables him to fly and gives him super-strength. At first glance, there is a striking similarity between John Henry Irons and military industrialist and playboy inventor extraordinaire Tony Stark and his superhero alter-ego Iron-Man. Although Steel appears as a thinly veiled knock-off of Iron-Man, he is in fact more than the crude copy suggested by the professional similarities and nature of their powers; both men encase themselves in flying armoured suits. However, John Henry Irons is invested with undeniable signifiers of black culture and history: most notably those of John Henry, a black American folk hero.

Since the American Civil War, John Henry, the steel-driving man, was an icon among blacks decades before any black superhero ever donned a mask. The John Henry narrative is a classic one of man vs. machine in which he competes against a steam-powered machine that drives spikes into railway tracks. Ostensibly the contest is waged to save John's job along with the other men who work as railroad labourers laying down and securing steel railroad tracks. Below the surface of

this narrative, however, the storyline functions to reimagine and preserve the memory of black people's relationship to the American economic order of the day in the figure of John Henry as representative of black labour's struggle in the face of overwhelming odds. Moreover, although the John Irons figure appropriates the moniker, 'Man of Steel,' which is a long-standing description associated with the original Superman, the use of the title by Irons references John Henry's folk moniker as the 'steel-driving man,' a railroad labourer unmatched at driving steel spikes into railroad tracks across America (Nelson 2006). Consequently, when John Henry Irons replaces Superman in his Steel superhero persona. which includes the use of a long sledge hammer as a weapon and the S symbol on his chest, he signifies the black American folk hero John Henry as the originator and true heir to the title 'Man of Steel' rather than the last son of Krypton.

Initially, the *Steel* series confined the narrative events of John Irons to Metropolis and to the elimination of gangs that proliferated in the wake of Superman's apparent death. For the most part, these types of stories are associated with virtually all superhero crime fighters and did very little to get beyond superhero clichés, much less articulate anything unique concerning blackness. Eventually, Steel would expand his superhero missions beyond the urban cityscape and explore a more explicit sci-fi tapestry of images and narratives which became a signature feature of his adventures. The armoured outfit he donned took on a cyborg-like status, a familiar theme in SF film (Telotte 2001), and inter-dimensional travel and first contact with various alien life forms were routinely presented. Despite Steel mainly fighting villains and saving lives in the inner-city, the character ultimately became a science fiction version of John Henry, revitalising a virtually obsolete black mythology with sci-fi elan. The black superhero Nick Fury, however, pushes the SF theme signalled by Steel even further in vesting black representation with a self-possessed aura of sci-fi authenticity along with signalling the promise of a post-race cultural politics in the near future.

Marvel Comics' Nick Fury was originally created as a grizzled eye-patch-wearing white superhero secret agent. Fury first appeared in *Sgt. Fury and His Howling Commandos* (1963) leading an elite group of World War II American soldiers. Soon after, he got upgraded to colonel in *Nick Fury, Agent of SHIELD* in the *Strange Tales* (1965) series. Fury was a cross between the early James Bond films and the 1960s television show *The Man from UNCLE* (1964–1968) with a dash of Flash Gordon futurism thrown in to add some sci-fi flavour to the mix. In the Nick Fury comics there was an assortment of robots, androids and hovercrafts which functioned as a symbol of American Space Age science and technology along with the cloak-and-dagger Cold War politics of the period. For nearly 40 years Nick Fury was a fixture in the Marvel universe, as the head of SHIELD, a hi-tech spy agency. The image of Fury as a superhero bureaucrat with a sleek handgun tucked in a con-

spicuous shoulder holster was dramatically transformed, however, in *Ultimate Marvel Team-up* (2001) when the white character was radically changed into a black man. Rather than merely colourising a white Nick Fury, the version of the character by Bryan Hitch (a Marvel artist) was surprisingly drawn to look just like Samuel L. Jackson.

At first glance such comic book casting may appear odd given that Jackson has played a series of menacing and unexpectedly amusing characters that have made him a household name with scores of moviegoers. Most notably, he is known for playing a droll philosophical hitman in Quentin Tarantino's *Pulp Fiction* (1994) or arguably the kilt-wearing drug dealer out for revenge in *Formula 51* (2001). Yet, his roles as the eccentric Mr. Glass in *Unbreakable* (2000) and Mace Windu, a stoic Jedi master in the *Star Wars* prequels (1999, 2002 and 2005) have also worked to solidify Jackson's status as a compelling SF figure and character actor who transcends the clichés of black racial identity and urban geography. This is an important distinction because it means that black representation is no longer limited to signalling acute anxieties concerning aggressive street style and culture. Instead, Jackson as the black Nick Fury in *Ultimate Marvels* signals the embrace of a brash brand of black sci-fi heroism in comic books and SF film. Given that Jackson reprises his comic book role for the *Iron Man* (2008) film, this makes the black comic book Nick Fury one of the most interesting black superheroes. He, in effect, supplants the white Fury and establishes the black version as the most relevant and possibly most recognised version of Nick Fury from this point forward. Consequently, Jackson's presence in the comic book series and a mainstream blockbuster film functions as a dramatic sci-fi symbol of the shifting status of black representation in American society. Samuel L. Jackson as Nick Fury, the frequently ruthless leader of a hi-tech militaristic agency and super-agent, represents how the intersection of technology and SF blackness is no longer confined to concocting a connection between primitivism and blackness, but instead vigorously associates hi-tech hardware and governmental surveillance with black racial identity.

Clearly, it is no surprise to anyone who has even the most fundamental working knowledge of American superhero comic books that the genre reinforces the prevailing moral framework of our society by using the hero figure to dramatically represent good and villains to represent evil. In other words, heroes and villains are continually pitted against one another, to affirm the beliefs of a culture and legitimise social values concerning what is right and wrong. But when these superheroes are black they represent more than dichotomised signs of 'good' or 'evil.' The sum of their representation often touches the fringes of the *Fantastique* and makes for complex characters. Certainly, the Black Panther is emblematic of the melding of the supernatural and super-science, but there is also the black female superhero member of the *X-Men*, Ororo, known as Storm. She is the black sci-fi high priest-

ess of the X-Men mutants. As leader of the group, she and her comrades frequently battle giant robots, called Sentinels, and zip around in a hi-tech rocket ship. Similar to Black Panther, the Storm character epitomises the imaginative space between science fiction and the supernatural with her mutant ability to change the weather, a power associated with the elemental energy of Earth and the environment.

Interestingly, as the most significant black female superhero in the comic book genre, Storm also articulates a black womanist perspective. She symbolises many of the struggles that black woman and women of colour in other nations face and resist. Lest we forget, Storm, a third-world woman of color (Kenyan ancestry), is not of a privileged background (an orphan who had to fend for herself on the streets); yet she has played a significant role as the keen and capable leader of the X-Men, a white male-dominated superhero organisation. Accordingly, the comic book figure of Storm stands as a powerful metaphor of the challenge that third-world women of colour face in their struggle to undo a subservient status as poor marginalised women by marshalling their talents for the eradication of patriarchy as a social project which is viewed as part and parcel of humanising and healing the planet (Hamlet 2006, Walker 1984). In this sense, Storm and the previous black superheroes discussed are significant black representations in that they bundle SF and race in ways that stretch crystallised notions, ideas, desires and fears associated with black identity and frequently speak to progressive political expressions of blackness.

Although science fiction has traditionally had little if anything to do with exploring black racial formation or identity, few genres are as self-assuredly representative of the intersection between science fiction and black racial dynamics as black superhero comic book characters. Accordingly, black superheroes have in various instances served not only as a bridge to link 'blackness' and futurism together, they have also provided an escape from conventional representations of black racial identity. Various black superheroes have instead offered a galactic vision of blackness, often as Afro-diasporic figures that fuse the shiny tomorrow land of extraterrestrial beings, experimental technoculture and cybertronic robots with the self-esteem politics of 'black is beautiful.' Certainly, the crude comic book liner notes associated with a slew of George Clinton funk albums expressed similar Afrofuturistic ideas and imagery. However, those themes were informed by and took their cues from an insurgent black music subculture commonly referred to as funk music (Vincent 1996).

Black superheroes, however, are not only mainstream figures but canonical representations within the institutional history of the American superhero comic book industry. Accordingly, the black superheroes of DC and Marvel comics such as Black Lightning, Black Panther, Nick Fury, Steel, Storm and others like Photon and War Machine speak to a broader scope and reach than alternative outlets like under-

ground 'zines' and black independent comic companies that illustrate black super-heroes. Moreover, along with imprinting the collective conscious of American society with enduring figures of comic book blackness, black superheroes have provided a forum for expressions of blackness that go beyond Superman's 'truth, justice and the American way' or the teen angst experienced by Peter Parker as Spider-Man. With black superheroes, the white worlds of science fiction were being appropriated years before films like the *Matrix* (1999) and Octavia Butler's ground-breaking novel *Kindred* (1979) became popular examples of the intersection of race and SF. Certainly, many of these black superheroes were and continue to be marginal figures in the comic universe. Nonetheless their presence in comic books often poached from SF presented a significant (re)imagining of black folk as innovative configurations of hi-tech visions of alternative worlds that stood outside the ideological constructs of America's racial hierarchy, and in doing so, offered some of the most stimulating SF models of the Afro-Diasporic experience to date.

REFERENCES

Barthes, R. (1972). *Mythologies*. Canada: Harper Collins.

Bernardi, D. (Ed.). (1996). *Birth of whiteness: Race and the emergence of U.S. cinema*. New Brunswick, NJ: Rutgers University Press.

Bogle, D. (1998). *Toms, coons, mulattoes, mammies and bucks: An interpretive history of blacks in American film* (3rd ed.). New York: Continuum.

Brown, J. A. (2001). *Black superheroes, Milestone Comics and their fans*. Jackson, MS: Mississippi University Press.

Danticat, E. (2007, Fall). Junot Diaz. *Bomb Magazine, 101*. pp. 88–95.

Eco, U., (1979). *Theory of semiotics*. Bloomington, IN: Indiana University Press.

Fanon, F. (1959). *Black skin, white masks*. New York: Grove.

Gray, H. (1995). *Watching race: Television and the struggle for blackness*. Minneapolis, MN: University of Minnesota Press.

Guerrero, E. (1993). *Framing blackness: The African American image in film*. Philadelphia, PA: Temple University Press.

Hamlet, J. D. (2006). Assessing womanist thought: The rhetoric of Susan L. Taylor. In L. Phillips (Ed.). *The womanist reader* (pp. 213–232). New York: Routledge,

Hebdige, D. (1981). *Subculture: The meaning of style*. London: Routledge.

Hudlin, R. (2006). *Black Panther: The bride* (nos. 14–18, pp. 14–18). New York: Marvel.

Hudlin, R. (2007). *Black Panther: Civil war.* (nos. 19–25, pp. 19–25). New York: Marvel.

Kirby, J. (2005). *Black Panther by Jack Kirby* (Vol. 1, nos. 1–7, pp. 1–7). New York: Marvel.

Nama, A. (2008). *Black space: Imagining race in science fiction film*. Austin, TX: University of Texas Press.

Nelson, S. R. (2006). *Steel drivin' man. John Henry: The untold story of an American legend*. London: Oxford University Press.

Omi, M., & Winant, H. (1994). *Racial formation in the United States from the 1960s to the 1990s* (2nd ed.). New York: Routledge.

O'Neal, D., & Adams, N. (2004). *Green Lantern/Green Arrow* (Vol. I). New York: DC Comics.

Priest, C. (2001a). *Black Panther: The client* (nos. 1–5, pp. 1–5). New York: Marvel,

Priest, C. (2001b). *Black Panther: Enemy of the state* (nos. 6–12). New York: Marvel,

Reynolds, R. (1994). *Superheroes: A modem mythology.* Jackson, MS: Mississippi University Press.

Rodney, W. (1974). *How Europe underdeveloped Africa.* Washington, DC: Howard University Press.

Snead, J. (1994). *White screens black images: Hollywood from the dark side.* New York: Routledge.

Steinberg, S. (1995). *Turning back: The retreat from racial justice in American thought and policy.* Boston, MA: Beacon.

Stromberg, F. (2003). *Black images in the comics: A visual history.* Korea: Fantagraphics.

Telotte, J. P. (2001). *Science fiction film.* London: Cambridge University Press.

Vincent, R. (1996). *Funk: The music, the people, and the rhythm of the one.* New York: St. Martin's Griffin.

Walker, A. (1984). *In search of our mothers' gardens: Womanist prose.* Pennsylvania, PA: Harvest.

Wright, B. W. (2003). *Comic book nation: The transformation of youth culture in America.* Baltimore, MD: Johns Hopkins University Press.

"Explorers" — *Star Trek: Deep Space Nine*

MICHEAL CHARLES POUNDS

SETTING A NEW COURSE

IN THE EARLY 1990S, AS WASHINGTON, DC SHIFTED ITS POLITICAL CULTURE TO accommodate a newly elected Democratic president—William Jefferson Clinton— a continent away, in Hollywood, one of the nation's largest media corporations, the Paramount Pictures Company, prepared to reformulate another of the nation's institutions, network broadcast television, with its roll-out of programming aimed at building a new broadcast network that would be called United Paramount Network (hereafter UPN). Paramount's decision was based at least in part on its success as a program distributor, so it immediately revisited *Star Trek* ™ , one of its most popular and successful media franchises, and commissioned a new series as the new network's foundation.[1] Clinton's presidency and the new *Star Trek* series resonated with Roddenberry's original theme that humanity's future is bright, that resolving race relations is one of the principal factors that will improve understanding of our pasts, expand our nation's outreach and cooperation with others and that creating high technology is the key to releasing a new bounty for all. Clinton's victory not only meant the end of 12 years of Republican rule, but his campaign and administration rejected the race-baiting rhetoric that characterized both Ronald Reagan's and George Bush's campaigns and presidencies.[2] In part, Clinton succeeded because he openly solicited the strategic support of different ethnic groups

within the Democratic Party's base, especially African Americans. In Clinton's presidency ethnicity was part of the solution for social issues and not mischaracterized as an intractable problem.[3] The Clinton administration embraced diversity as one of its most repeated themes.[4]

Unfortunately for the Clinton administration, its pursuit of a liberal agenda on social issues (like race relations, health care and gender rights) was thwarted by Republican majorities in Congress, especially during Clinton's first term. The new president pragmatically approved compromise legislation (like the North American Free Trade Agreement, welfare reform, Most Favored Trade Status for China and the deregulation of broadcasting) that favoured big business interests. He fought the battles he could win, like stimulating the economy, creating new jobs (especially in high-technology and computer businesses) and appointing record numbers of minorities and women at every level of the federal government.[5] And from the nation's highest office a new tone on race and race relations was sounded. Paraphrasing Frederick Douglass, as this new sacred effort[6] emerged, it rippled throughout the country to make race relations a central part of the national dialogue about how America might face its past squarely to better understand the present situation and more closely achieve its potential: expressed as the Clinton presidency's central theme of building a bridge to the future for Americans to cross together.

Three thousand miles away, as with the very lucrative example of *Star Trek: The Next Generation* (hereafter *ST: TNG)* television series, Paramount opted to produce its next *Star Trek*[TM] scion as a live-action, hour-long, weekly broadcast television series. *ST: TNG* proved so popular and profitable that Paramount was confident another *Star Trek*[TM] property would not only add to the parent company's balance sheet but advance its efforts to cobble together an *ad hoc* sixth U.S. broadcast television network: UPN.[7] The new broadcast television programme would be titled *Star Trek: Deep Space Nine* (hereafter *ST: DS9).*[8]

Unlike most prior popular science fiction films and television shows (and breaking with the existing *Star Trek*[TM] properties), this new series would not be set aboard a starship zooming about the galaxy at greater than light speeds, would not be about a starship captain romancing every available alien female, nor would it centre on Starfleet intervening in the affairs of other cultures (known as breaking the 'Prime Directive' of non-interference) to resolve conflicts in a process that asserts the primacy of Terran ideology (central to *Star Trek*[TM] is its United Federation of Planets, a United Nations-style assembly of advanced space-faring civilizations, that actually enshrines a Terracentric hegemony disguised as diplomacy). Important differences would distinguish this new *Star Trek*[TM] series from past ones. Chief among these was its casting of its lead character and commanding officer.

Across town, Warner Brothers, Paramount's rival, was mounting its own new science fiction television series, called *Babylon 5* (hereafter *B5)* to establish its sci-

ence fiction credentials and help launch its *ad hoc* fifth national broadcast television network; this one was known as the Prime Time Entertainment Network, or PTEN.

Throughout pre-production, science fiction fans 'flamed' Internet newsgroups with charges that J. Michael Straczynski 'owned' the concept of basing a science fiction television series on a space station and that Paramount had poached it. That both series bore interesting similarities made the debate hotter. The main action for both *ST: DS9* and *B5* take place on space stations from which each series takes its name. The title of both series includes a designating odd number. Additionally, these space stations are located in the far distant reaches of space, remote from Earth and all its familiar friends, foes and resources. Therefore, self-reliance is stressed. Each is led by a strong male Terran who is supported by a large and diverse professional staff, the best the space corps can offer. However, here the two concepts diverged. *B5* was positioned as an updated intergalactic spaceport and emphasized multi-year story arcs built novelistically; in television terms, the comparison would be to the 'soap opera' (i.e., portraying both familiar and exotic characters in a sequential organization of stories). The space station in *B5* is an Earth-built platform isolated and floating somewhere in space, supporting travel, commerce and understanding among sentient species. In contrast, *Deep Space Nine,* unambiguously built by aliens, is in geosynchronous orbit above the far-distant planet named Bajor. *ST: DS9* programmes developed along the familiar lines of the episodic serial. In *ST: DS9,* the proximity to Bajor is a constant source of detail and complexity for the series, enriching it with political and religious intrigue. The two programmes envisioned their key setting, the space station, differently, too. *B5* is a huge blue-grey cylinder that spins around its horizontal axis to create gravity. *Deep Space Nine* is a brown, horizontally-oriented circular construction with upper and lower docking ports mounted in brackets at intervals around its circumference.[9]

ST: DS9 executive producers Rick Berman and Michael Piller were entrusted to make the new series consistent with all of Gene Roddenberry's previous *Star Trek*[TM] productions and distinct from other science fiction programmes. From the earliest formative stages of the series' pre-production, Berman and Piller's day-to-day responsibilities and creative decisions affected the 'look and feel' of every aspect of the series. As they began preparing *ST: DS9,* Berman and Piller, like the rest of Los Angeles and a sizeable chunk of the television-viewing population of the United States, were riveted to their television sets as Los Angeles burst into civil conflagration following the acquittal of Los Angeles Police Department (LAPD) police officers charged with the brutal beating of motorist Rodney King, an African American. With several months to go in pre-production, Berman and Piller must have felt the mantle of Roddenberry's legacy most profoundly, because their next creative decisions revisited the soul of Roddenberry's original *Star Trek*[TM] vision.

In its original form, Roddenberry fashioned *Star Trek: The Original Series* as a media vehicle for responding to some of the country's core cultural issues of the 1960s: the Cold War, Vietnam War, the Civil Rights Movement and the belief that humanity's future depended on resolving disputes through a multi-national diplomatic agency, like the United Nations.

For more than 50 years, audiences came back, again and again, to revisit Roddenberry's vision of a daring and adventurous future. This future was a fictional place where a cross-section of humanity under the aegis of Starfleet and the United Federation of Planets work together and face all manner of foes to secure peace and prosperity. Star Trek™ represented Roddenberry's beliefs that to survive and reach the future humanity will have to embrace racial integration, that even the toughest, most intractable problems have solutions, and that technology is positive and will make existence easier and allow us to achieve our potential. With the passing years, the iterations of *Star Trek* have been different, subtly altered. But Roddenberry was always there approving the changes, making sure the core values of his vision were not violated. This history of reflection on the social scene is the vital subtext of the *Star Trek* ™ canon. This core was sacrosanct and defended by Roddenberry until about midway through *ST: TNG*, when Roddenberry's death shifted stewardship to Hollywood producers Berman and Piller.[10]

ST: DS9 would be the first *Star Trek*™ production that would not have Roddenberry available for creative consultation and to wade into battles with studio executives to defend its precepts. Even without his guiding presence, they affirmed the show's focus on contemporary American issues. Even without Roddenberry's ownership leverage behind them, they steered *ST: DS9* toward the themes of race, gender, ethnic difference, religion, imperialism and liberation to make them central to the series' core.

Moreover, *ST: DS9* became a *Star Trek*™ series like none before. From the outset, *ST: DS9* was marked by an unexpected, even uncanny, relation to contemporary television science fiction, *Star Trek*™ productions, popular culture and American society. In fact, Piller and Berman went on record in the trade papers, stating that they were so affected by the civil rebellion in Los Angeles from the summer before the launch of their new show that they wanted the series, especially its inaugural episode, 'The Emissary, Parts I and II' (airdate: 3 January 1993 and 10 January 1993) to reflect issues from contemporary American society.[11] As audiences tuned in to those first programmes, they toured a space station and its commercial hub called the 'Promenade Deck' that was an abandoned, smoking ruin. The similarity between the two television events and their images of civic destruction in mass circulation within six months of each other cannot be casually overlooked.[12] Nor can Berman and Piller's decision to mark the new *Star Trek*™. series indelibly with many of the social issues that characterized the original parent series and that would distinguish

it from comparisons with other past and present non-*Star Trek* science fiction television productions.

Therefore, any similarity between the televised images of the Los Angeles civil turmoil (e.g., the LAPD and national guard patrols, streets littered with assorted trash and burning cars, ordinary people frightened beyond belief and businesses shattered seemingly beyond recovery) and the look and feel of 'The Emissary, Parts I and II' was intentional (Tryer 1993). And the parallels kept coming. On 30 June 1992, after decades of questionable paramilitary-style policing under a succession of white (Anglo) commanders, the LAPD lost its autocratic and racially insensitive chief, Daryl Gates (tenure from 1978 to 1992). Gates was blamed for mishandling the civil disturbances and was unceremoniously dismissed by some of the region's same power-brokers who installed him in that post much earlier.[13] After a national search the metropolis welcomed a new police chief. In the nation's most distant of its lower-48 states, international cultural outpost and gateway to Asian markets, a 'new sheriff came to town.' And on *Star Trek's* latest fictional television spin-off situated at the farthest remove from Earth (yet still inside the Alpha quadrant that is home to Starfleet and United Federation of Planets), at the cultural and commercial gateway to the Gamma quadrant, another 'new sheriff came to town.' One real policeman, one fictional policeman: both 'sheriffs' are in command authority positions supervising paramilitary forces. The LAPD's new chief was Willie L. Williams (tenure from 1992 to 1997) and *ST: DS9's* new male lead character and *Deep Space Nine's* commander is Benjamin Sisko, played by the actor Avery Brooks. Both were middle-aged men, facing nearly impossible challenges from a variety of sources at the peak of their professional careers, and both were African Americans.

Media-producing studios and broadcasting networks are first and foremost businesses. The selection of material for television, the decision to move ahead with production, and the creation of competitive broadcast schedules are all financial considerations. What constitutes the popular taste of the moment and how many viewers from the most desirable demographic strata can be attracted to television programmes is the 'holy grail' of U.S. network broadcasting. As Paramount made the decision to create another broadcast network, it faced a situation that as a television programme distributor was fresh and fraught with problems. While Paramount did not have experience with starting up a new broadcast television network, four years earlier, in 1986, Rupert Murdock's News Corporation did. It successfully launched a fourth US television network called FOX Broadcasting (hereafter, FOX). Key to its success was FOX's appreciation of which networks already controlled which portions of the network television terrain. By 1990, FOX determined to consolidate its national coverage with a plan to gain profitability by going after the coveted 18–49 year old slice of the audience. The FOX plan included youth dramas (like *Beverly Hills, 90210, Party of Five* and *Melrose Place),* a vari-

ety show (called *In Living Color)* and science fiction programmes (like *The X-Files* and *The Adventures of Brisco County, Jr.).* *Star Trek: Deep Space Nine,* it can be argued, is the result of combining the first and last categories above and stirring well. *ST: DS9* takes advantage of the popularity of *ST: TNG* and adds a minority lead character that FOX and *The Cosby Show* audiences had already proved was attractive to the 18–49-year-old demographic and therefore profitable.[14]

These comparisons are not dismissable as mere chance parallels or coincidences. That media producers monitor cultural trends is certainly not news. American media conglomerates, like Paramount, are publicly-traded businesses whose fortunes ebb and flow based on their ability to anticipate and exploit mass tastes and trends and to effectively market media products designed to attract audiences that identify with mediated entertainment culture in its specific forms. Indeed, a very important part of the role of the executive producer and studio and network executives, not to mention the individual programme producers, known as 'show runners,' is to track public preferences for various entertainment commodities across categories (genres) and individual productions as measured by Nielsen ratings (television viewing), Showscan (music purchases) and box-office (film attendance) to gauge present mass attitudes and project future taste. Cultural production requires the investment of not only money but a good deal of time and effort in trying to appreciate the general social context and the ways it may be changing to meet the strains and stresses of the moment. This imperative is doubtlessly at the core of the original rationale and continuing resonance of *Star Trek* ™ .[15]

A LITTLE BACK STORY

Deep Space Nine, the fictional space station, is situated between the Bajorans (a humanoid race with a strong religious tradition that, as the series begins, has successfully fought for and gained its freedom after prolonged enslavement) and the Cardassians (a bipedal reptilian race with a strong military culture, superior technology and a seething racial animus toward Bajorans), who, defeated by the Bajoran resistance, withdraw from the orbiting command post Terok Nor (renamed Deep Space Nine by Bajor and Starfleet) to return to their home world. The Celestial Temple is an astronomical phenomenon that for Bajorans is the sacred residence of the holy Prophets, but Starfleet —and the more scientifically-minded—refers to it as the quadrant's only stable 'wormhole,' an unprecedented aid to intergalactic travel). The Prophets are mysterious alien inhabitants of the Celestial Temple/wormhole for whom linear concepts of space-time are meaningless and who seem linked to Bajor's past and future). The Ferengi are a diminutive, brown-skinned alien race whose entire society is organized around the profit motive, raised to the extreme.[16]

These *dramatis personae* clearly indicated that *ST: DS9* was not going to be a *Star Trek™* television series that would dwell on the wonders of future technology or being bold galactic explorers.

Controversy marked *ST: DS9* immediately. In fact, the series producers seemed to court it. As audiences tuned in to the series' inaugural episodes, 'The Emissary, Parts I and II,' they toured a space station with its commercial centre, the 'Promenade Deck,' recently hastily evacuated by the Cardassians and with destroyed stores showing the scars of battle and the fires of rebellion still burning. Into this bubbling cauldron of civil distress strides Captain Jean-Luc Picard, commanding officer of Starfleet's flagship *USS Enterprise 1701·D,* dispatched by the United Federation of Planets to welcome and install *Deep Space Nine*'s new commander.

In the *Star Trek ™* universe there can be no more important choice than that of the commanding officer, and on *ST: DS9* the commanding Starfleet officer functions on several levels. Here the commander is the representative of Starfleet in this region of space, the face of the series (point of identification for audience members and fans) and the emblem or central metaphor for series themes (crucial for writers/producers to appreciate in tackling new assignments). As one would expect, a good deal of calculation and second guessing goes into deciding who will put on the commander's uniform tunic. This fundamental franchise fact is underlined by having the male lead actor from the previous series, Patrick Stewart, make a guest appearance as Jean-Luc Picard in 'The Emissary, Parts I and II' to 'pass the baton to,' or, one might even say, 'anoint' his successor, Benjamin Sisko.

ST: DS9 is an unmistakable descendant of Roddenberry's original vision of *Star Trek ™*. It showcases racial tensions as conflicts between civilizations and cultures in space played against the impetus for harmony and understanding amid that diversity. However, in this instance *ST: DS9*'s producers developed a model of a lead character for the series, the principal point of audience attraction/attachment, that balanced general human emotions (including fatherhood and being a widower) and allegiance to Starfleet/Federation authority against his moral integrity as a diplomat/religious intermediary and member of an historically oppressed Terran minority. The Sisko character, an African American, differs from captains Kirk and Picard, because he married and started a family. That this would not be an easy balancing act is demonstrated by the issues raised and how they are presented in the series' two-part opener. Sisko is a leader who embraces the responsibilities of being a parent along with his professional duties. Conflicts may arise between these roles, but he is not willing to sacrifice one for the other. [17]

Rather than being nostalgic, *ST: DS9*'s producers decided to ground the series in the truth that interracial (much less intergalactic) understanding is all about confronting deep fears and terrible truths, the best and worst in us. During the series' opening episodes, Sisko receives his commission to command the station from

Starfleet's most lauded starship captain, Picard. But that is not all there is to Picard. He also killed Sisko's wife (and thousands more), as Lucretus, the leader of the Borg, during the space battle at Wolf 359 while trying to conquer Earth.[18] At the moment Sisko should be enjoying the height of professional recognition and advancement, he is nearly swamped with feelings of revenge and within arm's reach is the object of his wrath-filled desire for revenge: Picard! Now that is a dramatic set-up. Tension between two senior officers, friction along racial lines, hatred separating men who should be brothers in uniform and then there is Sisko's enmity directed at Picard for allowing himself to be transformed by aliens into Lucretus, the Borg's instrumentality who nearly destroyed Starfleet. How often has U.S. commercial mass entertainment dared attempt being so emotionally and racially charged?

The key to this lead character and the producers' conceptualization of the series can be clearly seen in these two episodes. Instead of celebrating with friends, family and colleagues, Sisko has a vision of being outside space and time: he is simultaneously in the Celestial Temple/wormhole with the non-corporeal 'Prophets'/wormhole aliens; he is back on Earth playing baseball; and back aboard his battle-damaged starship with shipmates and family during the battle with the Borg, helplessly watching his wife die, again and again. At the moment of professional advancement when he should be celebrating, he cannot. Sisko is not only 800 years from Earth/America/Africa chronologically, he is physically hundreds of light years from his father's New Orleans home, he is precisely nowhere and in several different places simultaneously, and at the same time within arm's reach of the man who killed his great love and wrecked his family! This is the very definition of a man, of a character whose identity is in constant, dynamic flux. Not the hero of rock-solid personality that predenominates and determines Western mass media from the dominant cultural perspective. Getting this character right is at the heart of the challenges the producers and writers faced, precisely because it is the narrative engine out of which so many similarly borderless stories could originate, that is, stories that negotiate boundaries of race, species, religion, politics, physicality/non-corporeality, gender, space-time, and war and peace. Clearly, Piller and Berman wanted their audience to boldly go beyond reveling in geek technology and to entertain a future at least as full of sentient complexity as our present world. The creation of Sisko as an African American character with an ambiguous identity (i.e., an identity that is non-linear and linear, corporeal and non-corporeal, Starfleet/Federation ambassador and emissary between Bajor and the Celestial Temple prophets, African American son of an African American father and African American father to an African American son and a part of the United Federation of Planets and a member of a marginalized Terran minority) allows strategic narrative development along routes that might not otherwise be explored by a *Star Trek*™ spin-off.

These episodes suggest that at the centre of this new *Star Trek* ™ series is an intention to use its lead character's complicated identity through which his ethnicity is threaded as a narrative engine for generating stories that might go beyond broken warp coils, trans mats and food processors and begin to ask audiences to be entertained by future societies' unfinished business in politics, religion, philosophy (issues ranging from defining terrorism vs. freedom fighting, examining euthanasia and exploring military culture vs. peace, etc.), Terran vs. alien psychology, race (adoption of children from one alien group by a member of another alien race), being a bi-racial or bi-species being, raising gender issues and the imperialistic lust for power and domination.

OUR MISSION

To investigate this perspective, an episode from the third season of *ST: DS9* was selected for analysis: 'Explorers' (airdate: 8 May 1995). To examine 'Explorers' and determine the various ways the character Sisko functions and how his identity as an African American facilitates narrative development (and the construction of meaning at non-narrative levels as well), the researcher applied a variety of critical theories selected from semiology, film, television and media critical studies and reception theory, and subjected the selected episode to repeated close readings.

The objective here is to understand the ways core cultural information, like attitudes, values and beliefs, is manifested and associated with characters of different ethnic backgrounds, social status, genders, occupations and other relevant categories, to create codes of representation. Mass media forms of communication, like television, are composed of production values or aesthetic elements, like editing, lighting, framing/composition, costuming, colour, music and sound, and *mise-en-scène*. Additionally, this analysis will extend its scope to include these aesthetic elements to appreciate the manner in which they support meaning as well.

A NARRATIVE AS PERSONAL LOG

The episode begins with its 'B story': Deep Space Nine's Chief Medical Officer, Dr Julian Bashir, meets a very attractive woman named Leta, who works in the space station's casino and is clearly sexually attracted to him: then Jadzia Dax, a senior Starfleet officer, brings him news that Dr. Elizabeth Lenz, the valedictorian of Bashir's Starfleet medical school class, is coming to Deep Space Nine in three weeks aboard the *USS Lexington*. Bashir, who was class salutatorian, because he mistook a pre-ganglion fibre for a postganglion nerve years ago, is still upset by Lenz's success. In the 'A' story, Sisko rejoins the Deep Space Nine after a brief research visit

to Bajor's museums to pursue his interest in archeology and antiquities. In his personal quarters, he eagerly shows off his new goatee with moustache and the results of his research to his son, Jake. Planet-side, working in a manuscript library, Sisko found information and drawings that support legends about ancient Bajorans creating solar ships and sailing all the way from Bajor to Cardassia, 800 years before the Federation's arrival. Bubbling over in excitement, Sisko tells Jake that he plans to build his own Bajoran solar sailing ship. A brief 'C' story involves Jake's budding interest in writing and his anxiety about leaving Deep Space Nine to study writing back on Earth. There is a short 'A' story montage sequence that shows Sisko collecting the tools and materials needed to build the Bajoran solar ship, and then he is shown working, beginning to build and test the components of his Ship.[19]

Later, as Sisko and Jake share a meal, he tells his son that he does not think his ship will necessarily reach Cardassia, but that if it gets through the Denorios Belt, an obstacle to navigation created by the pulverization of asteroids into rings of debris, he feels that he will have gone a long way toward proving that the ancient Bajorans could have made the space trip against the odds. He tries to convince Jake to join him, but Jake tells him he is waiting to see LeeAnn, his girlfriend, who is returning to Deep Space Nine at the same time the solar ship will be ready for launch. The next day, Jadzia Dax joins Sisko in the cargo hold where he is working to admire his craftsmanship and console him about Jake's decision not to travel with him. Meanwhile, Jake receives a message from the Wellington Writers Programme in Australia that pleases him: he finds his father and tells him that he changed his mind and now wants to accompany him on his test flight.

Sometime later, Jadzia Dax and Dr. Bashir are in the station's bar and he tells her that he is studying recent medical research, cramming like he is back in school, because his academic rival is about to arrive. Bashir confides to Jadzia that Deep Space Nine was always his first choice for posting after medical school and receiving his Starfleet commission. However, it forever seems 'second best' because Dr. Lenz could have taken it as her valedictory prize. In another part of the station, Sisko receives a personal message from Gul Dukat, a Cardassian military leader. Dukat contacts Sisko to try to dissuade him from making his journey. Warnings about running into rebels and possible mechanical breakdowns in space fail to dampen Sisko's spirit or intention, and the transmission ends with Dukat wishing the commander 'good luck.'

Next, the solar ship launches into space and rapidly leaves *Deep Space Nine* behind. On board, father and son deploy the mainsails and set and trim the spritsails. As it speeds through the spatial void, the solar vessel looks like a scarab attached by leathery tendons to gossamer butterfly wings.

En route Jake learns some of the facts about how they will be travelling. Sisko's one concession to their era is in the gravity plating he installed that makes it effort-

less for the two space sailors to move around their ship. Otherwise, knowing what the ancient Bajorans would probably have done has guided his choices. Interior space is limited, so when it is time to rest, he says they will sleep in their own individual hammocks. Jake discovers that the ship has a 'zero-gravity toilet' (but knowing how to use it is another matter).[20] There are no replicators onboard, so their food is 'zero-gravity rations' just 'like the ancient Bajorans had.' Sisko tells his son that he will do all of the course calculations and mid-course corrections himself without the assistance of computer automation. As they pause for a meal, the father points out to his comfortably space-age son that their ship makes no engine noise and is as quiet as the sailing ships of ancient Earth. He wonders aloud how the ancient Bajorans must have felt in their wooden ships, steering by their stars, and not knowing who they were going to meet or what they would find ahead of them. In this quiet moment, this father thanks his son, who he acknowledges did not really initially want to leave Deep Space Nine, for coming along with him. Jake, taking his turn, tells his father that there is something he needs to discuss with him, but first his father has to read one of his, Jake's, stories. Sisko asks Jake to watch the rigging and settles into his son's story.

On Deep Space Nine, a nervous Bashir waits for Dr. Lenz at a docking bay when Chief Engineer Miles O'Brien comes up to him and tells him that the *USS Lexington* has already docked and his passenger is already in Quark's bar. Bashir makes a beeline to the station's cocktail lounge and for Dr. Lenz. When she has finished her meal, she moves from her table and walks right up to Bashir without remembering him and leaves. He is visibly shaken.

Back on the solar ship, Sisko tells Jake how impressed he is with his writing but cautions him not to write about things that he has not experienced. There is some goodnatured joking between father and son. Then, Jake explains that he showed one of his stories to Mrs. O'Brien, Deep Space Nine's school teacher, who forwarded it to someone she knew at the Pennington School and that the day before they launched he received a communique from the school offering him admission for the next academic year. He tells his dad that he is really very surprised by this good news and that he had not applied or done anything to set this into motion. At this moment, there is a loud noise and their ship lists to one side. Sisko investigates and determines that a mast support gave way, the starboard sprit is fouling one of the main sails and nothing can be done to fix the problem. They ease off on the sheets a bit and jettison the sprit. This solves part of the problem, but there is still luffing. Sisko fires explosive charges that separate the sprit from the ship and sits back, feeling a little disappointed. At this point, Jake steps in to cheer up his father by pointing out that the ancient Bajorans must have run into similar problems, but they surely did not give up. Buoyed by his son's enthusiasm, father and son turn back to the manual labour of making course adjustments and continuing their journey.

On Deep Space Nine, Bashir and O'Brien are 'deep in their cups' in the chief engineer's quarters where the latter is teaching the former a drinking song. Bashir drunkenly recalls that Dr. Lenz walked right past him like 'I wasn't even there.' O'Brien fishes for an alternative explanation, but all that occurs to his alcohol-soaked brain is that she must love Bashir. This, however, is an idea that Bashir quickly rejects. Instead, Bashir resolves to confront Lenz and ask her point blank why she ignored him…tomorrow when the alcohol haze has lifted.

Back in space, the voyagers complete their course correction, tie-off the sheets, and break out the sleeping gear. Sisko has equipped the small ship with hammocks for each of them. Jake strings up his, spreads it open, gets into it and promptly falls onto the floor. They laugh. Sisko congratulates Jake about his acceptance to such a competitive school as Pennington. Jake replies that he plans to defer his admissions for a year to gain more experiences on Deep Space Nine. Sisko cautions against a rash decision by telling him what it was like for him when he left home to join Starfleet: how he was so homesick he transported back to his New Orleans home every night for the first few days just to eat dinner with his parents. His parents understood and welcomed him home each time. But after the fifth or sixth trip, Sisko says with a proud smile, 'you could not pry me away from that campus.' Jake tells his father that it is not for himself that he worries. He is concerned about his father and, specifically, about the fact that when he leaves his father will be all alone, that he does not have a girlfriend and that he has not been out on a date in more than a year. Jake wants his father to be happy and whole. Sisko cannot believe he is getting dating advice from his son. Father and son enjoy a good-natured chuckle about the situation.

Jake continues to press his point by telling father that he knows 'a very attractive lady that wants to meet you.' This light mood is suddenly punctured by a shudder that runs through their ship. When Sisko investigates he becomes concerned about the power of the force that just hit their craft. As the pair stare helplessly out the main porthole, the small ship begins to accelerate until it appears to reach faster-than-light speeds. Just as suddenly, the solar ship stops rocking and jittering. Sisko checks its systems and discovers that main power is off and that they are indeed travelling at warp speeds. Sisko examines the star charts but cannot find any phenomena that explain their experience. However, Jake notices that the charts do show something that Sisko identifies as tachyon eddies. Jake asks if they could have got caught up in them. Sisko is about to say that the tachyons should not have affected their ship when he realizes that their solar ship has a much larger surface area relative to its mass than a typical spaceship design. Since tachyons travel faster than light normally, Sisko conjectures, it could be that their impact upon the sails caused the warp-level acceleration. Jake finds that a mainsail and jib on the port side are

missing. When Sisko reaches for the sextant that he brought along, he finds it shattered in pieces on the deck. They are unable to fix their location or determine where they are going. As they realize a broken sub-space radio means they cannot even contact Deep Space Nine, they wonder if the tachyon surge has stranded them in space beyond rescue.

On Deep Space Nine in Quark's casino Bashir summons his courage, walks over to Dr. Lenz, sitting at a table alone, and introduces himself. They talk and Bashir learns that Lenz did not greet him because four years prior at a party someone misidentified a blue-skinned alien with antennae as Bashir. She even admits to being so nervous waiting backstage at graduation that she almost missed her cue, so she missed him there, too. Rival classmates and fellow Starfleet medical officers, strangers until this moment—Bashir congratulates her on besting him and on her posting to the *USS Lexington*. Instead of regaling Bashir with tall tales, Lenz reveals that her assignment aboard the starship is routine, hardly challenging and that on several occasions she has wished for Bashir's post on Deep Space Nine. Lenz, it turns out, is following one of Bashir's Bajoran medical research projects via their publication in research journals and expresses her admiration for his work. An old wound healed, Bashir invites Lenz, now a friend, to his infirmary where she can go over the latest results related to that project.

Onboard their solar ship, Jake tries to joke about their air supply, and his father reassures him that someone will find them long before the air runs out. Sisko and son return to an earlier topic before the distraction. 'So, tell me about this woman you want me to meet.' 'Well, she is a freighter captain.' 'Whew! A freighter captain?' Jake convinces his father to trust his taste and they make a pact. Sisko will go on a date with Jake's freighter captain, but Jake cannot base his decision on Pennington on how the date turns out. Jake agrees because he wants to wait at least year before going away, to learn more about himself and gain more experience on Deep Space Nine. Father and son look at each other knowing a rite of passage is coming. As Jake turns back to the main porthole, he sees something outside their ship and quickly calls to his father. When Sisko moves to share his son's point of view, he sees a small flotilla of Cardassians ships.

They are immediately hailed over radio by the commander of the Cardassian ship, Gul Dukat. 'I wanted to be the first to congratulate you on managing to make it all the way here.' Without knowing it, the Siskos entered the Cardassian system and proved that the ancient Bajorans could have made the same trip. Dukat reads an official proclamation that announces the coincidental discovery on Cardassia of an ancient Bajoran crash site that archeologists believe contains the remains of a Bajoran vessel whose journey the Siskos have recreated. The Cardassian space ships release a fusillade of fireworks to celebrate the occasion. Benjamin Sisko's

remarks dismiss any notion of coincidence, as the Siskos bask in the festive illumi-nation that the Cardassians are, in essence, embarrassed into staging.

BEYOND A *STAR TREK* NARRATIVE: SIGNIFYING RACE

This chapter examines 'Explorers,' an episode from *ST: DS9*, to determine whether the episode was informed in any way by the African American ethnic identity of two of its regular characters, Benjamin and Jake Sisko, and, if so, the extent to which that influence might be found at various levels of the programme. After selecting the episode, a detailed summary of its narrative was developed. Next, after apply-ing several research methods, like semiology, film and television theory, media crit-ical studies and reception theory, the deconstructed episode narrative will be discussed. The deconstruction step is necessary because commercial broadcast and cable media production devote a great deal of effort to structuring various modes (or genres) of cultural representation in such a way that the media's disruptive nature (local station identification, commercials, promotions for upcoming pro-grammes, etc.) is effectively elided or neutralized. On closer examination, commer-cial media are composed of time blocks (usually of 30 or 60 minutes), which in turn may be broken down into heterogeneous media content blocks for programme, advertisement and promotional material. These time blocks rotate through the various kinds of media content. In a specific long-form commercial television pro-gramme, like *ST: DS9*, two or three distinct plots or storylines (that is, 'A,' 'B' and 'C' stories) can be interwoven throughout the time blocks as well. Audiences receive different kinds of media content and, nominally, engage with them and are led by them back and forth among the programme's storylines. Audience attention moves through these narrative segments and through the other kinds of media material, lured by the promise of a complete narrative.

Part of the genius of media writing resides in the way these storylines reflect different aspects of an overarching or unifying theme for the episode. In 'Explorers' there are three storylines. The main, or 'A,' story focuses on Captain Sisko's desire to test the myth of ancient Bajoran space travel to Cardassia. The second, or 'B,' story centres on Dr. Bashir's reunion with the person who bested him for valedictorian of his medical school class. In a very brief third, or 'C,' storyline, Jake Sisko receives official notification that his writing efforts not only impress and move others (like his teacher, Mrs. O'Brien, on Deep Space Nine), but have earned him admission to a prestigious Terran writing programme. Bashir learns that Dr. Lenz prizes his medical research far above the boring routine of her deep-space mission. And as the first and third stories merge, the Siskos—father and son—an engineer by training and, therefore, an empiricist gains a new appreciation of life's mysteries and the fact

that truth can lie at the centre of myth, and a youth growing up and learning to care about his father's future as much as his own, respectively, strengthen their bond by discovering that each has sensitivity, creativity and a sense of adventure beyond their roles as parent and child, Starfleet officer and civilian, that add complexity and depth to their appreciation of the other. Seen from this point of view, all of these stories centre on the theme of critical self-evaluation. Put more plainly, all of these recurring *Deep Space Nine* characters come through their story with a renewed sense of self, and a stronger identity.

In 'Explorers' five separate blocks of programmatic content blocks were found. For convenience, these were labelled: (1) 'exterior views of Deep Space Nine'; (2) 'scenes on Deep Space Nine with Captain Sisko'; (3) 'scenes on Deep Space Nine with Dr. Bashir'; (4) 'exterior views of Captain Sisko's solar ship'; and (5) 'scenes on board Sisko's solar ship.' The limitations of this study preclude statistical sampling and analysis of the entire run of episodes from this science fiction series to determine whether five distinct content blocks were typical. However, it is clear that in 'Explorers' the overwhelming majority of programme time was allocated for the storyline relating Captain Sisko's enthusiasm for building and sailing his reproduction of an ancient Bajoran solar ship. Put another way, only 12 minutes, 18 seconds out of more that 41 programme minutes were used to convey a different storyline—Dr. Bashir's reunion with a member of his class from Starfleet medical school—and there were just 19 seconds of exterior views of the Deep Space Nine as hub of activity, as principal location for the series and as a logo for the *Star Trek: Deep Space Nine* brand. Instead, the majority of the episode's scenes centre on Sisko building his solar ship, sharing his interest in ancient (alien) culture, technology and lore as a means of bonding with his son, Jake, who is considering college back on Earth. These scenes total more than 27 minutes of narrative storylines, with just 1 minute, 8 seconds used for exterior shots of Sisko's recreated Bajoran solar ship in action in space.

From these numbers it is clear that the episode's narrative development is weighted overwhelmingly toward developing its African American characters. In the case of the Benjamin Sisko character, many of the episode's scenes build upon and flesh out his training as an engineer and his preoccupation with the challenges inherent in an unorthodox fabrication project using original materials and techniques. Also, there are several scenes that explore and deepen the relationship between Sisko and Jake. As they sail the solar ship together, Jake relates his feelings about the future, both his own as a writer and his father's as a bachelor. Jake urges his father to attend to his emotional needs by dating. In just under 30 minutes this episode expands both of these characters, adding to their existing attributes qualities relating to creativity: for Benjamin Sisko, we watch as he reads blueprints and fashions a faithful copy of the solar ship ancient Bajorans sailed, and for Jake, we learn about his proficiency in creative writing. The only other indepen-

dent storyline, the 'B' story, centres on the series' Middle Eastern medical doctor, Dr. Bashir, and plays out in a little over 12 minutes. Storylines about the Siskos show a more than 2:1 advantage in allotted time against those about the next most-featured character, Bashir.

Beyond these metrics, however, what sets 'Explorers' apart in the *Star Trek*TM canon is the amount of effort marshalled to depict these two featured, ethnic minority characters (i.e., African Americans) outside and beyond their Starfleet identification.[21] First, much more time is allotted for their storylines and character development. Moreover, it is clear that the goal of character development in this episode differs from the standard *Star Trek*TM character development. In the typical *Star Trek*TM narrative, an episode's challenges and conflicts are resolved by featured regular characters using their Starfleet education and experience to re-conceptualize the central crisis by applying their knowledge, albeit from a novel (improvised, untested or unproven) perspective. In this way, *Star Trek*TM characters are typically represented as courageous, resourceful and indefatigable but always within the Starfleet ethos.

In 'Explorers' that precept does not obtain. In place of that standard model for character development, the Sisko characters gain texture and depth through their individual explorations of interests that are clearly represented as outside of Starfleet parameters. In a very real sense, the development of Benjamin and Jake Sisko exemplifies W.E.B. Du Bois's formulation—nearly a century old, now—that African Americans present with 'two consciousnesses': one consciousness that develops to understand and to function within the dominant culture *(Zeitgeist)* and another consciousness that develops by observing and critiquing the dominant culture's attitudes, values and belief structures from the standpoint of an equally robust, separate and ethnic point of view *(Weltanschauung)*.[22] Benjamin Sisko uses an interest (archeology) clearly outside his Starfleet command functions to appreciate the technology and dreams of another ancient and marginalized culture, and Jake Sisko applies his talent (writing) to demonstrate his understanding of a wide palette of beings, their circumstances, motivations, actions and consequences.

The difference in 'Explorers' is the way this episode creates a new space for its featured African American characters to relate their core identities not to their Starfleet functions or dependencies but to an older, deeper, richer and much more personal identity than Starfleet offers. Evidence for this point is present from the series' two-part opening, when Benjamin Sisko is lifted out of normal space-time to experience another form of consciousness. Sisko is an ethnic minority, an Other, and from the series' beginning this gets represented by the fact that, without his consent or any effort on his part, he experiences his difference in the form of visions that he alone has and during which only he is challenged to use his personal background to bridge the seemingly infinite distance between the corporeal and the non-

corporeal, the tangible and the ineffable and different kinds of Others (Terran and extraterrestrial).[23] In 'Explorers' this same point is made, but in a perhaps less metaphysical manner. To accomplish this voyage, Benjamin Sisko will have to draw on his skills as an engineer and as a father, not those of a Starfleet officer. He will have to use another part of himself, that part that is outside of his Starfleet commander identity, that part that is Other. To put the matter bluntly, the Starfleet and Federation constructs allow and privilege ethnicity only to the extent it is subordinated to those institutional cultures. 'Explorers' clearly strips away the Starfleet/Federation veneers, so that a specific pair of ethnic Others have the room to develop as father and son and to test notions about another culture's earlier experience as heroic explorers.

From the first moments that Sisko appears in 'Explorers' there is something different about him. Fresh from a bit of planet-side relaxation and recreation, he is full of excited energy, and he is sporting a never-before-seen moustache and goatee. Gone is 'the buttoned-down, by-the-book' demeanour of a Starfleet commander, and in his place is an African American man who has passions outside of Starfleet and for whom a little ethnic-anthropological-cultural mystery is just the thing to get his 'juices' flowing. The particular mystery has nothing at all to do with Starfleet or Sisko's role as commander of Deep Space Nine and everything to do with his personal and minority group's pasts. As deep as his commitment to Starfleet as Deep Space Nine's commander is, his background as an engineer and father to an African American son and son of an African American father runs just as deep and true. This episode stresses these aspects of Ben Sisko.

In the typical *ST: DS9* episode, Commander Sisko interacts with a variety of beings: Bajoran civilians, military and religious, Starfleet personnel, Cardassian military and civilians, and a host of civilians from civilizations throughout the Alpha quadrant of space in his capacities as Federation envoy and/or Emissary of the Prophets. In 'Explorers' this range of possible interactions is drastically pared down to his Bajoran military attaché, the station's chief engineer and his oldest friend. These characters can be said to represent Sisko's past experiences in Starfleet (Dax), his present assignment as a Starfleet commander/ambassador in a new region of space (O'Brien) and his future that seems connected to Bajor and its Prophets (Nerys). But in his interactions with these three characters there are no conversations that have anything to do with Starfleet, his duties as station commander, or as spiritual conduit to the Celestial Temple. Later in the episode, his interactions are further focused on father and son issues.

It is worth noting that the settings in which Sisko is depicted contribute to this process of destabilizing the Commander Sisko/Starfleet/Federation character construct. The settings associated with Sisko step by step limit and reduce his Starfleet/Federation link or identity. First, we see him in his personal quarters with

his son and bursting to tell Jake about what he has found in Bajor's libraries: blue-prints and plans for building a Bajoran solar ship. Next, he is in the cargo bay with O'Brien and Nerys announcing his intention to use it as his workshop for build-ing his own solar ship. During this scene, he rejects O'Brien's suggestion to use state-of-the-art technology and tells him that he wants to build his ship using the same hand tools that the ancient Bajorans used. Then, later, on board his partially com-pleted ship, Dax and he discuss Jake's decision not to join his dad on the trip he is planning. They talk about how hard it is to be a father, to let go and give a son the space he needs to grow. None of these topics of conversation have anything to do with Starfleet or being the station commander. In fact, the one scene in which Sisko is shown in his commander's office on Deep Space Nine, he is leaving it and plac-ing Major Kira Nerys in charge while he is away. Clearly, the series producers and writers are carefully opening up a space for Benjamin Sisko to show that he is not reducible to being a Starfleet officer.

Additional evidence of this point can be found readily in 'Explorers.' For exam-ple, turning to clothing, it is clear that this detail supports the pattern above. When Sisko returns to Deep Space Nine from Bajor, he wears his Starfleet command uni-form. However, there is that new moustache and goatee. Visually, a conflict and a question are represented for viewers from the beginning of the episode. As excited as Sisko is about what he thinks he found on Bajor, once back on Deep Space Nine, will his command responsibilities overwhelm him and force him to shave off his sporty new look and resume his chair behind the imposing desk just off the station's command centre? No! He keeps the facial hair, and it is his wardrobe that changes. Off goes the Starfleet command uniform, and before you can spell 'sartorial,' he is wearing a simple plain pair of worker's coveralls as he begins transforming blueprints into a fabricated ship. And the episode's use of wardrobe as signification continues. Once the solar ship is built, Jake comes to the cargo bay to tell his father that he now wants to join him on his quest to prove the Bajoran myth fact and Sisko wel-comes him onboard wearing different civilian clothes. It is not just that he is no longer dressed as a worker, rather that he has picked a stylish ensemble: casual slacks, an open-V neck shirt and a very hip vest. Not just any kind of vest, either, but a vest made of Malian mud-cloth.[24] Its distinctive and unmistakable geometric patterns are clear for all to see. In an economy of moves, using wardrobe as one level of mean-ing, this episode transforms the Sisko character in two ways. First, he changes from an anonymous Starfleet officer, wearing the red-shouldered command tunic to a worker and from worker to a civilian. Second, he changes from a representative of Starfleet who suppresses any competing personal or group identification to his alle-giance as a Starfleet officer and Federation representative and into a grown-up African American man and father, a man who appreciates and displays his identi-

fication as a person of African descent (as well as someone who can sympathize with other colonized and marginalized races though they be well beyond his own Terran origins).

'Explorers' differs from standard *Star Trek* ™ fare in additional ways, too. It is not possible to overemphasize the importance of showing Benjamin Sisko working with his hands to create a solar ship from blueprints. Science fiction fans and *ST: DS9* viewers have seen this character as a station commander and as a military strategist, but in this episode he uses his mind and his hands to make something no one in his time has seen before. Sisko, a black man, works by himself, under his own impetus, and creates something unique on screen. This kind of representation is rarely associated with an African American character in American literature and media.[25]

In the realm of science fiction it is not rare to find characters that combine genius and practical skill. There are two examples of this kind of character in current circulation. One is Bruce Wayne who, to become the ultimate detective/crime fighter Batman, learns chemistry, physics and metallurgy and fashions a utility belt that is chockfull of unique tools and devices. The other is Tony Stark, who not only cannibalizes parts from various weapons into a crude suit of armour with offensive weapons, an internal power pack and rocket boots but then works tirelessly in his home workroom to refine the design using cutting-edge technology and hand tools to fine-tune his rocket boots and power reactor and perfect the suit's flight control surfaces and the software interface of his Iron Man suit of armour. So, in the fantasy universe there are examples of ingenious master builders that easily come to mind. But these are white or Anglo-American characters. Sisko stands virtually alone as an example of this kind of creative resourcefulness in a male African American character.

While Benjamin and Jake are on board the solar ship, there is a comic moment that happens so quickly that it is easily overlooked. However, it demonstrates how even a small, seemingly casual bit of dialogue may be revealing. Father and son have the solar ship under control and are relaxing. Jake is tired and says he wants to sleep. Benjamin points toward the ship's bedroom: an alcove and a woven rope hammock. Jake jokes by playfully calling out, 'Yo,' and Benjamin answers back, 'It's hammock time.' It is an easy, light mood between the Siskos. But mood alone cannot explain these dialogue choices. Associating the Siskos with expressions like 'Yo!' and 'It's hammock time!' links these fictional future African Americans with real, contemporary African American popular culture and cultural production (specifically, hip-hop culture). These expressions are more evidence that the producers and actors in this episode are creating a very different kind of space for cultural representation here. It is a space that is not only outside of Starfleet/Federation but outside of time

as well. These creative choices give these African American characters freedoms of action and expression that are not usually allowed within the highly structured regime of Starfleet/Federation protocols.

All this is not to say that the Siskos' journey is uneventful. Twice their small craft is buffeted, subsystems fail, and our intrepid travellers face catastrophe. It is the timing of these events and what is transpiring between father and son that allow a critical shift at these moments and allow us to read their subtext. The first instance occurs as Jake reveals his college acceptance to his father. At that moment, one of the solar ship's spritsails fails and is jettisoned. The second instance happens as Jake not only gives his father his permission to begin dating but is ready with a suggestion for an ideal woman for his father. In the middle of this topic of conversation, their small ship shakes violently and accelerates to warp speeds. Both of these crises are simultaneous with crises in the Siskos' relationship. Their ship and journey are threatened when Jake's college opportunity and his father's need for a female companion test their bond. As their solar ship weathers these trials, Jake says that he has decided to defer college to stay on Deep Space Nine and Benjamin Sisko agrees to start dating as long as Jake does not base his college future on his father's success with dating. Father and son resolve issues that could put distance between them and stress their emotional rapport. Their ship survives equipment failure and uncontrolled speed and arrives safely in Cardassian space, and as it does so the father and son relationship shows every indication it will survive the rites of passage both face.

CONCLUSION

Fictional future histories of planets, cultures and beings are among the foundations of the *Star Trek*™ universe. In that chronology, the stories and characters of *ST: DS9* occur 400 years beyond the present and four centuries after historical European captains, their ships and crews sailed dangerous oceans to find new lands and cultures beyond the horizon.[26] At the beginning of 'Explorers' we learn of a myth that 800 years before, Bajoran travellers sailed the stars in solar ships, discovered a neighbouring planet, Cardassia, and set foot on that distant, alien world (that would later enslave Bajorans). So, as 'Explorers' begins, it seems these notions of history, fictional and real, are being cycled through another reiteration. But not quite.

One of the highest values in the *Star Trek*™ canon is not Starfleet's Prime Directive, *per se*, or its protocols for handling every conceivable situation or even the Terra-centric bias of the United Federation of Planets. Running through all of these principles is another first principle; it is perhaps not evident to every fan of these cultural products, but it is embedded there. It is order, stability and the opposition

to change. But threading through these television series and motion pictures is another principle that is not carried by Starfleet and is not part of the United Federation of Planets charter. It is at the heart of every imaginary starship and deep in its technologies. Terran starships would have been impossible otherwise, and the Federation of Planets would be inconceivable without them. And, in this fictional future, that staple of starships, transporter technology would forever remain a dream. The element at the core of the *Star Trek* mythos, the human element, is ethnicity. Its starships speed through space because a fictional African American computer genius, Dr. Richard Daystrom, invented a revolution in computer science that made automation possible and reliable on an unprecedented scale. And crews and supplies move between ship and shore without time-consuming shuttle trips, irrespective of weather and through 'solid' matter because of another African American character, Emory Erickson, a physicist, who invented the transporter.

However, when these parts of the *Star Trek* ™ canon surface, their narratives do not just challenge the foundations of science, they are destabilizing, potentially fatal to the very idea of Starfleet. Both Drs. Daystrom and Erickson's follow-on inventions—the M5 multitronic computer and sub-quantum teleportation, respectively—offer space travel without crew or even spaceships. Neither is a welcome prospect for starship captains and the bureaucracies they serve. Neither succeeds. Is the only good future ethnic the one within Starfleet and/or the Federation?

When I first viewed this episode of *ST: DS9*, I was attracted to it as an example of what I considered essentially a two-character sketch that gave the series' African American actors portraying the Siskos father and son an opportunity as actors to explore the relationship between their characters. There did not seem to be any jeopardy.

Later on, still responding to the way the episode isolated these characters, I sought answers as to why this was so. Was it not possible to articulate these characters and their relationship as they went about Deep Space Nine, among its denizens? What compelled the episode's writers to cast these African Americans adrift in space, alone? Could the ethnic father-and-son relationship only be explored away from others? Why is Benjamin Sisko turning his back on his vaunted, highly visible and esteemed position as station commander/emissary to pilot a small vessel through unforgiving space? Was this a necessary strategy to set up the circumstances for the father to build his solar ship and prove he could make something complex and trustworthy (thereby confronting a persistent racial stereotype directly?) Okay. But if so, why the bold costume choices of dressing in Mali mudcloth and depicting him with a beard? Clearly, stepping outside of Starfleet does not make Sisko a threat to it.

Allowing Sisko to sport a moustache and goatee, take a hiatus from his command and sail off with his son all go to reiterating the central fact that his charac-

ter is not the typical Starfleet commander. Commanders like Kirk, Picard and Janeway maintain their authority by distancing themselves from others: their crewmates, other species and antagonists. In 'Explorers,' Sisko's core essence and strength is the fractal image of him working with his son toward a common goal. From this central image will develop the opportunity, near the series end, of Sisko marrying again. At the next level are his relationships with his crewmates and station figures. Then, he is enmeshed in Bajoran and Cardassian affairs. Because as commander and emissary he must balance conflicting interests: civilian and military, secular and religion, commercial and security, and Terran and extraterrestrial. His success has less to do with projecting himself as an unerring authority, as Federation envoy and asserting the Federation's hegemonic pre-eminence and power in the Alpha quadrant than with appreciating and respecting different points of view. Less with being a man of action, than being a man of deliberation and maturity. He is the very opposite of the lone commander asserting a hegemonic power's authority.

Moreover, in 'Explorers,' a cherished, history-making and culturally reaffirming moment for Bajor is recreated and chronicled by two African American characters. How is it that such an epoque-making event that revises the fictional history of the Alpha quadrant comes to be associated with this ambiguous, potentially rogue element: ethnicity? Then there is that design of the Bajoran solar ship: was its style reminiscent of ancient Egyptian design? Was this only my perspective? As I tried to answer these and other questions that the episode provoked, I began another relationship with this material, one that began the ruminations leading to this chapter.

As I thought about this episode, identified its specific elements and examined the ways these came together to create the narrative fiction of 'Explorers,' I found that I could not ignore the feeling that it was greater than the simple sum of its parts. Several years ago, I became aware of the work of the Rutgers University scholar, Ivan van Sertima, and his thesis of contact between the Old and New World pre-dating Columbus' voyages. Now, I turned to van Sertima's *They Came before Columbus: The African Presence in Ancient America* out of an abundance of curiosity. I had no idea what I would find and how and whether any of it could be of any use in answering the puzzle that 'Explorers' was becoming as I turned it over in my mind, first this way, then that. Readers should pick up van Sertima's book and engage his fascinating effort to pull together research from a variety of disciplines to correct our present-day incomplete understanding of the Age of Discovery and its antecedents.

As I found myself becoming fully engrossed in this remarkable, powerful, small book, I could not resist the way van Sertima's historical tale informed this fictional tale as well. To wit, I propose that 'Explorers' is, using Bernadette J. Bucher's term, nothing less than a 'transformation,' of our contemporary perceptive on ancient history packaged in a currently popular and readily appreciated form: the

space opera (Bucher 1975). It is in effect a popularization of the theory of ancient contact between the Mali Empire and the peoples along the east coast of South America and the isthmus that until very recently was a topic of debate, sometimes heated debate, solely among academics.

In 'Explorers,' the Siskos set out to test a myth about the space-worthiness of Bajoran solar ships and ancient contact across an ocean of space, only to learn, as they prove the voyage possible, that physical evidence of Bajoran contact has existed on Cardassia for some time (hidden or ignored to preserved that race's theory of superiority over the Bajorans). In 'Explorers,' the myth of Bajoran/Cardassian pre-warp contact is supported by an abundance of oral history, archival information and drawings of ships that were supposedly built for the voyage. In *They Came before Columbus,* evidence for revisiting history is found in comparative linguistics on both sides of the Atlantic, in documents found in Spanish archives, in Mali oral traditions, in the massive stone sculptures with African features and pyramidal architecture found at various sites in the southern New World. The elements of congruency are there. Alexander von Wuthenau found not only in South America African forms of terracotta but also ancient African skeletons in early, pre-Christian and medieval strata (von Wuthenau 1969, p. 167). Or, in the words of the Society for American Archeology in its May 1968 report: 'Surely there cannot be any question but that there were visitors to the New World from the Old World in historic or prehistoric times before 1492' (Baker 1971, p. 438).

Indeed, the Siskos' solar ship adventure has an actual parallel in Earth's past. Fictional father and son get caught up in tachyon eddies that carry their small vessel to speeds faster than light and deposit them within the distant Cardassian system. Multi-disciplinary research projects with historians, oceanographers, and archeologists, working in archives in Spain and studying the waters of the Atlantic off the west coast of Africa and the east coast of South America, now confirm that there are very strong ocean currents—in fact irresistible to human and wind-powered ships—that will carry ships and sailors from the west coast of central Africa to the eastern coast of South America and the Caribbean.

Even the Mali mud-cloth vest that Benjamin Sisko wears only aboard his solar ship adds to this episode's metaphorization of current historical findings. The Mali Empire of the fourteenth century was larger than the Holy Roman Empire and perhaps more wealthy and stronger. van Sertima points out:

> The court traditions and documents in Cairo tell of an African king, Abubakari the Second, setting out on the Atlantic in 1311. He commanded a fleet of large boats, well stocked with food and water, and embarked from the Senegambia coast, the western borders of this west African empire, entering the Canaries current, "a river in the middle of the sea" as the captain of a preceding fleet (of which only one boat returned) described it. (van Sertima 1976, p. 28)

I think 'Explorers' can be read as a transformation of the understanding we now possess about ancient contact between the people of the two sides of the Atlantic: one group a people of wealth, daring and sophistication, the other group more tribal and agrarian. In this reading, the characters of Benjamin Sisko and Jake, his son, are the only logical vehicles for this adaptation because they are the only series characters that are Terran and can trace their ancestry back through New Orleans and across the mid-Atlantic slave trade to Africa. This fact alone makes ethnicity a potentially positive narrative element.

Another explanation for selecting Benjamin Sisko as the node for this narrative may be found in the character's unique nature: he is a man who exists both inside and apart from the time-space continuum. He is the ideal candidate to challenge the norm and through his experience create a fresh and personal insight. And he is equally ideal for bringing the fictional present future into contact with the fictional past. One result that follows from his and his son's space travel is that the prideful Cardassians are forced to admit that the race they have dominated, considered technologically inferior and enslaved was able to accomplish the kind of travel Cardassia would not even attempt for centuries after Bajoran first contact?[27] Cardassia must put on display wreckage and other evidence of that ancient accomplishment to their chagrin. The echo of Western culture's attitude of superiority, technological pride and easy rationalization of slavery is obvious. What is new is that now evidence is accumulating that fourteenth-century Africans were as bold and at least as technologically advanced as their European neighbours.

Another explanation for using the Sisko characters may be more directly related to their ethnic background and by this I mean to raise the issue of the impact of this episode for contemporary audiences. By using the timeframe of 800 years and creating a narrative that separates Sisko from and discounts all of his relationships with Starfleet and his associations with duty in all its trappings, the producers may not only be making reference to the *Star Trek*™ canon's conventional chronology, which extends from the Age of Discovery to the *Star Trek* era, but by specifically using the contesting nature of the African American *Star Trek* character (here I want to refer back to the other African Americans like Daystrom and Erickson, though their contestation completely challenged Starfleet's very existence), the series producers have raised the ante, and in a sense 'called' the bet as to whether Sisko's little sailing vacation will ultimately cause Starfleet headaches in that corner of the Alpha quadrant.

By using the Siskos for this fantasy adventure, we are able to contemplate (not unlike the Cardassians) New World artifacts—like the pre-Columbian Negroid Teotihuacan head and others found in Vera Cruz, from Tlatilco, Tabasco, Chiapas, Guerrero and Mandingo heads made by Mixtecs of Oaxaca, and the oversized,

sculpted Negro heads of Vera Cruz, as well as heads and carvings, linguistics, religious and folk practices and other evidence found in other areas of the New World bordering the Atlantic as evidence that causes the Anglo world (read Cardassia) to admit with chagrin that their imperial expeditions were not the first visitors to the New World (read Bajor).

Now, at the end of 'Explorers,' we are able to tell a new story about another first contact, this one right here on our planet. In this revised history, the Old World discovering culture is not European, but African. Startling new evidence more than four centuries old documents that Africans used a strong east-to-west ocean current to travel to the New World and another strong west-to-east ocean current to travel back to the west coast of Africa. While Europeans limited their explorations by keeping coastlines in view, Africans, scholars' research now shows, made repeated voyages to the Western Hemisphere, contacted cultures there and maintained those relations for years.[28]

By de-centring 'Explorers' from the typical Starfleet/United Federation of Planets settings, employing various strategies to bring ethnicity to the foreground, situating ethnicity outside Starfleet limitations and crafting a narrative about the importance of rediscovering the past, *Star Trek* producers' and actors' work in 'Explorers' re-conceived the 'enterprise,' as it were, not as a part of European history solely, but as part of larger more inclusive history in which Africans were the first to go boldly into the unknown. After 'Explorers,' the *Star Trek* experience is revised and identification expanded by acknowledgement of its African origins as real and indispensable to appreciating the spirit of adventure and exploration that is the franchise touchstone and our shared legacy.

NOTES

1. At this point, this next *Star Trek* series was conceived of as a 'prequel' set in the same time period as *ST: TNG*. Maloney (1992b), 1 and 104.
2. Both Reagan and Bush chose to mis-characterise minorities as the sources of the nation's problems: immigrant demands on social services as costly entitlement programmes, affirmative action programmes as promoting the unqualified, ballooning federal deficits and expanding federal bureaucracies as examples of liberal excess, the loss of jobs with union protection and solid benefits (among the first causalities of mergers and acquisitions and the downsizing that inevitably followed) as inevitable realities of globalised markets and women entering the labour markets as taking jobs from white males.
3. Clinton not only rejected race-based politics but demonstrated with his easy-going demeanour and genuine comfort in various social situations with people of colour that minorities were not to be feared and viewed with suspicion. In fact, the Clinton administration clearly demonstrated by the number of minorities who held key positions in his

administration that minorities were highly skilled and part of the solution to social issues. Some of the more visible members of his administration included Henry Cisneros, Ron Brown, Colin Powell, Mike Espy, Alexis Herman, Federico Pena, Bill Richardson, Togo D. West, Norman Mineta, Rodney Slater, Hazel O'Leary and Jesse Brown.

4. In practice, inclusivity brought all stakeholders into the processes of fact-finding leading to legislation not unlike a town hall meeting, where every point of view could be expressed and considered as contributing toward arriving at a conclusion.

5. Clinton's commitment to improving race relations is perhaps best demonstrated by his creation of a presidential advisory board on race relations that toured the country holding town hall meetings and collecting testimony and other forms of data on race. The Advisory Board to the President's Initiative on Race was headed by the noted African American historian John Hope Franklin and included Thomas Kean, former governor of New Jersey, Angela Oh, a Los Angeles attorney and Judith A. Winston, educational consultant and lawyer. Clinton wanted to make the advisory board permanent and for it to assist future presidents' work through this persistent issue (Holmes 1998).

6. During the White House reception following his second inaugural speech, Abraham Lincoln searched the invited guests until he found Frederick Douglass. Lincoln knew that Douglass had attended the inauguration and he was eager to hear from Douglass what he thought of the speech. Douglass records that when Lincoln found him in the White House East Wing, Lincoln '[r]ecognizing me, even before I reached him, he exclaimed, so that all around could hear him, "Here comes my friend Douglass." Taking me by the hand, he said, "I am glad to see you. I saw you in the crowd to-day, listening to my inaugural address; how did you like it?" I said, "Mr. Lincoln, I must not detain you with my poor opinion, when there are thousands waiting to shake hands with you." "No, no," he said, "you must stop a little, Douglass; there is no man in the country whose opinion I value more than yours. I want to know what you think of it' I replied, "Mr. Lincoln, that was a sacred effort." "(am glad you liked it!" he said; and I passed on, feeling that any man, however distinguished, might well regard himself honored by such expressions, from such a man' (Wills 1999).

7. Paramount's interest in creating a sixth American television network, United Paramount Television, was based on the company being able to offer *ST: DS9* and *The Untouchables* for simultaneous syndication. While those series achieved ratings that competed with and surpassed network programs, Paramount waited to launch its 'weblet' until about midway through the third season of *ST: DS9*. Then, on 16 January 1995, Paramount announced a three-night schedule of programming. The UPN schedule attempted to capitalise on viewer acceptance of *ST: DS9* by launching the fourth *Star Trek* ™ live-action, television series, *Star Trek: Voyager* in a 2-hour special. See Maloney (1992a, 1992b, p. I).

8. The decision to launch a new *Star Trek* broadcast television series may not have reflected any Roddenberry plan or intention to continue generating spin-off media productions based on the *Star Trek* mythos. Indeed, quite the reverse might have obtained if Roddenberry had not died. Roddenberry stated to at least one *ST: TNG* writer that *Star Trek's* future properly lay in continuing to produce *ST: TNG* and develop stories that took the *Enterprise* and crew into the future, into new quadrants of space, into contact with new alien races, and into confrontations with new and different foes. 'Everything that was done on *Deep Space Nine* and *Voyager* could have been done on *The Next Generation*. He (Roddenberry) did-

n't see any reason to create new spinoffs when there was so much more to be done in *Next Generation.* . . . The decision to do *Deep Space Nine* and *Voyager* was a purely corporate decision. . .to create new *Star Trek* products that audiences were familiar with for the UPN network that was struggling to find viewers to support its business model.' Brian Alan Lane, telephone interview, 19 August 2008.

9. The different colour schemes of the two space stations may seem like a casual fact. However, researchers, like David Bernardi, have developed critical perspectives that acknowledge just this kind of detail and include it within a theory aimed at revealing the way ethnicity permeates creative decision making at some of the most fundamental levels of media production. B5's blue and grey and Deep Space Nine's bronze colour schemes pose interesting cultural and historical resonances that other researchers may pursue.

10. Gene Roddenberry died of cardiac arrest in Santa Monica, California on 24 October 1992 at the age of 70 (McFadden 1991).

11. Maloney (1992a). This attitude is not limited to producers of *Star Trek* properties. David Eick, one of the executive producers and creators of *Battlestar Galactica* in a recent newspaper article revealed that he and his producing partner, Ronald D. Moore, approached series production with a post-9/11 sensibility. Film critic Hal Hinson quoted Moore as saying: 'I saw this story as an opportunity to examine what we are going through now in the post-9/11 world. What are the issues we struggle with? What do we take responsibility for? What do we blame ourselves for, and what do we blame the outside enemy for? And how much of that outside enemy has to do with us' (Hinson 2003, p. 11). Virginia Heffernan, a television critic, ruminated about the updated series and asked: 'So what's it all about, this fancy *"Battlestar"?* The short answer is politics, whatever that means: genocide, abortion, torture, the clash of civilizations' (Heffernan 2006). In their latest incarnation, the series villain is a 'race' of man-made robots, called Cylons, who tinkered with their design, and, after a brief peace, returned looking all-too-human, but determined to terminate the brotherhood of man. Cylons cannot die and hew to an orthodox religion that privileges them rather than flesh-and-blood humans and justifies a total campaign against humanity. From the human's point of view, she continues: 'they're definitely Not Us . . . [T]he Cylons can be deprived of their rights without a second thought. They can be attacked and tormented because they're not even human. Or can they? Sound familiar?' See Heffernan (2006, p. 7). She is obviously leading readers to see that the interaction and representation between humans and Cylons are far from simple. Heffernan pointed out that Cylons were 'interacting with humans in all kinds of morally dubious ways: seducing them, recruiting them, torturing them, befriending them. The humans, for their part, both collude and rebel.' For Heffernan, these and other observations raise fundamental questions about the show's conception. For example, is this a thinly veiled metaphor for the way urban civilians are increasingly the victims of modem warfare? Eick described that series 'as a story about desperate people in the aftermath of a holocaust, searching for a way home. So our intention was to write a drama that reflected our times that just happened to be called "Battlestar Galactica"' (Rhodes 2007). In fact, on several episodes during the 2007 season that centred on the humans under Cylon domination on New Caprica, the writers introduced scenes of humans engaged as insurgents, suicide bombers against human-collaborating police at a New Caprica Police Academy graduation, mass detention sweeps and scenes of intense psychological and physical prison torture. These scenes raise themes that are

familiar from years of 'The Troubles' in Northern Ireland, the Second Intifada in Israel, and the American Occupation of Iraq. Clearly, the producers and writers of this series are trying to reposition their audience to identify with the oppressed in these scenerios and, thereby, to bring a fresh perspective and complexity to these situations often oversimplified by the contemporary mass news media. In that same article Eick, who was the executive producer and creator of the *Bionic Woman*, the Fall 2007 remake of the 1970s science fiction television series, stated that his version of the show and of its central character, Jaime Sommers, positions both squarely within contemporary society and the issues facing women now. Even after her bionic transformation, Sommers continues to struggle with workplace, family and career pressures that are easily identifiable to millions of contemporary American women (Rhodes 2007). Eick and Moore seem to understand the importance of bringing more women into the science fiction television audience back when they were starting *Battlestar Galactica* (Heffernan 2006). Heffernan points to one of the show's central characters, a female character, Laura, a middle-aged human who succeeds to the presidency of the fleeing colonial survivor fleet. Heffernan describes her as 'a seeming softie who may be a stand-in for the new sci-fi viewers, who are increasingly women; she's human, for one, and she's generally liberal, sympathetic to underdogs, a former teacher' (Heffernan 2006). Rising from teacher to head of Caprica's department of education to president, she finds that on New Caprica, even under Cylon occupation, her pacific demeanour buckles: 'she supports suicide bombing in public places and, thus, the murder of civilians by naive soldiers strapped with explosives. She cannot in good faith defend the practice, and she folds. Is she an American who might have supported the tactics of suicide bombers in the Middle East? Is the show's argument that resisting colonization is not only futile but sometimes immoral? Should the Iraqis—that is, the humans—just yield to occupation?' (Heffernan 2006, p. 7). Another example of the way American science fiction TV engages with contemporary audiences by bringing current events, the controversial and the technological to the central core of its conception is illustrated by the ratings success *Heroes*. Ginia Bellafante (2007) observed:

> If you missed "Heroes," the NBC Monday-night series about a group of people with extraordinary capabilities, then you have missed everything, which is to say, you have missed a show that exempts almost no subject of current political or social fascination from the roster of its interests.' 'Like Spider-Man movies of recent years, "Heroes" is deeply interested in the challenges of exceptionalism. What does it cost us to be indelibly gifted in a culture that increasingly demands specialization and personal branding? It is fairly safe to say that none of the heroes meet any standard psychological definition of happiness one has a multiple personality disorder. The seeds of good fortune are, of course, so often the flowers of despair...[w]hat sense of fulfillment or purpose there is comes in the collective effort to avert horrible outcomes, planned last season by a sinister organization called the Company [read: CIA], whose motives this year are less clear. "Heroes" borrows the stylistic elements of comic books and unfolds novelistically. But it derives its philosophy from theories of open-source culture that flourish in the field of technology, the belief that some greater good can be better achieved through the collaboration of people joined

by skills and affinities that transcend institutional allegiances. In the mind-set of "Heroes," these sorts of affiliations surpass the efficiency of governments, and 'last season "Heroes" seemed to take a disparaging view of a possible Giuliani presidency, casting aspersion on an Italian-American congressional candidate...who considered capitalizing on a disaster in New York to forge his political future' (Bellafante 2007).

Other American media cultural producers not working specifically in science fiction—like George Romero (who is best known for his zombie cycle of feature films and Carol Barbee and Jon Turteltaub (who are executive producers on the CBS broadcast television series *Jericho*, that posits a post-apocalyptic vision of the United States)—make it clear in recent interviews that they consciously use these subgenre platforms (horror and alternative history) to explore themes that reflect vital issues that are at the heart of the culture. Speaking about his forthcoming motion picture, *Diary of the Dead*, Romero laments on the way information inundates our society. 'It's scary out there, man...There's just so much information, it's absolutely uncontrolled. Half of it isn't even information. It's entertainment or opinion, I wanted to do something that would get at this octopus. It *[Diary of the Dead]* may be the darkest film I've ever done since Night of the Living Dead' (Dargis 2008).

12. Although *Star Trek: Deep Space Nine* debuted during the first two weeks of January 1993, it should be noted that financing, studio support, casting, scripting, rehearsal and set construction meant that pre-production was ongoing as the civil disruptions were spreading across Los Angeles and being televised to the rest of the country (Tryer 1993).

13. The LAPD has long served the interest of the region's bankers, real estate developers and politicians who advanced a model of unlimited horizontal expansion. LAPD Chief Parker, after World War II, organised and staffed his police force with ex-military police from southern states who would understand without burdensome instruction how to patrol LA's minority populations and limit their mobility as an adjunct to the city's moneyed, segregationist establishment's interest in generating wealth through stable real estate development. For more discussion of the relationship of the LAPD to the economic and political history of Los Angeles, see Davis (1990).

14. J.J. Abrams, a contemporary Hollywood writer, director and producer, understands this approach to the genesis of media products. Abrams's credits include *Felicity, Alias, Lost* and *Fringe*. In 2007, while he was preparing to direct the next *Star Trek™* motion picture, he was negotiating with Warner Brothers over a television series he owed them. To brainstorm ideas he turned to Alex Kurtzman and Roberto Orci. screenwritesr on *Transformers*, and together they 'traded ideas about beloved fantasy films and television series ("The X-Files," "Altered States," the early movies of David Cronenberg) but also looked carefully at procedural crime dramas dominating the networks.' Orci exposed more of this creative cross-pollinating process when he commented: 'When 6 of the Top Ten shows are "Law and Order" and "CSI," you have to be a fool not to go study what it is that they're doing' (Itzkoff 2008).

15. It is true that the latest *Star Trek* television series, *Star Trek: Enterprise* was cancelled after a brief four-year run (2001–2005), but Paramount in 2008 was in pre-production on a new *Star Trek* movie that was released on May 8, 2009. The persistent corporate interest in the *Star Trek* franchise may be directly related to the amount of money the 10 motion pictures

and five television series have produced. Paramount declines to state how much money *Star Trek*™ has made for it over the years. There are estimates that the *Star Trek*™ franchise earned $2.3 billion in TV revenues, more than $1.4 billion in motion picture box-office receipts and $4 billion in merchandise sales (Cavanaugh 2006, and http://www.reason.com/news/show/ 36827.html).

16. In physics, the concept of the wormhole dates back to 1916 and to Karl Schwarzchild's solution of Einstein's equations for the case of a single pinpoint star. Later generations of physicists found that at the centre of this pinpoint star is an amazing phenomenon: a black hole. Surrounding this black hole is an 'event horizon,' or point of no return, beyond which nothing can escape, not even light. If, however, one were to fall straight through the centre of a black hole, there on the other side you would find another universe (the passage was first known in 1935 as the Einstein-Rosen Bridge). In 1963, Roy Kerr determined that a black hole need not be a pinpoint singularity. According to his calculations, while objects spin as they shrink (think of ice skaters bringing their arms together and accelerating their speed of spin) they need not shrink down to a pinpoint star. Instead, there would be a spinning ring-like phenomenon. Still, if a person managed to fall through the ring, without touching it, then they would pass along the Einstein-Rosen Bridge (i.e., wormhole) into another universe. More recently, in 1988, Kip Thorne et al. found that under certain circumstances a wormhole could be transversable, and travelling through it would be no worse than air travel is today. It is interesting that this solution arrived just as Paramount was commissioning a new spin-off of *Star Trek*. Were the creators tipping their hats to scientists who had finally recognised a phenomenon that had entered fantastic literature with Lewis Carroll's *Alice's Adventures through the Looking Glass* when they made a wormhole a key part of the world of *ST: DS9?* (Kaku 2008, pp. 197–215).

17. Then, too, the series' conception of its commander officer, Sisko, was not like the commanding officers found in other *Star Trek* vehicles. For starters, Sisko was depicted from the first moment of the premier season's two-part opener as a family man. In those two episodes his wife who served on the *USS Saratoga* is killed by the Borg at the Battle at Wolf 359, and as its burning hulk is about to explode Sisko rescues Jake, his son, and they escape. There are no other examples in *Star Trek* properties of Starfleet command officers who are married. James T. Kirk, from *Star Trek: The Original Series*, fathered a child (*The Wrath of Khan*), but never married; his son is later murdered (*The Search for Spock*). Similarly, Jean-Luc Picard, from *ST: TNG* remained a bachelor throughout that sequel until its two-part conclusion, which is ambiguous on this point. For male lead characters, like Kirk and Picard, marriage and family were understood to be a limitation on advancement and an unnecessary risk, especially aboard a spaceship, where it could add an additional burden of calculation in any life-and-death decision a captain might have to make. *Star Trek's* one female leading character was the commanding officer of the *USS Voyager* in *Star Trek: Voyager* (the third spin-off series): Captain Katherine Janeway. At the beginning of this series Janeway is engaged to be married. However, circumstances result in her ship being tossed 65,000 light years into the Delta quadrant of space, and before she and her crew can retrace their path even halfway back to Earth, she receives a letter from her fiancé telling her that he never thought he would see her again and so married another. For Kirk, Picard and Janeway being a leader leaves no room for personal romantic relationships. A personal rela-

tionship would transform the imperial commander into a normal human being and devastate the illusion of perfection. Therefore, marriage and family were understood to be a limitation to advancement, and family was considered an unnecessary risk. Starfleet commanding officers were conceptualised as forceful individuals who stand apart from their crews because of their authority. Part of their responsibility is to maintain a critical distance between themselves, their crewmates and others. They need to remain aloof and avoid emotional entanglements, and are paragons of the rationalistic individual *(ego)* advancing the Federation agenda *(superego)*. While they often solicit information and expertise from other members of the crew, these relationships can at best rise to the level of friendship based on years of solving crises together to stabilise and promote the hegemony. Moreover, Sisko's relationship with his son is a prominent part of the series, and at the end of the series he plans to marry again (to Jake's freighter captain). This underlines the point that Sisko's role is not as the imperious commander. He displays deliberation and maturity because as commander and emissary he must balance conflicting interests: civilian and military, secular and religion, commercial and security, and Bajoran and Cardassian. His success as the Federation's envoy has less to do with projecting himself as an unerring authority and asserting the Federation's hegemonic pre-eminence and power in the Alpha quadrant than with appreciating and respecting different points of view. To function in his dual roles he has to develop beyond a comfortable, singular identification with Terran-based authority. And the Prime Directive is irrelevant because he is positioned between several competing extraterrestrial cultures. Sisko cannot afford to retreat within Starfleet/Federation protocols and rely solely on them. Sisko is the sole *Star Trek* commander who most often mediates conflicts between parties rather than trying to establish a *Pax Federation*.

18. Sisko's wife is introduced in 'The Emissary,' Part I and II in flashbacks that depict her death during the battle at Wolf 359 between Borg and Starfleet forces. Unfortunately, science fiction and American television seem to exhibit a tendency to kill off the female spouses in ethnic couples. For example, in *Star Trek: The Next Generation,* Worf falls in love with K'ehleyr, a Klingon female, and their love produces a child *(Star Trek: The Next Generation:* 'Emissary,' episode 46, airdate: 24 June 1989). However, she is murdered in a contest over who will succeed to the throne as emperor of the Klingon Empire in the next episode in which she appears *(Star Trek: The Next Generation,* 'Reunion,' episode 72, airdate: 5 November 1990). A more contemporary example of this tendency can be found in the Sci-Fi channel series *Eureka* (Cosby and Paglia 2006). In the first season of this show Henry, a brilliant physicist (played by Joe Morton), is reunited with his graduate school sweetheart Kim, a Chinese American scientist, after more than 20 years of separation (caused by a jealous white fellow scientist who uses one of Henry's discoveries to erase Henry's memory of Kim and take her for his own lover). But before the season concludes, she is murdered in a laboratory mishap that turns out to be part of a conspiracy. There are more examples, and they all point to the conclusion that ethnic males are constrained from maintaining romantic relationships and founding and keeping their families intact. This kind of character development reflects a very old stereotype to the effect that black and ethnic males are loners.

19. In the history of African Americans on American broadcast entertainment television programmes this stands out as a rare, if not virtually unique, instance of the depiction of an African American male reading blueprints and skillfully interpreting that information to build something complex and challenging with his own hands.

20. This moment of confusion about using a toilet in space seems based on and a neat 'tip of the hat' to an exactly similar moment aboard a Pan American (Pan Am) shuttle in *2001: A Space Odyssey* (Kubrick 1968).

21. In *Star Trek: The Next Generation*, Captain Picard leaves his ship briefly for a somewhat similar separation from his official duties to recuperate after his Borg assimilation at his family home in the French wine country. However, Picard is never really very far from being a Starfleet notable: there is talk of a parade to honour his return to his home town, his opinions are solicited about a project to create a new continent on Earth, and he is eventually offered the job of leading the project based on his Starfleet record. It might be said that the point of this episode is to reveal to Picard that his rehabilitation rests on his acceptance that his life within Starfleet means facing all kinds of risk, some as shattering as the abuse he experienced at the hands of the Borg, and that he can recover his bearings to the extent that he accepts his Starfleet identification as his core self; *ST: TNG*, 'Descent,' Part I and 'Descent,' Part 2, (airdate: 21 June 1993 and 20 September 1993).

22. This observation in principle should be properly understood to apply beyond its initial referent, African Americans, and to take on the full dimensions inherent in the term 'Pan-African.' In this way, the concept of dual consciousness applies equally to a descent from Africa whether they reside in North or South America or the African continent. The determinant factor is colonisation, regardless as to whether that domination was expressed through chattel slavery, apartheid or employment and residential discrimination and segregation that maintains the illusion of equality while carefully policing the best-paying and socially respectable employment, the best neighbourhoods and social institutions to restrict and deny access to Africa's descendents.

23. In fact, as the series draws to a close, Sisko learns that, while his father is an African American, his mother is a 'wormhole alien/celestial prophet' alien. Even his lineage displays a 'twoness,' albeit between Terran and Extraterrestrial parents and the very different points of view and expectations associated with each.

24. Among traditional African fabrics, one of the most eye-catching is the traditional Malian fabric known as *bògòlanjini* or mud-cloth.

25. Also in *ST: DS9's* third season, Sisko returns to Deep Space Nine with a new starship, named *The Defiant* ('The Search,' Parts 1 and 2, airdates: 26 September and 3 October 1994). In these episodes, Sisko is credited as engineer with designing and supervising the construction of the more durable and maneuverable, new class of ship. However, Sisko's efforts regarding this new, personal ship for the station's commander are kept off-screen.

26. Roddenberry selected this 400-year timeframe specifically so that the world of the viewer would be equally distant from The Age of Discovery and his future fictional world.

27. While it is never so stated, it is not inconceivable that, given the psychological construct of the fictional Cardassians, the early successes of the Bajorans as space travellers may have, again in this fictional universe, stimulated the Cardassians to reach for the stars and ironically enslave the very beings who had peacefully introduced them to space travel.

28. Findings from researchers elaborate contact between African and South America with evidence that ranges over many different aspects of individual African cultural practices. A good deal of this research is conveniently collected in van Sertima.

REFERENCES

Bellafante, G. (2007, November 5). In a troubled world, it's good to be exceptional. *The New York Times*, p. B4.

Baker, H. (1971). Commentary: Session III. In C. L. Riley, J. E. Charles, C. W. Pennington, & R. L. Rands (Eds.). *Man across the sea: Problems of pre-Columbian contacts.* Austin, TX: University of Texas Press.

Berman, R., & Piller, M. (1993, January 31). *Deep Space Nine.* 'The Emissary,' Parts I and II. Episodes 1 and 2. Los Angeles, CA: Paramount Pictures .

Berman, R., & Piller, M. (1994, September 26, and October 3). *Deep Space Nine.* 'The Search,' Parts land II. Episodes 47 and 48. Hollywood, CA: Paramount Pictures.

Berman, R., & Piller, M. (1995, May 8). *Deep Space Nine.* 'Explorers.' Episode 68. Los Angeles, CA: Paramount Pictures.

Bucher, B. J. (1975). The savage European: A structural approach to European iconography of the American Indian. *Studies in the Anthropology of Visual Communication, 2*(2), 80–86.

Cavanaugh, T. (2006, August/September). Happy 40th birthday, *Star Trek*: Why Captain Kirk's story is the story of America. *Reason Online: Free Minds, Free Markets.* Retrieved from http://www.reason.comlnews/show/36827.html

Cosby, A., & Paglia, J. (2006, October 3). *Eureka.* 'Once in a lifetime.' Episode 12. Los Angeles, CA: Universal Networks Television.

Dargis, M. (2008, February 15). Filmmakers who become their own zombie movie. *The New York Times*, C1.

Davis, M. (1990). *City of quartz: Excavating the future in Los Angeles.* New York: Verso.

Heffernan, V. (2006, October 26). In Galactica, it's politics as usual or is it? *The New York Times*, p. E7.

Hinson, H. (2003, December 7). Back to the sci-fi future, but this time putting the emphasis on realism. *The New York Times*, Automobiles, p. 11.

Holmes, S. A. (1998, September 18). Clinton panel on race urges variety of modest measures. *The New York Times*, p. A1.

Itzkoff, D. (2008, August 24). Complexity without commitment. *The New York Times*, Arts and Leisure, p. 17.

Kaku, M. (2008). *The physics of the impossible: A scientific exploration into the world of phasers, force fields, teleportation and time travel.* New York: Doubleday.

Kubrick, S. (1968). *2001: A space odyssey* [Film]. Los Angeles, CA: Metro-Goldwyn-Mayer.

Maloney, W. (1992a, October 26). Out of this world: 'Deep space' ratings off to a strong start. *Electronic Media*, p. 1.

Maloney, W. (1992b, January 6). Paramount planning new first-run effort. *Electronic Media*, pp. 1, 104.

McFadden, R. D. (1991, October 26). Gene Roddenberry, "Star Trek" creator, dies at 70. *The New York Times* or URL http://www.nytimes.com/1991/10/26/gene-roddenbury-star-trek-creator-dies-at-70.html?pagewanted=3&src=pm

Rhodes, J. (2007, September 23). Dark makeover for a '70s cyborg. *The New York Times*, Arts and Leisure, p. 2.

Roddenberry, G. (1989, June 24). *Star Trek: The next generation.* 'Emissary.' Episode 46. Hollywood: Paramount Pictures.

Roddenberry, G. (1990, November 5). *Star Trek: The next generation.* 'Reunion.' Episode 72. Los Angeles, CA: Paramount Pictures.

Roddenberry, G. (1993, June 21 and September 20). *Star Trek: The next generation.* 'Descent,' Parts I and II. Episodes 252 and 253. Los Angeles, CA: Paramount Pictures.

Tryer, T. (1993, February 8). 'Star Trek' chief pushes TV frontier. *Electronic Media,* pp. 3, 23.

van Sertima, I. (1976). *They came before Columbus: The African presence in ancient America.* New York: Random House.

von Wuthenau, A. (1969). *The art of terracotta pottery in pre-Columbian Central and South America.* New York: Crown.

Wills, G. (1999, September). Lincoln's greatest speech. *The Atlantic Monthly,* pp. 60–70.

Connecting to a Future Community

Storytelling, the Database, and Nalo Hopkinson's *Midnight Robber*

ALISA K. BRAITHWAITE

When Granny Nanny realise how Antonio kidnap Tan-Tan, she hunt he through the dimension veils, with me riding she back like Dry Bone. Only a quantum computer coulda trace she through infinite dimensions like that, only Granny Nanny and me, a house eshu. And only because Tan-Tan's earbug never dead yet….By the time she get pregnant with you, Nanny had figure out the calibration. She instruct the nanomites in your mamee blood to migrate into your growing tissue, to alter you as you grow so all of you could *feel* nannysong at this calibration. You could hear me because your whole body is one living connection with the Grande Anansi Nanotech Interface.

Your little bodystring will sing to Nanny tune, doux-doux. You will be a weave in she web. Flesh people talk say how earbugs give them a sixth sense, but really is only a crutch, oui? Not a fully functional perception. You now; you really have that extra limb. (Hopkinson, 2000, 327–28)

MIDNIGHT ROBBER (2000), CARIBBEAN-CANADIAN AUTHOR NALO HOPKINSON'S second novel, reveals the identity of its narrator in its last few pages. The reader discovers that the omniscient voice that flows freely from Standard English to a variety of Caribbean dialects and engages in free indirect discourse with its sometimes ill-fated protagonist Tan-Tan and her antagonist, her father Antonio; that interrupts its own narrative of Tan-Tan's *bildungsroman*-in-exile from her home planet of Toussaint on the prison planet of New Half-Way Tree with fables about Tan-Tan's alterego, the Midnight Robber; that translates the language of the bird-like inhabitants of New Half-Way Tree, the Douen, in a bold print ("'All this time she could

talk?' Tan-Tan asked Chichibud. *Talk to *me*!* Benta warbled.")—is none other than a house eshu, an artificial intelligence avatar generated by the Grande Nanotech Sentient Interface (Granny Nanny), an advanced computer program that controls the Nation Worlds (182). The revelation of the narrator's identity does not make Hopkinson's novel any less complex. Rather, it draws the reader into a tailspin of knowledge that forces her or him to rethink the entire reading process. What appears to be authorial is in fact artificial, and what masquerades as narrative is actually a collection of data strung together in order for a posthuman being, a baby at the point of birth named Tubman (after Harriet Tubman), to understand. What we interpret as a linear history is suddenly divided into its many components once we realize that it comes from a machine that processes information in 0's and 1's.

The Grande Nanotech Sentient Interface is a vast database of information pertaining to the Marryshevites, the inhabitants of the Nation Worlds, and it communicates with the Marryshevites through aural implants that connect to the brain and create a visual image of an eshu, named after the West African trickster god, Eshu-Elegbara, a crossroads figure who communicates with both humans and the divine. The eshu provides the Marryshevites with any information he or she needs about daily concerns such as weather and news, the education of children, and the development of new skills. In effect, all knowledge passes to the Marryshevites through the image of the eshu.

The choice to include Eshu the trickster god will be discussed later in the essay, but I would like to begin here with considering what it means for the narrative in front of us to be told by a database. Ed Folsom, one of the co-directors of the Walt Whitman Archive, a literary database about the author's life and work, has argued that the database should be considered the genre of the twenty-first century (Folsom, 2007, 1576). In assembling the Walt Whitman digital archive he notes the difference between the "physicality, idiosyncratic arrangement, [and] partiality" of the archive and the "virtuality, endless ordering and reordering, and wholeness" of the database that allows a reader to have seemingly endless access to texts that create a constantly evolving narrative (Folsom, 2007, 1575). The narrative possibilities of the database are quite dizzying. The "endless ordering and reordering" alone suggest an overwhelming amount of information just in the method of presentation, let alone the content itself. If we did consider the database to be a genre, what would its parameters be?

Katherine Hayles has responded to Folsom's argument by claiming a symbiotic relationship between narrative and the database that supplies the necessary parameters (Hayles, 2007, 1603). Hayles acknowledges the advances of the database in terms of the information it can provide, while at the same time appreciating the continued value in the technology of storytelling. As the database itself cannot create narrative out of the information it contains, labeling it a genre is a bit more suspect.

It still needs narrative, a story, in order to be accessible in any meaningful way to its readers. A database may contain endless narrative possibilities, but a narrative must be chosen and developed for us to understand its full value.

Hopkinson's text, however, seems to ask us yet another question regarding narrative and the database. Where Folsom seems to suggest that the database itself is a new form of narrative, and Hayles argues that the database needs narrative in order to be understood, *Midnight Robber* presents us with a database that can create its own narrative. The underlying concern in the relationship between database and narrative that Hayles's argument may suggest but *Midnight Robber* certainly teases out is about where the human element will exist in the future. Will humans still be in control of their narratives if the database becomes the genre of the future? By insisting that there is another step between the database and the reader, the construction of narrative itself, Hayles suggests that narrative could continue to be that human element. She defines narrative as an "ancient linguistic technology almost as old as the human species" that is "deeply influenced by the evolutionary needs of human beings negotiating unpredictable three-dimensional environments populated by diverse autonomous agents" (Hayles, 2007, 1605). The power to create, to produce narrative, then, is a technology that is inherently linked to human behavior. It is how we make meaning. Considering the database as narrative would suggest that the human element is not necessary. Even though Folsom considers texts such as "*Moby Dick*, 'Song of Myself,' and the Bible" as proto-database, the evolution of the genre could eventually mean a loss of that need to make meaning (Folsom, 2007, 1577). Hopkinson's storytelling clearly supports the importance of narrative production, that crucial step between the database and the audience, but when that production is controlled by the machine that *is* the database, she plunges us right back into the anxiety of the missing human.

This anxiety intensifies when we consider the role of narrative in cultural production. As Hayles notes, the stories we tell each other and ourselves help us to negotiate our environment, particularly when much of our environment is out of our control. These stories also help us to understand (and sometimes prevent us from understanding) ourselves. Our cultures are produced through collections of narratives that support and refute each other and that evolve as we continue to collect more information. Computer databases have made the archival process more efficient and have increased the volume of material, but humans, whether for good or for ill, have still continued to be the storytellers.

By introducing a world controlled and narrated by the database, the human element seems to disappear. Hopkinson's characters constantly consume narrative produced by a machine that simultaneously extracts information from them ("But a Marryshevite couldn't even self take a piss without the toilet analyzing the chemical composition of the urine and logging the data in the health records.") and then

spits it back out in oral stories that are easy for its audience to swallow (Hopkinson, 2000, 10). Although the eshu represents a return to an oral culture that often defined Caribbean narrative in opposition to the literary culture of the colonizer, Hopkinson introduces the possibility of an alternative form of control that seems complicit—the Marryshevites choose to be a part of the Granny Nanny community—but possibly dangerous.

We can't help but be reminded that as a Caribbean writer, Hopkinson is part of a tradition that has already fought for narrative control over how its culture is represented in text. Another Caribbean writer, George Lamming insists that being able to represent the "West Indian peasant" as a fully developed human being in the West Indian novel was about being able to control the narratives that are distributed about his culture (Lamming, 1960, 39). Having narrative control allowed the writers of his generation in the 1950s and 1960s to establish a literary culture exported to the rest of the world that, for better or for worse, spoke for a Caribbean people. Not only were they able to control how others read them, but they were also able to see their culture in print, to have their culture affirmed on the page. The works of Caribbean writers have created a tangible literary archive that augments the oral archives that are not as visible to outside readers.

In the *Midnight Robber*, when Hopkinson represents a future Caribbean community countless generations after slavery and colonization that is established by and for Caribbean peoples, oral narrative returns through the voice of the eshu and the writer disappears. At a moment in the future when it seems that the Caribbean community should be at the height of interpersonal connection, occupying its own world, on its own terms, that future is disrupted by the idea that the constructor of the narratives that bring the community together lacks the very humanity that the narratives support. I ask, does the disappearance of the human writer, then, equal a loss of narrative control for the Marryshevites, or does Hopkinson introduce us to a new possibility: that the database could actually produce the narrative that humans need to make meaning out of the information in their lives?

I raise these questions about narrative control to think about the ways in which narrative draws a human community together. Hopkinson asks us to imagine how such connections might evolve through technological innovation, but at the same time her text questions what the limits of those connections might be when more of them become fabricated by machines. As the current *proponent* of Caribbean speculative fiction, building an archive of her own that supports the field in which she is a pioneer, Hopkinson highlights the transformation of endless pieces of data into the narratives that give those data depth and meaning. This point of transformation is where I would like to focus in order to consider the importance of the human element and the power of connection in literary narrative.

THE CARIBBEAN SCIENCE FICTION DATABASE NARRATIVE

So when people ask me why a black Caribbean woman is writing science fiction, or why I'm not angry at having my work "labelled" as science fiction—a label I myself chose—or what science fiction has to do with the realities of black and Caribbean and female lives, I find myself thinking something along the lines of ain'tIawomanthisiswhatsciencefictionlookslike-mysciencefictionincludesme. (Hopkinson, 2004, "The Profession of Science Fiction, 60" 5–6)

With her first novel, *Brown Girl in the Ring* (1998), Hopkinson wrote a coming-of-age narrative of a black Caribbean woman in Toronto *and* a cyberpunk narrative with a protagonist able to hack into a spirit world existing alongside a dystopic Toronto. The juxtaposition of these two narratives sets Hopkinson's writing apart from both her Caribbean literary and her American science fiction predecessors. Although not the first black woman to write science fiction, she is the first of Caribbean descent to be acknowledged and bestowed awards as a science fiction writer.[1] A graduate of the Clarion Science Fiction and Fantasy Writer's Workshop, she proudly embraces the label of science fiction while simultaneously challenging its boundaries.

Hopkinson is not only important for being the first Caribbean writer to publish science fiction but also for becoming a proponent of science fiction by writers of color. With the publication of the anthologies *Whispers from the Cotton Tree Root: Caribbean Fabulist Fiction* (2000) and *So Long Been Dreaming: Postcolonial Science Fiction and Fantasy* (2004), Hopkinson has begun to create a canon that addresses speculative fiction from a global perspective.

The science fiction genre has a powerful culture attached to it. Science fiction conventions (called "cons"), fan clubs, and websites generated and run by readers have made the genre quite populist but have also narrowed its association to the most common reader who is white and male. The lack of diversity in the sci-fi fan community was so dire, that, as Hopkinson relates in an interview, a black fan had to be invented in order to address the problem:

Carl Brandon was the first black fan to make a name for himself in the science fiction community. Carl Brandon didn't exist. He was the fictional creation of white writer Terry Carr, who was in part responding to someone's racist comment that black people had no place in the science fiction community. Terry created Carl Brandon as a nom de plume, and Carl proceeded to become very active in the fan community, producing a fair bit of writing about events in the community. A lot of people came to think of Carl as a friend, and it was a bit of a traumatic event in science fiction fandom when the hoax was revealed…[P]eople of color met at Wiscon (the annual gathering of the feminist science fiction community) to begin to discuss how to raise the profile of people of color in the sci-fi community. The Carl Brandon Society was born out of that.…We chose the name Carl Brandon…[p]artly it was a sense of irony, too, a wry awareness that the first acknowledged black fan in the community was a true invisible man, more à la Ralph Ellison than H. G. Wells. (Nelson, 2002, 106)

The members of the society are writers, fans, and writer/fans who have created their own database of people of color who work in the genre. A wikipage allows anyone to post the names of writers of color who have produced texts that can be considered science fiction and/or fantasy.[2] These internet communities have changed the way that people of color enter and experience the genre. Writers now have webpages on which they publish parts of texts that they are working on as well as promote other writers in the community.[3] The database that they create, then, gives these writers access to a literary community that is growing in spite of the dominant culture that continues to define sci-fi fandom.

Black diasporic science fiction as a tradition and a community is strongly influenced by the technological moment in which it exists. As opposed to building a more traditional canon that we see in white American and European science fiction that begins with either Mary Shelley's *Frankenstein* (1818) or H. G. Wells's *The Time Machine* (1895), black diasporic science fiction has developed through a collection of fragments: short stories written by authors who may never publish books; texts by prominent writers like W. E. B. Du Bois and George Schuyler that have been redefined to fit into the speculative genre; the oeuvres of Samuel Delany and Octavia Butler that have been embraced by the white-dominated science fiction community; anthologies that have introduced lesser-known writers; websites that collect names and that advertise current writers; conversations that occur between writers and fans at sci-fi conventions. Although these fragments are also part of the dominant culture's science fiction community, its literary tradition is also amply supported by libraries, bookstores, and scholarly canonization. Black diasporic science fiction is still in the process of writing its narrative and is sustained by the connections made between readers and writers devoted to nurturing a community that explores issues about the future, science fiction and technology.

Hopkinson's participation in building the database for Caribbean and other black diasporic science fiction is related to her representation of the database in *Midnight Robber*. The Carl Brandon Society, a virtual online community named after an avatar for black people at sci-fi conventions, suggests the ways in which marginalized communities have had to build connections through absence and distance. Web chat rooms and wikipages have allowed such communities to come together in a virtual space that becomes somewhat of a prosthetic community when a physical one cannot be successfully maintained. There may not be enough money or bodies to have a people of color sci-fi convention, but writers and readers can meet quite easily through their computers as they build a database that will hopefully grow the community. People organize this community, but the machine is the necessary prosthetic that allows it to thrive.

When we turn to Hopkinson's novel, the community exists both physically and virtually. Caribbean peoples inhabit the same planet, and they are also all connect-

ed to the same database that reifies their physical sense of community, but at the same time absolves them of the responsibility for building that community. By juxtaposing the community Hopkinson has helped to create with the community that she imagines in a Caribbean future, a possible evolution of community building begins to emerge. One can imagine a progression from the oral narratives of the storyteller that unite a cultural community, to the written narratives that then introduce that community to other cultural groups while creating a physical archive for that community, to the use of computer databases able to store more information than the physical archive as the narratives and the members of that community increase, to a speculation about how powerful those databases may become in the production of narrative. My analysis of *Midnight Robber*, then, will be a tracing of this evolution that considers how and where the human element remains as the production of narrative becomes more technological.

THE PROSTHETIC COMMUNITY

I used the term "prosthetic" above to describe the virtual community created by the Carl Brandon Society and other web-based sci-fi fan exchanges because it is such an evocative term for the concept of replacement, and also because it is a term that stimulates us to think about the interaction between the human body, science and technology. The prosthetic body part has advanced from being made out of wood to being made from plastics that can be customized and fitted with computers that allow the part to move. And in the world of science fiction the prosthetic limb that actually improves upon human functions has been a common trope from the razor girl Molly in William Gibson's novel *Neuromancer* to the popular television shows of the 1970s "The Six Million Dollar Man" and "The Bionic Woman." *Midnight Robber* also adopts the trope of the prosthesis, but rather than imagining literal prosthetic limbs of the future, the text employs the term metaphorically in such a way that is crucial for understanding the evolution of narrative and community that the text represents.

Part of the inspiration for my metaphorical use of the term "prosthesis" is Brent Edwards's work on diaspora. In Edwards's formulation, he reminds us that although diaspora has been used in an abstract sense to suggest unity among African peoples who have been dispersed around the world, diaspora is a term that also signifies difference among those peoples. He argues that the use of the term diaspora "is not that it offers the comfort of abstraction, an easy recourse to origins, but that it forces us to consider discourses of cultural and political linkage only through and across difference" (Edwards, 2004, 30–31). To explain how this idea of difference manifests in the practice of diaspora, Edwards employs the French term

décalage, which means to restore "a prior unevenness or diversity" similar to his definition of diaspora. That unevenness is re-established by the removal of a prosthesis used to overcome it:

> Like a table with legs of different lengths, or a tilted bookcase, diaspora can be discursively propped up (*calé*) into an artificially 'even' or 'balanced' state of 'racial' belonging. But such props, of rhetoric, strategy, or organization, are always articulations of unity or globalism, ones that can be 'mobilized' for a variety of purposes but can never be definitive: they are always prosthetic. In this sense, *décalage* is proper to the structure of a diasporic 'racial' formation, and its return in the form of 'disarticulation'—the points of misunderstanding, bad faith, unhappy translation—must be considered a necessary haunting….Instead of reading for the *efficacy* of the prosthesis, this orientation would look for the *effects* of such an operation, the traces of such haunting, reading them as constitutive of the structure of any articulation of diaspora. (Edwards, 2004, 32–33)

If we imagine a community as a body, one of its vital limbs would be its method of connection, the part that allows a group of disparate people to believe that they are unified. For diaspora that limb might be "rhetoric, strategy, or organization," but for a community it might be shared space, shared language, or as Benedict Anderson (2006) has argued, shared narratives through print culture that create "imagined communities." Edwards's argument points out, however, that the limb that creates unity is always prosthetic and never actually organic to the metaphorical body. If the limb must always be prosthetic, then some kind of technology must always be employed to create it, whether it be the technology of storytelling, the technology of print culture, or the technology of the world wide web.

It is clear to see the ways in which Hopkinson would be invested in the technology of the "prosthetic community"—a term that I employ in order to focus on the metaphorical prosthesis that unifies the community—because of her position as a diasporic writer. Born in Jamaica, raised in Guyana, the Republic of Trinidad and Tobago, and Canada, educated in the Caribbean, the U.S., and Canada, and writing in Canada and the U.S., her transnational affiliations help to redefine what it means to be an "American" writer in the twenty-first century. Because she has so many disparate traditions to draw from, including Caribbean, U.S., and postcolonial literature, defining communities with which to interact provides structure within fluidity. Her participation in the sci-fi community through helping to build the prosthesis that unites sci-fi writers and fans of color further demonstrates her investment in the technology itself. She is actively considering how the community functions, how it grows, and how it influences the culture of science fiction. *Midnight Robber,* as a fictional exploration of the prosthetic community, allows us to see how the prosthesis works by creating a device that represents it. The ear-bug that connects the Marryshevites to the interface becomes the tangible prosthetic that creates community.

Toussaint is the prosthetic community in *Midnight Robber* united by the ear-bug. Named after the Haitian revolutionary Toussaint L'Ouverture, established by the Marryshow Corporation, named after T. A. Marryshow who is considered one of the fathers of the West Indies Federation, and run by Granny Nanny, a reference to Nanny of the Maroons who was a female leader of the slave rebellions in eighteenth-century Jamaica, the planet exists as a syncretic Caribbean space in which people speak several Caribbean national dialects and draw upon various Caribbean national histories. Rather than representing a Caribbean utopia (everything is far from perfect), Hopkinson imagines a Caribbean future in which technology and Caribbean syncretism come together to produce a world that centralizes Caribbean experiences.

Toussaint exists as a refiguring of historical visions for a Caribbean future. The fact that the Marryshevites arrive on Toussaint in spaceships labeled "Black Star Line II" shows the novel's connection to Marcus Garvey's imagined future for black diasporic peoples. His failed Black Star shipping line was going to be the means for a return to the African homeland. The line itself became a prosthetic, uniting African peoples in the Caribbean and in the United States who believed in Garvey's vision and invested money in his venture (Campbell, 1987, 61). Despite its failure, the vision for a unified community continues, but the ideas about how that community comes together necessarily change. *Midnight Robber* abandons the concept of returning to the homeland and replaces it with a journey further outward to science fiction's final frontier, outer space and an extraterrestrial homeland.

From childhood Hopkinson was interested in science fiction and therefore was inundated with narratives of space travel that refigured the story of colonization from a clash of global cultures to one of extraterrestrial cultures (the 1960s television show *Star Trek* is a prime example*)*. In her novel's future, however, the space pioneers/colonizers are Caribbean, individuals who were previously "on the receiving end of colonization" (Enteen, 2007, 262). Invoking the Black Star Line reminds readers of the past failure, which haunts the narrative like a phantom limb, but the new ships that successfully deliver the Marryshevites to Toussaint represent the role that technological advancement plays in achieving the unity that has been desired for generations. It is as if the peg leg prosthetic were replaced by a bionic leg that allows the wearer to jump and run.

The narrative, of course, is also haunted by yet another set of ships that are often read as the source of the desire for unity:

> Long time, that hat woulda be make in the shape of a sea ship, not a rocket ship, and them black people inside woulda been lying pack-up head to toe in they own shit, with chains round them ankles. Let the child remember how black people make this crossing as free people this time. (Hopkinson, 2000, 21)

During the yearly Junkanoo festival in which Marryshevites celebrate their arrival on Toussaint centuries before, the young Tan-Tan wears a hat shaped like the spaceships that delivered them. The gardener who grows the hat for her (trees on Toussaint can be programmed to produce whatever organic product one desires, including a raffia Junkanoo hat), in invoking the memory of slavery is not reaching back to that period but instead to the a time when the hat was designed as a *remembrance* of slavery. The hat is a symbol of the metaphorical amputation from the homeland, creating the initial phantom limb that Garvey's Black Star Line attempted to replace. What the gardener wants Tan-Tan to remember is not the slave ship that symbolizes amputation but the spaceship that is the successful prosthetic. The history of victimization inflicted by the slave ship is replaced with the history of the proactive frontier spaceship that allows the fulfillment of a vision.

The fulfillment of the vision is not without consequences. The prosthetic community of Toussaint is juxtaposed to the prison planet New Half-Way Tree, a space of exile. Those who Granny Nanny deems dangerous to the security of Toussaint are sent there and their earbugs are disabled. In effect, their limb of unification is amputated, and they struggle to survive without access to knowledge on a hostile planet. While Toussaint is colonized by the Marryshow Corporation with "Earth Engine Number 127" which creates a safe environment for humans, New Half-Way Tree "is how Toussaint planet did look before" where "the mongoose still run wild, the diable bush still got poison thorns, and the mako jumbie bird does still stalk through the bush, head higher than any house" (2). It is "the planet of the lost people," "a dub version of Toussaint, hanging like a ripe maami apple in one fold of a dimension veil" (2). It is also the environment in which Tan-Tan grows up after being kidnapped by her father, Antonio, who attempts to flee Granny Nanny's justice after murdering his wife's lover. His efforts to circumvent Granny Nanny's power land him in the same place that he would most likely have been sent, but he would not have been able to take Tan-Tan with him. Tan-Tan's presence on New Half-Way Tree is the key difference that will upset the balance between these two planets that depict the prosthesis and the amputation: the connection to community through Granny Nanny and the earbug, and the loss of that community in exile. It is this juxtaposition and Tan-Tan's travel between these two spaces that allows us to see the prosthetic evolve.

NANOTECHNOLOGY AND THE CYBORG COMMUNITY

> The tools, the machines, the buildings; even the earth itself on Toussaint and all the Nation Worlds had been seeded with nanomites—Granny Nanny's hands and her body. Nanomites had run the nation ships. (10)

And it was Ione who held her child as Doctor Kong syringed the nanomite solution that would form her earbug into the baby's ear. (47–48)

We try to contact your mamee when we find she nine years ago, but the nanomites growing she earbug did calibrate wrong for Nanny to talk to them across dimensions…Nanny couldn't talk to she again. (328)

The Marryshevites are a cyborg community. The nanomites inserted into the ear immediately after birth to form the earbug that connects them to Granny Nanny turn them into individuals who exist on the border between human and machine. The sixth sense that they gain makes them more than human because it allows their brains to connect to and immediately call up all the information of a vast database, but at the same time it makes them more *human* because it gives them access to the cultural narratives that, as Hayles argues, help them to understand their position in the world, and those narratives also connect them to each other.

Hopkinson's use of nanotechnology as the science that creates the earbug reifies the liminal space the Marryshevites occupy as cyborgs. As Colin Milburn has argued, the science of nanotechnology itself occupies a border between science and fiction: "Science fiction is not a layer that can be stripped from nanoscience without loss, for it is the exclusive domain in which mature nanotechnology currently exists…" (Milburn, 2008, 24–25). Based on the idea that molecules are small machines, nanoscience theorizes that one day in the future we will be able to make machines on the molecular scale that will be able to perform miraculous scientific advances. None of these machines currently exist, but the research to create them is funded on the promise that one day they will. Milburn argues that nanotechnology is a science that is as influenced by fiction as fiction is by science. The line, then, between the real and the imagined in science and science fiction is significantly blurred.

By choosing a science that involves speculation, Hopkinson makes a comment about the various forms of speculation that she includes in her novels. As stated above, *Brown Girl in the Ring* involves speculative elements from African spiritual cultures used alongside scientific advancements such as organ transplantation. While readers respond to organ transplantation with credibility because it happens in our contemporary era, African spiritual practices are relegated to magic and myth because they are not considered rational. Including a science in her second book that similarly lacks the hard evidence of the spirituality that she has written about before functions as a commentary on the fragile line between what is real and what is imagined, what is evidence and what is hearsay. Without suggesting which may be more or less real, she forces us to consider how we label all speculative phenomena. Do we consider the phenomenon itself or also the source that tells us about it?

Aside from occupying a liminal space itself, nanotechnology's appearance in this novel is also fascinating because of its focus on the smallest parts that create matter. While the Marryshevites travel through outer space to establish a new community, they also venture into the innerspace of their bodies to create that community. The nanomites remind us that even while we understand our bodies as whole, they are actually a collection of particles that the theory of nanotechnology suggests can be rearranged to be an entirely different entity with the reprogramming of said particles. In some ways, then, we can consider the body itself to be a kind of narrative that could theoretically change. Such a revelation produces a similar disorientation to the one the reader experiences upon learning that *Midnight Robber's* narrator is a computer database. Both the story and the body are careful arrangements of discrete bits, and the community mimics this arrangement, as well on yet another scale.

The strength of the Marryshevite community, then, comes from moving away from binary existences and embracing the discrete bits that create a syncretic identity that even includes the technological. In this way, Hopkinson's text resonates with Donna Haraway's arguments about the cyborg as a powerful identity for feminist resistance. Haraway describes the cyborg as "a kind of disassembled and reassembled, postmodern collective and personal self" that she believes "feminists must code" (Haraway, 1991, 163). We can see the ways in which such a definition overlaps with our understanding of Caribbean identity and Caribbean space. From the manifesto "In Praise of Creoleness" to Antonio Benítez-Rojo's (1992) image of the repeating island based on Chaos theory, to Edward Glissant's (1990) concept of a poetics of relation based on rhizomatic thought, to Paul Gilroy's (1993) formulation of the Black Atlantic, writers and theorists have continually theorized about the syncretic nature of the Caribbean that involves the breaking down and building up of both self and community. Its inhabitants are already quite familiar with the "profusion of spaces and identities and the permeability of boundaries in the personal body and in the body politic" that Haraway prefers (Haraway, 1991, 170). Hopkinson's Marryshevites transfer this "network" to Toussaint when they arrive. We must remember that Toussaint, although recalling a former pan-African desire to return the black diaspora to the African homeland, is actually a representation of a Caribbean diaspora that resettles itself on another planet. All Caribbean people may be brought together, and what brings them together is the way their bodies and their modes of living represent an amalgamation of difference. The Caribbean space is defined by its border-crossing, by its occupation of the liminal. Hopkinson, then, adds the relationship to the technological to this mix but at the same time shows how familiar the cyborg identity already is to the Caribbean subject.

Haraway (170) uses the terms "networking" and "weaving" to describe what she considers to be feminist practices that are ascribed to the cyborg persona, and these

concepts are essential to the community that exists on Toussaint. As the eshu informs us at the beginning of the narrative:

> Maybe I is a master weaver. I spin the threads. I twist warp 'cross weft. I move my shuttle in and out, and smooth smooth, I weaving you my story, oui? And when I done, I shake it out and turn it over *swips!* and maybe you see it have a next side to the tale. Maybe is same way so I weave my way through the dimensions to land up here. (Hopkinson, 2000, 3)

The metaphor of weaving appears throughout Hopkinson's text as both the creation of artisanal cloth and the creation of webs. The loom, an early technology for making cloth, was also instrumental in the production of narrative as textiles often told stories. The web references the current technology of the internet but again returns us to ancestral narrative as it references Anansi, the trickster figure in black diasporic folk tales. A character known for weaving linguistic webs that allowed him to find loopholes while catching his enemies, Anansi, and the 'Nansi Web, or Grande Nanotech Sentient Interface, reminds us of the intricate patterns that narrative creates that can both confuse and clarify.

It is no surprise, then, that the avatar that speaks to the Marryshevites, that relates the narratives that unite them, is modeled on the trickster god Eshu-Elegbara. Eshu-Elegbara is the mediator between the human and the divine, relaying messages between the two. Eshu is the crossroads, a liminal figure that allows translation between the binaries, enabling us to see what it can do but not what it is (Thompson, 1983, 19). The eshu performs this role for the Marryshevites as well, seemingly at the beck and call of the human, providing information at his or her will, but we also see the eshu asserting its own control over knowledge. The one who can tell the story can also alter it:

> The eshu's voice sounded like it had a mocking smile in it. Like even self Antonio's house was laughing at him? (Hopkinson, 2004, 4)

> "Mistress say is okay," chimed the eshu out loud. It confused Tan-Tan. She hadn't had any message from her mother. (54)

Antonio's ability to hear the derision in the eshu's voice just before he discovers himself to be a cuckold, and the eshu's unexpected support of Tan-Tan's choice to wear her Midnight Robber costume instead of the white dress her mother chooses for her shows the ways in which the eshu displays difference even in its role as supposedly impartial messenger. These minor disruptions exemplify how an apparent system based in 0's and 1's can still produce the unexpected.

Such a system also contains the unexpected in the form of the pedicab runners. A sect of Marryshevites who perform menial labor in spite of machines that conduct all manual work, and choose to disconnect from Granny Nanny for religious

reasons are still able to exist on Toussaint because they pose no threat to the security of the community (52). The pedicab runners are descended from the programmers who made Granny Nanny and as a result have greater access to the system. Their greater access enables them to choose how and when to enter the community, thereby preserving their privacy when necessary. They do not lose their cyborg status as the exiles on New Half-Way Tree do but instead grow in it as they realize how and when this identity is most beneficial to them. I would extend Nanny's concern for life and limb to not just include those of the individuals who inhabit Toussaint but also of the metaphorical body of the community as a whole that exists on the planet. Had the pedicab runners threatened the security of the community with their difference their behavior would be more suspect. Having space away from Granny Nanny does not negate the prosthetic that creates community so they can safely continue their practice.

The relationship between the Marryshevites and Granny Nanny, then, supports Haraway's assertion that "machines can be prosthetic devices, intimate components, friendly selves" and at the same time suggests that the relationship need not be hiearchical with humans on top, or antagonistic with the fear of the machine taking over (Haraway, 1991, 178). Haraway asks, "Why should our bodies end at the skin, or include at best other beings encapsulated by skin?" and Hopkinson's text answers with bodies that continually cross the boundary of skin as they connect and disconnect from Granny Nanny. And if we return to the metaphorical body with which we began, the community as a whole, we recognize that through connection to Granny Nanny the Marryshevites do not end at the skin, but unite to make a larger body with a shared brain facilitated by Granny Nanny. Their subjectivity becomes communal through technology.

ETHICS IN A POSTHUMAN COMMUNITY

> Increasingly the question is not whether we will become posthuman, for posthumanity is already here. Rather, the question is what kind of posthumans we will be. The narratives of Artificial Life reveal that if we acknowledge that the observer *must* be part of the picture, bodies can never be made of information alone, no matter which side of the computer screen they are on. (Hayles, 1999, 246)

> The concept of the subject as owning himself and owing nothing to society for this self or its capacities is evidence of a profound individualism that marks many version[s] of the posthuman. This emphasis on individualism and isolation evacuates our model of society from any ethical sense of intersubjectivity and collectivity, which is also what I suggest is lacking from many models of the posthuman. Instead, we require a vision of the subject and the posthuman in which embodiment is central and self is seen as something that emerges from community rather than as something threatened in its autonomy by others. (Vint, 2007, 13)

Both Hayles and Vint ask us to consider what kind of posthumans we are because the era of the posthuman is already upon us. We already live our lives symbiotically with machines whether we have a physical prosthesis or not. What is quite relevant for my discussion of *Midnight Robber*, however, is that both Hayles and Vint see the posthuman as still an embodied figure in an ethical relationship with community. Vint argues against conceptions of the posthuman that privilege the mind over the body as the sole source of identity, and Hayles similarly cautions against considering the posthuman through the lens of liberal humanism that privileges the self over the community (Hayles, 1999, 286–87). Antonio and Tan-Tan's exile on New Half-Way Tree engages the theoretical exploration of the posthuman and ethics that Hayles and Vint raise. As Marryshevites amputated from the community of Toussaint, Antonio and Tan-Tan must forge new connections on their own and reconfigure how they relate to the community around them. Their success or failure is a reflection of how they value their roles as members of Granny Nanny's web.

Antonio becomes Tan-Tan's antagonist because of his misunderstanding of how his community works. Despite being the mayor of Cockpit County, Antonio's concern is not about his constituency but about his personal reputation. We never see his work as a politician but instead observe his degeneration as an individual. His obsession with his wife's infidelity leads him to murder one of his compatriots and then abscond with his daughter to New Half-Way Tree. He befriends the pedicab runners only to use their special knowledge to poison his wife's lover and then to circumvent Granny Nanny's justice by running away before he can be sentenced. He deprives Tan-Tan of the community that she was just beginning to know and then proceeds to commit more heinous crimes against her while they struggle to live on New Half-Way Tree. On her ninth birthday, the first one she celebrates on the prison planet, Antonio begins sexually molesting her. The abuse does not end until Tan-Tan's sixteenth birthday when she murders him after he rapes her yet again. His final crime is to impregnate her. Antonio's actions represent egregious disruptions to societal order, and his punishment is a bloody death at the hands of his own child.

Tan-Tan, on the other hand, ostensibly an adult after the murder of her father, flees with the Douen, the original inhabitants of New Half-Way Tree (and Toussaint before the Marryshow Corporation colonizes it) and learns the value of community through observing the Douen's cooperative form of living. More importantly, Chichibud, her Douen friend, informs her that "when [she] take one life, [she] must give back two" thereby repairing and increasing the community she has damaged (Hopkinson, 2000, 174). The ethics of the Douen prepare her for returning to a human community in the future and for raising her son who will represent an evolution in the prosthetic community.

Granny Nanny's inability to save Tan-Tan from her abusive father is useful for the narrative because it allows us to see Tan-Tan's development as part of the community without the aid of the database, and it is also useful for the theoretical ideas that drive Hopkinson's text. The database may aid humanity in building community, but it is not a savior by any means. It cannot control or prevent human actions in spite of all the power we may bestow upon it. Antonio is still responsible for his crimes and Tan-Tan is still required to save herself. The benefit of Granny Nanny, then, is how it can reconnect Tan-Tan with her community despite her trauma in exile. Granny Nanny's absence during Tan-Tan's trauma reinforces the idea that human agency still takes precedence even in a highly technological age.

In an attempt to allay the fears of those who regard the posthuman as an end to humanity Hayles writes:

> But the posthuman does not really mean the end of humanity. It signals instead the end of a certain conception of the human, a conception that may have applied, at best, to that fraction of humanity who had the wealth, power, and leisure to conceptualize themselves as autonomous beings exercising their will through individual agency and choice. (Hayles, 1999, 286–87)

Hopkinson's novel makes a similar argument in its representation of Antonio. In spite of his connection to Granny Nanny, he does not believe himself to be part of a larger community. He lacks the humanity that would allow him to thrive in a communal society. Tan-Tan, although she wanders throughout much of the novel by herself, performing tasks as her alter-ego, the Midnight Robber, her actions are always in support of a reestablishment of community. In one town she publicly chastises a mother who tries to control her adult son; in another she exposes a bartender who has been cheating his patrons; and in the bush she rescues a woman by killing a frightening beast, the rolling calf (named after a Jamaican ghost or duppy) but then also rescues the now orphaned rolling calf baby and raises it herself. For the one life she takes, she gives back two.

Even though she can no longer hear Granny Nanny, Tan-Tan remains a part of the posthuman Toussaint community as Granny Nanny commands the nanomites in her body to enter the growing fetus inside her. Tan-Tan becomes the carrier of a new generation of posthuman that no longer needs the earbug prosthetic to connect to Granny Nanny. The nanomites become inseparable from the organic cells of her son's body. The baby Tubman, then, becomes the means through which Granny Nanny and New Half-Way Tree can connect. For Tubman, who will not be able to think of his connection to Granny Nanny as the result of a device that is separate from his body, the narrative of the eshu is more like his conscience than a separate machine. His body becomes the site for an expansion of his mind since it is the nanomites that blend with his cells that will give him complete access to

the knowledge of the interface. Simultaneously he becomes the prosthetic for New Half-Way Tree and its inhabitants, including his mother Tan-Tan whose devotion to community ushers him into the world. We can imagine, then, that the eshu who tells the story is also a voice that resides *within* Tubman as opposed to an external voice that speaks *to* him. As he is born singing the nannysong of Granny Nanny rather than having to learn it, her language *is* his language, and her voice *is* his voice. Tubman, then, is our narrator as much as the eshu is.

LOCATING THE HUMAN ELEMENT IN THE DATABASE NARRATIVE

> Part of what I was trying to do [in *Midnight Robber*] was to imagine how Caribbean culture might metonymize technological progress if it was in our hands: in other words, what stories we'd tell ourselves about our technology—what our paradigms for it might be. (from an interview with Nalo Hopkinson conducted by Dianne Glave, 2003, 149)

As Hopkinson's novel shuttles us far into the future of narrative production, it does not neglect to include the historical reminders that allow the story to feel familiar, particularly for a Caribbean audience. The narrative opens with the soothing language of the eshu telling its listener "[d]on't be frightened, sweetness…let me distract you little bit with one anansi story" (Hopkinson, 2000, 1). The fear for Tubman, of course, is the experience of his birth, but for the readers of *Midnight Robber* the tension concerns how narrative may change in the uncertain future. While we have experienced print technology's revolution of narrative through reproducing it and silencing it and are currently experiencing the digital age revolution that lets us carry an entire library in a handheld device, neither of these revolutions have yet to change the storyteller. Our growing reliance on technology, however, seems to suggest that a new storyteller could be possible in the future. What makes Hopkinson's digital storyteller so endearing, though, is the way that it returns us to modes of narrative that have been lost. The Granny Nanny database is an entirely oral/aural program using the most advanced technology to return us to the most primal form of human communication—sound. As Jillian Enteen has argued:

> By configuring oral transmissions as more intricate than written computer code, Hopkinson exposes the hierarchies that rank writing and the visual superior to the aural. Her operating language envisions an expansive system, beyond human perception, yet rooted in Caribbean music and of distinctively Caribbean invention. (Enteen, 2007, 273)

Even though the narrator is a computer, its narrative mode is more human than the technology of the book. Hopkinson's signature use of dialect speech and her introduction of second person narration in this novel humanizes the voice of the

computer by replacing the emotionless monotone associated with the machine with the lilting accent of human speech directed towards the reader as if she or he is the chosen listener. The storyteller speaks to us with a familiarity that draws us in. The use of call and response—"Crick crack" to start an oral story and "Jack Mandora, me nah choose none!" to end it—heightens the intimacy between storyteller and listener that the narrative style establishes (Hopkinson, 2000, 3, 329). By using these markers that would be familiar to Caribbean readers brought up on oral stories, the machine encourages its listener to respond just as it would to a person: "Monkey break 'e back on a rotten pommerac!" Like Hayles, Hopkinson sees the ways in which humanity and technology work symbiotically such that technology might enhance human connection rather than hinder it. The birth of Tubman, then, represents the syncretic blend of human and machine. As the next evolution of Marryshevite, he is a figure that secures the human element in the database narrative as he is both listener and storyteller of the tale that we read and becomes the metaphorical prosthesis that can create a community that connects through parallel dimensions. He takes on the crossroads identity of the eshu and like his namesake becomes the means of deliverance for the formerly amputated Marryshevites on New Half-Way Tree to become a part of their now diasporic community's future.

NOTES

1. *Brown Girl in the Ring* won the *Locus* Award for Best First Novel and was a finalist for the Philip K. Dick Award.
2. For example, I posted Erna Brodber's name to the website because I consider her latest novel *The Rainmaker's Mistake* (2007) to be an example of science fiction.
3. The *Dark Matter* anthologies, edited by Sheree Thomas are another way in which black diasporic writers have been able to be published and increase their renown among readers.

REFERENCES

Anderson, B. (2006). *Imagined communities: Reflections on the origin and spread of nationalism*. London: Verso.

Benítez-Rojo, A. (1992). The repeating island: The Caribbean and the postmodern perspective. In J. Maraniss (Trans.), S. Fish & F. Jameson (Ed.), *Post-contemporary interventions*. Durham, NC: Duke University Press.

Campbell, H. (1987). *Rasta and resistance: From Marcus Garvey to Walter Rodney*. Trenton, NJ: Africa World.

Edwards, B. H. (2004). The uses of 'diaspora.' In G. Fabre & K. Benesch (Ed.), *African diasporas in the new and old worlds: Consciousness and imagination* (pp. 3–38). Amsterdam, The Netherlands: Rodopi.

Enteen, J. (2007). On the receiving end of the colonization: Nalo Hopkinson's Nansi Web. *Science Fiction Studies, 34*(102), 262–282.

Folsom, E. (2007). Database as genre: The epic transformation of archives. *PMLA, 122*(5), 1571–1579.

Gilroy, P. 1993. *The black Atlantic: Modernity and double consciousness.* Cambridge: Harvard University Press.

Glave, D. D. (2003). An interview with Nalo Hopkinson. *Callaloo, 26*(1), 146–159.

Glissant, É. (1990). *Poetics of relation.* B. Wing (Trans). Ann Arbor, MI: University of Michigan Press,

Haraway, D. (1991). *Simians, cyborgs, and women: The reinvention of nature.* New York: Routledge,

Hayles, N. K. (1999). *How we became posthuman.* Chicago, IL: University of Chicago Press,

Hayles, N. K. (2007). Narrative and database: Natural symbionts. *PMLA, 122*(5), 1603–1608.

Hopkinson, N. (1998). *Brown girl in the ring.* New York: Warner.

Hopkinson, N. (2000). *Midnight robber.* New York: Warner.

Hopkinson, N. (2004). The profession of science fiction, 60: Sometimes it might be true. *Foundation: The international review of science fiction, 33*(91), 5–9.

Hopkinson, N. (Ed.). (2000). *Whispers from the cotton tree root: Caribbean fabulist fiction.* Montpelier, VT: Invisible Cities.

Hopkinson, N., & Mehan U. (Eds.). (2004). *So long been dreaming: Postcolonial science fiction and fantasy.* Vancouver, B.C.: Arsenal Pulp.

Lamming, G. (1960). *The Pleasures of Exile.* Ann Arbor: University of Michigan Press,

Milburn, C. (2008). *Nanovision: Engineering the future.* Durham, NC: Duke University Press,

Nelson, A. (2002). Making the impossible possible: An interview with Nalo Hopkinson. *Social Text, 20*(2), 97–113.

Shelley, M. (1992). *Frankenstein.* Boston: Bedford St. Martin's Press,

Thomas, Sheree R. (Ed.). (2000). *Dark matter: A century of speculative fiction from the African diaspora.* New York: Warner.

Thomas, Sheree R. (Ed.). (2004). *Dark matter: Reading the bones.* New York: Aspect/Warner.

Thompson, R. F. (1983). *Flash of the spirit: African and Afro-American art and philosophy.* New York: Random House,

Vint, S. (2007). *Bodies of tomorrow.* Toronto, ON: University of Toronto Press.

Wells, H. G. (2005). *The Time Machine.* New York: Penguin.

Science Fiction, Feminism and Blackness

The Multifaceted Import of Octavia Butler's Work

SHANNON GIBNEY

RECENTLY, OCTAVIA BUTLER HAS BECOME SOMETHING OF A PHENOMENON. She won the $500,000 MacArthur "Genius" Fellowship in 1995 for her lifetime achievement in the arts, becoming the first science fiction writer to do so. Later, in 2000, she was granted a similar lifetime appreciation award by the PEN American Center. Also in 1995, she was awarded both the Hugo and Nebula awards, science fiction's highest accolades, for the title piece in her short story collection, *Bloodchild and Other Stories*. There has also been a corresponding outpouring of analyses of her work in the past 15 years, as academia slowly begins to recognize the imaginative and political stakes of Butler's fiction. It is far stranger that Butler has been neglected for so long, since she is one of a small handful of Black women science fiction writers than it is that she is receiving so much literary attention lately. Before her untimely death in 2006, she had written 13 novels since her career began in 1976, more than any other Black woman writer in North America (Kenan 1991). In her work, she confronts issues of racial, political, and sexual stratification and oppression; explores the sociological underpinnings of society and definitions of humanity; and characteristically pens strong, emotionally rich female protagonists existing in multicultural worlds. Taken separately, each of these areas of inquiry are edgy enough, but altogether, they are downright explosive—even genre-bending. In fact, this chapter will argue that by circumscribing and disrupting various literary genres, Butler creates a hybrid imaginative space that

challenges our cultural conventions and assumptions explicitly through its content. Even more provocatively, the question of form and genre implicit within Butler's work forces us to confront the politics of labeling itself.

The specific literary genres that Butler builds on, undercuts, and surpasses in very particular ways are mainstream Black literature, mainstream science fiction, and feminist science fiction. Butler's novels have incredible resonance inside each of these literary communities. Each has claimed Butler as their own, in some sense, affirming the parts of her work that they find useful and relevant. Butler, as both an artist and a member of these respective communities, regularly negotiated the shifting meaning and significance of her writing from group to group as well as her own identity within them. As readers, we do the same (whether consciously or unconsciously), as collaborators with Butler in meaning. New discursive space is created through these interstices, broadening our notions of each genre and challenging us to read outside our comfort zones. This is necessary in order for the literature of any genre to develop.

As we examine this new discursive space, some primary questions will guide us. Our overarching inquiry is: What does it mean to the Black literary community to say that Octavia Butler is a Black, female, feminist science fiction writer? As we explore this wider question, the following smaller ones will guide us: What does this title mean inside the science fiction literary community? Can we read Butler as part of the (largely post-Black Arts) movement of Black women realist writers that ascended in the 70s—including Ntozake Shange, Alice Walker, and Toni Morrison? Do we agree with Hoda M. Zaki? She states in her article, "Utopia, Dystopia, and Ideology in the Science Fiction of Octavia Butler," that:

> Butler is part of the post-feminist utopian SF trend which emerged when writers who were deeply influenced by the second (1960s) wave of the women's movement began to use SF to explore issues from a feminist perspective, (Zaki 1990, 239)?

Is Butler implicated in and by the style, content, and ideological concerns of the SF genre in general? Do we see elements of more traditional SF concerns in her work? And finally, how did Butler see herself in this welter of ideological and identity allegiances? Why did she, a Black woman writer, choose SF as her genre—how did she use it to say what she needed to say? Does this matter in how we read her work? In fact, Butler would probably frown upon the major questions this chapter will address, since she stated her abhorrence for identity politics in many interviews (this idea is also expressed in her fiction):

> I don't like the labels, they're marketing tools, and I certainly don't worry about them when I'm writing. They are also inhibiting factors; you wind up not getting read by certain people because they think they know what you write, (Kenan 1991, 495).

As the above quote demonstrates, Butler clearly did not want her work pigeonholed or viewed simplistically. However, it would be erroneous to claim that she wrote in a vacuum. Like all writers, her literary and imaginative sensibilities were circumscribed by the culture (and subcultures) in which she existed—and in which she was a Black woman in "lived reality," who read almost exclusively the SF and nonfiction that informed her work in "literary reality."

If we are to understand the full impact and importance of Butler's work, we must locate it within the cultures it comes out of—no easy task, for all of the reasons outlined above. This will not be an endpoint but rather, a place to begin contemplating the significant contributions that Butler made to mainstream Black literature, mainstream SF, and feminist SF, and through them, altered some of the defining characteristics of these genres themselves.

BUTLER AS A BLACK WOMAN WRITER

Calvin Hernton's 1984 essay, "The Sexual Mountain and Black Women Writers," outlined the new role and prominence Black women writers began to achieve in the 1970s, within the Black and larger American literary communities. Although she existed on the fringe as a SF writer, Butler was also part of this movement. These writers, including Toni Cade Bambara, Audre Lorde, and Alice Walker, came of age largely during the Black Arts Movement. Their dissatisfaction with this movement's treatment and comprehension of Black women led many to "write themselves into" the existing literature. Their true experiences, as they saw them, were not clearly represented in black male writing. While Butler's work does not center on any sort of black community that we would recognize, most of her protagonists are strong black women (Lilith in the *Xenogenesis* series, Dana in *Kindred*, Lauren in the *Parable* series, etc.). These protagonists must often wrestle with issues of identity and politics. Dana, of *Kindred*, is married to a white man, and both must confront what this means when he travels back in time with her to the antebellum South. In *Parable of the Sower*, Lauren is constantly thinking about the political significance of race—how one's survival in the post-apocalyptic world she inhabits depends on how one's race is "read":

> They had been a black man, a Hispanic-looking woman, and a baby who managed to look
> a little like both of them. In a few more years, a lot of the families in the neighborhood would
> have looked like that. Hell, Harry and Zahra were working on starting a family like that.
> And, as Zahra had once observed, mixed couples catch hell out here (Butler 1993, 182).

Lauren's words reveal that contextualizing one's race within the chaos of her world can mean the difference between life and death. They also challenge the neat,

fixed racial categories that much of the Black Arts Movement's discourse relied upon and mobilized around. Butler's mixed race characters, and mono-racial characters in mixed race relationships, destabilize these conventional expressions of race, by insisting that race is a constantly moving target, something that can only be known in moments, before morphing into something else.

Butler's protagonists also usually try to subvert some form of past or future slavery. *Kindred* presents Dana as a contemporary Black woman who travels back in time, against her will, to confront a white ancestor on a slave plantation. In *Parable of the Sower*, Lauren must try to subvert the economic slavery that is slowly destroying all life on the planet; and in "Bloodchild" and *Dawn*, the human body is the site for colonization and inter-group procreation, not unlike what Blacks endured from white masters during American slavery. These primary characters are often outsiders—Lauren is an empath in the *Parable* series, and Lilith is the first human awakened by aliens to lead them, unwillingly, to interbreed in *Dawn*. Butler intimately understood the identity of "the other," being a Black woman in America, and then applied this to her rendering of these protagonists. Although Bambara, Lorde, Morrison, and Walker are all in the American realist tradition, their protagonists are also usually intelligent, emotionally resonant black women, who are outsiders for one reason or another. Walker's *The Color Purple* comes to mind, in which Celie discovers lesbian sexuality; in Morrison's trilogy *Beloved, Jazz*, and *Paradise*, black women protagonists are similarly maligned and separate themselves from their communities because of the various incarnations of love they pursue.

But if Butler can be viewed as part of a group of contemporary Black women writers with similar political and literary concerns, she can also be seen as distinct from them. For in one essential realm, Octavia Butler distinguishes herself from the main body of black American literature of the twentieth century: she does not view race as the "secret" of human character and relations but rather the human species, our fragmentation, endless will to power, to dominate and to control, as the "secret" that will either ultimately unite or destroy us. Racial and cultural divisions are only symptoms of a larger problem—our biologically determined craving for separation, hierarchy, and power (all this despite our formidable intelligence). In Butler's view, if Blacks were not oppressed by whites, if women were not largely ruled over by men, humankind would find some other, equally insidious forms of antagonism to pursue. As Zaki explains:

> For Butler, there is a pervasive human need to alienate from oneself those who appear to be different—i.e, to create Others. Even when she described the diminution of racial antagonisms among humans upon encountering a new extraterrestrial Other, she foregrounds how we seize upon our biological differences between the two species to reassert, yet again, notions of inferiority and discrimination, (Zaki 1990, 241).

This is not to say that Butler whole-heartedly embraces biological determinism—her work demonstrates that, however difficult, humans must strive to cross the cultural, linguistic, racial, and other chasms that separate and unify us as a group. She clearly disdains discrimination and violence in all its forms, while simultaneously recognizing that it is almost written into our genes. It is almost as if she is saying, "Let's admit that we have these hereditary tendencies. Now, what can we do about them, so that we have some hope of surviving?" Her answers to these questions are intriguing: in the short story "Speech Sounds," Rye connects with a companion/lover despite their loss of language, commits herself to him, loses him, and finally decides to become primary caretaker for two vagrant children he died protecting. We do not know if or for how long they will be able to survive under such post-apocalyptic conditions, but we understand that they have no option but to try. Lauren, of the *Parable* series, responds to transience through the course of her wanderings by inventing a religion based on the concept of change ["All that you touch,/You Change./All that you Change,/Changes you./The only lasting truth/Is Change/God/Is Change./ (Butler 1993, 70)]. She forms a small group of religious followers by the end of *Parable of the Sower*, and begins to fortify it in *Parable of the Talents*, even though the world as they know it is falling apart.

Therefore, we can see that while Butler's faith in humankind, and our longevity in general is weak, each of her books offers some hope for the species, however small. At the end of *Parable of the Sower*, we find Lauren and her small band of followers in the Pacific Northwest, struggling to establish a farm in the face of incredible violence. In "Bloodchild," Gan has reconciled his role as host animal within his Tlic family, and ultimately elects to spare his sister this painful experience. And Dana returns alive, without an arm, but alive nevertheless, from the slave plantation at the conclusion of *Kindred*. However, there is a tendency on the part of some critics (especially in the black literary community) to read Butler as espousing an overly optimistic view of humanity and our possible future. Robert Butler, for example, in his article "Twenty-First-Century Journeys in Octavia E. Butler's *Parable of the Sower*," argues that Butler's vision in that book was that of a lone, courageous Black woman oppressed by her violent environment, journeying to a safe, bucolic space. He says:

> But *Parable of the Sower*, like the vast majority of classic African American journey books, does not present a vision of apocalyptic despair or an enervating nihilism. The heroine of the novel can save herself and others by constructing a 'modern day underground railroad' taking them north to liberating new spaces (Butler 1998, 136).

I disagree whole-heartedly with this statement. The "liberating new spaces" that Robert Butler speaks of actually contain the bodies of Lauren's lover's family, burned to death. The Earthseed band is, in fact, surrounded by drugged people who want to kill them for their money and belongings, and a cold, suspicious township

that does not want them there. On the last page of the book, a central character says, "I don't think that we have a hope in hell of succeeding here," (Butler 1993, 295).

I believe that Robert Butler, as well as many other critics, misread Octavia Butler as continuing a narrative of hope and rebirth that is an essential element of mainstream, realist Black women's (and also Black men's) realist fiction. When we read Morrison's *Beloved*, we feel a cathartic release at the story's conclusion, when we learn that Beloved has gone back to that ethereal place from which she came. We know that her mother and sister have learned emotionally and spiritually from this very painful experience. Conversely, when we come to the end of Butler's *Dawn*, we feel extremely uneasy. On both visceral and intellectual levels, the idea of genetic interbreeding with the Oankali disturbs us, even though it is probably the only hope that humankind has of surviving. We wonder if Lilith will even live through the ordeal of "re-colonizing" Earth. And we have doubts that, if humankind were able to free itself from the Oankali, we would be able to avoid self-annihilation again. Although there are elements of hope in Butler's projects, this is not her central concern— revealing the hierarchical and self-destructive nature of the human species is.

BUTLER AS A SF WRITER

This brings us to our next area of inquiry: how does Butler's identity as Black woman writer, intersect with her selection of the SF genre as her preferred mode of expression? SF is generally and conventionally understood to be a literary mode for "scientific and technological extrapolation" (Sargent 1975, xiv), usually set in the future and involving some sort of journey or adventure. The hero (traditionally a white male) usually has to overcome some sort of adversarial faction or problem. Good SF writers are able to execute all of this while also entertaining the reader. Entertainment, in this context, is seen as an ongoing layering of details that encourage readers to suspend their disbelief for the course of the story and enter a different world of some sort (Bear 1996). Butler's work features all of these "essential" qualities of SF (except the traditional white hero), even though she sometimes branched off into the fantasy rather than the SF domain (as in *Kindred*). Of course, many critics view science fiction as a tangential subset of the larger category of fantasy literature anyway, which

> relates logical stories from the premise of the fantastic....In the twentieth century in particular, fantasy has assumed a central place in mainstream literature, specifically as a structural and allegorical element that has allowed authors from varied backgrounds to tell their stories to a universal audience (Burns and Hunter 2005, 137).

Some of Butler's work, such as *Kindred* and *Fledgling*, adheres to these more general qualities of fantasy (allegories and extensions of the "real world," except for one

important difference), while the bulk of her writing addresses the more specific concerns of SF. Most of the pieces in *Bloodchild and Other Stories* secure Butler's location with the SF genre, as they feature heroines and a hero (Gan, of "Bloodchild"), who exist in the far to near future and are inhibited by some sort of science/technology gone wrong or altered. Lynn of "The Evening and The Morning and The Night" has DGD, a disease caused by an unintended side-effect of a cure for cancer; Rye, of "Speech Sounds," cannot read or write, due to a sinister international malady that robs humanity of their language capabilities; and Gan of "Bloodchild" must come to accept that he will soon be implanted with Tlic "grubs" in order to ensure the longevity of his human-Tlic family.

Additionally, Butler's writing also highlights the element of adventure: Lauren, of *Parable of the Sower*, must embark on a postapocalyptic backpacking trip to the Pacific Northwest, and *Dawn* involves the survival or extinction of the human race as we know it. The "problem" in Butler's work is often sociological, such as loss of language in "Speech Sounds," social responsibility and genetics in "The Evening and The Morning and The Night." Finally, anyone who has read Butler's work can attest to its entertainment value and to how easily we agree to suspend our disbelief in return for engaging in a completely riveting parallel reality. All of these factors add up to secure Butler's place in mainstream SF.

However, writing SF per se was not what Butler was initially interested in. She began writing SF in 1959, at the age of 12, and was not deterred by the fact that, prior to the 1970s, the genre was a predominantly white, male, heterosexual enterprise. Butler grew up reading SF voraciously and has stated that some of her mentors and influences were Harlan Ellison, Felix Sultan, Frank Herbert, and Theodore Sturgeon. Sultan, in particular, may have been the first to establish the relationship between human beings and animals, and humans as just another animal, in her mind—a theme that predominates in her writing (Fry 1997). In fact, the books of all these authors inspired Butler to start writing in the genre, and their aesthetics influenced her work incredibly. Their writing showed her the limits of the possible—that she could write unlikely people and creative scenarios somewhere, regardless of the fact that she was a Black woman or that the body of work she was "writing herself into" was called SF. This was because the genre's stylistic, content, and ideological emphases and constraints (although Butler, herself, never read the latter as such) most appealed to her literary and expressionistic sensibilities. In fact, in a 1997 interview in *Poets and Writers*, she stated:

> As I've said before, I write about people who do extraordinary things. It just turned out that it was called science fiction...the reason I've stayed with science fiction to the degree that I have is because you can do almost anything in it, (Fry 1997, 61, 63).

Thus, we can see that Butler made a very deliberate, conscious choice as an artist to write in the SF genre. We could say that, for Butler, SF held the most imaginative potential—she could explore the major ideas that we now view as representative of her writing extensively (the biological dominance and hierarchical tendencies of the human species; social responsibility; the political ramifications of gender, race, culture, class, and economics), and in the manner in which she was most comfortable.

BUTLER AND SF FEMINISM

During the 1970s, SF was undergoing substantial changes in its ideologies and aesthetics, and Butler was part of this movement. Prior to this, the genre was dominated by "'space opera' themes of intergalactic war and time travel, and…populated by optimistic, super-hero-type protagonists," in the early part of the 20th century, and "…drug use, sexual licentiousness, and fear of nuclear war" after mid-century (Krstovic 2010). With the advent of the second wave of feminism, a new group of writers ascended into the SF literary landscape—women writers who pushed the genre to examine futures in which sexual, gender, and societal politics as we know them were radically altered. In fact, these writers, including Marge Piercy, Ursula Le Guin, and Joanna Russ, refocused the entire trajectory of the genre. By calling for an emphasis on the social and political aspects of futurism, rather than the conventional stress on technology, gadgets, and mainstream sex roles, they gave it a new credibility (Zaki 1990, Sargent 1975, Ellison 1964). These writers aligned themselves largely with the concerns of the predominantly white, feminist movement that was formulating at the time. These concerns included abolishing constrictive sex roles, exploring the female body and conventional notions of sex and sexual pleasure, abortion and women's rights over their bodies, and deconstructing essentializing notions of women in general.

Butler's work confronts all of these concerns and domains: we see Lauren in the *Parable* series, Lilith in *Dawn*, and Rye in "Speech Sounds," all express interest in and sometimes instigate the act of sex as well as take pleasure in it. Additionally, all of her female protagonists destabilize traditional notions of womanhood—Lauren carries a gun, is physically big and strong, and passes for a man in the *Parable* series. Lilith leads and subverts at least two potential uprisings of the small band of humans kept captive on the Oankali ship in *Dawn*. Dana, of *Kindred*, risks her life for the small chance of freedom from the tyranny of the slave plantation and also councils her white ancestor, Rufus, against rape and other forms of violence. It is also worth noting that Butler challenges our allegiance to normalized sex roles for men, and actually troubles the very categories of men and women themselves.

In "Bloodchild," it is the men who must bear the responsibility for giving birth to the Tlic. And Anyanwu changes from man to woman to animal and back again, in *Wild Seed*. In this way, Butler's work does conform to the dominant issues of the '70s feminist movement in SF.

However, Butler is singular within this group (as she seems to be in any literary taxonomy in which we might place her), as her writing often features Black female protagonists and explores the politics of race:

> ... her works chiefly differ from those of her Anglo sisters in that they embody an indirect critique of the liberal feminist imagination and politics expressed in contemporary feminist SF—a difference which, insofar as it is attributable to racial considerations, points to certain tensions existing between Afro-American women and the feminist movement (Zaki 1990, 239).

Butler never presents an overt critique of the "Anglo" focus of the 70s feminist movement; rather, her Black female characters, her choice of race and class as subject matter in addition to gender, and her predominant literary concerns of power and domination convey this message themselves. As stated earlier, many of her experiences as a Black woman found their way into her work (although this was not her primary message or focus), in a way that is absent in most feminist SF we encounter. It is this tension—her placement within the feminist SF movement and genre and at the same time outside of it, her status as a Black woman writer but not of realist fiction—that creates the richness, depth, and relevance that her work generates within her variegated readership.

A NEW VISION FOR BLACK FICTION, SF, AND FEMINISM

As a writer who was primarily concerned with her artistry, and less with her roles within various literary and ideological communities, Butler traversed the "borderlands" (to use Gloria Anzaldúa's word from *Borderlands/La Frontera*, 1987) she occupied quite gracefully throughout her career. She created what she wanted to, continually worked to improve her craft, and appeared to exist quite comfortably, as do most serious writers, within the worlds she created in her fiction. However, she emerged intermittently to discuss her intense dislike of labels and how they function in assessments of her work and person: "Labels are something that people just absolutely require, and there's nothing I can do about them" (Fry 1997, 63). This quote, as well as the one cited on page 101, suggest that Butler would have preferred us to view her as simply "a writer," rather than "a SF writer." She would also have preferred that we not make assumptions about her work because she was a Black

woman. She wanted readers to approach her work outside their subjectivities and individual tastes or prejudices. Of course, this is impossible, but it is not hard to see why the negative effects of such attitudes would irk an artist: reductive and unsupported analyses of the writing. These are the risks that Butler had to take in presenting her fiction to the public. And I am sure that, on more than one occasion, she felt that critics and readers were handling it without insight and intelligence because of their pre-conceived notions. However, I would argue that, in Butler's case, there are far more advantages to being "multi-labeled" than not labeled at all. Labeling, as much as we detest it as individuals, and as overzealous we may become with it, is part of what makes us human. There is simply too much information in our complex world to take in every waking moment without relying on certain assumptions, classification systems, and groupings. This does not abolish our social responsibility to closely monitor and self-consciously investigate the negative potential that labeling holds in our lives. What it does mean is that this labeling is, in my opinion, inevitable and necessary. But more important for Butler is the fact that to not be labeled at all is to be invisible, which she experienced for the first 17 years of her writing career (until the publication of *Patternmaster*, in 1976). When she was alive, I am sure that she would have agreed that as a serious artist, it is far more productive to be visible than invisible, if for no other reason than the fact that one is able to support oneself through one's work.

Furthermore, "multi-labeling" Butler has forced many communities to radically revise their understanding of art, ideology, and identity. The Black literary community has been made to see that science fiction can be an avenue into black expression and cultural examination. The "secret" of race upon which most mainstream, Black realist fiction relies is not the only "secret" of humanity that may be explored in Black literature. Mainstream SF groups have had to re-examine their prejudices and assumptions about portrayals of women, minorities, and the relevance of social issues in the genre. Her work has made this genre more accessible to a wide range of Americans, by showing that questions of power and agency can be explored meaningfully through brown female bodies, not just white male ones, and by giving cultural questions far more weight than technological ones. In addition, Butler has shown (white) feminists generally and SF feminists in particular that the stakes for a more complex and libratory literature include both race and culture in addition to sex and society. In this way Butler, as a Black woman feminist science fiction writer, stretched each of these groups' definitions of literature, identity, and possibility.

Is there any better function of the artist than this?

REFERENCES

Allison, D. (1990). The future of female: Octavia Butler's mother lode. In H. L. Gates, Jr. (Ed.). *Reading black, reading feminist: A critical anthology* (pp. 471–478). New York: Meridian.

Anzaldúa, G. (1987). *Borderlands/La Frontera.* San Francisco, CA: Aunt Lute.

Beal, F. M. (1986). Black women and the science fiction genre. *The Black Scholar, 17*(Mar/Apr), 14–18.

Bear, G. (1996). Skepticism and science fiction. *Skeptical Inquirer, 20*(5), 24+.

Burns, T., & Hunter, J. W. (2005). *Contemporary literary criticism* (Vol. 193, p. 137). Detroit, MI: Thomson Gale.

Butler, O. E. (1996). *Bloodchild and other stories.* New York: Seven Stories.

Butler, O. E. (1988). *Kindred.* Boston, MA: Beacon, rpt; first published Doubleday, 1979.

Butler, O. E. (1987). *Dawn.* New York: Warner.

Butler, O. E. (2005). *Fledgling.* New York: Seven Stories.

Butler, O. E. (1993). *Parable of the sower.* New York: Warner.

Butler, O. E. (2000). *Parable of the talents.* New York: Grand Central.

Butler, O. E. (1980). *Wild seed.* New York: Warner.

Butler, R. (1998). *Contemporary African American fiction: The open journey.* Madison, WI: Associated University Press.

Clute, J., & Nicholls, P. (Eds.). (1993). *The encyclopedia of science fiction.* New York: St. Martin's.

Cover, A. D. (1974, April). *Vertex* interviews Harlan Ellison. *Vertex, 2*(1), 37.

Davis, T. (1983, February 1). The future may be bleak, but it's not black. *The Village Voice,* 17–19.

Ellison, R. (1964). The world and the jug. In *Shadow and act* (pp. 107–144). New York: Random House.

Foster, F. S. (1982). Octavia Butler's Black female future vision. *Extrapolation, 23,* 37–49.

Friend, B. (1982). Time travel as a feminist didactic in works by Phyllis Eisenstein, Marlys Millhiser, and Octavia Butler. *Extrapolation, 23,* 50–55.

Fry, J. (1997, March/April). An interview with Octavia Butler. *Poets and Writers, 25,* 58–69.

Helford, E. R. (1984, Summer). Would you really rather die than bear my young?: The construction of gender, race, and species. In O. E. Butler (Ed.). Bloodchild, *African American Review, 28*(2), Black Women's Culture Issue, pp. 259–271.

Hernton, C. (1984, Winter). The sexual mountain and black women writers. *Black American Literature Forum, 18*(4), pp. 139–145.

Kenan, R. (1991, Spring). An interview with Octavia E. Butler, *Callaloo* (Science Fiction, Fantasy, Etc.: A Special Section), *14*(2), 495–504.

Krstovic, J. (Ed.). (2010). Science fiction short stories. *Short Story Criticism, 127,* 125–127. Detroit, MI: Gale, Cengage Learning.

Le Guin, U. (1975, November). American SF and the other, *Science Fiction Studies, 2,* 210.

Sargent, P. (1975). Introduction: Women in science fiction. *Women of wonder* (p. xiv), New York: Vintage.

Salvaggio, R. (1984). Octavia Butler and the black science fiction heroine. *Black American Literature Forum, 18*(2), 78–81.

Weinkauf, M. (1985). So much for the gentle sex. *Extrapolation, 26,* 231–239.

Weislmann, J. (1984, Summer). An Octavia Butler bibliography. *Black American Literature Forum, 18*(2), Science Fiction Issue, pp. 88–89.

Zaki, H. (1990). Utopia, dystopia, and ideology in the science fiction of Octavia Butler. *Science Fiction Studies, 17*(Part 2), 239–251.

The Absence of Meat in Oankali Dietary Philosophy

An Eco-Feminist-Vegan Analysis of Octavia Butler's *Dawn*

AMIE BREEZE HARPER

OCTAVIA BUTLER WAS A U.S. AMERICAN SCIENCE FICTION WRITER, BORN IN Los Angeles, who passed away in 2006. Along with Samuel J. Delaney, she has been the most prominent African American science fiction writer and is well known for how she pushes the reader to reanalyze normative notions of gender, sexuality, race, reproduction, and what it is to be human. Much of Butler's science fiction and fantasy writing can be considered to fall within the realm of speculative fiction. Two of the fundamental tenets of speculative fiction are that the stories take place in the future and ask the question "What if?"

> [S]peculative fiction is a term which includes all literature that takes place in a universe slightly different from our own. In all its forms it gives authors the ability to ask relevant questions about our society in a way that would prove provocative in more mainstream forms....In all its forms it is a literature of freedom, freedom for the author to lose the chains of conventional thought, and freedom for the reader to lose themselves in discovery. (Wyatt in Jackson and Moody-Freeman 2009, 128)

Additionally, Butler has a holistic understanding of humanity's role in maintaining or destroying Earth's ecosystem. In her books, *Parable of the Sower* (2000) and *Parable of the Talents* (2000), Butler explores a California in the not too distant future, in which the infrastructure of the USA has broken down, chaos is every-

where, and most importantly, food and especially water are difficult to access. The USA, a country that consumes 30% of the world's resources and once was the global hegemonic state, has abused its power and resources to the point that it has fallen to the bottom of the world's economic ladder. In both books, *Parable of the Sower* and *Parable of the Talents*, Butler places emphasis on the importance of self-survival and sufficiency through "getting back to nature." She provides an alternative view to contemporary notions about society, nature, and the environment. Learning how to grow one's own food and to respect nature is a core theme. In her earlier book, *Dawn* (1987), she also explores human beings' relationship to ecology, food, and construction of humanity. It is in this work, published in 1987, that she speculates a future in which human beings are forced into a situation in which they must rely on the help of an alien species called Oankali to save them. Part of this involuntary arrangement means that human beings are only allowed to consume non-animal based foods. Though quite a few authors have analyzed Butler's works through an ecocritical lens (See Plisner 2009), this chapter will be the first to look at *Dawn* through an ecofeminist *vegan* lens.

Dawn takes place in a post-apocalyptic future, in which human beings have obliterated most people and the ecosystem through nuclear war. The Oankali are an alien race who rescue the remaining few hundred human beings on Earth by transporting them onto their space craft and keeping most of them in a deep hyper-sleep for over a hundred years while they try to repair Earth's ecosystem. It is an intriguing notion that the Oankali, who 'save' human beings, believe that a plant-centered diet is crucial for humans to not perpetuate violence or destroy their planet.

In reading the text, I was very cognizant of the theme of food and its connections to harmony, violence, and healing. There are many striking moments in *Dawn* in which meaning surrounding food, human perception of subsistence off of "wild nature," healing, and sexual violence, come to the surface. Such moments seem to hint that the Oankali (and the literary creator of the Oankali, Octavia Butler) connect a society's consumption philosophies to either perpetuating or destroying physical and emotional harmony of the human body and spirit as well as the ecology of the earth. The Oankali belief systems about living beings can be defined as being rooted in the principles of *Ahimsa veganism*. It must be noted that the terms *vegan* and *veganism* are never used in *Dawn*, but it is clear that the Oankali practice such a moral system. The Vegan Society, the organization that coined the term "vegan," states that the heart of veganism calls for practice of Ahimsa or "compassion, kindness, and justice" for all living beings. This means that animals and their by-products should never be consumed, that they should not be used for medical experimentation, clothing, or in entertainment such as zoos or circuses. For

this chapter, my analysis of consumption practices, healing, and human-nature-interface with the non-human animal subject will be based upon a specific type of *vegan theory* called *feminist-vegan critical theory*. First coined by Carol J. Adams, this theory is a sub-theory of ecofeminism and looks at the interrelationships and

> connections between male dominance and meat eating. It argues that to talk about eliminating meat is to talk about displacing one aspect of male control and demonstrates the ways in which animals' oppression and women's oppression are linked together (Adams 1990, 13).

Adams, as well other eco-feminist-vegan critical theorists such as Marti Kheel and Will Tuttle, theorizes that meat-eating in the Western culture normalizes capitalism and colonialism, as well as consumption of non-human animals, destruction of natural resources, and the exploitation of females as sexual objects for heterosexual male desire (Kheel 2008; Tuttle 2005). Capitalism dictates that it is *natural* to turn living beings into commodities, property, and profit. In *The World Peace Diet*, Tuttle explains

> [the] first money and form of capital were sheep, goats, and cattle, for only they were consumable property with tangible worth....The first capitalists were the herders who fought each other for land and capital and created the first kingdoms, complete with slavery, regular warfare, and power concentrated in the hands of a wealthy cattle-owning elite....By commodifying and enslaving large, powerful animals, the ancient progenitors of Western culture established a basic mythos and worldview that still lives today at the heart of our culture (Tuttle 2005, 18–19).

Furthermore, a capitalist system that has its roots in the centrality of animal domination and consumption has created a dominant male status quo that normalized the enslavement and exploitation of other human beings as acceptable; for it was the males who engaged in the *killing* of animals, and this collectively created a dualistic culture in which male domination (patriarchy) over non-human animals and human females is the norm (Tuttle 2005).

> All ecofeminists consider the concept of hierarchical dualism responsible for the dominant power structures that form a constitutive part of patriarchal Western ideology. Particularly the nature/culture divide with its historically developed oppositions (male/female, mind/body, reason/emotion, human/nonhuman, white/black, etc.) is deplored as a discursive and practical means of power of a dominant race, class, gender, species over marginalized, inferiorized and instrumentalized "others." (Grewe-Volpp 2003, 15)

In addition, Adams suggests that the animal-based dietary philosophies of the West are linked to ill-health of the human body (Adams 1990). In *The Sexual Politics of Meat*, Adams writes

> The gestalt shift in which vegans see meat as death and meat eaters see meat as life influences the receptivity of each group to information that suggests association between meat consumption and disease. Vegans literally see veganism as giving life and meat as causing death to the consumers....They know that the cancer-preventive benefits of consuming vegetables such as broccoli, brussels sprouts, and cabbage have been demonstrated, from which they concluded that a vegan immunity to the degenerative diseases that plague our culture may arise. (Adams 1990, 149)

Eco-feminist vegan critical analysis on the interconnection among animal consumption, disease, and health provides the lens through which one can read Lilith's awakening. In the first chapter of *Dawn*, Lilith, the human protagonist of the book, awakens to discover she is in an unfamiliar place, and has a long scar across her abdomen. She eventually learns from one of the Oankali that she had had cancer; however, the Oankali had helped her "cure" it by enabling her body to absorb the cancer. Lilith notices the scar:

> "I have a scar," she said, touching her abdomen. "I didn't have it when I was on Earth. What did your people do to me?"
>
> "You had a growth," he said. "A cancer. We got rid of it. Otherwise, it would have killed you."
>
> She went cold. Her mother had died of cancer. Two of her aunts had had it and her grandmother had been operated on three times for it. They were all dead now, killed by someone else's insanity. But the family "tradition" was apparently continuing.
>
> "What did I lose along with the cancer?" she asked softly.
>
> "Nothing."
>
> "Not a few feet of intestine? My ovaries? My uterus?"
>
> "Nothing. My relative tended you. You lost nothing you would want to keep." (Butler 1989, 24)

Though Butler never tells the reader exactly what part of Lilith's body had a cancerous growth, the position of the scar next to where the uterus is located suggests uterine or ovarian cancer because Lilith notes that several women on her mother's side of the family had had the same cancerous growths she had. Instead of using synthetic medicines such as chemotherapy or evasive surgery to eradicate her cancer, the Oankali instead have her eat a diet that prevents the regrowth of cancer in her body. And presumably, because the Oankali do not believe in killing and eating animals, the diet they have given her is plant based. They tell her:

"Even the food you ate was produced from the fruit of one of the branches growing outside. It was designed to meet your nutritional needs."

"And to taste like cotton and paste," she muttered. "I hope I won't have to eat any more of that stuff."

"You won't. But it's kept you very healthy. Your diet in particular encouraged your body not to grow cancers while your genetic inclination to grow them was corrected." (Butler 1989, 35)

It is clear that the Oankali have an understanding that the propensity for certain cancers are not only linked to genetics (they note that Lilith's genetic lineage has a "talent" for cancer) but can be either exacerbated or suppressed by particular diets. Furthermore, the Oankali are able to understand how to eventually cure Lilith's cancer by using non-violent means. As mentioned earlier, the original definition of veganism is based on the principles of Ahimsa, meaning non-violence towards all beings. Lilith asks Jdahya, an Oankali, how they were able to learn that she had cancer and find a resolution for it.

"How do ooloi study?" She imagined dying humans caged and every groan and contortion closely observed. She imagined dissections of living subjects as well as dead ones. She imagined treatable diseases being allowed to run their grisly courses in order for ooloi to learn.

"They observe. They have special organs for their kind of observation. My relative examined you, observed a few of your normal body cells, compared them with what it had learned from other humans most like you, and said you had not only a cancer, but a talent for cancer."

"I wouldn't call it a talent. A curse, maybe. But how could your relative know about that from just…observing." (Butler 1989, 25)

Lilith's conception of medicine and healing stems largely from a Western culture in which it is *normal* to experiment on and torture non-human animals to gain "medical knowledge." A core tenet of vegan philosophy is to oppose medical experimentation on non-human animals. The Oankali's praxis of healing can be read as being rooted in Ahimsa-based vegan ethic in which they perform no forms of bodily violence on humans or non-human animals to develop medical cures or knowledge. Such a philosophy attempts to view all beings as having a non-hierarchal relationship and no relationships based on *domination* and *violence*. They even view Lilith's cancer in a non-violent manner. For example, instead of *attacking* the growth with scalpels and then throwing it away, they respect that the cancerous growth is part

of Lilith's body. The Oankali understand that a compassionate and open-minded perception of the implications of cancer only adds to a deeper understanding of how everything that happens in one's body is not only a mirror to their environment but can also reveal wisdom and new knowledge in healing the body. Societies such as the United States that produce food through heavily industrialized animal farming practices not only pollute the animal's body's with antibiotics and hormones that negatively affect the health of *humans* but also produce excrement and chemical run-off from these agribusinesses that pollute the ecosystem and cause our air and groundwater to become polluted, which then cause cancers we see in human beings living in such cultures (Jacobsen and the Staff of the Center for Science in the Public Interest 2006; Jensen 2006; Tuttle 2005).

A *violent* relationship with animals, how one produces food from their exploitation and how one pollutes the land through such exploitative practices, is a mirror of Lilith's bodily health. The Oankali's resolution to Lilith's cancer shows their non-violent, holistic and deeply symbiotic relational understanding of living beings and their ecosystems. Unlike most humans in Western societies, the Oankali claim to have a symbiotic and non-hierarchal relationship with living beings (animals and non-animals) in society; furthermore, they do not believe in violence against *any* beings. In their perception, human beings have a hierarchical and destructive relationship with living creatures (human and non-human living beings). The Oankali reflect Butler's perceptions of human beings during the 1980s, particularly during the height of Cold War anxieties between the former U.S.S.R. and USA. In a 1988 interview, Butler was asked what inspired her to create the *Xenogenesis* series (*Dawn* is the first book of the trilogy). Butler replies

> I tell people that Ronald Reagan inspired *Xenogenesis*—and that it was the only thing he inspired me that I actually approve of. When his first term was beginning, his people were talking about a 'winnable' nuclear war, a 'limited' nuclear war, the idea that more and more nuclear 'weapons' would make us safer. That's when I began to think about human beings having the two conflicting characteristics of intelligence and a tendency toward hierarchical behavior—and that hierarchical behavior is too much in charge, too self-sustaining. The aliens in the *Xenogenesis* series say the humans have no way out, that they're programmed to self-destruct. (Francis 2010, 23)

Octavia Butler connects the destruction of the human body, the destruction of Earth's land base (and its non-human life forms), and the relationship of what and how human beings consume to their hierarchical behavior. When she writes that humans in the *Xenogenesis* series (of which *Dawn* is the first book) are "programmed to self-destruct," she has created the fictional Oankali to help *reprogram* such behavior. One method of reprogramming, through the Oankali's eyes, is to have human beings eat vegan while on their space craft. Through *Dawn*, we see that

Butler speculates that if an alien species were to ever save humanity after the devastation of nuclear war, these species would practice a non-violent dietary philosophy. During the era in *Dawn* before nuclear devastation happened, Lilith speaks of her university studies. The nature of the conversation reveals how self-destructive and hierarchical behavior even manifests in the field of studies that Lilith was pursuing, during a time when the U.S. and the former U.S.S.R. were competing to expand and dominate other nations. While talking to the character Tate, a woman who was rescued by the Oankali, Lilith conveys that she was pursuing anthropology in college:

> "Anthropology," Tate said disparagingly. "Why did you want to snoop through other people's cultures? Couldn't you find what you wanted in your own?"
>
> Lilith smiled and noticed that Tate frowned as though this were the beginning of a wrong answer. "I started out wanting to do exactly that," Lilith said. "Snoop. Seek. It seemed to me that my culture—ours—was running headlong over a cliff. And, of course, as it turned out, it was. I thought there must be saner ways of life."
>
> "Find any?"
>
> "Didn't have much of a chance. It wouldn't have mattered much anyway. It was the cultures of the U.S. and the U.S.S.R. that counted."
>
> "I wonder."
>
> "What?"
>
> "Human beings are more alike than different—damn sure more alike than we like to admit. I wonder if the same thing wouldn't have happened eventually, no matter which two cultures gained the ability to wipe one another out along with the rest of the world."
>
> Lilith gave a bitter laugh. "You might like it here. The Oankali think a lot like you do." (Butler 1989, 130–131)

Lilith is referring to the 1980s when both the U.S. and the former U.S.S.R. were archnemeses, armed with enough nuclear power to destroy the planet. Simultaneously, during the 1980s, meat—in particular beef, the symbol of 'real' American masculinity—was central for conveying who was the "strongest" and most "masculine" presidential candidate (Adams 1990). The U.S. during this time period was led by the Reagan administration; it was an era in which right-wing Christian extremist thought was normalized in the fabric of U.S. American consciousness. Core American values related to being a "good" U.S. citizen continue to be enacted through individualism and hierarchal praxes as the norm, while holis-

tic and symbiotic ways of being and existing on Earth were—up until very recent-
ly—marginalized (Furman and Gruenewald 2004).

> Butler recreates the canon that previously served as Western culture's ideological foundation,
> establishing a new paradigm different from patriarchal and social hierarchical predicates.
> Through (hu)mans' development from modest to industrious beings, they have inherently
> failed in their ascendancy from a state of nature to 'civilized society.' Conversely, Butler posits
> that the state of nature can and must remain simultaneously active and engaging while social
> participants occupy the social sphere. Butler's 'return to nature' refutes the Western cultur-
> al narrative in favour of a symbiotic state, supporting mutualistic relationships and threat-
> ening competitive ones. These 'different,' or 'new,' beginnings suggest the possibility of
> returning to a stratified environment once considered threatening. (Plisner 2009, 147)

Scholars such as Jim Mason and Carol J. Adams theorize that human cultures that
have lost their understanding of a symbiotic relationship with other living beings
and natural resources and transitioned into a hierarchal relationship began exploit-
ing animals as/for food, thus becoming more inclined to accepting colonialism, dom-
ination, and violence as an acceptable cultural norm (Adams 1990; Mason 1997).
Mason gives special attention to the Western agri-culture's societal interpretation
of the Christian Bible in a way that made this hierarchal, patriarchal, and colonial
relationship a "natural" part of God's plan (Mason 1997). In addition, there are
scholars who theorize that a colonialist and objectifying approach to living beings,
along with a society's move from holistic plant-based diets to industrialized animal-
based dietary philosophies and destruction of the land base for profit are directly
related to an increase of human cancer rates (see Jacobson et al. 2006; Jensen 2006;
Mihesuah 2003) as well as normalization of violence against human beings (Adams
1990; Mason 1997; Tuttle 2005). A symbiotic and non-hierarchical relationship with
other living beings is a particular way of being human that is an "alien" concept for
many people raised and socialized in the USA. In *Dawn*, what becomes 'alien' to
'awakened' human beings who are in Oankali captivity is the Oankali concept of liv-
ing on a diet of plant-based food, being non-violent, and not killing and consum-
ing animals for sustenance. For example, not having access to fast food with animal
ingredients, such as hamburgers—"luxuries" found in an industrialized human
society—some of the desires and longings in awakened humans, such as Paul Titus.
Paul is a human being who was saved by the Oankali while he was a teenager and
lived with them through adulthood. He had no human companions, only Oankali
companions. When Lilith is first introduced to Paul Titus, she sees a different look-
ing type of food on Titus's table.

> Lilith stared at the food in surprise. She had been content with the foods the
> Oankali had given her—good variety and flavor once she began staying with

Nikanj's family. She missed meat occasionally, but once the Oankali made clear they would neither kill animals for her nor allow her to kill them while she lived with them, she had not minded much. She had never been a particular eater, had never thought of asking the Oankali to make the food they prepared more like what she was use to.

"Sometimes," he said, "I want a hamburger so bad I dream about them. You know the kind with cheese and bacon and dill pickles and—"

"What's in your sandwich?" she asked.

"Fake meat. Mostly soybean, I guess. And quat."…She took a few of his French fries, too.

"Cassava," he told her. "Tastes like potatoes, though. I'd never heard of cassava before I got it here. Some tropical plants the Oankali are raising."

"I know. They mean for those of us who go back to Earth to raise it to use it. You can make flour from it and use it like wheat flour." . . .

"Have you really thought about what it will be like?" he asked softly.

"I mean…Stone Age! Digging in the ground with a stick for roots, maybe eating bugs, rats. Rats survived, I hear. Cattle and horses didn't. Dogs didn't. But rats did." (Butler 1989, 90–91)

What I find noteworthy about this passage is how Butler connects Titus's dreams of animal-based fast food with his negative perception and anxieties of a new planet Earth in which he would no longer have access to cattle or killing them to make his hamburger. I argue that Butler is suggesting a link between human aggression and violence that objectifies non-human animals and has created a capitalistic and industrialized ideology based on degradation of the land for meat-eating and fast food industry practices. It is no secret that U.S. consumption of hamburgers alone requires pollution of the land base and decimation of the South American rain forest for grazing cattle. This has led to a rise in cancer-related illnesses and deaths (Jacobson et al. 2006; Robbins 1987). Could it be that the Oankali realize this and, therefore, they do not give human beings animals to consume nor allow them to develop another capitalist, imperialist, and industrialized society? Earlier in this chapter, I quoted *The World Peace Diet* by Dr. Will Tuttle, who wrote that there is a direct connection of capitalism and violence in cultures that normalize the commodification and consumption of non-human animals.

> The first money and form of capital were sheep, goats, and cattle, for only they were consumable property with tangible worth. In fact, our word 'capital' derives from *capita*, Latin for 'head,' as in head of cattle and sheep. The first capitalists were the herders who fought

each other for land and capital and created the first kingdoms, complete with slavery, regular warfare, and power concentrated in the hands of a wealthy cattle-owning elite (Tuttle 2005, 18).

And what of men like Titus who have lived half their lives with the Oankali, both without meat or a human female to reproduce their Western human sense of "manhood"? During their first meeting together, Titus attempts to rape Lilith. She tries to talk him down from this violent behavior and he hits her.

She fell hard, but was not quite unconscious when he came to stand over her.

"I never got to do it before," he whispered. "Never once with a woman. But who knows who they mixed the stuff with." He paused, stared at her where she had fallen. "They said I could do it with you. They said you could stay here if you wanted to. And you had to go and mess it up!" He kicked her hard. The last sound she heard before she lost consciousness was his ragged, shouted curse. (Butler 1987, 95–96).

Is his aggressive behavior towards Lilith's refusal to have sex with him, somehow connected to the fact that he spent the first 14 or 15 years of his life in an industrialized Western human society in which both animals, the land and the environment, and human women were constructed as objects to be used and consumed by men?

In *The Sexual Politics of Meat*, Adams theorizes that in the West, meat is a symbol of true manhood, while plant-based diets are referred to as inferior and "feminine"; meat is a symbol of patriarchy: "To remove meat is to threaten the structure of the larger patriarchal culture" (Adams 1990, 37). Just before Titus attempts to rape Lilith, he conveys to her that she is crazy to accept the new mode of being "human" that the Oankali have offered to her, which involves a new type of human society not based on industrialism or violence. I would argue that Titus becomes upset with Lilith because she is more willing to accept the new lives that the Oankali have given them. This could be read that Lilith's acceptance of the Oankali philosophy of subsistence reflects her rejection of a capitalistic, patriarchal, violent, and dominating value system that is rooted in the consumption of meat that Titus desperately wants and misses. It cannot be taken lightly that cattle raised for beef/hamburger consumption is connected to a Western history of colonialism, performances of masculinity, the commodification of nature as well as the objectification of females as sexual objects for male consumption (Adams 1990; Mihesuah 2003; Mason 1997).

In *Dawn* I see that Butler is representing a view similar to that articulated by Carol J. Adams regarding her theory on the "pornography of meat," linking the normalization of male domination and male consumption of meat in the global West

to the pornographic representations and sexual consumption of the female body. Titus attempts to rape Lilith after the noticeable absence of animal products from Titus's meal, his mention of dreaming about hamburgers, and being irritated with Lilith's acceptance of the plant-based "back to raw nature" Oankali philosophy. In depicting this, Butler links, as Adams has noted, meat consumption to violent sexual consumption of women's bodies. Adams theorizes that violence upon animal bodies in slaughterhouses and sexual violence against human female bodies are a part of "our general socialization to cultural patterns and viewpoints; thus we fail to see anything disturbing in the violence and domination that are an inextricable part of this structure (Adams 1990, 43)." In *The World Peace Diet,* Tuttle writes

> Viewing animals merely as meat and objects to be consumed, we find that women, like animals, are also often viewed merely as meat to be used sexually. As Carol J. Adams points out, animals and women are linked in our culture through pornography, advertising, and the popular media, with 'food' animals being seen as sexualized females who want to be eaten, and women linked with animals as sexual objects that want to be used. (Tuttle 2005, 47)

In analyzing Titus's behavior through a feminist-vegan critical theory, I ask, is there a connection to Titus's yearning for hamburgers and his lack of awareness of the violence of both spending his formative years in a hamburger culture as well as a culture that teaches him that Lilith is also available for him to consume—whether she agrees or not? Though the Oankali thought that Lilith would make a potential "mate" for Titus, they did not expect Titus to pursue her with such violence and force. What does it mean that despite being within a peaceful, holistic, and vegan-based Oankali community for 15 years, Titus longs for red meat and treats Lilith like a "piece of meat" to satisfy his own sexual urges? After spending so much time in such a Western culture, this suggests that certain human beings—males in particular—can never rid themselves of anthropocentrism and dominating attitudes towards other living beings.

I believe that in *Dawn* Butler uses Titus to represent Westernized omnivorous heterosexual human men, who have developed their sense of being human and masculine around an industrialized meat-eating culture. They are individuals/humans who apparently would never accept a new life, or even a new way to be human, without access to red meat and women as consumable sex objects. I agree with Butler's use of Titus to present such types of human beings. In reflecting on the role of females in the novel, when one considers healing the body of Lilith and the body of Earth, it seems that Butler has constructed Lilith as the heroine because she represents a new type of potential leader for a new type of human beings that can reproduce themselves in a way that embraces holistic, symbiotic, and less violent approaches to being human.

SPECULATING A NEW HUMAN RACE

Lilith represents a performance of blackness that goes against the stereotypical Black female depicted in the mainstream USA media. Butler's heroine represents a future Black womanhood in which traditional performance and expectations of blackness, in regard to gender, consumption, and reproduction, go against the stereotypical norm of the 1980s. Though the use of science fiction to provide social commentary has a long tradition, "it has not given much attention of issues of race and ethnicity in the context of imagined futures" (Jackson and Moody-Freeman 2009, 128). Butler offers a "What if" possibility in *Dawn*, regarding deeply thinking about future racial-sexual (Black woman) identities. There is an underlying premise, at least in the USA, that a true Black woman is heterosexual, has a Black man as her spouse, and enjoys eating chicken. Most importantly, she is expected to be subservient and not a leader (Hill Collins 2000, 2004; Williams-Forson 2006). As a resident on the Oankali spaceship, Lilith definitely does not eat the "Gospel Bird." She falls in love with a Chinese male named Joseph, through the help of the Oankali, becomes pregnant with Joseph's sperm and Oankali genes, and is asked by the Oankali to lead a new human race. Food, identity, and reproduction are all linked. What Butler achieves with the development of Lilith's character is the creation of a type of human that deconstructs 1980s Western norms on many levels. She speculates that humanity cannot have a future of survival unless binaries around definitions of human, animal, reproduction, etc., are dissolved. For example, being a normal human being, at least in the USA, has always meant that one reproduces their body's needs through the consumption of non-human animals. The Western definition of 'human' is tied to power in a way that creates a binary: human and non-human animals. Even though human beings are in fact animals, the Western definition of human is predicated upon a belief that humans are separate from, and superior to, non-human animals. Carol J. Adams writes

> While it goes without saying that 'humans are animals' the way this insight has been used has been hierarchically, i.e., racial and sexual distinctions were used to equate people of color and women with other animals or to impute animal characteristics on those who were not white, propertied men. 'Human' became a definition not only about humans versus (other) animals, but also defining who among Homo sapiens would have the power to act as 'humans'—voting, holding property, making laws, committing violence with impunity. Human has always been a label that is tied to power. (Adams 2006, 120)

Lilith's willingness to save humanity through accepting the Oankali's terms of vegan consumption potentially reflects a future type of human species who are not as extremely anthropocentric as the humans from Lilith's pre-nuclear war society.

Second, Lilith's overall collusion with the Oankali's rules represents a type of

human being who will potentially resist binary ways of thinking that makes the ideologies around anthropocentrism so commonplace and normative during the period in which Butler wrote *Dawn*. Binary and hierarchical thinking manifest most visibly through white heteropatriarchal social constructs of race, gender, reproduction, and speciesism in the 1980s (Hill Collins 2000, 2004). For example, the social construct of race is rooted in the binary of white vs. non-white human beings. In such a racial binary, human beings are expected to reproduce themselves by mating with other human beings who are of their own race. While on the Oankali ship, it appears that all the rescued human beings who have been awakened by the Oankali select sexual partners who are of similar races to themselves—all except Lilith. The Oankali reveal that some of the humans in her group do not like that Lilith chose Joseph, a Chinese man. Nikanj, an Oankali, says, "there are already two human males speaking against him, trying to turn others against him. One has decided he's something called a faggot and the other dislikes the shape of his eyes. Actually, both are angry about the way he's allied himself with you" (Butler 1987, 156). The anger against Joseph manifests from homophobic, anti-miscegenation, anti-Chinese and speciesist sentiment rooted in hierarchical binary thinking (i.e., normal heterosexual vs. abnormal homosexual; normal same race mingling vs. abnormal miscegenation; normal animal consumption vs. abnormal veganism). Observing the Oankali's ideologies of interspecies symbiotic partnering also creates a type of anger in Lilith's human peers that stems from societies in which speciesism is the norm. One of the tenets of veganism is to oppose speciesism.

> Speciesism is species-selfishness. It is arbitrarily to give priority to the interests of our species simply because it is OUR species, in a similar way as we could give more importance to the interests of our ethnic group, social group, continent, nation, tribe, clan, family and, ultimately, ourselves. All these are examples of selfishness which start from its simplest form, selfishness relating to the individual, and extend to groups for no other reason than because the individual is part of them. (What Is Speciesism?, 2010)

Furthermore, Nikanj explains to Lilith how some of his Oankali peers are surprised that Lilith selected Joseph as her partner. Nikanj says:

> "Ahajas and Dichaan are mystified," it said. "They thought you would choose one of the big dark ones because they're like you. I said you would choose this one—because he's like you."
>
> "What?"
>
> "During his testing, his responses were closer to yours than anyone else I'm aware of. He doesn't look like you, but he's like you." (Butler 1987, 161).

Despite coming from a 1980s human society in which she is expected to perform

her Black womanhood by selecting a heterosexual Black male as her mate, Lilith courageously follows her heart and partners with Joseph. I believe that this is profoundly suggestive for a novel written during the 1980s when interracial coupling was largely condemned. It suggests that the Oankali have selected Lilith as the leader of a new type of human species that will potentially reproduce themselves and nourish their bodies through less violent dietary practices as well as partnering with other human beings who do not necessarily come from the same race. Lilith's acceptance of an Oankali vegan diet and sexual relationship with a Chinese man is difficult for many of her human peers to swallow, particularly since she is going against the stereotype of how a Black-woman-human should be. In a sense, Lilith/Butler is disrupting the oppositional binaries and human-centered power structures that have literally held together the social constructions and proper place of black-woman-human.

Maintaining images of U.S. Black women as the Other provides ideological justification for race, gender, and class oppression. Certain basic ideas crosscut these and other forms of oppression. One such idea is binary thinking that categorizes peoples, things, and ideas in terms of their difference from one another (Keller 1985, 8 in Hill Collins 2000). For example, each term in the binaries white/black, male/female, reason/emotion, culture/nature, fact/opinion, mind/body, and subject/object gains meaning only in relation to its counterpart (Halpin 1989 in Hill Collins 2000).

Another basic idea concerns how binary thinking shapes understanding of human difference. In such thinking, difference is defined in oppositional terms. One part is not simply different from its counterpart; it is inherently opposed to its "other." Whites and Blacks, males and females, thought and feeling are not complementary counterparts—they are fundamentally different entities related only through their definition as opposites. (Hill Collins 2000, 70)

Images of Black womanhood within the U.S. American status quo are those of mammies, servants, ignorant, inferior, and deviant women. They are constructed this way by the white racial status quo as an oppositional binary so the white racial status quo can exist as the superior human. In *Dawn*, the Oankali chose Lilith to be a leader to convince the remaining human beings to transition into a new type of human being that dissolves such oppositional binaries and begins to accept the possibility of inter-species symbiotic relationships. A Black woman as a leader of a new human race is unfathomable for those humans rescued by the Oankali who are racist (as well as homophobic and sexist). In the Western world during the 1980s, the white heterosexual male privileged human was the opposite of the stereotypical black woman: he is the natural leader of humanity, and he consumes red meat, garners sexist and often racist ideologies about females and non-white people, and advocates

turning Earth's natural resources and non-human living beings into commodities that drive a ecocidal capitalist society (Adams 1990; Hill Collins 2000, 2004; hooks 1992; Mason 1997; Tuttle 2005). Aside from *Dawn,* within most popular USA-based science fiction/fantasy, the protagonist is almost always a white heterosexual male who rarely has to think about race or gender oppression within the context of being human; his privileged location of being both male and white are simply an invisible norm. However, Butler's novels tend to complicate such an invisible norm because she creates protagonists who are Black females. Such a strategy makes visible the abnormality of such normative concepts as to who counts as a proper human protagonist for the genre of science fiction (Francis 2010). Ultimately, I believe that Butler is suggesting what would have to happen for an alien species to select a Black woman as humanity's leader (versus the white male savior in most sci-fi) is that the alien species would not be rooted in the binary of racialized-gendered hierarchies that runs rampant at least in the United States.

However, even though Lilith does not completely agree with the Oankali's plans to "help" save humanity, they have selected her as the best potential leader for the new human race because she is the least resistant against their belief system. However, this does not mean that Lilith's decision is an easy one. Her struggle with this new agreement reflects an overall struggle against hierarchical binary thinking that humans of the Western world have built the very definition of human on. Lilith never really becomes conflicted with the questions, "Am I still human if I don't eat animals?" or "Am I still a true Black woman [human] if I partner with a Chinese male?" She accepts the breakdown of binaries around the place of animal in one's diet and same-race heterosexual coupling. What becomes an emotionally devastating concept to Lilith's binary thinking around the construction of "what is human," is the idea of interspecies reproduction. The Oankali believe that if humanity will be saved, it will have to be through not just a vegan and cross-racial ideology of reproduction but also through an interspecies symbiotic relationship with all beings, including the Oankali.

Throughout *Dawn,* awakened human beings are sexually partnered with not just a human mate but also a sex-neutral Oankali called an ooloi. While humans have sex with their human partner, an ooloi would join them and greatly enhance the sexual pleasure for the humans. At first, the humans were disgusted by the idea of inter-species sexual pleasuring. However, it only takes a short time for the humans to turn their disgust into a desire for the sexual pleasures that ooloi offer. One gets the clear sense that Lilith struggles with the role that Oankali will play in the return of humans to Earth as she learns that human egg and sperm will not mix without the help of Oankali genetic mixing. She is terrified about the possibility of losing her sense of being human, especially when she learns that she is preg-

nant. Nikanj, the Oankali that had had an intimately symbiotic relationship with her and Joseph explains that the child in her womb is a mixture of Lilith's, Joseph's and Oankali genetics. Nikanj tells Lilith:

> "I have made you pregnant with Joseph's child. I wouldn't have done it so soon, but I wanted to use his seed, not a print. I could not make you closely enough related to a child mixed from a print. And there's a limit to how long I can keep sperm alive."

> She was staring at it, speechless. It was speaking as casually as though discussing the weather. She got up, would have backed away from it, but it caught her by both wrists.

> She made a violent effort to break away, realized at once that she could not break its grip. "You said—" She ran out of breath and had to start again. "You said you wouldn't do this. You said—"

> "I said not until you were ready."

> "I'm not ready! I'll never be ready!"

> "You're ready now to have Joseph's child. Joseph's daughter."

> "…daughter?"

> "I mixed a girl to be a companion for you. You've been very lonely."

> "Thanks to you!"

> "Yes. But a daughter will be a companion for a long time."

> "It won't be a daughter." She pulled again at her arms, but it would not let her go. "It will be a thing—not human." She stared down at her own body in horror. "It's inside me, and it isn't human!" (Butler 1987, 242–243)

Interestingly, even though Lilith was accepting of cross-racial reproduction, enjoyed inter-species sexual gratification with her ooloi, she is terrified of inter-species reproduction and what that means for human beings. What makes her response interesting to me, is that there was a time during European and American colonialism that African people were not considered human beings and that the white representative of the racial status quo were terrified of what would become of humanity if whites would mingle with Africans and or Black slaves.

With such complicated situations occurring in *Dawn,* I think what Butler offers to the genres of science fiction and particularly speculative fiction is a way to think deeply about the interconnectedness of the violence of non-human animal use, our humanity and relationship to other living things, and the potential impediments of oppositional binary thinking when it comes to a better future for human beings.

Though Butler's Oankali alien species never name their philosophies as Ahimsa and ecofeminist veganism, the Oankali's perception of life is incredibly interesting food for thought. Published in the late 1980s, *Dawn*'s ecofeminist vegan context can be seen manifesting within current activism as to how to save humanity from the devastation many humans in the West have caused to ourselves and the ecosystem. Currently, it is 2010 as I write this chapter, and one does not need to search too long on the internet to find books and organizations throughout the world that insist that the way to world peace must start with non-violent relationships with all forms of life. Such philosophies were very rare during the 1980s in the USA, but in 2010, organizations such as PeTA are thriving, and it is not uncommon to attend an event about environmentalism without a workshop or lecture that shows how eating hamburgers is more devastating to the environment than driving an SUV. Groups such as PCRM (the Physician's Committee for Responsible Medicine) promote a vegan lifestyle as well as ban the use of non-human animals for medical experimentation. Instead, PCRM advocates prevention of diseases such as cancer, obesity, heart disease, and diabetes through a compassionate and non-violent holistic vegan diet (Physician's Committee for Responsible Medicine 2010). And unlike the 1980s, the USA of 2010 has made the concept of not abusing or exploiting our natural resources a common ideology, a significant number of people refer to as "going green." Organizations such at the Ella Baker Center for Human Rights and Grind for the Green out of Oakland, CA, teach others how and why oppositional binary thinking has created environmental racism, structural racism, and classism that have manifested as polluted communities and sick brown and black people in the Oakland area (Ella Baker Center for Human Rights 2010; Harris 2010). While the 1980s mainstream population spouted rhetoric that naturalized the division of human beings, 2010 shows a more global push for coalitions across all lines (such as racial, ethnic, religious, national, species) to achieve a more peaceful planet. Lastly, there has been a dramatic increase in global chapters of vegetarian, vegan, and animal rights organizations. One can see the results of a less violent treatment of animals in legislation that has been passed that, for example, make battery cages for chickens illegal in certain regions in the USA. And more and more people are questioning where their animal food products are coming from and are opting to not support companies that place animals in conditions of extreme suffering and pain or companies that are less eco-sustainable in the way that they produce their products. People are realizing that violence enacted upon other living beings comes back to their own bodies and livelihood in some way, shape, or form.

Through the creation of the Oankali and exploration of their philosophy of living, Butler connects a society's consumption and environmental philosophies to either perpetuating or destroying the physical and emotional harmony of the human

body and spirit as well as the ecology of the earth. Ultimately, in *Dawn*, I think what Butler is asking is not only asking, "What does it mean to be 'human' in the near future?" I think she asks the reader to consider, "What violence has occurred for me to remain in the social category of 'human' (with all its subset categories based on oppositional binaries), and how do less violent relationships with all living beings enrich me as a living being—not just human-being?"

REFERENCES

Adams, C. J. (1990). *The sexual politics of meat: A feminist-vegetarian critical theory*. New York: Continuum.

Adams, C. J. (2006). An animal manifesto: Gender, identity, and vegan-feminism in the twenty-first century. *Parallax, 12*(1), 120–128.

Butler, O.E. (1987). *Dawn*. New York: Warner Books.

Butler, O. E. (2000). *Parable of the sower*. (Warner Books ed.), New York: Warner.

Butler, O.E. (2000). *Parable of the talents*. New York: Warner Books.

Butler, O. E., & Morrissey, P. (1989). *Xenogenesis*. (Book Club ed.), New York: Guild America.

Ella Baker Center for Human Rights. (2010). Oakland, CA. Retrieved from http://www.ellabakercenter. org/page.php?pageid=1

Francis, C. (Ed.). (2010).*Conversations with Octavia Butler*. P. W. Prenshaw (Ed.), Literary Conversations Series, Jackson, MS: University Press of Mississippi.

Furman, G. C., & Gruenewald, D. A. (2004). Expanding the landscape of social justice: A critical ecological analysis. *Educational Administration Quarterly, 40*(47), 47–76.

Grewe-Volpp, C. (2003). Octavia Butler and the Nature/Culture Divide: An Ecofeminist Approach to the *Xenogenesis* Trilogy. In *Restoring the Connection to the Natural World: Essays on the African American Environmental Imagination* (ed.) S. Mayer. New Brunswick: Transaction Publishers (Rutgers University).

Harris, Z. (2010). *Grind for the green*. Retrieved from http://www.grindforthegreen.com/

Hill Collins, P. (2000). *Black feminist thought, knowledge, consciousness, and the politics of empowerment*. (Rev. 10th anniversary ed.). New York: Routledge.

Hill Collins, P. (2004). *Black sexual politics : African Americans, gender, and the new racism*. New York: Routledge.

hooks, bell. (1992). *Black looks : Race and representation*. Boston, MA: South End.

Jackson, S., & Moody-Freeman, J. (2009). The genre of science fiction and the black imagination. *African Identities, 7*(2), 127–132.

Jacobson, M. F., & The Staff of the Center for Science in the Public Interest. (2006). *Six arguments for a greener diet*. Washington, DC: CSPI.

Jensen, D. (2006). *Endgame* (1st ed.). New York: Seven Stories.

Kheel, M. (2008). *Nature ethics : An ecofeminist perspective (Studies in social, political, and legal philosophy)*. Lanham, MD: Rowman & Littlefield.

Mason, J. (1997). *An unnatural order: Why we are destroying the planet and each other*. New York: Continuum.

Mihesuah, D. A. (2003). Decolonizing our diets by recovering our ancestors' gardens. *American Indian*

Quarterly, 27(3/4), 807–839.

Physician's Committee for Responsible Medicine. (2010). *About Pcrm*. Retrieved from http://www.pcrm.org/about/index.html

Plisner, A. (2009). Arboreal dialogics: An ecocritical exploration of Octavia Butler's *Dawn. African Identities, 7*(2), 145–159.

Robbins, J. (1987). *Diet for a new America*. Walpole, NH: Stillpoint,.

Tuttle, W. (2005). *The world peace diet: Eating for spiritual health and social harmony*. New York: Lantern.

What Is Speciesism? (2010). Retrieved from http://globalphilosophy.blogspot.com/2006/04/what-is-speciesism.html

Williams-Forson, P. (2006). *Building Houses out of Chicken Legs: Black Women, Food, & Power*. Chapel Hill: The University of North Carolina Press.

Speculative Poetics

Audre Lorde as Prologue
for Queer Black Futurism

ALEXIS PAULINE GUMBS

At night sleep locks me into an echoless coffin
sometimes at noon I dream
there is nothing to fear.

AUDRE LORDE "PROLOGUE" (1971)

LORDE'S 1971 POEM "PROLOGUE" REAPPEARS AS THE EPIGRAPH HAUNTING Jewelle Gomez's intergenerational lesbian vampire novel *The Gilda Stories* and haunts Octavia Butler's last work, the vampire novel *Fledgling*. This chapter places Lorde's work in the context of the speculative (a context Lorde is rarely if ever read within), arguing for a speculative poetics that contextualizes and makes possible the political intervention of Black speculative fiction, specifically through the figure of the vampire. Placing the black lesbian feminist warrior mother in a vampire genealogy, Lorde, as undead poetic subject, offers an understanding of queer intergenerationality and Black futurism.

Queer intergenerationality, as I define it, is the practice of being present to what can be generated and then shared between moments in times and encounters, that is not necessarily linked to generations in the patriarchal familial sense. The figure of the vampire as characterized by Lorde, Gomez and Butler is especially helpful in understanding the possibility of intergenerational connection without the reproduction of patriarchy because the engendering of vampire family is already queer, erotic and external to the narrative of biological reproduction.

If, as the genre of speculative fiction implies, the future and present are shaped by the limits of our imaginations, what does it mean to project words past your own death while at the same time inhabiting a queer refusal to reproduce the world that made you necessary? What is the role of the undead poet as a maternal, outlaw and vampire figure?

Jose Muñoz argues (against Lee Edelman's polemic *No Future*) that queer politics must be radically futurist because of the dire unacceptability of the present political situation, especially for queer people of color. But even these queer utopianists (or anti-anti-utopianists as Judith Halberstam says) shy away from the complexities of birth and the presumed heteronormativity of intergenerationality. I am interested in looking at the two rhetorically impossible claims "Black maternity" and "queer intergenerationality" together through the figure of the vampire in order to examine what future ways of being we might critically create. In my work the term queer is an intervention, a question about how the world is made and remade. In my work, and in this chapter, queer is that which questions and revises the social reproduction of the meaning of life. Queer, beyond being the name for those of us who scare the status quo with our blatant desire for each other, also does the theoretical work of revealing the channels through which racism, sexism and homophobia are reproduced as terms of living and offers an alternative meaning of life to be made out of our lust for each other and for a world free from oppression. The vampire is a queer figure because she does this work of embodying life and making futures on abnormal terms that seduce or awaken an undead vision for life beyond what we know.

In this chapter I will offer a poetic invocation of the vampire subject, an exploration in form of the poetic impact of the vampire within the social matrix that requires Black feminism as a speculative and poetic process, followed by an in-depth reading of "Prologue" itself designed to offer it as a precedent, context and ancestor text for our ongoing readings of Black feminist speculative and science fiction.

I.

At Noon

I begin this poem with you. You. Dangerous sound and word warrior who was never meant to survive. Who instead stays up late nights making new days possible. Vampire. If you could see your reflection you would know what I know, which is that you give rhythm back its secret and forgotten name, stopping the pulse of the world as we know it. You should already know this. You take my breath away. I am in love with a vampire, pea-coat collar upturned, nocturnal sleep cycle, dark gorgeous

seductive way of revealing vulnerability everywhere on me, especially here, penchant for old dark places with high ceilings, she who has lived many lifetimes, the works. Everything but an affinity for bats.

And I am a morning person, Lorde help me. But someone who was looking closely could have predicted that this would happen to me. Happen to us. The vampire is the Black Queer Future. Deliciously dangerous: our legacy.

Conservatives have been telling us the truth all along. Black women are queers raising up an underworld that threatens the light of a capitalist day. Black lesbians will destroy the American family. Our kind are dangerous because we show that there is something better beyond the tick of capital where life breaks down into differentially billable hours. *Do you want to live forever?*

My doctoral work is about the queer survival of Black feminism and the redefinition of Black mothering as radical authority in a revised meaning of life. I didn't write too much about vampires in graduate school, but I could have. If I wanted to look at the mothering practice in *Gilda Stories*, the Black lesbian vampire novel by Jewelle Gomez where a young girl escapes from slavery and is raised by an indigenous woman and a secretly black woman vampire named Gilda, whose name she takes in her transformation. Or Octavia Butler's creation of a cosmology in *Fledgling* where a young-looking Black vampire barely survives the slaughter of her eldermothers, dangerous because they have produced a young vampire dangerous like those of us with melanin because she can face the sun. Or Pearl Cleage's forthcoming novel where supermodel skinny Black movie makers from New Orleans lament their need to farm Morehouse College boys for their reproductive purposes. The Black woman vampire has done and is doing queer work in fiction but the vampire I fell in love with first was a poet. Enter the never meant to survive presence that survives: Audre Lorde.

Undead Audre

Nobody thinks Audre Lorde is a vampire, but many would agree with me that Audre Lorde somehow walks the earth even though she died of breast cancer almost 20 years ago. Audre Lorde is best remembered for her poem, "A Litany for Survival," a poem anchored by the haunting refrain "we were never meant to survive" and punctuated by the injunction that therefore "it is better to speak." "A Litany for Survival" shows up on blogs, at rallies against police brutality, reprised in the section headings of third wave feminist anthologies. This is a sacred repetition because it is so much of the way that Audre Lorde survives into the present. "Prologue" is a poem that I have never heard anyone read aloud, though it actually uses the word survival just as much as the litany, and it survives in a more literary way. As we

noticed at the start of this chapter, Jewelle Gomez reproduces three lines from the "Prologue" in her vampire novel. Gomez reminisced at "Sister Comrade," an event in honor of Audre Lorde and Pat Parker at the Oakland, California at the First Congregational Church on November 3rd, 2007, that her mentor Audre Lorde told her *The Gilda Stories* was a novel and not a book of short stories.

Prologue is an interesting poem. A literary act. Interestingly the *last* poem in *From a Land Where Other People Live*, her first collection with Black Arts Movement forum, Broadside Press, "Prologue" in its placement and its form is a very literary gesture towards something extra-textual. What happens after you finish this book? What will you make this act of reading a prologue to? What happens after in general? Which is a question about survival. The speaker in Lorde's poem is undead, unable to see her own reflection because of a literary scene that seeks to deny pieces of who she is, but she, out of her coffin, projects a queer future where "The children remain/like blades of grass over the earth and/all the children are singing louder than mourning/all their different voices sound like a raucous question." And the question that many of my white queer studies colleagues over the past years ask is what could possibly be queer about someone who still believes the children are our future? This is not a queer vampire, an anti-future death-driving demon from Lee Edelman's hell and Hitchcock polemic. This is a mother. Why does she care so much about children? About survival? Doesn't she know there is no future?

And this is why the vampire is so useful for clarifying the contours of a queer Black feminist futurity. Because like Jose Muñoz says, in this world, for queer young people of color to even survive, to even imagine that they would exist within the future is quite a queer proposition in the face of the state and hate violence used to erase them from the planet as themselves. Because we live in a world where population control means exactly what the fuck it sounds like. Where Audre Lorde can't stop writing about how a grown white police officer was acquitted for shooting a 10-year-old kid in the back while saying into his radio, a recording that was played in court "die you little motherfucker." How is it that "the children remain?" How do we even think about the future when our field of vision is so clouded with death? Audre Lorde offers the vampire, a queer figure who binds you to her for life with her mouth, seduction and choice. A figure who lives with death, whose life is defined as death and who yet walks the earth keeping me up all night.

> At night sleep locks me into an echoless coffin
> sometimes at noon I dream
> there is nothing to fear.

There is something to fear. If I am a Black woman, blood has been used against me. Thick drink, unattributed glue, my blood has been ink in the nightmare story of capitalism, used as evidence of how oppression can be inherited, my blood has been spilled to mark the limits of the livable, the boundaries outside of which that state does not give a fuck about life or love or fairness. Or to be precise, my blood has been made the key decoration in a landscape where life is defined against what I create with my body and with my hands. If I am a Black woman, blood has been the slick trap of complicity, used to buy a false loyalty through silence. Blood has been used to deny me water. Who am I to have all this blood breathing through my walking crucifix, who am I fooling? Who am I tempting? If I am a Black woman blood has been used to paint a fence around what life can mean. To picket my very existence. If I am a Black woman, I cannot even afford the blood that fills me.

But if I am a vampire . . .

There is something to fear. This is about the vampire as a figure of queer Black feminist survival. A fearful figure hailing us with the challenge of what it would mean for Black women, queer outcast visionary women in particular to have agency and power over the meaning and circulation of blood. In *Against Race* Paul Gilroy asks us to celebrate the potential of the genome age, when race is no longer a matter of blood, but rather the domain of a newer metaphor, the gene. However I think that in a time when 13 Black women can be found hacked to death in pieces all over a house in Cleveland, when woman after woman disappears in Rocky Mount, blood is more than a metaphor, and the figure of the undead is more than a mythological being from a reimagined region of Eastern Europe. Blood is a narrative resource, drained and spilled to tell a cruel story about what life means inside a racist biopolitical version of common sense. There is another message to be written here.

Touch your fingertips to your jugular and you will feel the same tentative pulse happening again and again, a ticking clock, rhythm, a story, your blood is chanting something as it moves through so concentrated and insistent so close to your voice box and your silence. It is an intimate site for the reproduction of who you are. How tentative, how gentle, the repetition of who you are. And how queer the vampire figure, ready to halt the reproduction of the heritage inflected fictions of whose life is for sale at what price and make you like it. That is the queer thing, where queer is an intervention to the social reproduction of a killing narrative about what life means and an invitation to a dangerous alternate form of intimacy.

Audre Lorde said:

Hear my heart's voice as it darkens
Pulling old rhythms out of the earth
That will receive this piece of me
And a piece of each one of you

When our part in history quickens again
And is over

And I am asking you.

Do you want to live forever?

II.

Prologue for Future Black Queer Speculative Readings

It is clear from my work and my tone in this chapter that if I am not sure about whether I want to live forever, I have a vested interest in the transmission of the poem "Prologue" into an unimaginable future through its use in the work of my fellow literary critics and futuristic Black feminist scholars of speculative and science fiction. In the remainder of this chapter I hope to offer tools that will make "Prologue" accessible and attractive as a text through which to deepen our collective understanding of the poetic source and impact of Black feminist speculative and supernatural fiction, especially vampire novels, by inviting questions about form, audience and purpose.

Prologue as Extra-Poetic Form

"Prologue" seeks to prepare the way for something besides itself, beside and besides poetry. The last poem in the book comes before whatever the reader will do after reading, the afterlife of a set of poems the reader has survived. Pre-textual, and post-textual at the same time, Lorde's engagement with the form of the prologue allows her to perform a haunting act that is queerly futuristic.

Though a prologue almost always appears at the beginning of a bound text, most authors, editors and publishers admit that it is usually written after the to-be-published work is completed. The prologue is a backward look and a warning to the reader about what is to come. The queer temporality of the prologue is a privileged standpoint. She who writes the prologue has seen what the reader has not. In the act of creating the prologue, the writer is a prophet, speaking with the authority of a pre-publication intimacy with the completed work. The prologue, "at once before and after" like the speaker Lorde's later "Litany for Survival," has a queer relationship to the production of the text and to the role of subjectivity within the poetic text. Queerly considered, the prologue is proof that the speaker has survived the production of the text, and through having been in some way transformed or even produced by that text, she can critique it. In this manner, Lorde's use of form teaches

us about why her poetic work is theoretically important, not just as I and other Lorde scholars theorize about it, but *as theory* in and of itself. Lorde uses the prologue in order to create a speaker who can speak past her own life, and to create a text that can critique its own textuality from within, providing a palimpsest upon which the vampire speaker can critique the norms of reproductivity in common understandings of race, gender and sexuality through the model of her critique of the reproductive contractions of her own participation in the Black Arts Movement.

Untimely, like a prologue, the speaker in Lorde's "Prologue" is "haunted" from the outset by the first word of the poem. The poem starts

Haunted by poems beginning with I

a meta-critique of the act of beginning a poem (within the act of beginning a poem) which achieves a number of effects (Lorde, 1973, 96). First, the speaker asserts that poems can do the work of haunting. Later we will find that the poet speaker is "in a echoless coffin" and unable to see her own reflection, an explicit vampire perspective, but the poem is also ghostly (Lorde, 1973). Haunted and haunting, this poem is for and from the undead, those who survive death in life, faced with the limits of subjectivity. This is a particularly important stance for Lorde as a female and lesbian poet within the Black Arts Poetry movement to take because as Sharon Holland argues in *Raising the Dead*, the threat of the "BLACK FEMALE" ghost is a projection of the transformative potential of the outcast, disenfranchised onto a fear of death (Holland, 2000, 2). The homophobia of the Black Arts Movement and the perception of many participants in the Black Arts movement that homosexuality comes from outside of Black communities and threatens a Black reproductive future, positions Lorde's poetic speaker to haunt the imagined Black community with her alternative relational and poetic structure, her dangerous subjectivity, her queerness. It is the limit of the subjective, "poems beginning with I," and the danger of what a given speaker may produce (as a queer mother or a warrior poet), that characterizes the speaker's horror.

Lorde's use of "I" is a reminder of the identity-based poems that characterize Lorde's colleagues in the Black Arts Movement. This critique is boldly launched in a book published by Broadside Press, an important press of the Black Arts Movement poetry industry. From the beginning, the poem puts itself in conversation with other poems and distances itself from the declaratory stance of many of the poems that were popular in the Black Arts publishing industry. The work of Black poets testifying, declaring their humanity, their first-person stances on life has created a position that haunts the poet who might seek to speak outside of such a straightforward concept of subjectivity. One way to understand the haunted position of this poem is the space between orality and textuality within the Black Arts Poetry Movement. Distinct from the dominant literary market, Black Arts Poetry

imagined itself to be more live, more oral (Baraka, 1999, 62 and Neal, 2000, 90). The poems were performative, referencing a tradition of Black preachers in store-fronts and on corners and directed towards a living audience preceding contemporary hip-hop and spoken word to come.

The very name of Broadside Press refers to a strategy of passing out and post-ing poems, with the intention of making political Black poetry part of the every-day lives of Black people. However, Lorde's other poetic influences were long-dead British poets whose words came to her only as text, and whose poetic force was in their projection of written poetry across time, reproduced through an educational apparatus and a literary industry that kept such work, from dead poets, alive, for silent audiences of readers to revere. The position of Lorde's poetry is queer in either context. The speaker in "Prologue," haunted, undead and haunting, takes on the characterization of whiteness or the consent to how Amiri Baraka and others characterize whiteness as death in the Black Arts lexicon (Baraka, 1999, 220). Instead of consenting to the binary that the architects of the Black Arts Movement created, defining "Black poetry" against "white poetry" and even more forcefully against "colored or Negro poetry" that aspired towards whiteness, I want to argue that Lorde's poetry creates a speaker that is at once present, (a)live and already past, textually embalmed. Thus the status of the speaker or writer, the "I" in the poem, is at stake.

The opening line of "Prologue" makes this tension explicit, but it is not the first place this tension emerges in Lorde's work. In one of her first published and best-known poems "Coal," Lorde navigates the question of whether the poet is *present* in time or in space. Much beloved, and commonly understood to be, like many of the poems in the Black Arts Poetry Movement, a definition and affirmation of Blackness as a valid place from which to speak, "Coal" is and is not a "poem begin-ning with I."

"Coal," published in Lorde's first collection *The First Cities* is one of her best remembered poems, and one of the poems that put her on the map in the Black Arts industry. As Megan Obourn points out, the poem is often read as an affirmation of Blackness (Obourn, 2005, 220). Centering on the relationship between coal and diamonds, the poem includes content like "I am Black because I come from the earth's inside," a statement that resonates with the emerging cultural nationalist idea of Blackness that characterized most of the Black Arts Movement. Ultimately this is about the racialized, differential value of words,

How a sound comes into a word, coloured
By who pays what for speaking. (Lorde, 1968, 4)

This poem lives on the line between words as rhythmic sound and words as mean-ing within an economy reproduced by the differential value that the reproduction

of racism makes possible. The word "I" then, is particularly important in this context of "who pays what for speaking" because it establishes the authority and either the proximity or distance of the speaker. And "Coal" may or may not be a poem "beginning with I."

STARTING

I

Is the total Black (Lorde, 1968, 4)

Coal introduces ambiguity into the essential statement of Blackness that the Black Arts Movement requires. Maybe "I" is the speaker, speaking in the Black vernacular: "I is the total Black, being spoken . . ." Maybe "I" is a numeral introducing an unpunctuated question: 1. is the total Black being spoken from the earth's inside(?). Maybe the numeral "I" is still a subject position: "one is the total Black" distancing the speaker from the subjectivity of Blackness. The multiple possible readings, achieved by a simple line break after "I," offer a critique of the relationship between these three possibilities. The fact that the poem *may* start in the Black vernacular but may not, means that the use of the Black vernacular is being called up for critique, especially since Lorde uses an antiquated (or contemporary British) spelling of the word "coloured" in the same stanza. (Lorde, 1968) What is the relationship to language implied and inhabited by the Black poet? "Who pays what for speaking"? The line break that causes the ambiguity, the dis/ease and unpredictability at the beginning of "Coal" seems to suggest that the relationship to language and audience implied by the Black Arts context is in some way broken. I would suggest that for Lorde, publishing and marketing herself in a Black Arts literary context, that break is apparent. While Lorde published and won awards with Broadside Press, the most recognized press within the Black Arts Movement, her editor, Dudley Randall censored her homoerotic poetry, and the marketing material of the press always tried to fit her into the frame of the Black cultural nationalist mother that she was not (Broadside Press Collection, Box 1, Folder 1).

For readers of Black feminist speculative fiction, the precedent of Lorde's experiments with and critiques of form, and the way she brings meditations on dominant and contemporary forms into poetry, offers a way to frame and complicate discussions of Black feminist speculative and science fiction as interventions into dominant fictional modes. What distinguishes visionary fiction formally from other Black fiction practices? How do Black feminist authors of visionary/speculative/science fiction explain their choices to write within or transform existing genres? How do Black feminist speculative fiction authors deploy the novelistic devices of the epistolary novel, the first person fictional narrative differently or in conversation with other Black feminist novelists? Are there futuristic approaches to novel-

istic form or queer temporalities in narration that reveal Black feminist texts that are not commonly read as speculative or science fiction as part of the project of Black speculative fiction?

Subjectivity and the Queer Black Character

The question of haunting in "Prologue" is not only about choices in form or which word begins a poetic work. The question of subjectivity is primarily about whose voice is credible within the discourse of Black literary production and why. In "Prologue," Lorde faces questions that continue to "haunt" readers and writers of Black speculative fiction about whether the project of Black speculative fiction is extraneous to, deeply rooted in, contradictory to, or collaboratively participating with a larger Black literary tradition. She also faces questions about whether a generic choice overdetermines the legibility of an author. Though elements of the supernatural appear in most of Toni Morrison's work and her work is studied by theorists of Black speculative fiction, she is not widely considered to be a science fiction author. Do novelists who release a first work that is marketed as science fiction get pigeon-holed? Are speculative fiction authors considered "not black enough" to contribute to discourses on Black literature as a whole? How can speculative fiction and the queerness of challenging reproductive norms in our bodies and in our bodies of work and within our literary community open space to reimagine the possible work of Black authors? Do Black feminist speculative fiction writers haunt the wider literary field or are they themselves haunted by a literary marketplace that separates African American Literature from speculative fiction?

Lorde's work is instructive again. In "Prologue" when the poet admits to being "Haunted by poems beginning with I," Lorde's own poem, "Coal" and its role in the Black Arts trajectory, participates in this haunting.

> *Haunted by poems beginning with I*
> *seek out those who I love who are deaf*
> *to whatever does not destroy*
> *or curse the old ways that did not serve us.* (Lorde, 1973, 96)

Like in "Coal," the "I" in 'Prologue' signifies multiply. It is the context that the speaker comes from, describing the poems that precede it in the emergent Black Arts Poetry movement, and it is the beginning of a new line "I/ seek out those whom I love who are deaf." As Amitai Vai-ram points out, this use of *apo koinou,* the double function of one word into two different units of syntax, disrupts the unity of the subject. "I" is the object and the subject here, the objectified subjectivity for which the "I" proves inadequate. Note that the action of the first stanza is described as an inverse of something else, seeking those "who *are* deaf to whatever does *not* destroy," the repeated "who," searching for a compounded visual and sonic absence, is a

ghostly act. The broken alliterative "d" in the poem (deaf, does not destroy/did not serve…followed up in the rest of the stanza, with "dying," "distinction," "death," and "dream") acts as a drumming in the mouth calling up ghosts. The haunting and the seeking here come from the speaker's description of the horror of reproducing identity. Like the line break in "Coal," the line break across which the "I" spills, says that the relationship between the speaker and the subjectivity implied by the act of speaking/writing a Black Arts poem is broken and ruptures certain speakers. The queerness of the speaker breaks her apart from the assumptions of her audience.

> *I speak without concern for the accusations*
> *that I am too much or too little woman*
> *that I am too Black or too white* (Lorde, 1973, 96)

However the policing of appropriate identity politics remains a concern for the speaker, after mentioning the "terrible penalties for any difference," the speaker reveals the ways in which community audibility seems to be contingent on the reproduction of sameness: "my own voice fades and/my brothers and sisters are leaving." (Lorde, 1973, 97)

Lorde uses word placement and repetition as formal strategies that make her tense relationship to the poet audience visible. The word "Hear," is a somewhat doomed plea towards an audience that becomes more and more distant in time and space. As the last capitalized word in the long first stanza and the isolated first word of the second stanza the request performs the spatialization that the objectified subject needs in order to perform the critical work of addressing difference and connection across time beyond a reproductive identity politic.

> *and through my lips come the voices*
> *of the ghosts of our ancestors*
> *living and moving among us*
> *Hear my heart's voice as it darkens*
> *pulling old rhythms out of the earth*
> *that will receive this piece of me*
> *and a piece of each one of you*
> *when our part in history quickens again*
> *and is over:*
>
> *Hear*
> *the old ways are going away*
> *and coming back pretending change* (Lorde, 1973, 96)

Lorde's poetic strategies perform the proclamation of the poem. Old words go away and come back pretending change. For example, "Hear" in the transition between stanzas remains the same in capitalization and in function as the first invocation, but the second "Hear" stands alone after a space and before the line break making

the isolation of the speaker visible, and her demand that the audience "Hear" that much more necessary. Like the "old ways," phrases repeat only slightly changed. If we look at the noun "heart" as a further repetition of the verb "hear," we can sense the emotive urgency of the request to "hear." Tellingly, the words that repeat with slight changes are words about the distance between the speaker and the audience. For example, "My brothers and sisters are leaving" becomes "are my brothers and sisters listening?" This slight transition reminds the reader that the distance between the speaker and the family, is in some ways a matter of who is willing to listen to the queer message the speaker brings. It is appropriate that these formal strategies that highlight the distance between the audience and the speaker use the familial terminology used to demarcate community within the Black Arts Movement ("brothers and sisters"), because the poem seeks to put pressure on the heteropatriarchal form of the family that the cultural nationalism of the Black Arts Movement affirmed. In order to do this work, the speaker must take on a supernatural form, the vampire, the undead, and the poem itself must take on a queer form in order to provide a definition of survival that does not reproduce the heteropatriarchal family but still asks for a form of hearing that comes from the heart.

Utopia and Horror: Vampire Genres for Radical Futures

"Prologue" is a poem about the poetic, seeking to move past the description of selves, woman, Black, white into the production of an alternative future that refuses reproduction ("deaf/to whatever does not destroy/or curse the old ways that did not serve us") but at the same time envisions a future utopia where:

> The children remain
> like blades of grass over the earth
> all the children are singing
> louder than mourning
> all their different voices sound like a raucous question
> but they do not fear the blank and empty mirrors . . .
> The time of lamentations and curses is passing. (Lorde, 1973, 98)

In order to do this work, and in anticipation of Black feminist vampire novelists, Lorde draws on the generic traditions of both horror and utopia. Generically producing horror and utopia at once, this poem, hinges on the stakes of reproduction and the possibilities of productive relationality on different terms. Revealing the trickery through which

> the old ways are going away
> and coming back pretending change
> masked as denunciation and lament
> masked as a choice (Lorde, 1973, 96)

Breaking the poem itself in key places, including the "I" that haunts the first line but only becomes a subject in relation to the second line, the "Hear" that repeats across a stanza break, Lorde practices poetics as a break in the identity mirror in which the vampire cannot see herself anyway, a possibility that reflection can fail to produce identicality and disrupt the integrity of the singularly embodied being instead:

> *until our image*
> *shatters along its fault.* (Lorde, 1973, 97)

"Our image" not "My image." Lorde is collectivizing vampire subjectivity to reveal the fragmentation of the patriarchal terms in which cultural nationalism would imagine itself while at the same time recuperating the concern for the future that usually justifies a patriarchal family-centered and homophobic point of view within Black liberation conversations. A realistic accountability for the future, Lorde argues here and elsewhere, means acknowledging the fact that Blackness is already external to patriarchy, a haunting presence that the (white) patriarchal structures characterize as antithetical and destructive of the norms they were built to perpetuate. And likewise the patriarchal norms, designed to reproduce racism, directly threaten the survival of Black people. Lorde takes the queer approach, prioritizing the existence of a Black, and therefore deviant, future, over the deadly patriarchal self-understanding of cultural nationalism. Lorde remains haunted by a parental relationship that she survives, becoming a monster. The central passages of the poem go back in time, describing the poet's childhood, revealing the bankruptcy of survival, if survival is the reproduction of fear and internalized racism in the parental relationship.

> *Yet when I was a child*
> *whatever my mother thought would mean **survival***
> *made her try to beat me whiter every day*
> *and even now the colour of her bleached ambition*
> *still forks throughout my words*
> *but I **survived***
> *and didn't I **survive** confirmed*
> *to teach my children where her errors lay...*(Lorde, 1973, 97)

Lorde links her mother's abusive practices to a definition of survival that would have required Lorde to become "whiter every day" and transforms the definition of survival through repetition. Lorde has survived past the context of that survival, like a prologue she is able to critique and reframe the context of her own life, because she has survived past her mother's definition of survival. This frames her later suggestion in "A Litany for Survival" that "those of us who learn to be afraid with our mother's milk...were never meant to survive." Jewelle Gomez remembers this fear in *The Gilda Stories*, when Gilda the elder suckles Gilda the younger, feeding her

blood to soothe her fear and ease her transition into vampire life/undeath (Gomez, 1991, 46). For Lorde poetic vampire subjectivity is also a rebirth. Survival moves from the noun to the past tense to the present tense. As Lorde teaches the reader and her own children the errors in her mother's definition of survival, she enacts another form of survival for her mother, while interrupting the social reproduction of internalized racism. Interestingly, one of the few end rhymes in this poem hints that there are traces of reproduction even in the act of resistance. "Whiter every day" finds an echo five lines later in "where her errors lay" with an almost identical end rhyme and with a trochee rhythm that reverses the heartbeat of the iambic with the tripping rhythm of repeating childhood lessons as a parent. And the speaker admits that her mother's internalized racism still survives in the "colour" of her own (British) word choices, while asserting that her mother contradicts, at the same time through "loving me into her *bloods Black bone*," the mother is the source of the rhythmic alliterative Black authenticity that places Lorde in a Black Arts context to begin with. Lorde continues after two stanzas

> My mother survives now
> through more than chance or token.
> Although she will read what I write with embarrassment...(Lorde, 1973, 98)

"My mother" in both cases is the sign for the productive need to intervene in the meaning of survival in the context of violence. In her revision of the poem in *Undersong,* Lorde takes out the "now," leaving the stronger declarative "My mother survives" (Lorde, 1992, 112). And the act of the poem makes this production visible and offers a rival productivity. Lorde as vampire, mother, poet redefines survival to be inclusive of death and transformation in order to barter the utopian future where non-linear children "like blades of grass over the earth" disperse without the requirement of patriarchal family or reproduction. Lorde herself offers her own death, after her undead prologue, choosing the printed alternative of poetry over the inscribed bodily and disciplinary reproduction of self through the social reproduction of children, offering:

> my children do not need to relive my past
> in strength nor in confusion
> nor care that their holy fires
> may destroy more than my failures
> Somewhere in the landscape past noon
> I shall leave a dark print of the me that I am
> and who I am not
> etched in a shadow of angry and remembered loving (Lorde, 1973, 98)

In this theory of disembodied survival the temporality of light offers a lasting contradiction, a good death. At first the poet speaks at noon "without shadow," but finally her words become "etched in shadow" written, but dependent on memory, a queer

reading practice that may or may not be accepted. Lorde distinguishes between her survival in writing and the perpetuation of her own consciousness, because whatever transformative future occurs she will be

> *none the wiser*
> *for they will have buried me*
> *either in shame*
> *or in peace.* (Lorde, 1973, 98)

"Prologue" is a precursor to the statement we need. Prologue is a death poem. "Our poets are dying" the poet tells us and "I hear even my own voice becoming a pale strident whisper." (Lorde, 1973, 96) The "Prologue" is the poet's intergenerative act, not to perpetuate her own life, but to imagine utopia instead of experiencing it, such that that the children "remain" but "do not need to relive" the violence that makes her own survival relevant.

In this way "Prologue" though rarely read, does survive in the poetic work of Black feminist speculative fiction authors. The speaker in "Prologue" is a poet, is a parent, is a vampire. And "Prologue" itself survives as the epigraph to Lorde's mentee Jewelle Gomez's Black lesbian vampire novel *The Gilda Stories*:

> *At night sleep locks me into an echoless coffin*
> *sometimes at noon I dream*
> *there is nothing to fear.* (Gomez, 1991, 8)

Sixteen years after Lorde's death Jewelle Gomez reminisced on Lorde's influence on her own best-known work *The Gilda Stories* and revealed that through the vampire subjectivity of poetry Lorde's influence on Gomez's form survived queerly. It was Audre Lorde, Gomez remembered at the "Sister Comrade" gathering mentioned above, who insisted that what Gomez offered as a collection of short stories was indeed a novel about a long vampire life where Gilda inhabits more than one body and lives for multiple centuries. The model of survival within death that Lorde theorized in 'Prologue' survives with a difference in Gomez's contribution to the Black lesbian feminist literary context.

> *Somewhere in the landscape past noon*
> *I shall leave a dark print*
> *of the me that I am*
> *and who I am not*
> *etched in a shadow of angry and remembered loving*
> *and their ghosts will move* (Lorde, 1973, 98)

This is "angry and remembered loving," inspired by the fact that Black feminist literary practice was never meant to survive. The survival and reimagination of Black feminist literary practice in the work of contemporary Black feminist vampire novelists offers us the opportunity to remember how dangerous and transformative our

survival as writers and readers from the underworld really is. Audre Lorde survives. The aforementioned work is "Prologue" to Lorde's own statement in "The Cancer Journals" that "death is not the enemy." (Lorde, 1980, 13) Death, embodied and elaborated in the figure of the vampire is an invitation, taken on by Black feminist speculative fiction authors, to investigate what life might mean if persistence is not defined by consent to reproducing social norms. The Black feminist vampire, already looming large in the public imaginary in the figure of the Black welfare queen as a drain on societal resources, is reborn in the vampire as a critique and a question. What are you afraid of? Lorde's work to invoke vampire subjectivity as a Black feminist futurist vantage point opened up the space for Black feminist speculative and fantasy authors to *speculate* on spectral meanings of life, that resonate exactly because they reveal the flesh of oppressions deepest fear. *That we will live forever.*

REFERENCES

Baraka, A. (1999). How you sound? *The Baraka reader.* Berkeley, CA: Thunder's Mouth.
Napier, W. (Ed.). (2000). Expressive Language. *African American Literary Theory: A Reader.* (pp. 62–64). New York: NYU Press.
Broadside Press Collection, Box 1, Folder 1. Woodruff Manuscript and Rare Book Library, Emory University.
Gomez, J. (1991). *The Gilda stories: A novel.* Ithaca, NY: Firebrand.
Holland, S. (2000). *Raising the dead: Readings of death and (black) subjectivity.* Durham, NC: Duke University Press.
Lorde, A. (1968). *The first cities.* New York: Poets.
Lorde, A. (1973). *From a land where other people live.* Detroit: Broadside.
Lorde, A. (1976). *Between ourselves.* New York: Eidolon.
Lorde, A. (1980). *The cancer journal.* San Francisco, CA: Spinsters/Aunt Lute.
Lorde, A. (1992). *Undersong: Chosen poems old and new.* New York: W. W. Norton.
Neal, L. (2000). Some reflections on the black aesthetic. In N. Winston (Ed.), *African American literary theory: A reader*, (pp. 89–91). New York: NYU Press.
Obourn, M. (2005). Audre Lorde: Trauma theory and liberal multiculturalism. *MELUS, 3*(30), 219–245.

"Why white people feel they got to mark us?"[1]

Bodily Inscriptions Healing,
and Maternal "Plots of Power"
in Jewelle Gomez's "*Louisiana 1850*"

MARIE-LOUISE LOEFFLER

SPECULATIVE FICTION ALLOWS FOR THE IMAGINATION OF ALTERNATIVE OR oppositional realities and worldviews and thus presents a unique opportunity for writers to upend hegemonic power relations and normative social conventions that are taken for granted by the dominant society and difficult to transgress within realist frameworks. This chapter will focus on a particular instance of this phenomenon in Jewelle Gomez's "Louisiana 1850" (1991), which features a highly subversive interracial maternal relationship between the fantastic figure of a Native American vampire and a former slave child. By employing the speculative within the trope of what I call the 'maternal vampire,' the short story is able to imagine a bond between these two female characters that crosses racial divides. Even more so, it allows for the construction of revisionary literary spaces in which not only formerly suppressed voices can be recovered and healing initiated but also traditional racial and gendered power hierarchies can be inherently re-defined as the Native American vampire and her Black 'daughter' gain control over their bodies and their lives.

As Sheree Thomas (2000) illustrates in her groundbreaking anthology *Dark Matter*, the construction of imaginary alternatives to past and present social reality does not present a recent phenomenon in Black fiction in African American literature but encompasses a long-standing tradition (xii). Nevertheless, research on and criticism of fantasy, science fiction and horror literature have either been (largely) silent on the contributions of Black writers—because the field has large-

ly been dominated by white male writers, editors and publishers—or has mainly directed its focus towards works by such pivotal authors such as Samuel R. Delany and Octavia E. Butler (xi). Only in the last decade have a greater breadth and diversity of speculative fiction by less well-known contemporary Black women authors, such as Jewelle Gomez, Tananarive Due and Andrea Hairston, gained more extensive critical attention. This trend is reflected in collections like *Mojo* (Hopkinson 2003), *Dark Matter* (Thomas 2004), and *Afro-Future Females* (Barr 2008). Flouting the norms of probability and verisimilitude, these women writers have not only actively unveiled and recreated a formerly silenced historical past, recovering "things forgotten and the tragedy of forgetfulness" (Okorafor-Mbachu 2008, 131). Their works have also envisioned highly subversive alternatives to hegemonic constructions of reality by re-negotiating rigid racial and gendered divisions.[2] This observation holds especially true for the portrayal of cross-racial (maternal) relationships, which—placed in the realm of the speculative—allow Black women writers to explore and re-codify societal scripts based on hegemonic racial and gendered hierarchies within past and future settings, opening up spaces within which imaginary alternatives become possible.

This also holds true for Jewelle Gomez's "Louisiana 1850," a short story which centers around the 'birth' of a Black female vampire, 'the Girl,' and in which a Native American vampire, Bird, plays a vital role.[3] As I contend, the maternal relationship that develops between the two is based on the overwhelming reciprocity of their histories of oppression in the short story—leaving scars on their bodies and their psyches that signify both Bird's and the Girl's marginal positionalities within the setting of the white-supremacist 19th-century South. Aside from redefining traditional tropes of speculative fiction in general, and horror fiction in particular, by infusing her story with a strong sense of the historical past of slavery and focusing on issues of marginalization and oppression because of racial and gender identities, I will argue that Gomez's use of the speculative in the form of the vampire simultaneously enables her to imagine a highly transgressive plot. Besides formulating a counter-discursive conception of their bodies, which fundamentally challenges the racial and gendered categories set up by the system of slavery, these two marginalized characters recover their voices and textualize long-forgotten (maternal) histories within 'maternal borderlands,' thereby undergoing a transition from object to subject as they begin to heal their scarred selves. Most importantly, however, by employing the mode of the fantastic within the trope of the 'maternal vampire,' the short story accomplishes an imagining of what Anne Koenen (1999) has so pointedly referred to as "plots of power" (229), that is, plots "where women gain [...] power over their own lives, power over men" (227). In this regard, Gomez's short story emphasizes the two female characters' ability to reclaim control over their lives beyond the restrictions imposed by a white racist society in that they inherently

reverse its power dynamics. Moreover, its fantastic maternal plot carves out a space within which the Black female voice and the legacy of slavery can ultimately be immortalized, and both the Native American vampire and the Black child can become whole.

"MAKING THE IMPOSSIBLE POSSIBLE":[4] SLAVERY AND BLACK WOMEN'S RE-APPROPRIATION OF SPECULATIVE FICTION

While the works of contemporary African American writers are generally characterized by a strong emphasis on the historical past and its repercussions for the present, a body of texts by Black women writers which turned to the nineteenth century in order to speak the unspeakable—the African American past and its legacies under the institution of slavery—began to emerge in the late 1960s. Beginning with Margaret Walker's historical novel *Jubilee* (1966) a large number of contemporary Black female authors have revisited the historical period of slavery in the last few decades. Their shared point of emphasis has been in striving to re-write history from a Black perspective—giving a voice to the formerly silenced and erased.[5] As Deborah McDowell (1989) has pointed out, Margaret Walker's *Jubilee* presented the catalyst for a large number of Black women's neo-slave narratives, which have been similarly concerned with the iconography of the Black female body and the inextricability of racism and sexism for their Black women characters. However, while *Jubilee* focused on a realistic, documentary-like mode of representation, Black women's textual representations of slavery after the late 1970s began to disrupt the formal conventions of earlier neo-slave narratives, creating radically innovative narrative strategies for fictionalizing the historical past of slavery. Tim Ryan (2008) identifies Octavia Butler's novel *Kindred* (1979) as a crucial transitional text in late twentieth-century fiction about slavery, as it presents a novel that moves beyond literary realism into speculative fiction by creating a contemporary Black woman narrator who repeatedly travels back in time to a nineteenth-century plantation (115).

Similar to Butler's famous work, numerous speculative novels and short stories by Black women writers of the 1980s and 90s have merged depictions of the historical past of slavery with its seeming antithesis—the fantastic. They have repeatedly utilized genres such as science fiction or horror that have historically largely ignored both issues of race and gender, and, as in the case of science fiction, were often mainly written by and targeted at white, middle-class, heterosexual males. In so doing, these Black women writers have interrogated and "problematiz[ed] concepts of the alien and the monstrous, exposing them as ideological constructs" (Palmer 2007, 212)—one need only think of Othering mechanisms of alien cultures in science fiction.[6]

Yet Black women writers have also infused speculative fiction with a profound political and social impetus. This is especially highlighted in the aforementioned emphasis on history and cultural legacy within a field that has often been assumed to be ahistorical. By actively re-creating their own history within the realm of the speculative, these writers have not only countered the enforced silencing of Black voices but have also thrown into relief white hegemonic writings of history by giving central prominence to oral culture in general and Black female perspectives in particular. As Black women speculative writers have thus challenged hegemonic perceptions of reality, they have simultaneously laid bare the oppressive structures and underlying ideologies of both patriarchy and racism that have led to the negation of the Black female experience. Even more so, however, they have employed the speculative in their works as an outlet for both protesting social injustice and re-configuring the very fabric of existing power relations within patriarchal and hegemonic societies themselves—rendering previous dominant subject positions as no longer viable.

Black women's reappropriation of the conventions of speculative fiction is also apparent in the replacement of the possessive individualism of white male speculative literature with a strong emphasis on the communal. This shift, as Anne Koenen (1999) notes, not only serves political purposes but also "removes the dimension of (disturbing and horror-inducing) defamiliarization" (45) and thus presents an innovative strategy to confront and negotiate contemporary social and political issues.[7] However, besides fundamentally re-defining conventional tropes of speculative fiction, contemporary African American women writers have also harnessed its highly subversive possibilities. In addition to allowing for the recovery of formerly suppressed voices and thus opening up a realm for new discursive positions, the speculative creates subversive spaces that allow for the re-definition of traditional racial and gendered power hierarchies by proposing highly revisionary alternatives.[8] In Anne Koenen's (1999) words, the speculative thus offers the "possibility of alternative modes of being" (307).

In this respect, a recent body of speculative fiction by Black women writers which is similarly engaged with the historical past has turned to the vampire, as it presents a highly transgressive speculative figure that has the capacity to cross all kinds of borders and boundaries. Thus, the vampire, as Veronica Hollinger (1997) has pointed out, poses a "real threat in any cultural moment that invests heavily in assumptions about stable reality, essential humanity, and clear-cut ideologies of good and evil" (201). Not surprisingly then, since the 1970s and early 1980s, a large number of women writers, such as Angela Carter, Suzy McKee Charnas and Chelsea Quinn Yarbro have started to employ vampire protagonists in their fiction, turning them into prime characters to primarily negotiate issues of gender-based oppression and resistance. These (early) feminist re-definitions of the traditionally white,

male genre were complicated by an exploration of the intersection of gender and racial issues in the fiction of African American women writers beginning in the early 1990s. Their depiction of multiracial vampires has inherently reconfigured portrayals of traditional vampire protagonists—who previously had ranged from landowners to Southern plantation masters—by inscribing the genre with voices from the margins (Jones 1997, 157, 153).

Similar to redefinitions of genres such as science fiction and fantasy, Black women writers have also radically transformed vampire fiction by merging it with the history of slavery. This strategy has not only resulted in hybrid narrative formations (Spaulding 2005, 101) but has simultaneously broadened the narrative conventions of both neo-slave narratives and vampire fiction, opening up imaginary worlds which allow for the reconfiguration of racial and gendered codes of representation. In this respect, the trope of what I call the 'maternal vampire'—female vampires characterized by being both "character[s] of larger-than-life proportions" (Gomez 1986, 8) who hold a substantial amount of power, as well as by an emphasis on mutual exchange and maternal nurturance reminiscent of Joan Gordon's 'sympathetic vampires'[9]—presents a highly transgressive and empowering fantastic figure. While the maternal vampire plays a crucial role in reconfiguring traditional conceptions of the vampire and of speculative fiction in general, it also encompasses an innovative strategy for exploring interracial relationships in particular, as it constructs subversive literary spaces within which hegemonic hierarchies can be questioned and revised and the indivisible intertwining of race and gender paradigms can be analyzed. This notion becomes even more pronounced within the historical setting of the nineteenth-century South—a place and time that was characterized by starkly demarcated racial and gendered hierarchies. It is within this framework that interracial relationships centered around the speculative figure of the maternal vampire embody a highly innovative discursive strategy that allows Black women writers to construct marginalized characters who find their voice, gain agency over their lives, and form meaningful bonds across racial and cultural lines. Jewelle Gomez's short story "Louisiana 1850" is a case in point.

THE ATROCITIES OF SLAVERY: THE SCARRED FEMALE BODY[10]

From its very beginning, Gomez's text not only graphically illustrates the marginal positions of its female characters within a white hegemonic society. It also draws extensive attention to the physical and psychological scars etched onto the bodies of both a slave girl and a Native American woman. Set in the middle of the nineteenth century in the plantation South, "Louisiana 1850" focuses on a slave child protagonist simply called 'the Girl.' Having escaped from slavery, the Girl is rescued

by a lesbian Lakota vampire, Bird, and her white vampire companion, Gilda. As the Girl finds refuge in a brothel owned by Gilda,[11] the short story graphically describes a strong maternal relationship that develops between the Native American vampire and the child.[12] This bond between the two characters, I argue, is based on a common foundation: a shared past of exploitation and abuse that is 'written' onto their bodies and their psyches. The marks point to the most essential aspect of what it meant to be racially Other(ed) within the white supremacist system of slavery: the loss of control over one's own body.

As Carol Henderson (2002) has noted, the institution of slavery not only inscribed its power in the form of brandings, whippings and other forms of inhumane treatment, but "institutionalized the marking of the Black body as chattel" (113). These practices not only pathologized, but ultimately commodified the Black body within the system of slavery (24). Besides being prone to bodily violations in the form of physical punishment, slave women were also inherently vulnerable to all forms of sexual coercion, especially rape. Portrayals of the physically and psychologically marked Black female body are highly apparent in the slave girl protagonist, the Girl, who—time and again—is faced with the threat of rape by white men. Indeed, Gomez's short story opens with an attempted rape of the Girl by a white overseer, bespeaking the utterly vulnerable status of her body within the system of slavery:

> She looked up at the beast from this other land, as he dragged her by her leg from the concealing straw. His face lost the laugh that had split it and became creased with lust. He untied the length of rope holding his pants, and his smile returned as he became thick with anticipation of her submission to him, his head swelling with power at the thought of invading her [...]. The girl was young, probably a virgin he thought, and she didn't appear able to resist him. He smiled at her open, unseeing eyes, interpreting their unswerving gaze as neither resignation nor loathing but desire [...]. He rubbed his body against her brown skin and imagined the closing of her eyes was a need for him and his power. (1997a, 111)

This scene clearly highlights the omnipresence of the belief in white male superiority within the structure of the slave society. The white overseer—himself in a low social stratum for a white person—is entirely convinced that the Girl will submit to him. More importantly, however, it not only emphasizes the marks of slavery inflicted upon the bodies of Black women but exemplifies how the Black female body was *read* within the system of slavery as what Lynda Hall (2000) has called "a territory to be vanquished and forced into surrender" (409).[13] Moreover, as the overseer interprets the Girl's reaction not as terror but as desire for him, this depiction further signifies on the *pervasiveness* of racialized and sexualized stereotypes of female slaves within the discourse of slavery. Thus, this depiction profoundly underlines the double commodification that the black girl faces because of both her 'race' and gender.[14]

While this portrayal reveals the extent to which the system of slavery claimed ownership over Black female bodies by physically and psychologically marking and scarring them, these inscriptions of slavery are not limited to the bodies of slave women. Bird is not only similarly characterized by her marginalized status because of her racial exclusion as a Native American within a white hegemonic society, but her marginality is literally 'written' onto her body. This conception is already alluded to in her very first description in the text. Framed through the eyes of (white, male) townspeople and the local patrons of the brothel, her body is exoticized by emphasizing that the "Indian girl" features prominently "among their local curiosities" (Gomez 1997a, 114). More significantly, however, the Native American woman is marked by her survival of a smallpox epidemic—a traumatic experience which leaves behind corporeal and psychic marks. As R. G. Robertson (2001) has pointed out, smallpox epidemics were deliberately used against American Indians to speed up white colonial expansion, leaving those who survived profoundly marked by deep, round scars spread all over the body (40). Aside from the trauma of surviving a smallpox infection brought in by white men who, as Bird notes, "breathed the disease into my people and sold it to us in their cloth" (Gomez 1997a, 122), Bird's body is marred by lesions and scars. Her skin thus represents a surface upon which meaning is inscribed, as her scars become the visible indicators of white dominance and control.

However, although inscriptions on the bodies and psyches of the Black slave girl as well as the Native American woman reflect Toni Morrison's (2008) pivotal assessment that within the system of slavery, "to be female [...] is to be an open wound" (163), their corporeal marks also serve another important function. As I contend, it is through the reciprocal *reading* of the characters' physical scars that a shared history of oppression is established, leading ultimately to trust and a nurturing maternal relationship between the two characters. This deciphering of bodies as texts in Jewelle Gomez's short story is apparent in the scene that relates the very first dialogue between Bird and the Girl, an exchange that I quote below:

> Tell me again of this *pox* please?' the Girl asked [...] 'When the deaths came, some members of my clan moved away from the others. [...] I was sick for a time as we traveled, but we left it on the trail behind us.' Bird ached as she spoke [...].'Do you still have spots? Yes, there are some on my back. There is no more infection, simply the mark [...].' Bird's voice trailed off. 'Can I see your spots?' Bird [...] turned her back toward the lamp. The Girl's eyes widened at the small raised circles that sprayed across the brown skin. She let her fingers brush the places where disease had come and placed a small finger gently atop one spot, fitting into the indentation at its center. [...] Bird reached down and took the Girl's hands in her own. Their fingertips where calloused in a way that Bird knew was not the result of light cleaning and washing done at the house. She nodded and pressed the small hands to her face [...]. (1997a, 122–23; emphasis in original).

This dialogue presents the first attempt of both characters to get to know each other on a more personal level, to speak to each other about their respective pasts. However, while trying to relate her traumatic memories, Bird feels bodily pain ("Bird ached as she spoke") and she is ultimately unable to communicate to the Girl all that happened ("Bird's voice trailed off")—and unspeakable things still remain unspoken. However, while Bird's overwhelming pain makes it impossible for her to articulate her traumatic experiences within the framework of language,[15] her body becomes the central site of communication. It is through the decoding of each other's bodies by touching each other's scars that the two characters establish a reciprocal 'language'—an act that reveals the complexities and deepness of their traumas. By tracing the lines of their scars—the smallpox lesions and the scarred hands marked by hard labor—their bodies become texts in themselves that narrate the unarticulated horrors of the past.[16] More importantly, in their attempt to comprehend the manifold figurations of their scars, both the Native American woman and the slave child recognize and acknowledge the overwhelming reciprocity of their respective histories of oppression and abuse. This incident establishes the foundation of their subsequent relationship and profoundly shapes it in the future.

It is within this reassuring bond between the two that the Girl, over time, recovers from muteness—with the maternal relationship increasingly functioning as a catalyst to narrate their past. Bird, as the text makes clear, is not only "pleased with the comfort she felt [...] at the sound of the Girl's voice, which in the past year had lightened to seem more like a child's than when she'd first come" (Gomez 1997a, 122), but increasingly encourages the Girl to weave her own stories from the memories of her (slave) family:

> The Girl could close her eyes and almost hear the rhythmic shuffling of feet, the bells and gourds. All kept beat inside her body, and the feel of heat from an open fire made the dream place real. Talking of it now, her body rocked slightly as if she had been rewoven into that old circle of dancers. She poured out the images and names, proud of her own ability to weave a story. Bird smiled at her pupil who claimed her past, reassuring her silently. (139–40)

As numerous scholars have pointed out, the act of breaking silence and finding one's voice is of fundamental importance in African American literature, as narrating one's own story not only presents the initial step of shaping and defining one's own identity but encompasses a powerful stance of autonomy and control over one's life.[17] Furthermore, these oral reconfigurations offer a potent means of rebellion against constraining social scripts, as they oppose the suppression of unacknowledged voices and histories. By transforming silence into speech, Bird and the Girl not only define their voice and further strengthen their relationship but also undergo a transition from object to subject—formulating a counter-narrative that explicitly challenges a white discursive domination over their bodies.

Thus, the maternal bond in the short story encompasses what I describe as 'maternal borderlands'—in-between spaces in which a "silence [is] broken, a void filled, an unspeakable thing [is] spoken at last" (Morrison 2000, 44). With this term I allude to Gloria Anzaldúa's (2007) concept of 'borderlands' (originally coined in 1987), which, in Anzaldúa's usage, describe liminal spaces in which "two or more cultures edge each other, where people of different races occupy the same territory" (preface). These transformative spaces function as a powerful site of resistance by challenging patriarchal and hegemonic power structures and thus constitute a crucial part in formulating a new consciousness (Anzaldúa 1987, 99–104)—a notion that is also highly apparent in Gomez's short story. The 'maternal borderlands' in "Louisiana 1850" are also reminiscent of bell hooks's (1990) discussion of margins as spaces where one is not only "able to redeem and reclaim the past, legacies of pain, suffering, and triumph in ways that transform present reality" (147), but which also function as a realm in which counter-narratives can be formulated that make transformation, resistance and empowerment possible (145). While the slave girl and her Native American maternal companion are able to voice their pain and recover past memories within these 'maternal borderlands,' I will show in the following that they also functions as a site from which hegemonic constructions of 'reality' can be thrown into relief and alternative worldviews can be imagined. As the short story transcends the limits of probability and verisimilitude, the speculative trope of the vampire allows the two female characters to reclaim control over their bodies and their lives beyond the restrictions imposed by a white, racist society—in short, it creates a fantastic maternal plot in which both can construct themselves as whole.

WRITING MATERNAL "PLOTS OF POWER"

The singular dynamic of the speculative within Gomez's story is first emphasized in early descriptions of Bird's life as a Native American lesbian vampire at Woodard. Her fantastic abilities not only allow her to defy the racial and gendered categories that she is to embody within the patriarchal and hegemonic of the 19th century South, but—within her maternal bond to the slave child—also extend to the slave girl. While having experienced bodily oppression and abuse in her youth—instances of exploitation and racial markings that were closely tied to her marginal position as a Native American—the text makes clear that her status as a fantastic figure opens up a realm of autonomy and control previously unknown to her. As a vampire, Bird follows an independent and self-sufficient profession as the manager of Woodard's, "the most prosperous establishment in the area" (Gomez 1997a, 114). She thus carries a considerable amount of economic influence and power. Furthermore, while

being exoticized by the town as the "only Indian girl" (114) in the brothel, the short story soon reveals that Bird repeatedly takes control over and plays with this image, employing it in an absolutely calculated manner by wearing "sparely adorned dress[es]" with "thin strips of leather bearing beading" (114) in order to draw large numbers of patrons to the brothel, thereby increasing her own and Gilda's profits.

Furthermore, Bird repeatedly ventures into the countryside in a "dusty jacket and breeches" (134) at night, traveling "so quickly she was invisible" (133). This state of motion constitutes a powerful escape from restricting limitations and a propelling force for resistance, as she is able to move away from white hegemonic control and disease brought by smallpox to her tribe. In addition, her life as a vampire not only grants her economic power and unencumbered movement but simultaneously provides her with significant physical powers. This is most profoundly illustrated through implied textual markers as Bird preys on white men. Thus, she radically reverses supremacist constructions of power as the Other inscribes herself on the white, male body.

As the fantastic maternal bond between Bird and the slave child grows, Bird's supernatural vampiric powers profoundly transform the Girl's life as well. Soon after her arrival, the Girl becomes Bird's "assistant in the management of the house" (Gomez 1997a, 125), a position that both reflects Bird's trust in the Girl and marks a profound shift from enslaved labor to a state of increasing independence and influence. Furthermore, the Girl discovers a previously unthinkable mobility in her relationship with Bird, whose vampiric strength and endurance empower her to protect the slave child from the sexism and racism she would otherwise face. For the first time after she escapes, the Girl thus becomes "comfortable enough to venture outside" (119) and experiences an unencumbered freedom of movement on trips and journeys to towns that is not overshadowed by any fear of recapture.[18] Hence, her newly found mobility clearly signifies a highly liberating and empowering stance as it grants her a great deal of agency within the mid-19th-century setting. More importantly, though, this first evasion of white, patriarchal control also contains the potential for throwing into question a privilege that is traditionally connoted as male and enables her to literally and metaphorically move out of the spaces that had been assigned to her under the system of slavery, an act that is inherently transgressive.

Besides becoming a maternal figure for the Girl in terms of nurturance and protection, Bird also plays a crucial role as a mentor for the slave child. As the two characters start to develop a stronger bond, "it was Bird who decided that she would teach the Girl to read. Every afternoon they sat down in Bird's shaded room with the Bible and a newspaper, going over letters and words relentlessly" (Gomez 1997a, 120). This portrayal of a Native American vampire teaching a former slave child how to read and write comprises a central scene in Gomez's text. As the short story makes clear, Bird's unusual identity as a fantastic figure, as well as the power

and autonomy that this entails, gives her the authority to teach the Girl undisturbed whenever she chooses—an activity that fundamentally subverts the foundations of a system that severely prohibited the acquisition of literacy for slaves. More importantly, however, acquiring the ability to read and write also constitutes a crucial formulation of agency for the slave child, as Bird not only encourages the Girl to tell the stories of the past but also to textualize them.[19]

By so doing, the Black girl is taught an ability that plays a significant role in Black women's literature: the recovery of the past not only through telling but also in writing—an act that is highly liberating. While this portrayal echoes the fundamental importance of what Samira Kawash (1997) has referred to as "writing [...] the self into being" (30) within African American literature in general, the short story further complicates the concept of literacy by contrasting the Bible that is the prime example of white patriarchal discourse with the female characters' own textualized stories:

> Bird taught the Girl first from the Bible and the newspaper. Neither of them could see themselves reflected there. Then she told the Girl stories of her own childhood, using them to teach her to write. She spoke each letter aloud, then the word, her own hand drawing the Girl's across the worn paper. And soon there'd be a sentence and a legend or memory of who she was. And the African girl then read it back to her (Gomez 1997a, 121).

By turning their memories and traumatic experiences into textual evidence, both Bird and the Girl formulate powerful sites of agency over the discursive construction of their lives and their past. Furthermore, by utilizing an alternative framework of rhetorical strategies these two characters not only question the validity of white power structures but ultimately create a counter-narrative, which, similarly to other Black women's slave narratives, inherently deconstructs and re-writes the white master narrative of the past.[20] However, their mastery over language is even further highlighted by the characters not only writing in English but also in French and their tribal languages, which significantly broadens the traditional importance of 'writing oneself into being.' Thus, this instance of revision of white historiography, centered around the fantastic figure of the maternal vampire, constitutes another crucial site of resistance in the short story—as it enables both the Girl and Bird to actively oppose their marginal status as silenced and invisible discursive objects.

Notably, for the Girl, this act of writing herself into existence also creates what Athena Vrettos (1989) has termed 'curative domains,' that is, spaces where healing can be achieved through narrating and thus claiming one's own story of the past (456).[21]As Farah Jasmine Griffin (1996) has further noted, the textual documentation of memories, especially in terms of painful or traumatic past experiences, holds a highly "transformative potential" for "re-imagining the Black female body" (521)—that is, it represents, what Griffin has referred to as, important "acts of textual heal-

ing" (521). While bodies, as Griffin further notes, "can never return to a pre-scarred state" (524), instances of textual healing can nevertheless trigger a process of reclaiming one's own body. As the short story illustrates, the Girl not only excels in storytelling, but "her facility with languages" in general becomes progressively more "excellent" (Gomez 1997a, 129), surpassing even the other women at the brothel as "the best student [Bird has] ever had" (24). This increasing "eagerness to learn" (Gomez, 122) as well as her thorough "enjoy[ment of] the lessons" (Gomez,120) reflect the crucial importance for the Girl of articulating and textualizing herself as an autonomous being. Thus, Bird's teaching of the ability to write her past into being further underlines the restorative character of her maternal role and becomes an important step in redefining the Girl's subjectivity.

However, the unique dynamic of the speculative within the interracial mothering relationship between the Native American vampire and the Black girl is most drastically illustrated in the highly unusual 'birthing' act between the two characters in the short story. Although Gilda performs the first step in the Girl's transformation, the text emphasizes that Bird must "complete the circle" (Gomez 1997a, 147) as an essential part of the birthing process. In fact, the child's life utterly depends on Bird's completion of the ritual, which is especially apparent after the first bite, as the Girl "lay weak, unmoving except for her eyes, now dark brown flecked with pale yellow" (148), her life fading away. Upon Bird's return, a scene follows which is suffused with maternal metaphors:

> Bird sat against the pillows and pulled the Girl into her arms. She [...] pulled aside her woolen shirt and bared her breasts. She made a small incision beneath the right one and pressed the Girl's mouth to it. The throbbing in her chest became synchronous with the Girl's breathing. Soon the strength returned to the Girl's body; she no longer looked so small. Bird repeated the exchange, taking from her as Gilda had done and returning the blood to complete the process. She finally lay her head back on the pillows, holding the Girl in her arms, and rested. Their breathing and heartbeat sounded as one for an hour or more before their bodies again found their own rhythms (149).

The act of taking blood and the transformation of humans into vampires have traditionally been depicted in terms of a violent, almost orgasmic and ultimately lethal sexual act—with the fangs of the vampire biting the victim's neck. However, Gomez reconfigures these implications not only by foregrounding the blood exchange between two women but also by erasing the 'penetrating' teeth from the act of the vampire's bite, as Bird makes the incisions with her fingernail. What is most striking about this scene is its strong evocation of breastfeeding. Matching what has been considered one of the most biological experiences of motherhood with an inherently non-biological, fantastic form of reproduction based on choice, the image of the female vampire holding and nursing the girl from an incision in the skin of her chest is not only strongly reminiscent of Renaissance *maria lactans* paintings but carries

further symbolic meaning. It profoundly underlines the dimensions of closeness that Bird and the Girl have achieved in their relationship because breastfeeding requires close attention to a child's needs, such as tiredness or hunger.[22] Moreover, Bird's nursing of the girl portrays a state of pre-Oedipal bonding between mother and child, who enter into a form of symbiosis by giving up distinct corporeal boundaries (compare Gubar 1997, 226). As Mary Caputi (1993) has argued, "pregnancy, birth and lactation […] break down or disallow physical and psychic boundaries between mother and child, and thus invoke a 'wandering' or 'fuzziness'" (38). Instead of focusing on a central father figure, then, Gomez's portrayal of the retreat to a symbiotic stage focuses entirely on female bonding and thus undermines a normative construction of the nuclear family.[23]

Furthermore, the use of the speculative in the form of the 'nursing' Native American vampire not only illuminates the permeable boundaries between the two female characters as they blend into one within the mother-child dyad but simultaneously emphasizes the crossing of any dichotomized racial distinctions. This transgression of racial boundaries is further enhanced by having Bird and the Girl exchange blood, not milk. While the feeding vampire has—up to the 1980s—been conventionally framed by associations of contamination and violence and has been used to reflect anxieties over transmittable diseases ranging from syphilis to AIDS,[24] Gomez changes these parameters. Bird's and the Girl's mixed blood is not perceived as 'tainted' but is presented, as Ellen Brinks and Lee Talley (1996) have pointed out, as entirely nourishing and necessary to 'birth' the Girl into her new identity as a black female vampire (166). Thus, the exchange of blood between Bird and the Girl profoundly disrupts any essentialized notions of fixed and static racial categories, presenting instead the fluid identities of the two female vampires.

However, the extraordinary potential of the fantastic to create imaginative frameworks of alternative worldviews is best illustrated in the Girl's ultimate metamorphosis from human being to vampire. While instances of metamorphosis in men's literature often encompass traumatic experiences for its male characters that are linked to loss of control and powerlessness, women's narratives of metamorphosis follow an entirely different dynamic. Besides portraying bodily transformations of female characters as deliberate acts, which highlights their role as agents, not as victims, metamorphoses in women's narratives present a significant source of power (Koenen 1999, 228–231). In this respect, bodily changes hold a particular significance in terms of protecting and (re)claiming agency over the female body. As Anne Koenen (1999) has discussed, "[t]he fantastic process of transformation gives women a control which they formerly lacked—the real world forces women to realize their powerlessness, their status as objects of male desire and violence, while fantasy provides the means to gain control over their lives and especially their bodies" (231).

These conceptions are of profound relevance in Jewelle Gomez's "Louisiana 1850," in which the Black girl's metamorphosis into the speculative figure of the vampire simultaneously transforms her into a Black woman of exceptional dimensions. While as a Black female former slave, the Girl would have still been vulnerable to white male transgressions if she were to venture into the countryside without Bird's protection, her transition into a vampire turns her into someone who now holds a substantial amount of power. As her preternatural abilities help her assume full control over her own body, her new vampire status thus presents for the Girl formerly unimaginable possibilities. Besides gaining the ability to fight and defend herself, as Lynda Hall (2000, 396) has asserted, the Girl's need to feed off of humans not only plays with, but ultimately deconstructs any assumptions of white male dominance and objectification of her.[25] As the short story reveals, it is the formerly marginalized Black female body which becomes the hunter, a portrayal that entirely reverses conventional dynamics of victim and predator.[26] In addition, this unusual depiction also flips around the very foundation of slavery, as it is the Black (vampiric) woman who sustains herself by 'feeding on' and thus using white male bodies, an act that further marks her transition to a powerful fantastic being.[27]

Moreover, her 'birth' into a vampire not only further underlines her ability to move freely within the context of slavery but emphasizes that for a vampire, there is only "open space, no barriers" (Gomez 1997a, 144). Thus, the Girl is now able to transgress *any* spatial (and even temporal) boundaries held in place within a white hegemonic society. In fact, the short story closes with the Girl "speed[ing] into darkness [...] moving so quickly that the farmhouse was all but invisible" (Gomez 1997a, 151)—a description that highlights her very state of uncontainability—a most powerful stance of autonomy and control over her body.

Significantly, the Girl's shift from human to vampire not only signifies a metamorphosis from powerless to powerful being—it also marks a rite of passage from mortal human to an immortal vampire. Thus, while the Girl's immortality implies that she will physically survive her former abusers, she will also live to tell her own, her mother's, and Black women's life stories in general. Thus, according to Miriam Jones's (1997) assessment, the Girl is thereby able to keep alive "historical events from the perspective of those marginalized by or made absent from standard accounts" (154) in future centuries to come. As a personified legacy of slavery, her presence will ensure that Black lives and voices will never be written out of history.[28] Indeed, in one of her later lives in the 2020s, the Girl becomes a writer out of the necessity to "shar[e] some of the many stories she had gathered in her long life," since people "hav[e] conspired to forget their past" (Gomez 1991, 220). By textualizing and sharing her stories with a large audience, the Girl thus makes known the centuries of Black women's oppression and resistance, *immortalizing* both her

mother's oral heritage and, to use Alice Walker's (2004) words, the stories of "the lives of those women who might have been Poets, Novelists, Essayists, and Short Story Writers" themselves, but "who died with their real gifts stifled within them" (234).

Thus, similarly to women's narratives of metamorphosis in general, the Girl's birth into the life of a vampire bespeaks a crucial source of identity for this young Black woman—a birth that ultimately marks her inscription into a matrilineal tradition of lesbian vampirism. While preserving her mother's cultural heritage, as is repeatedly stressed in the later *Gilda Stories*, the Girl also acknowledges the legacy passed on to her through her maternal relationship with the vampire Bird.[29] This is most apparent on the level of naming, as the Girl gives herself the pen name Abby Bird in her later life as a writer. By consciously choosing a name that echoes that of her vampiric life-giver, the Girl thus honors the importance of this fantastic figure in her life, whose mothering provided for her a realm in which not only her body is reborn, but in which she also gains new subjectivity. It is within her maternal bond with Bird that the Black vampire daughter is able to incorporate her own memory into a narrative of the past that chronicles a tradition of Black women's oral history—keeping alive the voices of those erased and suppressed from history for centuries to come. More importantly, however, the Girl's birth into a vampire ultimately signifies a (re)birth into the self, as she is able to reclaim what Audre Lorde has so fittingly termed her 'me-ness,' reaching a new sense of "of completion [...] and comfort with her new life" (Gomez 1997a, 50) at the end of the short story. Thus she achieves what her slave mother was unable to attain: she survives whole.

As a result, this interracial maternal bond set in the realm of the speculative not only echoes the transgressive potential of mother-daughter plots in fantastic literatures by women writers in general, as Gomez's portrayal of Bird and the Girl's bond similarly "represents the prototypical example of a utopian space [...] beyond the reaches of misogynist [and racist] reality" (Koenen 1999, 57). Gomez's fantastic mother-daughter relationship centered around the trope of the maternal vampire also presents a unique strategy to inherently rewrite conventional (white, male) speculative fiction in general and vampire fiction in particular. She infuses the field(s) with an entirely new vision that focuses on those voices that have been suppressed, uncovering and bringing to light those hidden histories that have long gone unacknowledged. Even more so, however, by employing a figure that is not only powerful but also able to transgress multiple borders and liminalities, Gomez's text allows for an entirely innovative exploration of interracial relationships within fantastic contexts. It is through her use of the speculative in the form of the maternal vampire that Gomez is both able to analyze and undermine the very patriarchal norms and hegemonic structures that are responsible for gendered and racial hierarchies, and simultaneously construct a discursive space in which both gendered and racial divisions can be altered and re-signified—a truly revolutionary depiction.

NOTES

1. Gomez 1997a, 123.
2. Dubey (2008) has pointed out this aspect, largely in respect to Butler's work. However, it also holds true for Black women's speculative fiction in general.
3. This mothering constellation between a Native American woman and a Black slave child is highly unusual in African American women's fiction. To my knowledge, the only other text that features this unique mother-daughter relationship is Toni Morrison's *A Mercy* (2008).
4. Nelson 2002, 98.
5. For a further discussion of the importance of re-writing hegemonic constructions of history in African American women's literature, see Mitchell 2002.
6. As Madhu Dubey has argued for the genre of science fiction, the "alien is typically encountered, comprehended and subsumed by a human perspective; rarely (if ever) is the alien the subject of narration" (40).
7. Compare hooks 1991, 55.
8. This assessment is based on Darcie Rives's (2006) study of early 20th century speculative fiction but is also applicable to contemporary African American women's speculative fiction. Numerous scholars have commented on the enormous potential speculative fiction holds for African American writers especially. For example, Anne Koenen argues that the speculative creates alternative literary spaces that can "break open hegemonic discourses and, in that gap, articulate a construction of reality that places up new ways of seeing" (1999, 55). Paul Youngquist notes further that speculative fiction offers the potential to not just invoke "the memory of historical suffering, but the reappropriation of the spaces in which it occurred, toward the end of shifting relations of power and multiplying freedoms" (2003, 340).
9. As Joan Gordon (1988) has pointed out, in contrast to traditional vampires, 'sympathetic vampires' cease to be "greedy and rapacious" (234), and instead are multi-dimensional characters who are "flexible, adaptable, and possess stamina" (230). In addition, these vampires also often hold a deep knowledge of the historically specific social structures and hierarchies surrounding them—a knowledge that is often paired with intimate personal experiences of oppression due to their ethnic, vampiric or sexual identities.
10. My reading of Gomez's text in the following subsection is indebted to Carol E. Henderson's study *Scarring the Black Body*, which discusses the multiple figurations that scars can embody. In particular, I build on her interpretation of bodily marks as being simultaneously signs of wounding and hegemonic inscription as well as signs of healing and resistance.
11. The depiction of a brothel owned by a woman is highly unusual in American literature in general and women's literature in particular. As Sarah Appleton Aguiar (2001) has pointed out, even the portrayal of prostitutes is seldom found in women's literature and is more prevalent in popular and romance fiction (75). While brothels traditionally carry implications of patriarchal control and sexual exploitation of female bodies, the brothel in Gomez's short story instead signifies a feminist space in which women not only consciously chose to live but in which they are also in charge—a highly liberating conception within the 19th century framework of the text. Indeed, the women in the brothel form close-knit relationships amongst each other, which are highlighted within the frame of its "huge kitchen" (Gomez 1997a, 114) where women often sit "around the table […], eating […], laughing at stories, or discussing their problems" (119). Besides being able to reject male customers, these women generally refer to their male visitors "with a tinge of indulgence as if they were children being kept busy while the women did important things" (131).

12. While Gilda's whiteness would, in a realist story, imply highly disparate power relations between her, a runaway slave child and a Native American woman, the short story disrupts preconceived expectations of their relationships through the use of the fantastic in the form of the vampire. Gilda's marginal status as a vampire not only places her outside of accustomed social roles and physical spaces, but, more importantly, outside of the traditional power imbalances between whites and Blacks in the setting of the nineteenth century and thus makes an egalitarian relationship between these three female characters plausible. Indeed, Gilda not only establishes a deeply loving relationship with Bird that is based on respect and trust, in which both run and share the profits of the brothel equally. The text also depicts the relationship between the white woman and the slave child as trusting from the initial encounter onwards, as Gilda never assumes a subservient role for the Girl based on her status as a (former) slave. Instead, having seen human cruelty, death and "the dark color of blood as it seeped into the sand" (Gomez 1997a, 118) many times, as well as having lived in exile for most of her 300-year existence, Gilda wants to protect the Girl and establish a meaningful bond between the two.

13. Gomez's text abounds with numerous examples of white male physical transgressions against the Girl—instances that further emphasize the brutalities inflicted upon the Black female body under the system of slavery. In fact, as the Girl's memories imply, the Girl might have already been abused on the plantation, which could have been the reason for the child's escape after her mother's death.

14. See Patterson 2005, 36.

15. This reading is based on Carol Henderson's argument that traumatic experiences and the (mental and physical) scars they leave behind can be so painful that they cannot be articulated within "the realm of a traditional linguistic system" (2002, 98).

16. See Hall 2000, 417.

17. See, for example, Davis 1993, Fulton 2006, and Smith 1991.

18. Although her escape from slavery already presents a crucial instance of resistance against a system that strictly enforced control over the movement of slaves, her status as a runaway slave after her escape nevertheless makes her inherently vulnerable to bodily violations and thus does not entail the freedom of movement she later finds within her relationship with Bird.

19. See Brinks and Talley 1996, 161.

20. For further discussions of this scene, see also Brinks and Talley 1996; Jones 1997; and Koenen 1999.

21. For a more in-depth discussion on the healing power of the spoken and written word in Gomez's (1991) *The Gilda Stories* in general, see Fulton 2006.

22. This argument is based on Fiona Giles's (2003) study *Fresh Milk*, which describes the dimensions of bonding and closeness between mothers and infants during breastfeeding.

23. This argument is influenced by Koenen's (1999) analysis of breastfeeding in Toni Morrison's *Beloved*. For further discussions of breastfeeding in terms of (racial) boundary transgressions and re-configurations of the Oedipal family, see Giles 2003, Gubar 1997, and Williams 1992.

24. For further discussion of the use of the vampire to signify disease and pollution, see Patterson 2005.

25. While traditional vampire fiction portrays women largely as "victims or objects of desire" (Gomez 1997b, 89), Gomez's exceptional depiction of a Black female vampire employs the "concept of predator/vampire," but also "strip[s] away the dogma that has shaped the vampire figure within the rather Western, Caucasian expectation" (87–88). Besides featuring a Black woman (and not a male vampire) who desires (and has the ability to kill in self-defense), feeding is usually not a fatal act in the short story but an exchange of dreams for blood.

26. For further analyses of the reconfiguration of the hunter/predator dynamic, see Jones 1997 and Patterson 2005.
27. For a similar assessment, see Koenen 1999, 236.
28. For further analyses of the embodiment of history in Gomez's short story, see Fulton 2006; Koenen 1999; Palmer 2007 and Rody 2001. As Caroline Rody (2001) notes, the Girl "move[s] beyond the identity derived from the original mother to another 'differentiated' and 'independent' identity" (82). While Rody focuses on the Girl's vampire identity in general, my emphasis, however, is on the influence the fantastic maternal relationship with Bird has on the Girl.

REFERENCES

Aguiar, S. A. (2001). *The bitch is back: Wicked women in literature*. Carbondale, IL: Southern Illinois University.

Anzaldúa, G. (2007). *Borderlands: The new mestiza*. San Francisco, CA: Aunt Lute.

Barr, M., (Ed.). (2008). *Afro-future females: Black writers chart science fiction's newest New Wave trajectory*. Columbus, OH: Ohio State University Press.

Brinks, E., & Talley, L. (1996). Unfamiliar ties: Lesbian constructions of home and family in Jeanette Winterson's *Oranges are not the only fruit* and Jewelle Gomez's *The Gilda stories*. In C. Wiley & F. R. Barnes (Eds.). *Homemaking: Women writers and the politics of home* (pp. 145–171). New York: Garland.

Caputi, M. (1993). The abject maternal: Kristeva's theoretical consistency. *Women and language, 16*(2), 32–38.

Davis, C. (1993). Speaking the body's pain: Harriet Wilson's *Our Nig. African American Review, 27*(3), 391–404.

Dubey, M. (2008). Becoming animal in black women's science fiction. Of course people can fly. In M. Barr (Ed.). *Afro-future females: Black writers chart science fiction's newest New Wave trajectory* (pp. 31–51). Columbus, OH: Ohio State University Press.

Fulton, D. S. (2006). *Speaking power: Black feminist orality in women's narratives of slavery*. Albany, NY: SUNY Press.

Giles, F. (2003). *Fresh milk: The secret lives of breasts*. New York: Simon & Schuster.

Gomez, J. (1986). Black women heroes: Here's reality, where's the fiction? *Black Scholar, 17*(2), 8–18.

Gomez, J. . (1997a). Louisiana 1850. In G. Naylor (Ed.), *Children of the night: The best short stories by black writers, 1967 to present* (pp. 109–151). Boston, MA: Little, Brown.

Gomez, J. (1997b). Recasting the mythology: Writing vampire fiction. In J. Gordon & V. Hollinger (Eds.), *Blood read: The vampire as metaphor in contemporary culture* (pp. 85–94). Philadelphia, PA: University of Pennsylvania Press.

Gomez, J. . (1991). *The Gilda stories*. New York: Firebrand.

Gordon, J. (1988). Rehabilitating revenants, or sympathetic vampires in recent fiction. *Extrapolation, 29*(3), 227–234.

Griffin, F. J. (1996). Textual healing: Claiming black women's bodies, the erotic and resistance in contemporary novels of slavery. *Callaloo, 19*(2), 519–536.

Gubar, S. (1997). *Racechanges: White skin, black face in American culture*. New York: Oxford University Press.

Hall, L. (2000). Passion(ate) plays 'wherever we found space:' Lorde and Gomez queer(y)ing boundaries and acting. *Callaloo, 23*(2), 394–421.

Henderson, C. (2002). *Scarring the black body: Race and representation in African American literature*. Columbia, MO: University of Missouri Press.

Hollinger, V. (1997). Fantasies of absence: The postmodern vampire. In Joan Gordon, & Veronica Hollinger (Eds.), *Blood read: The vampire as metaphor in contemporary culture* (pp. 199–212). Philadelphia, PA: University of Pennsylvania Press.

hooks, b. (1990). Choosing the margin as space of radical openness. In *Yearning: Race, gender, and cultural politics* (pp. 145–153). Boston, MA: South End.

hooks, b. (1991). Narratives of struggle. In P. Mariani (Ed.), *Critical fictions: The politics of imaginative writing* (pp. . 53–61). Seattle, WA: Bay.

Hopkinson, N. (Ed.). (2003). *Mojo: Stories*. New York: Warner Aspect.

Jones, M. (1997). *The Gilda stories*: Revealing the monsters at the margins. In Joan Gordon & Veronica Hollinger (Eds.), *Blood read: The vampire as metaphor in contemporary culture* (pp. 151–168). Philadelphia, PA: University of Pennsylvania Press.

Kawash, S. (1997). *Dislocating the color line: Identity, hybridity, and singularity in African-American literature*. Stanford, CA: Stanford University Press.

Koenen, A. (1999). *Visions of doom, plots of power: The fantastic in Anglo-American women's literature*. Frankfurt a. Main: Vervuert.

McDowell, D. (1989). Negotiating between the tenses: Witnessing slavery after freedom—*Dessa Rose*. In D. McDowell & A. Rampersad (Eds.), *Slavery and the literary imagination* (pp. 144–163). Baltimore, MD: Johns Hopkins University Press.

Mitchell, A. (2002). *The freedom to remember: Narrative, slavery, and gender in contemporary black women's fiction*. New Brunswick, NJ: Rutgers University Press.

Morrison, T. (2008). *A mercy*. New York: Knopf.

Morrison, T. (2000). Unspeakable things unspoken: The Afro-American presence in American literature. In J. James & T. D. Sharpley-Whiting (Eds.), *The black feminist reader* (pp. 24–56). Malden, MA: Wiley-Blackwell.

Nelson, A. (2002). Making the impossible possible: Interview with Nalo Hopkinson. *Social Text, 20*(2), 97–113.

Okorafor-Mbachu, N. (2008). "Of course people can fly. In Marleen Barr (Ed.), *Afro-future females: Black writers chart science fiction's newest New Wave trajectory* (pp. 131–132). Columbus, OH: Ohio State University Press.

Palmer, P. (2007). The lesbian vampire: Transgressive sexuality. In Ruth Bienstock Anolik (Ed.), *Horrifying sex: Essays on sexual difference in gothic literature* (pp. 203–232). Jefferson, NC: McFarland.

Patterson, K. D. (2005). 'Haunting back:' Vampire subjectivity in *The Gilda stories*. *Femspec, 6*(1), 35–46.

Rives, D. (2006). *Fantastic writing, real lives: Gender, race, and sexuality in early twentieth-century American women's speculative fiction* (PhD dissertation). University of Nebraska-Lincoln.

Robertson, R. G. (2001). *Rotting face: Smallpox and the American Indian*. Caldwell, ID: Caxton Press.

Rody, C. (2001). *The daughter's return: African-American and Carribean women's fiction of history*. New York: Oxford University Press.

Ryan, T. A. (2008). *Calls and responses: The American novel of slavery since* Gone with the Wind. Baton Rouge: Louisiana State University Press.

Smith, V. (1991). *Self-discovery and authority in the African American narrative*. Cambridge, MA: Harvard University Press.

Spaulding, A. T. (2005). *Re-forming the past: History, the fantastic, and the postmodern slave narrative*.

Columbus, OH: Ohio State University Press.

Thomas, S. R. (Ed.). (2000). *Dark matter: A century of speculative fiction from the African diaspora*. New York: Warner.

Thomas, S. R. (Ed.). (2004). *Dark matter: Reading the bones*. New York: Warner.

Vrettos, A. (1989). Curative domains: Women, healing and history in black women's narratives. *Women's Studies, 16*(4), 456. Quoted In Fulton 2006, 104.

Walker, A. (2004). *In search of our mothers' gardens: Womanist prose*. New York: Harcourt.

Williams, P. J. (1992). *The alchemy of race*. Cambridge, MA: Harvard University Press.

Youngquist, P. (2003). The space machine: Baraka and science fiction. *African American Review, 37*(2/3), 333–343.

The Unshakable Intent to Commit Genocide

Walter Mosely's *The Wave,* 9/11 and Politics out of Context

BRANDON KEMPNER

WHEN MOST READERS THINK OF SCIENCE FICTION, THEY IMMEDIATELY THINK OF the far future: metal cities, robots, spaceships, and all the gleaming apparatus of future technology. These imagined landscapes have been a fertile ground for Afrofuturist writers, allowing them to contrast the promises of the future with the harsh realities of racial and economic oppression. Works such as Samuel Delany's *Babel-17* (1966) and *Trouble on Triton* (1976); Octavia Butler's Xenogenesis series— *Dawn* (1987), *Adulthood Rites* (1988), *Imago* (1989)—Nalo Hopkinson's *Midnight Robber* (2000); and Walter Mosley's *Futureland* (2001) have all critiqued the archae- ologies of the future, reversing the erasure of race that had characterized earlier, white-authored science fiction. Nonetheless, this focus on the far future, as rich as it can be, is only one possible approach to writing Afrofuturist fiction. Mosley's most recent science fiction novel, *The Wave* (2006b), takes Afrofuturist critique in an interesting new direction. Instead of focusing on the future, Mosley sets *The Wave* in contemporary America and, by doing so, is able to provide a very specific and detailed critique of post-9/11 American politics.

In *The Wave,* Mosley offers a variation of the alien invasion novel, launched some hundred years ago with H.G. Wells's *War of the Worlds* (1898). In Wells's sub- genre of science fiction, an outside force threatens to destroy humanity. In the face of a monstrous Other, humanity pulls together to repel the invader, usually over- coming all economic and racial differences along the way. In *The Wave,* Mosley neat-

ly inverts this paradigm of solidarity. Mosley gives his readers an African American main character (Errol) who aligns himself with the invading Wave, an extra-terrestrial collective intelligence with the ability to absorb and transform humanity. Errol chooses the invader after witnessing the ways that the American government responds to the perceived "threat" of the Wave with overwhelming force and violence. The government, led by Dr. David Wheeler, leads an all-out campaign of violence against the Wave, ranging from brutal experimentation to an all-out effort to exterminate the Wave. As Errol phrases it, the government has an "unshakeable intention to commit genocide" (Mosley 2006b, 133) even though it only partially understands the Wave. Mosley depicts the government as incapable of imagining any mode of existence other than a perpetual America of capitalism and globalism. In contrast, Errol makes an imaginative leap, and he embraces the collective posthuman future offered by the Wave.

By placing his novel in the immediate present and showing the American government's excessive reaction to a threatening outside force, Mosley forces his readers to compare *The Wave* and post-9/11 American politics. While this comparison is tantalizing in and of itself, Mosley's own writings on post-9/11 American politics, contained in his philosophical works *What Next* (2003) and *Life out of Context* (2006a), provide an invaluable background for reading *The Wave*. In these texts, Mosley offers a sharp critique of America's reaction to the 9/11 attacks, the injustices of the Iraq War, and American globalism. Mosley focuses on how the American government's post-9/11 policies have erased or obscured other possible contexts of American life. At the same time, Mosley argues that the unique social, economic, and historical experiences of African-Americans can help readers see beyond the ready-made context of American ideology. Mosley even concludes *Life out of Context* with a defense of science fiction, highlighting its ability to create new contexts. As such, *The Wave* is the ideal bridge between Mosley's political ideas and his Afrofuturist concepts. Errol himself, by making the imaginative leap necessary to embrace the otherness of the Wave, operates as the perfect example of Mosley's concept of creating new contexts for understanding American social realities.

Furthermore, we can identify this act of imagination as fundamentally Afrofuturist. This chapter will argue that *The Wave* extends the critiques of *What Next* and *Life out of Context* by re-contextualizing the War on Terror I situating it in a science fiction setting (the War on the Other/Alien). As Mosley argues in *Life out of Context*, "our desire for freedom and justice needs to be put into a viable context" (2006a, 99); Mosley's Afrofuturist techniques in *The Wave* allow him to do exactly this. I will argue that Mosley, by setting his text in the present, transforms his main character into an Afrofuturist. It is up to Errol to imagine an American world that extends beyond the global/capitalist/democratic system as it currently exists, to literally force himself out of the context created by the American govern-

ment and to develop a new politics and a new ideology. At the same time, the reader is challenged to participate in this act of imagination, this act of de- and re-contextualization. As such, *The Wave* operates as an Afrofuturist text on multiple levels, involving the author's act of creation, the character's act of imagination, and the reader's participation in those conceptions of the future.

FROM FUTURE TO PRESENT: WALTER MOSLEY'S AFROFUTURISM

As a theoretical concept, Afrofuturism focuses on the ability of African American writers to imagine a future beyond the limits of current culture, dominated as it is by specific racial and social ideologies. The term, coined initially by Mark Dery in his essay "Black to the Future" (1993), was expanded and refined in Alondra Nelson's influential article "Future Texts" (2002). In this, she lays out a basic definition of Afrofuturism: "Afrofuturism can be broadly defined as 'African American voices' with 'other stories to tell about culture, technology, and things to come'" (Nelson 2002, 9).[1] Nelson argues that such texts are inherently critical: "They excavate and create original narratives of identity, technology, and the future and offer critiques of the promises of prevailing technoculture. In addition, these contributions, gathered under the term *Afrofuturism*, offer takes on digital culture that do not fall into the trap of the neocritics or the futurists of one hundred years past" (9). Numerous other critics have followed Nelson's lead and explored the ways that white-authored science fiction erased race as a significant component of human life. In his introduction to the Afrofuturism issue of *Science Fiction Studies*, Mark Bould notes that "From the 1950s onward, sf in the U.S. magazine and paperback tradition postulated and presumed a color-blind future," and that this "color-blind future was concocted by whites and excluded people of color as full subjects" (2007, 177). Sandra M. Grayson, in her book *Visions of the Third Millennium: Black Science Fiction Novelists Write the Future* makes the same point, that "Science fiction writers of African descent are engaged in a genre that initially was hostile toward and excluded black people" (2003, 2). This hostility, then, "unthinkingly reproduces white privilege" (Lavender 2007, 187) and, by doing so, falsely depicts such privilege as inevitable, natural, and uncontestable.[2] As such, a great deal of Afrofuturist criticism has focused on African American writers who have contested the historical exclusion of race from science fiction. Sheree R. Thomas's anthology *Dark Matter: A Century of Speculative Fiction from the African Diaspora* (2000) presents a wide variety of such fiction and demonstrates the depth and range of Afrofuturism.[3]

The Wave, by shifting its critique to the present, expands on this understanding of Afrofuturism. In this novel, the primary focus lies not in contesting science fiction's historically color-blind future but rather in directly engaging the present.

In contemporary American politics, as Mosley discusses in *What Next* and *Life out of Context*, there is an erasure of African American ideas in the construction of the immediate future. In *The Wave*, Mosley creates an original narrative that critiques the prevailing American ideology; his focus is not necessarily on "technoculture" or "the futurists of 100 years past," but rather on how post-9/11 American politics eliminates other possible American futures. Mosley's own formulation of black science fiction emphasizes how science fiction can critique the present. In his essay "Black to the Future," Mosley focuses on how science fiction is a "literary genre made to rail against the status quo" (2000, 406).[4] For Mosley, science fiction demands that a contemporary writer "imagine a world beyond his mental prison. The hardest thing to do is to break the chains of reality and go beyond into a world of your own creation" (407).

Mosley melds his variation of Afrofuturist technique with his critique of the present, namely the way that contemporary American politics erase the possible contributions of African American thinkers. As he writes in *What Next:*

> Because of the unique history and daily experience of African American people, I believe that we have a singular perspective on the qualities of revenge, security, and peace that will positively inform the direction of our nation's sometimes ill-considered stands. It is, I believe, important to air certain ideas and insights that arise from that African American experience as they relate to our enemies and our friends. (Mosley 2003, 7)

Instead of looking more broadly at historical white privilege, Mosley, as an author, uses *The Wave* to look specifically at American national privilege, the kind of national privilege that has only been highlighted in the post-9/11 world. Since those attacks, American unilateralism has created an environment where American global domination is deemed inevitable, natural, and uncontestable. In fact, the government officials of *The Wave* argue explicitly that this dominance is necessary:

> It is true that there have been moments when the United States government has taken the initiative, and when the rest of the world has questioned our authority. This time, however, we don't want to make any mistakes. No public bickering, no petty blame by potentates and socialists. The threat that faces our world is clear and present. Without immediate action, civilization as we know it—mankind itself—may soon be destroyed. (Mosley 2006b, 103)

The central feature here is the fundamental slippage at the end of the speech, how the speaker leaps from "civilization as we know it" (i.e., American civilization) to "mankind itself." That conflation—that American civilization is mankind itself—is the core object of critique in *The Wave*. By embracing the Wave, Errol embraces a situation where "civilization as we know it" will, in fact, end. As a result, Errol and Mosley force readers to ponder whether or not contemporary American civilization should continue as we know it.

So, instead of focusing on the historical erasure of race from science fiction, usually future oriented, Mosley is firmly focused on the present. The sparse criticism that has been written about Mosley's science fiction focuses on his earlier novels *Blue Light* (1998) and *Futureland* (2001), and does so in the light of the "future" component of Afrofuturist theory. While *The Wave* shares a great deal in common with *Blue Light*—another alien invasion novel where the invader has the possibility of positively transforming humanity—the context and setting of the two books vary widely. *Blue Light* is set in the utopic ferment of the 1960s, and *Blue Light* takes full advantage of its countercultural setting as a way of probing the possibilities of that era.[5] By operating within the same setting and sphere as the Easy Rawlins novels, Mosley extends the discussion of those texts with *Blue Light*.[6] *Futureland* is a more traditional dystopic novel, set in an American future dominated by consumerism and capitalism and has often been read as Mosley's variation on the dystopic genre. [7]

The Wave, when it is referenced at all, is usually read along such lines, as simply another example of a utopic/dystopic Afrofuturist novel. While such readings are perfectly valid, they unintentionally diminish *The Wave*'s critique of the present. Juan F. Elices argues that Mosley's science fiction is an example of "how the novelist draws and builds upon the foundations of both SF and dystopian literature in order to allegorize the search for a symbolic home in which African American sociocultural traditions are preserved and empowered" (2008, 133–134). Elices extends this reading to *The Wave*, seeing Errol's resistance to the government in broadly utopic terms. Indeed, Elices argues that Errol is resisting older forms of Western racism: "Dr. Wheeler seems to capture the most insidious side of Hitlerian ideology" (145). Dr. David Wheeler is the scientist in charge of eliminating *The Wave*, and, as discussed below, he performs a number of viciously sadistic experiments on the human manifestations of *The Wave*. By not locating our reading of Dr. Wheeler's genocidal urge in the past, but in the present, we can provide a new reading of *The Wave* that charts a different Afrofuturist territory than Mosley's other science fiction novels.

LIVING OUT OF CONTEXT: MOSLEY AND POST-9/11 POLITICS

In addition to being a relatively new kind of Afrofuturist text, one rooted firmly in the present instead of looking either to the past or the far future, Mosley also brings something fundamentally new to the world of post-9/11 fiction. First, *The Wave* is one of the few compelling science fiction novels written about those attacks. Aside from William Gibson's *Pattern Recognition* (2003), the science fiction world has largely ignored 9/11.[8] This may be because post-9/11 fiction has tended to focus almost exclusively on the story of the individual experiencing the events of 9/11. In

his *Out of the Blue: September 11 and the Novel*, Kristiaan Versluys argues that such fiction attempts to "affirm the humanity of the befuddled individual groping for an explanation, express the bewilderment of the citizen as opposed to the cocksureness of the killers, and give voice to stuttering and stammering as a precarious act of defiance" (2009, 13). In his reading of celebrated 9/11 novels such as Don DeLillo's *Falling Man* (2007) and Jonathan Safran Foer's *Extremely Loud and Incredibly Close* (2005), Versluys argues that these books continued the focus on the events of 9/11 and the trauma incurred by those who witnessed the events.[9] *The Wave* is a new kind of post-9/11 fiction because it moves its readers beyond the notion of 9/11 as trauma, and instead focuses on the political aftermath of those attacks.

Reading *The Wave* as a post-9/11 novel means little unless Mosley has something interesting to say about post-9/11 American politics. Mosley's focus lies not in trauma, revenge, or the "why us" question, but instead it interrogates the American government and their military action against perceived terrorist threats. Furthermore, by bringing a specifically African American perspective to post-9/11 politics, Mosley is able to move well beyond the conventional and limiting understanding of America's global role. Mosley is also one of the few African American writers to write so explicitly about 9/11, and, given that there are some 100+ novels that deal fairly explicitly with 9/11 and its aftermath, the absence of African American voices is noteworthy.[10]

In *What Next* and *Life out of Context*, Mosley provides a powerful, coherent argument against post-9/11 American global policy, approaching the issue from the perspective of African American imagination. Mosley's central thesis in these books is that the specifics of African American experience can provide new insight into American global policy (namely the war in Iraq), and that these new insights could, if properly understood, chart a new course for America. *What Next* begins with Mosley observing the 9/11 attacks from his Greenwich Village apartment. What bothers Mosley the most in *What Next* is the presumed complicity of African Americans with post-9/11 American foreign policy: "It has struck me that the political voices of Black America have been comparatively quiet since the events of September 11th....Many people might say, and I'm sure they think, that the silence of Black America is a tacit agreement with U.S. international policies" (2003, 85–86). Mosley vigorously denies this "tacit agreement," instead arguing that Black America has been conditioned into silence (86). Throughout *What Next*, Mosley makes an impassioned argument that the African American community needs to resist American globalism, and instead of remaining complicit with American global interests, to resist them. He asks, "How can we, Black people of America, who have suffered so much under the iron heel of progress, stand back and allow people to starve and die as silently and unheralded as our own ancestors did on those slave ships so many years ago?" (37).

The target of Mosley's critique is the way that American global and military dominance is depicted to the American people as "inevitable." In *Life out of Context*, Mosley applies this logic to the Iraq War. Mosley argues that American citizens were told, by their leaders, that Iraq possessed weapons of mass destruction. It turns out that they did not; nonetheless, as Mosley sees it, 100,000 Iraqis were killed in our names, or, as Mosley puts it, "the deaths of thousands, all of whom, in relation to us, were innocent" (2006a, 3). As such, Mosley wishes to "uncover and articulate methods we could employ to make the world safer for the millions who are needlessly suffering. It seems to me that each and every one of us needs to consider our potential to make a better world because the ones who lead us are themselves in dire need of direction" (3). To resist the domination imposed by the American political system (both Democratic and Republican), Mosley focuses on the idea of "context." If a new context were created, American citizens (whether African American or otherwise) could see themselves differently, and, by re-imagining themselves, act more responsibly. As Mosley puts it, "I am living in a time that has no driving social framework for a greater good" (16).

Much of *Life out of Context* focuses on ways of creating context, whether in the formation of an African American political party or of simply forcing Americans to think beyond national and social interests. Mosley's argument centers on the idea that Americans have simply grown to accept the context provided by the ruling political parties, and that they cannot see beyond this framework. Again, the Iraq war is his central point where, "They gave us the wrong information and still we listen to them as if they were fully capable of telling the truth" (2006a, 68). As a result, "We are living a life out of context with our own belief systems, with what we believe to be good and right....We are all culpable of our nation's actions; all of us. But we don't feel guilty because in some way we don't acknowledge the crimes" (68–69). Near the end of *Life out of Context*, Mosley's impassioned plea for a transformation of American politics, he writes that "if we turn away, genocide will be committed in our name, paid for with our dollars" (88). While Mosley is speaking directly of the Iraq war here, the same anti-genocide message runs throughout *The Wave*.

This concept of "culpability" and the possibility of resisting the "nation's actions" are at the center of *The Wave*. In that novel, Errol is given the same choice that the American people have been given regarding the Iraq War. While it would be possible to read *The Wave* as an allegory of the Iraq War (an enemy with unknown destructive power is met with overwhelming destructive force), I think it is more useful to see how Mosley uses his science fiction context to help shift Errol—and his readers—away from the idea of an inevitable global context of United States events. This link, between a new context and science fiction, is even present in *Life out of Context*, since that volume—rather oddly, in fact, since Mosley does not

mention literary technique anywhere else in that text—contains a defense of science fiction.

Near the end of *Life out of Context*, Mosley includes a brief defense of science fiction. In it, he claims that science fiction operates by forcing the reader to compare the imagined world (whether future or past) with the present (Mosley 2006a, 91–92). Or, as Mosley expands, "The science fiction story is almost always a criticism of the lives we are living today. Once we can imagine a different world or technology, then we see ourselves in a new light. We are able to question the contexts of our lives that have hitherto seemed absolute" (93). Just as there is a profound failure of imagination in regard to future texts, Mosley points out the failure of imagination in the present. While the science fiction world has long imagined utopias and dystopias scrubbed of any African American presence, our current world also fails to imagine anything beyond our present power structure. Indeed, Mosley's understanding of Afrofuturism takes us directly into the present: "If we allowed ourselves to speculate on the two words *what if*, we would be committing an act of rebellion that even the FBI and the CIA, backed up by the Patriot Act, would be powerless to counteract" (94). The specific reference to the Patriot Act, and the broad powers that the United States government has to suppress terrorist threats, seems to clearly indicate the direction of *The Wave*, where an African American character is going to come into decided conflict with the government. *The Wave* and *Life out of Context* were published in the same year, and cross-fertilization across the two texts is clearly evident.

THE THREAT OF ALIEN INVASION: 9/11 AND PATRIOTIC SOLIDARITY

The Wave uses its "what if" to "rail against the status-quo" by focusing on Porter Errol. A relatively average man, Errol is suffering through a sort of general alienation: his parents are dead; his wife has run off with his one of his friends; he has sold his house, and has left behind his career as a computer specialist. The novel begins with Errol receiving a series of mysterious phone calls from a voice saying that it is "cold and naked" and lost "in the trees" (Mosley 2006b, 1). The voice claims to be Errol's father, who died six years ago from cancer. Although he does not believe the voice, Errol goes to his father's gravesite and discovers a young man. This man tells Errol that he is indeed his father and claims that he has been reincarnated as a young man as a result of "the Wave." Errol nicknames the man GT (since he keeps saying "good times are coming") and takes him home. Through the first third of the novel, Errol staunchly refuses to believe that GT is his father, believing instead that GT is his father's illegitimate son.

Mosley begins the novel with Errol's failure of imagination. Despite the fact that GT knows things only his father could have known, Errol refuses to believe that GT is his father: "it doesn't make any sense. People don't just rise up out of the grave" (Mosley 2006b, 48). While Errol's sister immediately accepts the young man as their father, Errol is incapable of seeing beyond the logic of the world he has always lived in. The seemingly fantastic rebirth, and the chance to emotionally reconnect with his dead father, serves to highlight the general emptiness of Errol's life, or as he puts it: "My life up to the age of twenty-seven had gone off without a hitch, except for the death of my father…then all of a sudden things started going wrong" (83). At the beginning of *The Wave*, Errol is incapable of making an imaginative (Afrofuturist) leap into the unknown; he clings to his reality because he lacks the ability to imagine any other context, even though that context is giving him almost nothing.

Nonetheless, Errol initially rejects GT. After confessing several more secrets, GT vanishes, and Errol is glad he is gone. Errol's rather mundane life drags on for almost half the novel, with only minor incidents—he finds a new girlfriend, his pregnant sister falls ill—until he is suddenly detained by government officials from a secret agency. While in custody, he is approached by Dr. David Wheeler, who proceeds to tell Errol about the Wave, "the greatest threat that the human race has ever faced" (Mosley 2006b, 101). Wheeler leads Errol to a detention facility, where they are joined by a group of international scientists, political leaders, and capitalists. The government has captured a variety of Wave-controlled humans. Wheeler, through a series of brutally violent demonstrations (limb severing, etc.), tries to convince the assembled crowd that the Wave is a threat by showing them their non-human powers: their ability to "possess" humans; their ability to grow back limbs; their ability to come back from the dead, and their general imperviousness to harm. Wheeler tells the group that the Wave, in an attempt to establish dominance on Earth, has been reincarnating humans as "ghouls" and is creating "an invasion force, the likes world has ever seen" (102). Wheeler then implores his audience of diplomats, businessman, and world leaders to join with him to fight off these "demons from hell" (107).

Up to this point, Mosley has crafted a fairly standard science fiction novel in the classic sub-genre of the alien invasion. The Wave initially comes across as scary, frightening, and a threat to humanity. The horror element is of particular significance here, because Mosley initially depicts the Wave as revolting and fundamentally non-human: "lonely creatures forlorn in the twilight, the half-life, the sad sad waiting and hungering and longing for a memory" (Mosley 2006b, 31). This horror tone helps lull the reader into believing the narrative will be a conventional alien invasion drama. Given the Wave's propensity of reincarnating the dead as ghouls, its notion of collective intelligence, and its alien resistance to harm, Mosley

could have easily turned *The Wave* into a patriotic thriller.

Indeed, an important background for *The Wave* is science fiction cinema, particularly the alien invasion films that actor Will Smith popularized in the 1990s. The films *Independence Day* (1996) and *Men in Black* (1997) demonstrate a logic of racial coming-together: as alien entities threaten Earth, racial differences are set aside for the greater "national" or "human" good. Although the general tone of those movies is quite different, with *Independence Day* being serious and *Men in Black* comic, the basic plots are the same: an African American main character aligns himself with the United States government/military to fight off the alien invader. In his book *Black Space: Imaging Race in Science Fiction Film*, Adilifu Nama (2008) carries this reading forward to Will Smith's post-9/11 film *I, Robot* (2004). In *I, Robot*, Will Smith's character once again joins with mainstream (white) society to battle an outsider (renegade robots) that threatens the national way of life. Nama argues that the film affirms "the belief that patriotic soldiery transcends racial loyalty, even if only in American pop culture" (2008, 41). An outside threat is supposed to, in this genre, lead to an erasure of racial difference.

What Next, Life out of Context, and *The Wave* all reverse the simplistic formula of Will Smith's movies. The same rush to unity occurred in post-9/11 America, where it was simply assumed that African American experience, insight, and understanding would be put aside in exchange for the "patriotic solidarity" of combating the terrorist threat. All good Americans were expected to fully support government action. Mosley actually begins *The Wave* by focusing his readers' attention on this theme of "patriotic duty." In the first chapter, Mosley gives us a story about Errol's cousin, Albert Trellmore, a "bookkeeper and arsonist" (2006b, 3), who "every Fourth of July, set fire to one of the big corporations or production companies around Georgia. He loved fires and hated what big business did to the poor" (3). According to Errol's grandmother, he did this on the Fourth of July because he "called it his patriotic duty" (3). Albert only gives up his annual arson when he accidentally kills several hoboes after torching a train depot. Albert's resistance to American big business through his alternative mode of patriotism foreshadows Errol's own eventual understandings. Albert's unique understanding of America—of seeing how big businesses abuses the poor—leads to an alternative understanding of patriotism (rejecting American ideology, as represented by the Fourth of July). While Albert's initial response is one of violence, he eventually comes to reject that violence once he sees the impact of that violence on innocent lives. Equally important is the way that Albert's response is steeped in the very specific black history of American racism, and that this African American experience is transmitted down to Errol in the form of stories from his grandmother. In this way, Errol is able to draw on his and his family's experiences of being Othered by American society; this unique perspective allows him to see what is being done to the Wave.

This early sequence better prepares us for Errol's eventual rejection of patriotism demanded of him by the American government and the violence being done to the Wave in the name of American security. The parallels to Mosley's post-9/11 American politics are only strengthened while Errol is held by the government. When Errol complains that he is being detained illegally, Wheeler points out that such detention is fine "when it comes to Homeland Security" (Mosley 2006b, 114). Errol fires back that "you can hardly call amoebas terrorists" (114). Mosley has drawn his metaphorical connection. Wheeler is treating the Wave with the same kind of "all or nothing" mentality that the United States government has treated terrorism. Despite the fact that there is no proof that the Wave is actually a threat—it presents a transformation of human life, not an eradication of it—the Government responds to that threat the only way it knows how, with overwhelming violence.

While Errol is initially tempted by the solidarity offered by Dr. Wheeler, that temptation vanishes once he sees the government's brutal treatment of the Wave. To demonstrate the "threat" of the Wave, Dr. Wheeler shows Errol and some other officials a young girl trapped in a cage. This girl, a manifestation of the Wave, begins by screaming, "Please don't hurt me. Please don't" (Mosley 2006b, 99). Dr. Wheeler then orders a soldier to cut off her arm. The soldier complies, and the assembled crowd watches as she screams in pain. Since she is part of the Wave, she is able to heal quickly; as her arm begins to grow back, the soldier goes berserk and savagely mutilates her: "suddenly the soldier screamed and rushed at the little girl. He began hacking her with his razor-sharp bayonet. Off came her legs and remaining arm, off came her screaming head" (100). Dr. Wheeler makes no move to stop the soldier, and Errol is appalled by this display. He watches in horror as "an ever-widening circle of blood spread out from the flesh of the dismembered child. Her mouth opened spasmodically as if she were trying to speak. Her eyes, open wide, once again were gazing at me" (101). Dr. Wheeler triumphantly proclaims that, "It was not a child that was slaughtered before you, but a monster in the guise of innocence" (101).

Errol immediately rejects Dr. Wheeler's treatment of the Wave, and this marks the beginning of his acceptance of the Wave as a viable alternative to humanity as we know it. As Wheeler lectures about the threat of the Wave, Errol thinks, "Is he insane?" (Mosley 2006b, 101). The disjunction between this powerless girl who has been hacked to death and the government's overwhelming desire to destroy her species pushes Errol into making an imaginative leap, a leap to where he can accept the radical difference of the Wave as a positive, not a negative. Dr. Wheeler is unable to make that imaginative leap, and he can only view the Wave as a threat. In the little girl, he sees only the threat of terrifying difference. Errol, on the other hand, is able to recognize Dr. Wheeler's treatment of the Wave as an atrocity, and that Dr.

Wheeler's reaction represents an "insanity from which there seemed to be no escape" (103).

It is important to note that Dr. Wheeler never proves that the Wave is a threat to humanity; he only demonstrates that the Wave is different from humanity. Dr. Wheeler thinks that having others witness this difference will be enough to engender patriotic solidarity. Errol rejects this logic. He remarks that, "I was sickened by the display. So far, Wheeler hadn't proved the threat of the creatures. All he had shown was that they were superior but also helpless. It was as if a bunch of apes had captured a heavenly host of angels and were torturing them for their beauty" (Mosley 2006b, 107). There is an act of powerful imagination here. By rejecting the government's violence, he aligns himself with the Wave, identifying it with "angels." As Errol is exposed more and more to the way the government is treating the Wave—Dr. Wheeler gleefully shows Errol dozens of captured Wave creatures and the brutal experiments they are performing upon them—he becomes more and more capable of embracing a Wave-based future, not a human-based one.

This act of imagination is what we can term as Afrofuturist. While Dr. Wheeler is trapped in what we could term the prevailing ideology of contemporary America, Errol moves beyond that limiting viewpoint. Early science fiction could only imagine the future through the limiting lens of white privilege, and the government in *The Wave* can only imagine an American future in one limiting context, that of continuing exactly the same without any real change. Furthermore, Mosley shows that the government can only react to the threat of change in limited and violent ways. Since *The Wave* depicts that violence in such stark and unappealing ways—as in the willful tormenting of other sentient creatures via the dismembering of a young girl— Errol's rejection of that prevailing ideology is all the more appealing. Errol is able to imagine beyond Dr. Wheeler's construction of the future and instead imagine a future that includes the Wave. As such, Errol's reimagining of the Wave is one of the main Afrofuturist acts of the novel.

The later plot of *The Wave* re-enforces the boldness of this act. Because Errol has imagined a future outside of the American context he has been provided, he becomes a living threat to the American government. The rest of the novel charts Errol's ability to imagine beyond national interest, to accept the change that the Wave represents and, instead of fearing it, to embrace that possibility. At the same time, the American government reacts more and more violently to the Wave, hurtling down the path to genocide. Once Dr. Wheeler has finished demonstrating the "threat" of the Wave, he asks for Errol's help, pointing out that Errol is "their only human friend" (Mosley 2006b, 104). Wheeler wants to use the connection Errol has to his father to round up all manifestations of the Wave. When Errol refuses, he is placed under house arrest, with Dr. Wheeler invoking the government's

power to "protect national security." Errol eventually escapes and joins up with his re-incarnated father and other manifestations of the Wave. The government quickly develops weapons capable of destroying the Wave and sets out to exterminate all traces of this alien threat. As Errol sides with the Wave, the United States government comes to treat him as an enemy of the state. In *Life out of Context*, Mosley set up a possible showdown between imagining "what if" and the Patriot Act. In *The Wave*, he has delivered a literary version of that showdown, with Errol imagining "what if" and the government striving to violently dismember and destroy that kind of thinking.

BEYOND HUMAN: THE PROMISE OF THE WAVE

While Errol's explicit resistance to the government is one important part of the novel, the Wave itself, and the way its collective nature provides an alternative to contemporary America ideology, is equally significant. The Wave is eventually revealed to be a kind of black sludge, billions of small amoeba-like entities that can enter into other life forms and symbiotically absorb their memories, experiences, and knowledge. The black color of the Wave provides another rich metaphorical layer to Mosley's novel. The government's fear of the primordial blackness of the Wave echoes some of the traditional racist fears of white America, the fear of being overwhelmed by a dangerous "Other." While the color of the Wave alludes to those fears, Mosley also goes beyond them, since the Wave is ultimately far more alien and transformative than any other human culture could be. By absorbing human beings and other creatures, the Wave transforms those life forms into parts of itself. Instead of being a series of separate, discrete creatures, all manifestations of the Wave are collectively linked directly together. Errol frequently describes this oneness in glowing terms: "they merged, shared completely. Such communication was a kind of surrender that had no use for subterfuge or misdirection. All knowledge for [the Wave] was concrete and complete" (Mosley 2006b, 115). All parts of the Wave are one; it represents a single entity, manifested in a number of different forms and guises.

The Wave's process of absorption is shown to be slow, and in the novel, the Wave only assimilates and transforms those who have already died. As such, it poses no immediate threat to humanity; the absorption of humanity would take several generations, and individual humans (such as Errol) could live their lives out as human, and then be reborn as part of the Wave after their death. Errol is enthusiastic in his embrace of the new possibilities the Wave offers, even coming to remark that "I had come to see the sludge from the pit as God" (Mosley 2006b, 168).

There are several reasons that the Wave seems to offer such a powerful and

viable alternative to normal human life. As is the case with Errol's father, the Wave can bring the dead back to life, complete with the memories of their past lives; as such, the Wave offers a kind of eternal life. Secondly, the Wave offers a rapturous sense of belonging, experienced by Errol many times in the novel. Rather than being an isolated and directionless human, his communion with the Wave connects him to a greater whole. As the Wave puts it, "'We offer a greater vision, a world without division. Hope'" (156). Lastly, the Wave seems to offers an alternative to industrial society. With all aspects of the Wave working as one, there is no competition, no violence. The Wave represents a non-hierarchical and utterly peaceful society. Indeed, the novel shows the Wave having to learn violence from humans (by absorbing the knowledge from the dead): "It had learned to kill in order to protect itself" (172). Before encountering humans, the Wave knew nothing of violence. Furthermore, since the Wave can absorb all kinds of creatures, not just humans, the ultimate world of the Wave would be a completely unified Earth, with all living creatures being part of one whole, living symbiotically and peacefully together.

The Wave's unique form—a kind of collective identity that works by the slow and peaceful absorption of other entities, not their violent assimilation—can be read metaphorically as Mosley's vision of how humanity could proceed away from the realm of global capitalism. The Wave's focus on the collective, not self-interest, provides a powerful alternative to contemporary American life and the violence being done to preserve it. As a novel, *The Wave* presents this kind of unity quite positively. By the end of the novel, Errol constantly refers to the Wave as "God," and the Wave itself, speaking through one of its manifestations, argues that humans are attacking it because "they know that the Wave is superior to man. Maybe we present an end to the dream of humankind as rulers of all they see" (Mosley 2006b, 179).

Here, we see how Mosley's depiction of the Wave is deeply and fundamentally Afrofuturist. In imagining a non-violent collective consciousness capable of taking over the Earth, Mosley has imagined a future completely different from the prevailing technoculture we live in. Whether or not being absorbed into a collective, extra-terrestrial sludge really represents an ideal human future is not the point. Indeed, *The Wave* glosses over some of the complexities of that absorption and does not really discuss in detail whether human beings would want to be brought back from the dead or whether they would want to give up their free will to become part of this new "God." The novel sets up a highly polemical contrast between the government and the Wave and does not present a middle ground between absorption and genocide. In the imagined world of the novel, characters are either for joining the Wave or for exterminating it. This exaggerated duality forces readers to call into question the kind of duality present in our own politics and forces them to think beyond simple us/them dynamics. Instead of reading *The Wave* as Mosley's ideal

future, the novel should be read as a future imagined by Mosley to call into question the present. By focusing our attention on the government's violent rejection of the otherness of the Wave and Errol's ability to imagine a unity with the Wave, Mosley forces us to question our own contemporary environment. This act of imaginative thinking—what Mosley identifies in *What Next* as the act of asking "what if"—is what forces readers to imagine beyond our specific context.

IMAGINING BEYOND THE "ECOSYSTEM OF TERROR"

Errol's resistance to the violence waged in America's name mirrors what Mosley described as his initial reaction to the events of 9/11, of what he saw in "that column of smoke" billowing up from the Trade Centers: "We—Black men and women in every stratum of American society—live in and are part of an ecosystem of terror. We, descendents of human suffering, are living in a fine mansion at the edge of a precipice. And the ground is caving in under the weight of our wealth and privilege" (Mosley 2003, 26). For Mosley, America's global domination, its refusal to change, and its violent tendency to protect its own economic and political self-interests, all create an "ecosystem" where terrorism can grow and flourish.

To frame this in terms of Mosley's notion of context, the American government clings to its context of protectivism, isolation, and violence, whereas Errol is able to imagine beyond that context and create a new outlook on life. To frame this in terms of Afrofuturism, Errol is able to imagine a future that does not necessarily reflect the ideologies, limitations, and oppressions of present-day American ideology. This act of imagination helps to draw the readers of *The Wave* into a sharp critique of contemporary America. As the novel progresses, the difference between the government's idea of national good and Errol's idea of humanity's good become more and more obvious, forcing us to see that the context the American government operates within may not be the best context for humanity.

Errol identifies this same self-protecting impulse of the American government as an "unshakeable intention to commit genocide" against anything that is different from the contemporary order of American life. Indeed, Wheeler is most terrified that the aliens would show humanity a different way to live: "Wheeler and his superiors worried that this was a kind of alien propaganda; that if these ghouls (his word, not mine) could lobby among the living, then they might start some movement that would retard the necessary actions needed to exterminate all XT cellular life" (Mosley 2006b, 131). Errol is initially locked into the context he has always known, that of believing that humans are destined to be caught up in American style capitalist democracy, and that this system, in and of itself, represents humanity. He comes to see, though, that the Wave offers the potential of radical and substantive change.

The later half of *The Wave* is peppered with Mosley's attacks on contemporary American political ideology. Errol is able to escape from the government facility, and joins up with the Wave and its human manifestations. Errol and the Wave hide themselves in the forest, and Errol, through a series of visions and conversations, comes to better accept the Wave as a post-human alternative, "beyond the human experience of living or dying" (Mosley 2006b, 168). The Wave itself goes on to explain that "you, all of humanity, are the space before the first word in that dialogue. Your idiom is like the babble of an infant when its only notions are of hunger and pain" (177). Mosley consistently depicts humanity (in its current incarnation) as primitive, poisonous, and deadly. In the end, the Wave is highly critical of humanity: "The Wave is not the vermin-like quality of humanity"—or, at the least, the American government—emerges as Wheeler succeeds in his genocidal plan. Wheeler designs a toxin that can exterminate the Wave and proceeds to hunt down and kill the Wave. Late in the novel, soldiers carry out this genocide, bursting in and slaughtering almost all the incarnations of the Wave. Errol is barely able to escape with a small portion of the Wave in its black sludge form. Errol hides the Wave, only to be arrested again as the government tries to collect and eradicate all remnants of the alien invasion. Errol is held for another 14 months, but the government is unable to find any more traces of the Wave and smugly concludes that their genocide has worked. The novel ends with Errol witnessing the remaining portion of the Wave communicating with another alien entity, and he then goes off to search to find more deposits of the Wave on Earth.

As such, *The Wave* ends ambiguously. Errol is unable to prevent the American government from exterminating the current incarnation of the Wave: "I was the sole survivor of a war that had nearly slaughtered an entire race" (Mosley 2006b, 204). We do not know, at the end of the novel, if Errol will succeed in bringing the Wave back. The Wave does succeed in one way, however. Despite almost being killed, the Wave has managed to take over the body of Dr. Wheeler. This remnant of the Wave joins up with Errol to search for more of the Wave. It is unclear, though, whether or not they will succeed. This uncertain ending serves two purposes. First, it realistically reflects the power of the American government to suppress and destroy other possible configurations of the future and thus re-enforces the connection between the American government in the book and the reservations about the real American government Mosley expresses in his non-fiction. Change is not as easy as simply wishing for an alien to invade and transform American power structures. Second, by leaving the ending open, Mosley involves both Errol and the novel's readers in an ongoing act of imagination. Instead of providing Errol with a ready-built and new context, *The Wave* forces him to continue searching for this context. This need for continued searching is the same message that manifests itself throughout *What Next* and *Life out of Context*: that Americans need to be actively search-

ing and trying to create new contexts for themselves. Errol's lack of closure bleeds over to the reader and keeps that space of searching and imagination open; readers finish the book still asking "what if?"

MOSLEY'S NEW CONTEXT

Judith Butler, in *Precarious Life: The Powers of Mourning and Violence*, argues that Americans need to move beyond the limiting context of American unilateralism:

> But if we are to come to understand ourselves as global actors, and acting within a histori-
> cally established field, and one that has other actions in play, we will need to emerge from
> the narrative perspective of US unilateralism and, as it were, its defensive structure, to con-
> sider the ways in which our lives are profoundly implicated in the lives of others. (2006, 7)

The Wave almost perfectly embodies the understanding that Butler is calling for. By focusing on America's "defensive structure," the way that the government will do anything to protect the American way of life, and how the Wave offers a non-violent alternative, Mosley forces his readers to think about the way all human life is interconnected. Should we be connected by the American government's unilateralism through lines of violence? Or by the Wave's collectivism? While Butler calls for a better understanding of mourning and empathy to make this transformation, Mosley is able to do this through his Afrofuturism. If we return to Nelson's definition of Afrofuturist writing, of texts that "create original narratives of identity, technology, and the future and offer critiques of the promises of prevailing technoculture" (Nelson 2002, 9), we can see that Mosley has fulfilled this definition. The novel, by forcing readers (and Errol) to imagine beyond the ready-made American ideology of "protect America at any cost," draws those readers into a greater engagement and critique of the present moment. The specificity of that present moment, as post-9/11 American policy, and not the more nebulous "promises of prevailing technoculture" referenced by Nelson, is what makes *The Wave* a vital and significant expansion of Afrofuturist technique.

Mosley's act of Afrofuturist imagining pushes readers to contrast the government's response in *The Wave* (the genocide) to what Mosley sees as America's irresponsible, violent, and indefensible actions since the 9/11 attacks. For Mosley, the responses to those attacks revealed the way that America's unilateralism and commitment to a very specific kind of global dominance obscure other contexts which may be more viable, positive, and life-affirming. In *The Wave*, he takes us/readers through exactly the same kind of journey, using science fiction motifs to foreground this crisis. As Errol witnesses the government's treatment of *The Wave*, he draws on his experiences and imagination to reject violence and free himself from the patriotic American context of "destroy the invader." Through imagination,

through this "what if," Errol is able to re-imagine himself—and, thus Mosley's science fiction allows for a series of rich metaphors—to re-imagine humanity as well.[11]

That act of imagination, of course, is the ultimate significance of the journey Errol takes in *The Wave*. Errol himself, by making the leap necessary to embrace the otherness of the Wave, operates as the perfect example of Mosley's concept of creating new contexts for understanding American existence. This act of imagination further highlights how Mosley is able to, by shifting politics from the actual to the imaginary, break the American government's insistence that the world continue in exactly the same economic, social, political, and military fashion as it exists now. The parallels in the way that the American government treats the Wave as a terrorist threat, by immediately resorting to military action and presumed genocide, force readers into the active comparison Mosley emphasizes in *Life out of Context*. Because the reader is forced to "think outside of the system that defines you," this allows us to imagine "a wholly different world and then imagine how we would live in that world—then we would see the flaws in the way we live today" (Mosley 2006a, 94). Regarding the Wave, the genius of Mosley's work is found in the contrast that the reader is forced to make between the imagined world and the actual world and the imaginative leap of "what if" the reader confronts in the novel.

NOTES

1. Dery first defined the term Afrofuturism in his "Black to the Future" as, "Speculative fiction that treats African-American themes and addresses African-American concerns in the context of twentieth-century techno-culture—and, more generally, African-American signification that appropriates images of technology and a prosthetically enhanced future—might, for want of a better term, be called Afrofuturism" (1993, 736). Dery briefly discusses the influence of this term in his "Black to the Future: Afro-futurism 1.0" (2008).

2. De Witt Douglas Kilgore's *Astrofuturism: Science, Race, and Visions of Utopia in Space* provides an interesting and much more favorable reading of race and white science fiction from the 1950s to the present, arguing that while such developments as the spaceflight movement and science fiction have been "considered almost exclusively within the frame of its complicity in the dominant projects of regnant America" (2003, 238), there is a more radical and freeing agenda inherent in those texts.

3. Sheree Thomas's *Dark Matter: Reading the Bones* (2004) (the sequel to *Dark Matter*) and Nalo Hopkinson's *So Long Been Dreaming: Postcolonial Science Fiction* (2004) also include a number of Afrofuturist stories that grapple with the present and immediate future. In particular, Hopkinson's musings on science fiction—that "to be a person of colour writing science fiction is to be under suspicion of having internalized one's colonization" (2004, 7) and that science fiction "makes it possible to think about new ways of doing things" (9)—closely mirror many of Mosley's ideas.

4. Mosley never uses the term "Afrofuturism" to describe his own work or the work of other African American writers.

5. Charles Wilson, Jr. explains: "Set in the turbulent 1960s, when many Americans, especially young people, began to question the very social structures that previous generations took for granted and accepted as right and proper, the novel proposes a more enlightened way of viewing one's world and oneself" (2003, 145). See also Wilson's further discussion of *Blue Light's* context (2003, 158–161). Alternatively, David Smith (2001) looks at the role of consciousness and Otherness in "Walter Mosley's *Blue Light*: (Double Consciousness) Squared."

6. See Wilson: "With *Blue Light* Mosley enters the realm of science fiction writing while still employing strategies from his detective fiction" (2003, 145).

7. See Elices (2008, 138–143). Alternatively, critics have seen *Futureland* as a variation on the cyberpunk genre, one that extends beyond the limitations of that genre. See Sandy Rankin's (2008) "The (Not Yet) Utopian Dimension and the Collapse of Cyperpunk in Walter Mosley's *Futureland: Nine Stories of an Imminent World*" and Derek Maus's (2008) "Cyberfunk: Walter Mosley Takes Black to the Future."

8. Alex Link argues that "William Gibson's *Pattern Recognition* situates the September 11, 2001, terrorist attack in a broader twentieth-century narrative of massive capitalist expansion inextricably yoked to repressed and traumatic violence" (2008, 209). Mosley is also making the same connection between capitalism and violence, although the violence in Mosley's world is not "repressed."

9. This concept of trauma has proved to be one of the most influential lenses for reading 9/11 fiction. In addition to Versluys, see David Simpson's *9/11: The Culture of Commemoration* (2006) and E. Ann Kaplan's *Trauma Culture* (2005) for a broad discussion of trauma as related to 9/11.

10. African American response may have been discouraged after the media firestorm concerning Amiri Baraka's controversial "Somebody Blew Up America" (2007). Baraka's poem received extensive and negative media coverage for its perceived anti-Semitism. For a concise analysis of the Baraka controversy, see Jeffrey Melnick's *9/11 Culture* (2009, 29–32).

11. Several other contemporary Afrofuturist writers have had their main characters make similar imaginative leaps. One example is Octavia Butler's Xenogenesis novels, where the main character Lilith must imagine an existence where humans are combined with aliens and turn into something both new and post-human. In particular, the opening sequences of *Dawn* show Lilith caught in her older American context, and only via imagination is she able to accept something new. Ti-Jeanne, the main character of Nalo Hopkinson's *Brown Girl in the Ring* (1998), is trapped in a dystopic future full of organ-harvesting, poverty, and violence and can only resist that future to making the leap to embracing traditional Caribbean religion. These texts differ substantially from *The Wave*, though, by being set substantially in the future, with *Dawn* set after an apocalyptic war and *Brown Girl* set in Toronto after the economic collapse of that city.

REFERENCES

Baraka, A. (2007). *Somebody blew up America & other poems*. Philipsburg, St. Martin, Caribbean: House of Nehesi.

Bould, M. (2007). The ships landed long ago: Afrofuturism and Black SF. *Science Fiction Studies, 34*(2), 177–186.

Butler, J. (2006). *Precarious life: The powers of mourning and violence*. London: Verso.

Butler, O. E. (1987). *Dawn*. New York: Warner.

Butler, O. E. (1988). *Adulthood rites*. New York: Warner.

Butler, O. E. (1989). *Imago*. New York: Warner.

Delany, S. R. (1966). *Babel-17*. New York: Ace.

Delany, S. R. (1976). *Trouble on Triton*. New York: Bantam.

DeLillo, D. (2007). *Falling man*. New York: Scribner.

Dery, M. (1993). Black to the future: Interviews with Samuel R. Delany, Greg Tate, and Tricia Rose. *South Atlantic Quarterly, 92*(4, Fall), 735–778.

Dery, M. (2008). Black to the future: Afro-futurism 1.0. In M. S. Barr (Ed.), *Afro-future females: Black writers chart science fiction's newest New-Wave trajectory,*(pp. 6–15). Columbus, OH: Ohio State University Press.

Elices, J. F. (2008). Shadows of an imminent future: Walter Mosley's dystopia and science fiction. In O. E. Brady & D. C. Maus (Ed.), *Finding a way home: A critical assessment of Walter Mosley's fiction* (pp. 133–147). Jackson, MS: University Press of Mississippi.

Foer, J. S. (2005). *Extremely loud and incredibly close*. Boston: Houghton Mifflin.

Gibson, W. (2003). *Pattern recognition*. New York: G.P. Putman's Sons.

Grayson, S. M. (2003). *Visions of the third millennium: Black science fiction novelists write the future*. Trenton, NJ: Africa World.

Hopkinson, N. (1998). *Brown girl in the ring*. New York: Warner.

Hopkinson, N. (2000). *Midnight robber*. New York: Warner.

Hopkinson, N. (Ed.). (2004). *So long been dreaming: Postcolonial science fiction & fantasy*. Vancouver, B.C.: Arsenal Pulp.

Kaplan, E. A. (2005). *Trauma culture: The politics of terror and loss in media and literature*. New Brunswick, NJ: Rutgers University Press.

Kilgore, De Witt D. (2003). *Astrofuturism: Science, race, and visions of utopia in space*. Philadelphia, PA: University of Pennsylvania Press.

Lavender, I. III. (2007, July). Ethnoscapes: Environment and language in Ishmael Reed's *Mumbo jumbo*, Colson Whitehead's *The Intuitionist*, and Samuel R. Delany's *Babel-17*. *Science Fiction Studies, 34*(2), 187–200.

Link, A. (2008). Global war, global capital, and the work of art in William Gibson's *Pattern recognition*. *Contemporary literature, 49*(2), 209–231.

Maus, D. C. (2008). Cyberfunk: Walter Mosley takes black to the future. In O. E. Brady & D. C. Maus (Ed.), *Finding a way home: A critical assessment of Walter Mosley's fiction* (pp. 148–160). Jackson, MS: University Press of Mississippi.

Melnick, J. P. (2009). *9/11 culture: America under construction*. Chichester, West Sussex, UK: Wiley-Blackwell.

Mosley, W. (1998). *Blue light: A novel*. Boston, MA: Little, Brown.

Mosley, W. (2000). Black to the future. In Sheree R. Thomas (Ed.), *Dark matter: A century of speculative fiction from the African Diaspora* (pp. 405–407). New York: Warner.

Mosley, W. (2001). *Futureland*. New York: Warner.

Mosley, W. (2003). *What next: A memoir toward world peace*. Baltimore, MD: Black Classic.

Mosley, W. (2006a). *Life out of context: Which includes a proposal for the non-violent takeover of the House of Representatives*. New York: Nation.

Mosley, W. (2006b). *The Wave*. New York: Warner.

Nama, A. (2008). *Black space: Imagining race in science fiction film*. Austin, TX: University of Texas Press.

Nelson, A. (2002). Introduction: Future texts. *Social Text, 20*(2, Summer), 1–15.

Rankin, S. (2008). The (not yet) utopian dimension and the collapse of cyperpunk in Walter Mosley's *Futureland: Nine stories of an imminent world*. In D. M. Hassler & C. Wilcox (Ed.), *New boundaries in political science fiction,* (pp. 315–338). Columbia, SC: University of South Carolina Press.

Simpson, D. (2006). *9/11: The culture of commemoration*. Chicago, IL: University of Chicago Press.

Smith, D. L. (2001). Walter Mosley's *Blue Light*: (Double consciousness)squared. *Extrapolation: A Journal of Science Fiction and Fantasy, 42*(1, Spring), 7–26.

Thomas, S. R. (Ed.). (2000). *Dark matter: A century of speculative fiction from the African Diaspora*. New York: Warner.

Thomas, S. (Ed.). (2004). *Dark matter: Reading the bones*. New York: Aspect.

Versluys, K. (2009). *Out of the blue: September 11 and the novel*. New York: Columbia University Press.

Wells, H.G. (1898). *War of the worlds*. London: William Heinemann.

Wilson, C. E. (2003). *Walter Mosley: A critical companion*. Westport, CT: Greenwood.

Techno-Utopia and the Search for Saaraba

DEBBIE OLSON

IN 1927 DIRECTOR FRITZ LANG CONSTRUCTED A DYSTOPIAN VISION OF A society ruled and then destroyed by modern technology. Lang's famous black and white silent film, *Metropolis,* presents a futuristic world divided into two groups: the "thinkers," who live above ground and rule the city and are portrayed wearing white or light garments, and the "workers," who live below ground and are in some scenes physically tied to the machines that they work with. The workers are always clothed in dark uniforms. *Metropolis* is a vision of a technological hell, where workers run machines ten hours a day so that the "thinkers" can live with ease and abundance above ground.

Though *Metropolis* was a commentary on the dangerous belief that machines and industrialization were the correct path to a perfect society, it may also be viewed as a metaphor for today's belief in a similar type of social perfection: a utopia through technology—a techno-utopia—and the racial divisions created (intentionally or not) by that technology, supported and perpetuated by predominantly Western science. Western and Eastern societies have developed numerous technologies that have significantly changed the lived and material conditions of human existence for those societies that can afford to utilize them, while the labor and resources of those who cannot, predominantly Third World peoples, are exploited in order to create the wealth and amenities (diamonds, gold, textiles, clothing, electronics, oil, etc.) for the techno-utopia of the former.

The visual distinction in *Metropolis* between the thinkers and workers could easily be seen as a similar division between the material/technological West and the more "primitive" less developed Third World.[1] Lang's *Metropolis* opens with the "day shift" and the workers marching in slow unison towards the factory. The workers move in stilted and eerie synchronicity toward the elevator that will take them to the Undercity. They are dressed in identical black overalls, a jacket, and black cap. The sameness and mechanical nature of the workers are clearly presented through the use of costume with black (dark) representing the nonhuman, dim-witted, and lackadaisical nature of the workers—but the sameness of each worker's outfit also symbolizes a loss of individuality, of self—the "industry's most insidious and dangerous application of technology [that is] captured in an image" of the sartorial uniformity of the workers as they mindlessly shuffle towards the machine (Minden & Bachmann, 2000, 347). In contrast to the workers underground, the above ground is introduced as the "pleasure garden," an analogy for the Western idea of Eden, where everyone wears white or light-shaded clothing. These "thinkers" are portrayed as intelligent, civilized and cultured, graceful and eloquent in comparison to the dull, ragged, slow bodies and pinched, blank faces of the workers. These characterizations of the two groups in *Metropolis* may also be read to reflect similar ideas in some Western societies about the inability of Third World peoples, and Africa in particular, to participate in or create technology and the social conditions necessary to produce a social utopia.

The depiction of science in *Metropolis,* particularly the mad scientist's creation of an android woman who ultimately brings destruction to the workers, is repressive, exploitive and exclusionary toward the workers. The division of people in *Metropolis* is very similar to the division of access to today's science and technology, particularly in parts of Africa where the West's colonization of that continent has created similar racial divisions: Blacks as "workers" [slaves] and whites as the "thinkers." Though official colonization of Africa ended in the mid-70s, cultural colonization of Africa continues unabated, predominantly through the use of Western technology. One way the West continues its hegemonic control of parts of Africa is through its monopoly on technological innovations and the distribution of technologies such as film, cell phones, internet access, economic markets, health care, etc. As Adam Banks argues, "Racism is enforced and maintained through our technologies and the assumptions we design and program into them—and into our uses of them," and those assumptions have become a subtle part of scientific rhetoric and the underlying racist notions of who can create and use science and technology (2006, 10).

African films offer a much different perspective on the West's notion of a technological utopia and though "the core of the utopian impulse is a belief that life can and ought to be improved" (O'Har 2004, 484), it is the West's erroneous

assumption that it holds the only model for social improvement and advancement, that Western technology is a "natural" evolution in human civilization. How then do Africans negotiate the techno-racism pervasive in Western films? One way Africa resists the negativity of Western science and technology in Hollywood films is through a counter visual rhetoric—African films that conceptualize technology in ways that do not privilege the techno-utopia of the West as a predetermined inevitability but rather show how the West's monopoly on (white) science and technology will eventually lead to destruction and a loss of humanity. In this chapter, I will explore the representation of technology in Amadou Saalam Seck's 1988 film *Saaraba*, which questions the West's quest for a technology-driven utopia and instead privileges the African conception of a utopian society where human connections, rather than technology, are the way to paradise.

The problem with the Western conception of science as natural is that this perspective originates from social structures and conditions that are themselves perceived by the West as naturally better or more "right" than other forms of social structures or conditions. Sophie Tyson argues that:

> Underlying these positions is a particular idea of technology—that its development is inevitable irrespective of its social, technical, economic, cultural and political contexts. This is a determinist argument in which technology follows its own evolutionary development, with the outcome being that society just has to adapt to it. The problem with this is that it assumes those who produce new technologies, such as scientists, are not influenced by the broader society. However, technology is not some independent force that can control us from 'out there,' but is shaped by economics, politics, culture, history, and so on. (2001, 15)

The belief that scientific advancement can only happen in the West, and then must be benevolently spread to the rest of the world, positions the West as the harbinger of the only "natural" utopia, the utopia of an exploitive capitalist and racist technology.

Contrary to popular belief, science in practice is *not* universal but is shaped and influenced by social forces and conditions that work to reinforce Western ideologies and interests by directing the questions science asks and the data scientists collect and evaluate. In 1883 Francis Galton coined the term "eugenics" as a moral philosophy to improve human worth by encouraging the breeding of the ablest and healthiest people. Eugenicists in the early twentieth century argued that "defectives should be prevented from breeding through custody in asylums or compulsory sterilization" which resulted in a number of sterilization laws including a 1935 Oklahoma law requiring the forced sexual sterilization of repeat criminals (eugenicsarchive.org, *Skinner v. Oklahoma* 1942). The eugenics movement was coined as the "science of racial cleansing" and was used to "prove" the superiority of the white "race" and by scientific means show the "natural" inferiority of Blacks, Hispanics, and other peoples of color.

How much has changed in the scientific community since eugenics? Forced sterilization thankfully ended, but the belief in white superiority as a biological "fact" is still argued by some scientists. For example, the 1911 *Encyclopedia Britannica* entry for "Negroes" reads in part:

> Mentally the Negro is inferior to the white. The remark of F. Manetta, made after a long study of the Negro in America, may be taken as generally true of the whole race: "the Negro children were sharp, intelligent and full of vivacity, but on approaching the adult period a gradual change set in. The intellect seemed to be clouded, animation giving place to a sort of lethargy, briskness yielding to indolence." We must necessarily suppose that the development of the Negro and white proceeds on different lines. While with the latter the volume of the brain grows with the expansion of the brain-pan, in the former the growth of the brain is on the contrary arrested by the premature closing of the cranial sutures and lateral pressure of the frontal bone. This explanation is reasonable and even probable as a contributing cause; but evidence is lacking on the subject and the arrest or even deterioration in mental development is no doubt very largely due to the fact that after puberty sexual matters take the first place in the Negro's life and thoughts. At the same time his environment has not been such as would tend to produce in him the restless energy which has led to the progress of the white race; and the easy conditions of tropical life and the fertility of the soil have reduced the struggle for existence to a minimum. But though the mental inferiority of the Negro to the white or yellow races is a fact, it has often been exaggerated; the Negro is largely the creature of his environment, and it is not fair to judge of his mental capacity by tests taken directly from the environment of the white man, as for instance tests in mental arithmetic; skill in reckoning is necessary to the white race, and it has cultivated this faculty; but it is not necessary to the Negro.
>
> On the other hand Negroes far surpass white men in acuteness of vision, hearing, sense of direction and topography. A native who has once visited a particular locality will rarely fail to recognize it again. For the rest, the mental constitution of the Negro is very similar to that of a child, normally good-natured and cheerful, but subject to sudden fits of emotion and passion during which he is capable of performing acts of singular atrocity, impressionable, vain, but often exhibiting in the capacity of servant a dog-like fidelity which has stood the supreme test. (Chisolm 1911, 344–345)

The scientific language in this encyclopedia description of "Negroes" from 1911 is not much different than the scientific rhetoric in R. Herrnstein and C. Murray's infamous 1994 study on race and intelligence, *The Bell Curve*, where they argue that whites and Asians are "naturally" more intelligent than Blacks or Hispanics, or the rhetoric in Vincent Sarich and Frank Miele's *Race: The Reality of Human Difference* (2004), where they argue against the thesis that race is a social construction and instead assert that the non-white races, and particularly Blacks, are an evolutionary-based, less-developed form of homo sapiens, who are *naturally* less developed than whites and, as a result of their deficiencies, face their own extinction. Though these works may represent only one strand of American scientific thinking, the fact that some (white) scientists today still try to "prove" the biological inferiority of other

races is a significant comment on the pervasiveness of a race-based mindset within some segments of the science community.

In contrast to Western ideologies about individual racial superiority, African cultures are increasingly resistant to Western style scientific objectives as the isolation of the individual within modern technological culture runs counter to traditional African communal ideologies. The technological challenge for many African societies is multidimensional because they work to retain their communal traditions, combat Western notions of Black inferiority and Western global economic forces, provide a foundational infrastructure to support new technologies, and then utilize and promote those technologies that best work within African social contexts. A daunting task. But in order to develop "meaningful access to any technology" Africa must be allowed access to the "political power and literacies" (Banks 2006, 17) that are intricately woven into the framing of scientific knowledge, something many African societies struggle to acquire in the face of Western-controlled global economic, education, and information monopolies.

In practice, in the West and in Africa, Westernized attitudes towards science and technology are maintained by a continual hegemonic adherence by social institutions to the daily significance of race in modern social structures—for example, by collecting data on race from job applications, welfare applications, health care applications, life insurance applications, college applications and even at grocery stores and fast food restaurants. Race *appears* to matter and nowhere is race more at odds with technology and techno-utopian ideals than in Western films. One only needs to look at the lack of characters of color in most futuristic (or science fiction) Hollywood films, or, if there are characters of color they are in minor, supporting roles and are usually the first casualties of whatever technological aberration is unleashed on an unsuspecting society. For example, in *Terminator 2* (dir. James Cameron, 1984) it is the *Black* scientist, Miles Dyson, who ultimately begins the chain of events that lead to world nuclear war and human domination by machines, leaving an underlying impression that science in the hands of Blacks leads to destruction. Through years of this type of Hollywood racialized scientific rhetoric, the West has perpetuated the illusion that whites are synonymous with the *Metropolis* "thinkers," while people of color are merely the "workers" who can never achieve the technological utopia that the West envisions for itself.

TV OR NOT TV

Saaraba opens above the clouds; the first scene is a bird's-eye view of soaring through the heavens, then swooping down to glide along the ocean. Then the images fade into a plane landing at an airport and the protagonist, Tamsir, goes through customs in Dakar, Senegal, West Africa. Through voice over, Tamsir

explains that he has spent the last 12 years in metropolitan Paris, France, and has turned his back on "the white man's technology" and is returning to his African home to reconnect with his roots, to find himself.

The next scene is a jarring visual juxtaposition of the extreme poverty and modern prosperity of Dakar. As Tamsir travels from the airport, the camera's slow pan begins screen left and shows a large shanty-town made up of a rainbow of mismatched plywood and rust-colored corrugated metal shacks. The camera then pans slowly to the right, across a modern highway and Dakar's contemporary skyline, filled with modern high-rises and factories, comes into view directly across from the shanty houses. This opening scene foregrounds the conflict between the dream of a modern techno-utopia against the realities of poverty, establishing the division between "workers and thinkers." Following this dramatic opening sequence, the film next illustrates the power of Western television to alienate families (or individuals).

The previous scene dissolves into a shot of a car squealing on a dirt road. The camera pulls back and reveals the squealing car is actually on a TV screen and Tamsir's cousins, Aunt, and Uncle are all sitting around the TV. As Tamsir enters they welcome him home to Dakar, but they are apathetic and their attention is clearly focused on the TV and only halfheartedly on Tamsir. In an offhand manner they ask Tamsir how he is, their heads continually turning back to the television; the TV and its media fantasy are more engaging to them than Tamsir himself. The family merely absorbs Tamsir into their collective audience position and their enraptured engagement with the TV images. The power of the images to capture the entire family's attention despite the presence of their long-absent visitor depicts the seductive influence of technology as a negative consequence of modernity on the African family. Many scenes in *Saaraba* emphasize the disruptive effects of technology on the traditional familial community, particularly in the later scenes with Tamsir's cousin, Sidy, who has effectively "tuned out" of society completely (his advice to Tamsir is to "smoke a joint and do not waste time worrying about things you cannot change.")

Tamsir's reception by his city relatives is contrasted sharply by his reception at his parent's rural village. This scene reinforces a common theme in African film that contrasts the isolation and distraction of modernity with a more personal, family-centered, traditional society. He is greeted warmly and animatedly by all the women of the village when he arrives. Shouts and cries of joy meet Tamsir as the entire village turns out to welcome him. There is no modern technology evident in the village and when Tamsir is with his family, they all interact enthusiastically; their attention is focused on Tamsir and each other, not on a television set. The elder men of the village ask Tamsir to attend a meeting about the proposed electricity, water, and sewage system that is scheduled to be installed in the village, the trappings of modern technology. Though Tamsir has been away for many years, he is given the

responsibility and respect as the elder son to represent his family as an equal member of the community in the discussion about what technology the village should allow and how to deal with it.

The next scenes involve the village men meeting with their MP (Member of Parliament), who is supposed to "represent" them and their interests in government. The scene illustrates the false promises of a government that ignores the real concerns of those who follow traditional ways of life. The MP is dressed in western style suit and tie, promises electricity, clean water, and the instillation of a sewage treatment plant. The MP is round-faced, jovial, with a wicked twinkle in his eye that belies his high-brow speech which guarantees modernity to the village. The MP explains that the reason for this modernization of the village is the prolonged drought which has made their fields barren and "uneconomical," a rhetorical metaphor for the government's belief in the barrenness of traditional ways in the face of modernity's advancements. He further promises a tourist center and a salt factory, holding his arms wide to encompass all and assures the villagers that it will create many jobs and bring the village into the "modern" age.

A few villagers ask questions and raise concerns, which the government official minimizes by offering comforting assurances with a salesman's panache. But the MP's attitude is paternal and condescending; his answers to specific questions by the village men are vague and lack specifics. One villager in particular, Alpha Yoro, stands up and explains his concerns. The drought has diminished his herd, his "only possession," and he worries that the modernization proposed by the MP will destroy what is left of his herd. The film foregrounds Alpha Yoro's concerns in a close-up shot of his face as he asks the question; concern for his livelihood and fear of such vast changes are evident. His final comment that he will not accept what his "ancestors would not have accepted" illustrates the film's attempt to reconcile the socio-political meeting of tradition and modernity. The ongoing negotiation between tradition (herding as a livelihood) and modernity (the MP's promises of jobs in factories and tourist industries) highlights the villagers localized desire to keep their traditional way of life with the desire to survive in a globalized, modern economy.

It is during this segment that one village member, Demba, interrupts the meeting to ask if anyone has a chain for his motorcycle so he can ride to Saaraba—the land of plenty (utopia) where everyone is happy. It is significant in the film that the viewer is first introduced to the fabled utopian society of Saaraba at the very moment when the MP promises to provide the villagers all of the "utopian" conveniences of modern Western society. In this scene, the idea of utopia is introduced by a character who, in the film, is the village simpleton—sweet, but not taken very seriously. He spends his days working on the motorcycle he acquired when the white

priest left the village. The motorcycle functions in the film as a symbol of modern technology, and the motorcycle's "movement" will provide the means for reaching the utopia that Demba seeks.

In the next scene technology, described as the "machine," is explained as an integral part of a utopian society; indeed, utopia is where people do not have to work because machines do all the work (machine as savior); it is a place where technology replaces labor (Garden of Eden) and also provides material goods (materialism is equated with utopian social conditions) which people "naturally" desire. After the village meeting, Demba reveals to Tamsir that the white priest told him about Saaraba where "machines work for people. A country where machines produce all sorts of things." Demba believes that Saaraba is paradise on earth and must be the place the white priest described where people do not have to work, and they have a lot of "things." Here Western materialism and capitalism are presented in Fordist notions of production, where human labor is replaced by mechanical means, and that mechanism itself is understood as utopian. The fact that Demba becomes so infatuated with a mythical place of ease told to him by a white priest (a symbol of Western colonialism through religion) reinforces the film's notion of the corruption of ideals of both work and community through the seduction of a technological "life of ease." Demba's pursuit of, and unwavering belief in, Saaraba parallels the village's pursuit of modern technology, as the village is seduced by the MP to accept (and believe in) all the modern accoutrements the MP has promised.

In the West, the idea of "being digital and being free are one and the same" (Winner 1997, 1005). Freedom from hardship and suffering becomes equated with objects of science and technology, a belief that is contrary to much in African social structures. Yet through the pervasiveness of Western media in African societies, it is an idea that has unfortunately taken root. For many cultures in Africa "utopian dreams have been codified as a political [and social] ideology" even though many of the digital technologies are still very much out of reach in the majority of African countries (Winner 1997, 1001). Demba is the only character in the village who has a motorbike or any other mechanical means of transportation (a symbol of modernity) which he plans to use to reach Saaraba; only a machine can bring him to the fabled land of machines and technology where there are plenty of "things." Tamsir is disillusioned by the West and he struggles to find his identity in the interstice of Europe and Africa. Though Tamsir tries to convince Demba that the machines need humans to work them, that the "white man's technology" is not utopia, Demba will not be dissuaded and evinces a stubborn, childlike belief (the Western stereotype) on the promises of the utopia the white priest described. Demba's character borders on a caricature of how white science has constructed Blacks—"the mental constitution of the Negro is very similar to that of a child, normally good-natured and cheerful, but subject to sudden fits of emotion and passion

during which he is capable of performing acts of singular atrocity, impressionable, vain, but often exhibiting in the capacity of servant a dog-like fidelity which has stood the supreme test" (Chisolm 1911, 344–5). In making use of the Western stereotype of the childlike African, the film comments on the seductiveness of the glittering "toys" of western technology, while at the same time criticizes those Africans who allow themselves to be seduced, clearly signified in both Demba and his unwavering belief in the white priests' "utopia," and the MP character, who was at one time himself a villager (he thanks the village men for their support that allows him to be a MP).

SELF-DISCOVERY

One of the major themes in *Saaraba* is the search for an identity (represented by Tamsir's search for identity) that is free from Western ideologies, a common theme in African film. When Tamsir first arrived back in Dakar, his father told him that "tradition determines your identity" as Tamsir searches for a way to reconcile his years in Paris with the negative things he sees in Dakar, particularly the number of beggars and the wide gulf between poverty and wealth. Poverty is frequently juxtaposed against wealth in *Saaraba*—shanty town/modern highrise, village/city, mechanical/horse and cart, literacy/illiteracy.

The film seeks to complicate the binaries between poverty and wealth, tradition and modernity, and explores technology's place in the construction of these matrices. Finding identity may mean searching for, and achieving, a healthy balance between multiple and layered forms of tradition and modernity. In one particularly significant segment of the film, the death of Tamsir's father, technology and tradition become intertwined with desperation and death in Tamsir's search for identity.

The scene opens with Tamsir's dying father being "rushed" by mule-cart to catch the train that will transport him to the hospital (despite the MP's "donation" to the village of a German-made ambulance). As Tamsir cradles his father's head, his father asks if Tamsir has "found his tradition." Tamsir says yes, but much is still a mystery. Tamsir explains, in part, that the "technology of white people seems inseparable from our day and age." The film then cuts to the cow herder, Alpha Yoro, who holds a knife over his sleeping daughter. In voice over, he explains that he must kill her as a sacrifice to the gods in order to save his dying herd.[2] He holds the knife with two hands and slowly raises it over the child's head. The film cuts back to Tamsir and his father, who tells Tamsir that the world has become more complicated and that is why it is "better to resemble one's day and age, rather than one's father" and that while it is important to know one's traditions, "no matter what you inherit from your

father you'll never be like him." This statement serves a dual purpose: it allows Tamsir to embrace both modernity and tradition, and it functions as a parallel reference to the European colonial "fathers" who left their colonized "children" to fend for themselves when they pulled out of Africa: postcolonial societies have been unremittingly battered by Westernization ever since that time, yet cannot, and should not, be like their colonial "fathers."

These polysemic "death" scenes put to the forefront the poverty of the villagers' material condition. While Tamsir's father dies because of the lack of modernity, Yoro's daughter is saved by that modernity (the motorbike that allowed Demba to reach them in time). For Demba, the motorbike, a utopian artifact, reinforces his singular belief in the beauty and perfection of Western technology. For Tamsir, however, the lack of modern technology (access to an ambulance and medical care) intensifies his conflicted dual identity: Westernized, yet empty of any meaning vs. poor villager easily duped by false promises. The complexity of negotiating identity (individual as well as cultural) within both traditional and modern society is compellingly exposed in *Saaraba*. The film does not offer a simple answer.

It is central to the film that science and technology (particularly regarding health care) be portrayed as real conditions with real effects that are positive and that tradition cannot always substitute for the advances of science, but it is the lack of *access* to those technologies that the film criticizes, while at the same time refusing the idea that Westernization-through-technology is the only way to achieve modernity. The film offers a compromise between technologies, presenting to the spectator the reality of social *choice* for which technologies benefit Africans (the ambulance) while preserving African cultural distinctions, and those technologies which are detrimental to the social dynamics and values within African societies (such as ignoring family to watch television).

The film cuts back to the Alpha Yoro, who begins to bring the knife down on his sleeping child. Demba quietly appears behind and stops him, removing the knife from Yoro's shaking hands. The film cuts back to Tamsir and his now-deceased father and the cart (which had missed the train—signaled by the long, mournful train whistle in the background) slowly turns back toward the village. As Tamsir cradles his dead father, Alpha Yoro speaks in a voice-over, explaining that the village witch doctor (representing tradition) had told him the only way to save his herd (from destruction by drought and modernity) was to sacrifice his child. The moment is visually significant in that the metaphorical "death" of tradition is cradled by the "modern" and together they move slowly towards a place (the village) that is the site of ongoing struggle for supremacy between them both. Tamsir's father died because of the lack of technology (symbolized by the ambulance, which would not transport Tamsir's father, and a child was saved by technology (symbolized by Demba arriving on his motorbike). Here the complex interconnectedness of a lack of

knowledge (the witchdoctor's remedy) within tradition is juxtaposed by the lack of available technology available to all that could save lives. Demba's motorbike, on which he labored by himself, allowed Demba to arrive in time to save Yoro's child, but the ambulance, a gift from the fully Westernized MP, was full of promise but did not deliver. Technology in *Saaraba* becomes the vehicle (represented literally as a *vehicle*) for cultural reconciliation of the local with the global forces of modernity that threatens their way of life: careful choice allows freedom.

From the film's beginning, Tamsir seeks to find his identity which vacillates between the lure of European modernity and the densely textured authenticity of village tradition. In contrast, Demba believes utopia—Saaraba—is where he will find his identity. For Demba, white technology, is the answer to all questions and all problems. The West's attempts to alter the African identity are a means of reshaping African culture into the Western image in order to "guide" her progress towards a capitalist, materialist market economy that will support the West's corporate interests, where "rapid changes in technology and associated developments in social practice can only be described by a reformulated evolutionary theory, a theory of biotechnical evolution" whose sole purpose is profit, become a significant theme within Tamsir's search for identity (Winner 1997, 999). Ultimately, the film's comment on identity recognizes in technology "the power fantasies of late-twentieth-century American [white] males. . . . [who] envision radical self-transformation and the reinvention of society in directions its devotees believe to be at once favorable and necessary"(Winner 1997, 1005). But as the film's final scenes show, Tamsir and Demba's search for Saaraba symbolizes a much different direction than towards a Western vision of techno-utopia.

SAARABA AND THE END OF THE WORLD AS THEY KNOW IT

During the festival scene where the village is celebrating with music and dance the anticipated arrival of electricity, sanitation, and water (symbolizing technology and modernity), Demba finds Tamsir and tells him his bike is now working and they can go find Saaraba. As during the scene with Tamsir's father, the film cuts to a parallel narrative. The government agent is leaving the festival in his car. The film cuts back and forth between the car carrying the government agent, and Demba and Tamsir on the motorbike, both vehicles are driving on steep, twisting, turning roads. Demba and Tamsir top a hill and Demba stops to take a look to get their bearings. It is night and the camera captures Demba's view of the myriad of lights that spread out in front of him—the lights from the city, from the factories, and the moving lights of cars on the highway. The next shot is an extreme close-up of Demba's wild-eyed face as he smiles and says "Saaraba" over and over, laughing hysterically.

He is backlit in deep blue, and his face resembles a rabbit caught in the headlights as he is mesmerized by the "technology" below him. The film cuts to the government representative who, filled with food and drink, is fighting sleep as his car speeds along. He finally loses control and the tires squeal (foreshadowed by the similar scene on the TV at the film's beginning) as his car skids off the road, down an embankment, and comes to rest against a tree. The film cuts back to Demba who has started his motorbike and in his exuberance to reach Saaraba, speeds off down the hill towards the lights and what he believes to be utopia. He speeds down the hill, repeating "Saaraba" over and over, misses a turn, skids off the road, and both Demba and Tamsir fly off the bike. The camera then shows a close-up of the bike, wheels spinning slowly, and the headlamp slowly fading until it goes dark—visually reaffirming that technology is a dead end.

The final scenes demonstrate the complexity and irony, in the search for an identity—individual and national—that unites traditional with modern. The film then cuts to the government representative who is being removed from his car by medical personnel: the German ambulance he donated to the village, waiting to take him to the hospital. This scene presents a stark contrast to the mule cart used to transport Tamsir's dying father. The film next cuts back to Tamsir cradling a dying Demba, whose shattered body reflects his shattered illusions of technology's ability to transport man to paradise. Tamsir, crying, tells Demba not to worry, that they will find Saaraba. Demba's final words reflect the film's dual message of the hope and betrayal of Western technology: "[I] found it already. I am in Saaraba. Man needs his fellow Man. If you fight for humanity, and for your fellow man, you'll go to Saaraba." A melodramatic ending by Western standards perhaps, but Demba's final words and the image of the broken motorbike and car carry a complex message—do not depend on white technology to save you; Africa must depend on and construct herself and her own technology, her own utopia. Utopia *for Africa* is not the Western ideal (that is itself illusory), and the pursuit of an ideal standard that does not reflect the true consciousness of Africa will lead to death.

Yet, technology in *Saaraba* is not itself viewed as incompatible with African society, but, rather, it is the lack of the available machines and technology and their equitable distribution that is incompatible with African communal ideals. That the ambulance responded to the government agent and *not* to Demba and Tamsir's accident—and earlier, was not available to take Tamsir's father to the hospital—foregrounds that the negotiations with Western technology within African political structures are one-sided and elitist. As Harding argues "not only are the benefits and costs of modern science distributed in ways that disproportionately benefit elites...but science's accounting practices are also designed to make this distribution invisible to those who gain the benefits" (Harding 2006, 46). If modernity is to become a part of African culture its benefits must be class and color blind—it

must be made available to all people, not just to those in power or in government. In the film, Saaraba is a place where machines, technology, and science should work for ALL the people.

CONCLUSION

The "political unconscious" of science is imbued with assumptions about the truth-seeking abilities of science which has become, in part, the basis for universal ideologies and what Harding calls the "unity thesis" of modern science: "The unity thesis overtly makes three claims: there exists just one unified world, one and only one possible true account of that world ('one truth'), and one unique science that can piece together the one account that will accurately reflect the one truth about the world" (2006, 137). In the pursuit of techno-utopia, the unity thesis describes a science that could be seen to function like a Lacanian *objet a*, a desire that is continuous because it can never be attained, a desire the West counts on in its unending influx of media that showcases the miracles of science and technology products. For Demba, Saaraba is the unattainable *objet a*, the technological teaser, the promise of an easy life that the machines, like the motorcycle, represent. Ironically, Demba spends the majority of the film "working" on the motorcycle in order to make it function, a labor that he does not equate with machines in general, and a labor that certainly contradicts his insistent belief in the utopian machines of Saaraba. The possession and seeming conquest of the motorcycle gives Demba a false sense of scientific attainment, a quasi-utopian feeling that fuels his desire for the fabled technology of Saaraba, and the "land of plenty," while ignoring his own participation in creating a working machine. Demba unconsciously moves towards modernity through his technical knowledge, yet his wild race towards a false and *idealized* modernity causes his death.

For Tamsir, however, his witness to tradition's impotence highlights the benefits of the modernity he initially considered turning his back on. Tamsir is then himself impotent, unable to save Demba after the motorcycle crashes. The film's final scenes show Tamsir cradling a dying Demba, as he had recently cradled his father, while the MP (whose car crashed at the same moment as Demba and Tamsir) is placed in the donated ambulance and attended by a doctor, discombobulates any notion of the film privileging one view or the other. Modern technology kills and saves with equal vigor.

But Western-dominated science and technology in Africa is not an indigenous entity. It is a colonizer with objectives that ultimately do not intend to advance Africa as a continent but to exploit African people's desire in order to fill the coffers of the Western corporate elite. Rather than an influx of humanitarian science and tech-

nology projects, Western corporate-sponsored scientists decide "which aspects of nature modern sciences describe and explain, and how they are described and explained, [and] have been selected in part by the conscious purposes and unconscious interests of European expansion. . . . Thus, culturally distinctive patterns of both systematic knowledge and systematic ignorance in modern sciences' pictures of nature's regularities and their underlying causal tendencies" (Harding 2006, 43) tend to produce an African challenge to the West's monopoly on science and technology.

Science as a practice in Africa is, according to Coetzee, "just as 'externally oriented' as economic activity [in Africa is], serving Europe rather than Africa. The integration of traditional knowledge into the world system of knowledge has set Africa in a position of underdevelopment and backwardness in relation to Europe" (2002, 551) that has so far been difficult to transcend. Coetzee believes science and science study in Africa tend to support the unity ideal that Harding earlier referred to and, perhaps in consequence, within African popular culture images of science and technology translate as an insistence that "science speaks in a monologue, thereby elevating [a type of] authoritarianism to a social ideal, when [science] asserts that it is desirable for everyone to acknowledge the legitimacy of one culture's [i.e., the West] claim to provide the one true account of the world" (Harding 2006, 123). M. B. Ogunniyi (1988) argues that the "African concept of causality, chance and/or probability is based upon a different logic than that of [Western] science" (3–4), which does not always support the Western science's profit-driven model. For Ogunniyi, Western science is less concerned with people than African science (4). According to Coetzee, "Scholars in Africa have done a kind of 'mental extroversion,' choosing research programmes answering only to the expectations of the metropolitan worlds. So theoretical work done in Africa has become bound to 'a kind of insularity' in the sense that the research done by Africans in Africa does not answer to the needs and concerns of Africans. The result [has been] African scholars [whose] scientific endeavors in Africa are put in the service" of the metropolitan West and multi-national corporations whose profits do not stay in or benefit Africa (Coetzee & Roux, 2002, 551). The "mental extroversion" of scientific research Coetzee describes possibly functions to inhibit choices to seek innovations that are culturally inspired and instead, may push some African scholars and researchers into an increasingly narrow critical space from which "the promise of humane, voluntaristic, self-conscious, democratic, social choice-making in and around technology" that would benefit Africans instead forces many researchers [to] . . . cast their lot with ideas that reject or even mock choice-making of that kind" (Winner, 1997, 1000) in order to at least participate in a viable way within the scientific arena. Despite the West's apparent domination of science practice, there is a vibrant and rich science community within Africa. Yirenkyi Lamptey argues, in agreement with

Ogunniyi, that it is a difference in the approach and methodology of African science that the West cannot understand (2008, 70). Lamptey views Western science as less effective than African science because Western science discounts and ignores the spiritual aspects of the natural world in sole favor of the empirical. Such dismissal of the spiritual affects the questions those scientists then ask and the methods they use in order to discover the answers. In Lamptey's view, African science is more of a true science. Yet, African science struggles for recognition and support, as Natasha Gilbert reports. At the 2009 G8 summit held in Italy, while the agenda on Africa included such items as "tackling the effects of climate change and safeguarding biodiversity," it did not address support for African science. Mohamed Hassan, director of the Academy of Sciences for the Developing World, stated that "African governments have to put their house in order first" before investment in African sciences can be encouraged (qtd. in Gilbert 2009, 16). Such condescension is typical of the West's view of Africa, despite the many scientific discoveries by African scientists.

The film *Saaraba* points out that for the MP and other corrupt African elites like him, utopia achieved through duplicity and a charlatanism that takes advantage of consumer trust and lack of technical/mechanical knowledge may actually result in dystopian material conditions (paralysis) for those who believe the illusion of modernity-as-savior (a dystopia that is prefaced by the film's earlier framing of the shanty town across the highway from modern high-rises). It is no "accident" that it is the MP who is "saved" by the modern ambulance, though he is seriously injured (the film hints that he is paralyzed, an allusion to the paralytic velleity of government promises). The MP achieves nothing but his own "corruption" (framed as his physical paralysis). He delivers convincing government-sponsored discourse (like the white priest) but does not follow with any action. As *Saaraba* shows, "to an increasing extent, the technological world of the late twentieth century is one [where] everyone is made to feel expendable" (Winner, 1997, 994). And for the dominant Western science/techno government (and corporate) elite (the MP), the most expendable are those people (Demba) who are charmed by miraculous images into believing Western science is the only way to truth and enlightenment, to paradise on earth. In *Saaraba*, it is the unity of the spiritual with the empirical that is at the core of what Tamsir seeks, and what Demba learns in the last moments of his life. Modernity CAN save, but it must be a modernity achieved on Africa's terms, not the West's.

Films like *Saaraba* interrogate Western cinematic images of perfection-through-technology and unmask the utopian illusion cast by Western images of magical gadgets and digital fantasies, of the desire for a life without effort or creativity, to reveal instead the reality of the dystopian social conditions of isolation, inhumanity, selfishness, corruption, greed and apathy that modern technology can bring. The film

weaves an intricate polyrythmic web of interconnections between modernity and tradition that cannot be easily separated. Perhaps a utopian society may be achieved if a cultural balance is struck between science/technology and humanity/community. As O'Har argues, "what is the point of [the efficient technological] social order? Control and conformity," rather than technological use that elevates the material conditions for *all* people. Cinematic images of technology-as-modernity then become a hegemonic device for the West. Colonialism is masked in a new package (images of technological utopia) and presented to Africa by the old colonizers—a "utopian" ideal society where all is (Western) mechanized perfection (2004, 482). In the end, *Saaraba's* message is to engage u in reflection about a careful and thoughtful choice: Africans must choose to incorporate technology for broad social benefit and deny the corrupt Westernized individuality that segregates technological access to only the "elite." As Tamsir learns to integrate both modern technology and traditional values in his search for identity, so must Africa learn to integrate Western technological advances with traditional communal concerns. As Demba says, "man needs his fellow man. If you fight for humanity, you'll go to Saaraba."

NOTES

1. Though Lang's film is in black and white, subtle shades of gray and black are still used in such a way as to be visually representative of the different classes—worker as dark and thinker as white.
2. During the village meeting about the electricity and sewage systems, Alpha Yoro is desperate to save his herd which is dying from the drought. His herd is his only source of wealth or living, and he does not understand the desire of men to "give up their freedom to herd" in order to be slaves to a boss. For the herder, the capitalist system is tantamount to death.

REFERENCES

Banks, A. J. (2006). *Race, rhetoric, and technology.* Mahwah, NJ: Lawrence Erlbaum.
Chisolm, H. (1911). *Encyclopedia britannica.* Google books (pp. 344–345). Retrieved from http://books.google.com/books?id=PSGqT_wYSrsC&pg=PA344&lpg=PA344&dq=hugh+chisol m+encyclopedia+britannica+negroes&source=bl&ots=IggCfuzL7w&sig=MqmYAbTc1VaWuvPw 2aUaAqkn03M&hl=en&ei=VvTzS7mvLaPAM9GnjfMN&sa=X&oi=book_result&ct=result&res num=1&ved=0CBgQ6AEwAA#v=onepage&q&f=false
Coetzee, P. H., & Roux, A. P. J. (Eds.). (2002). *The African philosophy reader.* New York: Routledge.
Freire, P. & Macedo, D. (1997). Scientism as a form of racism: A dialogue. In J. L. Kincheloe, S. R. Steinberg, & A. D. Gresson III. (Eds.). *Measured lies: The bell curve examined* (pp. 423–432). New York: St. Martin's.
Gilbert, N. (2009). African science drops down G8 agenda. *Nature News, 460*(16), 16. Retrieved from www.nature.com
Harding, S. (2006). *Science and social inequality: Feminist and postcolonial issues.* Chicago, IL: University of Illinois Press.

Kincheloe, J. L., & Steinberg, S. R. (1997). Who said it can't happen here? In J. L. Kincheloe, S. R. Steinberg, & A. D. Gresson III (Eds.). *Measured lies: The bell curve examined* (pp. 3–47). New York: St. Martin's.

King, J. E. (1997). Bad luck, bad blood, bad faith: Ideological hegemony and the oppressive language of hoodoo social science. In J. L. Kincheloe, S. R. Steinberg, & A. D. Gresson III (Eds.). *Measured lies: The bell curve examined* (pp. 177–192). New York: St. Martin's.

Lamptey, Y. (2008, June). African science v. western science. *New African*, 70–75.

Minden, M., & Bachmann, H. (2000). *Fritz Lang's* Metropolis: *Cinematic visions of technology and fear.* Rochester, NY: Camden House.

"The Negro" 1911 *Encyclopedia Britannica. The Bell Curve Debate* Eds. Russell Jacoby and Naomi Glauberman. New York: Random House, 1995. p. 438–439.

Ogunniyi, M. B. (1988). Adapting western science to traditional African culture. *International Journal of Science Education, 10*(1), 1–9.

O'Har, G. (2004). Technology and its discontents. *Society for the History of Technology 25*, 479–485.

Rhines, J. A. (2003). Agency, race, and utopia. *Socialism and Democracy, 17*(2), 91+.

Sarich, V., & Miele, F. (2004). *Race: The reality of human differences.* Boulder, CO: Westview.

Tyson, S. (2001). Technological utopias or dystopias: Is there a third way? *Social Alternatives, 20*(1), 15+.

Winner, L. (1997). Technology today: Utopia or dystopia? *Social Research, 64*(3), 989–1017.

Towards a Black Science Fiction Cinema

The Slippery Signifier of Race and the Films of Will Smith

STEPHANIE LARRIEUX

IN AN ONLINE CHATROOM INTERVIEW IN 2001, FAMED AUTHOR OF SPECULATIVE literature Nalo Hopkinson was asked to comment on the current status of Black representation in science fiction. She acknowledged the genre's efforts to disengage from the historical representational practice of what scholar Adilifu Nama refers to as "structured absence and token presence," in which "Black people are missing, or if they are present, they are so extremely marginalized and irrelevant to the narrative that they are, for all intents and purposes, invisible" (Nama, 2008, 10).[1] Hopkinson credited the growing contributions of Black authors of science and speculative fictions, for example, Octavia Butler, Samuel Delany, Tananarive Due, and Steven Barnes, among others for redressing structured absence and token presence in the literary arts. With respect to Black representation in science fiction film and television, however, Nalo Hopkinson expressed her frustration with what she identified as the genre's continual retreat from portraying complex and diversified Black cultural experiences and perspectives. With an admittedly small pool of science fiction films and television programs to choose from that featured Black people or interests, Hopkinson focused specifically on the work of actor Will Smith:

> Then there was Will Smith in *Wild Wild West* (1999), a total piece of fluff as a movie, but the really wonderful thing about Smith is that as soon as you put him in film, there goes your color blindness. Even the way he moves brings an African sensibility to the work. *Independence Day* (1996) had tons of problems, but Smith played his character as a Black man. He did the same in *Men in Black* (1997). (Glave, 2003, 156–57).

What is most intriguing about Nalo Hopkinson's comment is how it articulates the salience of race and racial identity. Her observation suggests that it is not only significant that Will Smith is cast in lead roles, but that he also performs the roles unequivocally as a Black male.

Will Smith himself noted the challenges of navigating the complexities of race as a Black actor in Hollywood. He spoke candidly about his personal experiences with respect to preparing for his role as James T. West in the Barry Sonnenfeld film adaptation, *Wild Wild West* (1999). In a conversation with the director, Smith recounted:

> I said to Barry, 'I've seen the TV show, and there are a few subtle differences between myself and Robert Conrad.' Barry said, 'You're taller and no one is going to notice.' I said, 'Barry, I'm black.' And he said, 'No one knows you're black!' I told him that I think a couple of people might have noticed that (Longsdorf, 1999, Y01).

Smith's commentary identifies race as an indelible and positive marker of identity, whereas Sonnenfeld's neutralizing remark, "No one knows you're Black," exhibits the very sort of colorblindness that both Nalo Hopkinson and Smith critique. In this instance, Black identity in science fiction film is rendered simultaneously readable and inscrutable, seen and unseen, acknowledged and disavowed. The contrast between Hopkinson, Smith, and Sonnenfeld's perspectives hence begs the question, does Will Smith's cinematic representation refute or promote colorblindness? The answer, arguably, is both.

Will Smith—notable actor, producer, writer, and musician with an extensive dossier of credits and accolades—has the special distinction of being one of most prolific and successful actors of Hollywood cinema. As only one of a handful of active Black male lead stars in Hollywood in general, let alone in science fiction film, Smith has significantly influenced the genre of science fiction film with a remarkable number of blockbusters over the past fifteen years. His popularity with contemporary audiences aside, Smith's science fiction films extend beyond mere entertainment. Smith's work not only begins to redress the issue of structured absence and token presence, but it does so in ways that make a substantial contribution to the diversification of visual and narrative representations of Black cultural identity and sensibilities in popular culture. A Black man in the position to save the world from annihilation, which is the narrative basis of all of Smith's science fiction films, is new for Black cinematic representation. Smith's successful reprisal of the trope through the characters he plays is evidence of mainstream acceptance of expanding notions of Black subjectivity.

Several factors have contributed to the emergence of Will Smith as the preeminent Black science fiction film star. The star himself identifies his abiding sense of self that was established early on through his disciplined upbringing, personal determination, and good timing as the keys to his success navigating the predom-

inantly white Hollywood entertainment industry as a Black man. This chapter seeks to identify and engage the specific socio-cultural and historical factors at play that have facilitated Will Smith in performing lead roles distinctively as a "Black man" as well as racially neutral characters. It examines the circumstances that have enabled Smith to perform in a fashion which either foregrounds or eschews but that does not debase his Black identity, despite the persistence of structured absence and token presence in science fiction film and television. Furthermore, the chapter is concerned with how the science fiction films of Will Smith not only contribute to the genre but also the specific ways in which Smith's performances expand or further cement the archetypes of Black cinematic representation. Ultimately, the essay argues that the collection of Will Smith science fiction films—*Independence Day* (1996), *Men in Black* (1997, 2002), *Wild Wild West* (1999), *I Robot* (2004), *I Am Legend* (2007), and *Hancock* (2008)—offers nuanced interpretations of historical experience and diversified representations of Black identity.

WILL SMITH—THE RISING STAR: HOW THE MAN BECAME LEGEND

Willard Christopher "Will" Smith, Jr. was born on September 25, 1968 to refrigeration engineer Willard, Sr. and his wife, a school board administrator named Caroline of West Philadelphia, Pennsylvania. The couple's first-born son grew up in the middle class Black community of Wynnefield along with his three siblings—older sister named Pam, and younger twins Harry and Ellen (Marron, 2000). Smith attended a predominantly white Catholic elementary school before attending Overbrook High School—a public institution that largely served the local Black population. The stark distinctions between the two educational environments and the experiences they afforded Smith undoubtedly informed how he established himself as a crossover artist later in life. The formative experience of first attending Our Lady of Lourdes Elementary, then Overbrook for high school yielded a type of racial awareness that infused his comedic talents. Brian Robb's biography quotes Smith recalling his time in school:

> I went to school with all white people for nine years and then all black people for three years. Comedically, that helped me, because I have a great understanding of what black people think is funny and what white people think is funny. I'm able to find the joke that everyone thinks is hilarious, the record everyone thinks is moving, or a great dance record—walking that line where it's very specific to everyone, but universal at the same time. I think that transition is what helped me bridge the gap, because that's what my success has been about: bridging the gap between the black community and the white community. Black people enjoy comedy about the way the world is, while white people enjoy humor about how the world should be (Robb, 2000, 14).

Smith credits his success in part to the support of his close-knit family and an unrelenting work ethic that was instilled in him as a youth. His signature self-confident demeanor and charm, he admits, hail from a combination of sheer determination and a fear of failure. In an interview with *Parade Magazine*, Smith remarked, "I've always had a horrible fear of not achieving. I think that comes from my relationship with my mother and especially my grandmother, who believed I could do anything. She held me in such high esteem that I never wanted to fail her. She and my mother were central in my life" (Rader, 2004).[2]

Smith expressed an interest in becoming an entertainer early in childhood. His grandmother Helen Bright often volunteered her grandson to perform in the pageants at her Baptist church. Smith regularly opted to participate in talent competitions and DJ house parties in the neighborhood. He also elected to play the role of the class clown in school whenever possible. Though a precocious youth, it became clear before long that formal education held little appeal for Smith. Even though his standardized test scores were enough to earn him a scholarship to the Massachusetts Institute of Technology, Smith would forgo attending college to focus on becoming a full time performer (Maggie Marron, 2000, 12).

Will Smith's entertainment career first began in the music industry. He cultivated his penchant for music early in high school where he wrote and performed rap rhythms and rhymes in the 1980s. At age 16, while rap music was transitioning from being an inner-city phenomenon to a mainstream enterprise, Smith collaborated with childhood friend Jeffrey Townes to form the rap duo D.J. Jazzy Jeff & the Fresh Prince.[3] They released their first album titled *Rock the House* two years later in 1987, which generated the hit single "Girls Ain't Nothing but Trouble." The success of the single inspired a second album in 1988—*He's the DJ, I'm the Rapper*. The album's catchy, upbeat rhythms, humor, and radio-friendly positive lyrics proved a successful formula. Not only did the album sell more than three million copies, but its most successful track, "Parents Just Don't Understand," earned the duo the first-ever Grammy awarded to a rap artist later that year (Rader, 2004). Despite commercial success, however, some critics and other rap artists in the industry dismissed the music as "suburban rap," claiming that it was too clean-cut, fluffy, or lightweight, and not reflective of the contemporary inner-city Black experience that hip-hop sought to express. Smith's music consciously shunned the glorification of violence, drug use, misogyny, and other negative characteristics associated with the form (Nickson, 1999, 4). In defense of his wholesome image, Smith stated:

> When I came into the rap world, I didn't want to go in the direction it was headed. I've always innately known that was wrong. I couldn't have my mother at work, and my record comes on the radio, and she hears, 'Look at that ass, mama,' or something (Rader, 2004)...I just never want my family to be embarrassed like that (Robb, 2000, 5).

By his late teens, Smith was a multimillionaire. He fell into financial difficulty in his early twenties when he overspent his fortune, and the third Jazzy Jeff & Fresh Prince album *And in This Corner* flopped. Greatly indebted to the Internal Revenue Service, Will Smith, on the brink of bankruptcy at age 21, was forced to regroup and reinvent himself. The opportunity to do so came through television.

Smith's previous success in music helped him make the transition to the medium of television when he landed the lead role essentially playing a fictionalized version of himself in NBC's *The Fresh Prince of Bel-Air*. The comedy about the antics of a wisecracking, street savvy, "fish-out-of-water" teen from Philadelphia who is sent to live with wealthy relatives in California, ran for six seasons from 1990 to 1996. Smith recounts, "I was one of the first of the hip-hop generation on television, so there was a sense of wonder if it was going to translate, about how America would accept this hip-hoppin,' be-boppin,' fast-talking kind of black guy" (Robb, 2000, 45).

DJ Jazzy Jeff also participated in the show but only on and off for a few seasons in the beginning. With Smith garnering more and more attention on his route to becoming a multimedia superstar, the rap duo amicably disbanded by the mid-1990s after recording the lukewarmly received album *Code Red*. This was also the time in which Smith met and after three years divorced his first wife, Sheree Zampino. The marriage produced a son in 1992, Willard C. Smith, III (also known as Trey). Smith remarried in 1997 to actress Jada Pinkett and fathered two more children, Jaden and Willow.

Not all of the attention Will Smith attracted during this period was positive. He continued to weather the swath of criticism that claimed he was too generic, too accommodatingly apolitical, or outright not "Black" enough. In response to his critics, Smith replied, "I don't think anyone can dictate what's Black and what's not Black....My point of view isn't limited. It's very broad. It's more than the Black experience" (Nickson, 1999, 31–32). Smith biographer Chris Nickson offers a compelling analysis of the performer's artistic work. Of Smith's music, Nickson writes, "What the Fresh Prince offered in his rap was entertainment, geared at a generation rather than a color. He offered universals, not specifics, and appealed every bit as much to whites as to Blacks. There was nothing that threatened the power structure, nothing even to cause offense" (Nickson, 1999, 4). Nickson extends a similar critique to Smith's television work on *The Fresh Prince of Bel-Air*, "It offered an 'edge' of sorts, but one that was largely blunted. It never tried to proclaim that it was from the street or the ghetto—places that had never been part of Will's past, either in fact or fiction. It was designed as primetime entertainment, nothing more or less, and that meant that its mission was to appeal to the largest possible number of people" (Nickson, 1999, 4).

The success of *The Fresh Prince of Bel-Air*, whose popularity rivaled that of *The Cosby Show*, solidified Smith's appeal with wide-ranging audiences and secured his star status. Smith continued producing television and recording music throughout the 1990s, but as a solo artist. He successfully made the transition from television to motion pictures, enjoying critical acclaim with the breakout film *Six Degrees of Separation* (1993), and his follow-up hit *Bad Boys* (1995) co-starring Martin Lawrence, which established Smith as a bonafide action star. Having secured his acting credentials, Smith readied himself to tackle a new challenge—science fiction film.

THERE'S SOMETHING ABOUT WILL SMITH

Will Smith has acknowledged openly that his one of his greatest desires in life was to become one of Hollywood's biggest, most bankable actors. The criticism of his work may be in effect the bi-product of an admittedly carefully designed and purposely implemented work plan. In several interviews including *The Today Show* with host Matt Lauer, Smith conceded that his career path to date has been "meticulously planned and executed" (*The Today Show*, June 23, 2008), particularly with respect to the genre of science fiction film.

> During the years of *The Fresh Prince of Bel-Air* I studied entertainment thoroughly. Every step was a calculated step. For example, I looked at trends. I looked at the top ten movies of all time, and seven of them had creatures in them: *ET, Jurassic Park, Close Encounters of the Third Kind, Jaws*. It was like, okay, let's make movies that have creatures in them (Robb, 2000, 6).

Smith's career calculations paid off, earning him the nickname of the "King of the Fourth of July Weekend," since so many of his films have successfully debuted during the coveted time slot. Virtually all of his science fiction blockbusters opened during the summertime and earned in excess of hundreds of millions of dollars each upon initial release.

Smith's crossover success could not have been possible, however, had it not been for the trailblazing efforts of Black male leads such as Sidney Poitier, Harry Belafonte, and Denzel Washington. Washington in particular was initially looked upon to become the great breakout crossover Black star of the post-Civil Rights era. He possessed the talent to do so, but despite having made a variety of movies including ones in the science fiction film genre,[4] Washington was unsuccessful in producing a major blockbuster or, "one of those films that becomes the all-time top ten money-makers and embeds itself and its stars (for better or worse) in the national consciousness" (Nickson, 1999, 1) the way Will Smith has. What is it specifically about Will Smith that has enabled him to succeed in the science fiction

film genre where others have either failed or had limited success?[5] The answer lies in the calibration of Smith's image.

Smith's onscreen persona is a combination of the boy-next-door image with a slight outspoken irreverence whose edge is most often smoothed away by humor. His characters and performances exhibit a Black subjectivity that is composed partly of the upstanding exemplar a la Sidney Poitier, but that also embodies the swagger of the no-nonsense badass hero of the blaxploitation film tradition (i.e. Richard Roundtree of *Shaft*), and finally infused with the impeccable comic timing and brashness of the likes of Eddie Murphy—a notable stylistic influence on Smith's craft. "Eddie is the only person I ever imitated," Smith confesses. "He inspired a generation of Black comedians, in the same way that Richard Pryor had" (Robb, 2000, 46). Smith's performances, as Adilifu Nama describes, "laid the groundwork in the 1990s for a more central, defiant, and charismatic version of black cool to enter the science fiction film genre...Will Smith's cool-guy persona enabled him to explore new worlds and to go places where few Black actors have ever gone before" (Nama, 2008, 39).

Smith's mere presence onscreen ensures a heightened visibility of black identity. As Smith explains, "I love the fact that I'm Black in Hollywood. When you're the underdog you can say anything, you can do anything, because you're not expected to win. You have absolutely nothing to lose. Leonardo DiCaprio has a more difficult time staying in his position than I have staying in mine because, well, I'm not expected to be here in the first place" (Robb, 2000, 7).

On the one hand, Smith's cool persona essentially allows him to play a new kind of character in the lexicon of Black cinematic imagery—that of the ordinary black man called to do extraordinary things. As Jan Berenson suggests, what is truly remarkable about Will Smith's success is that "he's done it all by himself smashing stereotypes and managing to stay squarely in the hearts of the American public. Simply put, people like Will Smith. He makes us laugh; he's made us care about his screen characters and about himself. We feel for him, we laugh with him, we root for him" (Berenson, 1997, 2).

On the other hand, however, the cool-guy formula results in a non-threatening type of Black masculinity. Smith still plays an ordinary man called to do extraordinary things, but one whose racial identity is merely incidental. *Men in Black* director, Barry Sonnenfeld, said of Smith "His self-confidence is so winning that you want to hang out with him, you want him to teach you how to be like him" (Marron, 2000, 8). Smith's performances thus enable both white and Black audiences to temporarily forget the material conditions many Blacks face, for example, decreased economic and educational opportunities, health disparities, and increasing incarceration rates among the male population. In this regard, Smith serves as

an example of how Black racial difference has been incorporated into dominant society, but in a way that renders it neutral. His tremendous commercial success is proof that racial difference has been made palatable. Being a "racialized Other" is now acceptable, acknowledged, embraceable, and even celebratory but consequently also potentially depoliticizing.

THE RIGHT (BLACK) MAN FOR THE JOB: MAKING HIS MARK ON THE SCIENCE FICTION FILM GENRE

Will Smith's representation of subjectivities distinctly marked as Black man as described by Nalo Hopkinson, creates potential opportunities for bolder articulations of Black identity as revealed through the heroic protagonists Smith typically portrays. Such representations broadly explore questions and themes of Black identity, particularly with respect to the invocation of the trope of saving the world from destruction. This narrative constant featured in *Independence Day* (1996), *Men in Black* (1997), *Wild Wild West* (1999), *I, Robot* (2004), *I Am Legend* (2007), and *Hancock* (2008) identifies Will Smith as the right (Black) man to get the job done well. Smith acknowledged the notion's groundbreaking significance and racial implications, "I was happy to be a Black man saving the world…Black people have been saving the world for years, only nobody knew it" (Nickson, 1999, 3).

Roland Emmerich's film *Independence Day* (1996) presented Will Smith with an opportunity to extend his range and develop as a major science fiction action star while attempting to forge new cinematic representations of Black identity. In the lead role of US Marine Corps pilot Captain Steven Hiller, Will Smith is charged with defending the world against hostile alien invaders. The original script of *Independence Day*, as with all of Smith's science fiction films, did not identify the protagonist as specifically Black. "It wasn't intentional," director Roland Emmerich claims. "It wasn't written like that…I talked to Will and he said, 'The script has no reference to it. Should we reference it?' I said, 'No, because you are a hero, period. It has nothing to do with your color, race, or religion'" (Robb, 2000, 86).

The casting of a Black male as the lead, however, was significant, particularly given the time of the film's production. *Independence Day* emerged in the wake of the Rodney King riots of the early 1990s, a period of renewed fractures and tension in race relations in the United States. Amy Taubin describes the film as:

> A feel-good picture about the end of the world, or rather about how the end of the world is averted by good men who put aside their racial and ethnic differences to come together in a common cause. It's the answer to Rodney King's plea in the aftermath of the LA riots: 'Why can't we all just get along?' We can, it seems, but only under the threat of an alien invasion (Taubin, 1996, 6–8).

The film offers an optimistic vision of America—one that highlights the country's capacity to band together to overcome trial and tribulation, with the affable, charismatic Will Smith at the helm. Smith recounts, "In the film, we as a planet are about to be annihilated and if we can't put our prejudices—our racism and sexism and all our 'isms'—behind us, then we will all be destroyed. So interestingly enough, the movie is about the unification of the entire world" (Robb, 2000, 91–92). This particular formulation, as Despina Kakoudaki asserts, "serves as a major incentive for the revival of humanist notions of community and patriotic identification" (Kakoudaki, 2002, 112).

Independence Day earned a record-breaking $83.5 million during its opening weekend (Nickson, 1999, 3). In addition to the film's special effects and visual spectacle, the film's grand success was largely attributed to Smith's performance of Hiller as the intelligent, driven, results-oriented, masculine, all-American serviceman. Reflecting on Hiller as a character, Smith stated, "He's interesting because he's definitely serious, but he's also able to be funny. I've never experimented with that before. It's either been one or the other" (Robb, 2000, 90).

One of the subplots of the film is Hiller's desire for professional advancement beyond the Air Force Academy. Questions of class rather than race come into play when Hiller is initially denied admission to the National Aeronautic Space Administration (NASA) because his girlfriend, played by Vivica Fox, is an exotic dancer. The opportunity for redemption comes through accomplishing the extraordinary task of saving the world from the invaders. Smith's character adeptly appropriates various forms of technology throughout the film. He expertly pilots planes, brandishes artillery, detonates bombs, and hatches brilliant plans all in effort of defeating the alien attackers and staking a claim that ensures a future not only for greater humanity, but more specifically for his Black future wife and her son.

In one scene from *Independence Day*, Hiller shoots down an alien attack ship in the desert. He exits his bomber, expeditiously approaches the alien creature and punches it in the face without uttering a word. The comic effect of the onscreen action endears the character to the audience. It also fully exposes the audience's embrace of Smith's image and this particular representation of Black subjectivity. Acceptance of Smith as the hero signals and affirms that traditional cinematic representations of black subjectivity in the genre of science fiction film that were previously relegated to the margins through structured absence and token presence have now migrated from the margins to the mainstream. Ultimately, as Amy Taubin argues, "*Independence Day* is proof that Black culture has become the sign of hipness, coolness and above all in-touchness not just for subversive types (from beatniks to skateboarders) but for the mainstream middle-class" (Taubin, 1996, 6–8).

Independence Day crowned Will Smith the "leader of the new cool." "It was one

of those projects that comes along once in a career. It has everything. You laugh, you cry, and it has action. It has an ensemble cast. It has everything you could ever want in a movie. I'm also probably the first Black guy to save the world" (Robb, 2000, 86). Audiences embraced Smith in the role of the world's savior and continued their exposure to this new articulation of Black subjectivity as revealed through the successes of Smith's next five films, all of which featured the same narrative trope. Reprising the role of the Black hero holds added significance for Smith, "I want to play positive characters. I want play characters that represent really strong, positive Black images. So that's the thing I consider when I'm taking a role after I decide if it's something that I want to do. At this point, I don't want to play a gangster, unless it's a role that has a different or more positive message" (Robb, 2000, 115). Smith's mission statement reveals a racial consciousness that actively attempts to thwart colorblindness through the use of positive Black imagery and representation, in spite of the potential for that same imagery to produce colorblind or racially neutral readings.

In *Men in Black* (1996) and its 2002 sequel directed by Barry Sonnenfeld, Smith plays the consummate smart aleck Agent Jay—a New York City police officer who is recruited by a secret government-like operation to monitor the activities of the aliens from outer space living on Earth. When the agency enlists a new member, the individual is stripped of all aspects of his/her identity, including name, date of birth, home, etc., and any other markers of the person's previous life. The veteran Agent K played by Tommy Lee Jones informs his novice partner Agent J in the montage sequence, where Smith's character is first outfitted in his new uniform and identity as a "Man in Black," that they are a part of an elite force that operates above and beyond systems of law. Smith's character coolly replies as he smoothes out his finely pressed suit and slips on his sunglasses, "You know what the difference is between you and me?...I make this look good."

Smith's characterization operates on two levels of racial subjectivity that exposes the slippage between colorblind and non-colorblind readings of his onscreen image. Agent J, in order to perform his duties at the bureau, must in no way stand out or attract attention to himself. The fact that he is the only black "Man in Black" working at the bureau, necessarily individualizes him, even when half of his colleagues are creatures from outer space. Hence, Smith's witty, cool-guy persona trumps the plot device of having to "blend in" in that it further accentuates his Black identity that he "makes look good."

Will Smith reprises the role of the self-possessed, confident, trustworthy, and resourceful man who delivers results, and who also happens to be Black, in all of his other science fiction films. *Wild Wild West* (1999) likely stands out as one of Smith's most racially explicit science fiction films to date. The film expressly foregrounds racial themes using humor. The film is peppered with references to slavery and Black

subjugation including the massacre of a Black free town called New Liberty. Will Smith plays Civil War hero and Secret Service agent Capt. Jim West, a debonair, trigger-happy, man of action, whose racial identity is routinely a topic of discussion. In an early sequence in the film, for example, there is an allusion to the "N" word made in reference to West that is uttered by one of the villains. West promptly dispenses with the villain before he can even finish reciting the epithet.

In another sequence, West accidentally gropes the bosom of a white woman at a costume ball in the South. As penalty for this indiscretion, the audience of white partygoers calls for West to be hanged. As the Southerners cart West off to be hanged, he quips with classic Will Smith comic delivery, "Never drum on a white lady's boobies at a big red neck dance...got it." West ends up using his wits and humor to delay the hanging just long enough for his colleagues to rescue him. Regarding the film's racial content, Smith stated, "I think we really pushed the envelope with that one. We have a comedy scene with a Black man standing in front of a noose. That's edgy" (Longsdorf, 1999, Y01). The film's hyper racial consciousness fully obviates any possibility for a colorblind reading. Virtually every aspect of the film accentuates the fact that Will Smith, as a Black man in the Old West, is a stranger in a strange land. In this respect, Smith performs the role distinctly as Black man precisely as Nalo Hopkinson observed.

Another Will Smith science fiction film that addresses racial themes but through dramatic metaphor rather than humor is *I, Robot* (dir. Alex Proyas, 1994). The film, an adaptation of an Isaac Asimov novel, depicts the city of Chicago in the year 2035. In this futurescape, robotic technology has been so fully integrated into society that robots practically outnumber humans. The robots, however, remain subordinate to humans, having been created specifically to serve as replacements for the human underclass. As a customized servant population, the robots are assigned a broad range of jobs that the human beings no longer wish to do themselves, including various forms of manual labor, construction, childcare, and domestic work. A montage early in the film details how the robots came to occupy their second-class social positioning in society.

In one sequence, a large shipping container is wheeled into a bustling downtown area full of people. The doors of the vessel open and the people crowd around to peer in at its contents. Inside is an arrangement of hundreds of tightly packed robots perched on hangers. The onlookers soon wave their money around in feverish demand for the products as the vessel operator commences auctioning the merchandise. In a matter of moments, virtually all of the robots are sold off like the commodities they were intended to be and carted away by their new owners. The robots suffer routine indignities at the hands of their humans, and before long, the robots band together and revolt. The robots institute martial law as part of the upris-

ing, and capture and execute their human masters. The insurrection is eventually repressed and human dominance is restored in the end.

The allusion to the institution of American chattel slavery in the sequence is unmistakable. The robots are auctioned off in a public square out of a vessel that resembles a transatlantic slave ship. They organize a rebellion in opposition to their exploitation and oppression, but it is inevitably quelled, not unlike the historical instances of slave uprising in the Americas.

In this film, Will Smith stars as Lieutenant Del Spooner—a police officer with a chip on his shoulder. Although his environment is distinguished by state of the art technoculture, Spooner opts for the simplicities of yesteryear, actively incorporating outmoded items into his quotidian experience as a postmodern proclamation against the technophilic nature of contemporary urban life. He routinely abstains from employing robot labor whenever possible. For example, he proudly dons vintage Converse sneakers and a leather jacket past its prime as a badge of honor, and rather than make use of the standardized auto-drive feature equipped in his flying car, Spooner prefers to drive in manual mode.

A self-proclaimed paranoiac skeptical of all change, Spooner grows wary over the course of the film of the exponentially expanding robot population and of human overdependence on robot technology. He brings this skepticism to his investigation of the murder of prominent robotics technologist Dr. Alfred Lanning (James Cromwell)—the original creator of the artificially intelligent domestic servants. Spooner soon discovers that Lanning, at the time of his death, was developing a sentient robot prototype capable of experiencing complex human emotions. The robot, called Sonny, identifies more as human than as robot and spends a great portion of the film trying to convince Spooner and others of this fact. Spooner, distrustful of all robot technology, accuses Sonny of being involved with the murder and sets out to prove it. Robot psychologist, a former colleague of the murdered scientist, [Dr. Susan Calvin (Bridget Moynahan)] assists Spooner in solving the mystery but not before she confronts Spooner about his hostility towards the robots.

It is eventually revealed that Spooner has personal reasons for working the case. His distrust of robot technology stems from an incident in which a robot, following the protocol of its programming known as the "three laws of robotics" elected to rescue Spooner rather than a little girl from a car accident after determining that Spooner had a greater likelihood of survival. The laws state 1) A robot may not injure a human being, or through inaction allow a human to be harmed; 2) A robot must obey any commands given to it by human beings unless the orders conflict with the First Law; and 3) A robot must protect its own existence as long as doing so does not conflict with the First or Second Law. Spooner regards the rescue robot's inability to override protocol and act independently to save the girl as a gross mis-

calculation and failure. Spooner's distrust of the robot technology is vindicated in the end when the robot slaves revolt and turn on their human masters, exacting revenge for their mistreatment and abuse.

Spooner's fixation on the murder case is explained by the fact that not only was the murdered scientist the innovator of robotics technology, but he was also integrally responsible for saving Spooner's life and career. As a result of the accident, the narrative reveals that Spooner's arm was amputated and replaced with a mechanical prosthesis designed by the doctor.

I, Robot arguably offers the most metaphorically complex racial reading of Will Smith's Black identity. Spooner is already marked as a marginalized subject in the film by virtue of the fact that he is African American. He is additionally marginalized by the fact that, for all intents and purposes, he himself is a cyborg. This disclosure is first revealed to the viewer at the end of a car chase scene when Spooner slams his fist into a wall, breaking off a large chunk of it without flinching. It is further explicated when a large scar on his shoulder is exposed during a shower sequence. In short, Del Spooner is literally composed of the very technology he abhors, and his visceral disdain for robotic technology signals a curious self-loathing at the core of his identity. In the end, however, as with all of Will Smith's science fiction films, order is restored as a result of his character's heroic sacrifice. In the specific context of *I, Robot*, the righteous hero restores order as a Black man.

In *I Am Legend* (dir. Francis Lawrence, 2007), Will Smith plays Dr. Robert Neville—a military virologist who is among the few remaining human survivors of a biological holocaust. A virus initially engineered as a weapon has turned humans into bloodthirsty maniacs. Smith's character, immune to the effects of the virus, takes on the responsibility of developing a cure before what is left of the human race becomes extinct.

I Am Legend is a remake of the 1971 science fiction film *The Omega Man* that stars Charlton Heston as Neville. The central premise of the original film and the remake revolves around the impact of isolation on the protagonist. *The Omega Man* is a racial allegory that attempts to explore new paths for forging coalitions between Blacks and whites at the tail end of the Civil Rights movement. In *I Am Legend*, the character's racial identity is treated as happenstance. Only a handful of visual or narrative signifiers of race highlight the fact that Smith is Black. For example, as the disorienting effects of isolation begin to set in, Neville attempts to hold onto his identity through song and the memory of his deceased wife and child. Neville adopts the music and lyrics of Bob Marley and intermittently invokes Rastafarian cosmologies to ground himself as he battles the mutant plague victims. For the most part however, what is represented to the viewer is an ordinary man (who happens to be Black) driven against all odds to save humanity. *I Am Legend* in this respect facilitates a colorblind reading of Black subjectivity.

In Peter Berg's 2008 film *Hancock*, Will Smith plays John Hancock, an unconventional superhero. Hancock possesses characteristic enhanced abilities including superhuman strength and agility, the capacity to fly at supersonic speeds, and rapid healing. Hancock is not the typical superhero in that he is a disaffected, vulgar, unkempt curmudgeon that is often intoxicated. Hancock's reckless behavior and boorish demeanor routinely alienate the residents of Los Angeles—the city he elects to protect. The general population thinks of Hancock as a jerk and a nuisance rather than hero and role model. Hancock eventually undergoes an image makeover with the help of Ray, a public relations executive played by Jason Bateman in efforts to regain the affections and appreciation of the public.

The character of John Hancock is a departure for Will Smith at first glance in that at least initially the protagonist is largely unlikable. As *Entertainment Weekly* movie reviewer, Lisa Schwarzbaum writes, "one of the feats Smith sets for himself in his latest attempt at Fourth of July box office superheroism is to apply his kryptonite-resistant personal likability to a character who is, at first glance, a real schmuck" (Schwarzbaum, 2008).

Indulging in the crudeness of the character gave Will Smith an opportunity to play against aspects of his own "meticulously planned and executed" archetype—at least temporarily. The climax of the film reveals that Hancock in fact is no ordinary superman—he is in actuality a 3,000-year-old god—a fact that he forgot about as a result of an 80-year bout of amnesia. The audience endures Hancock's unsavory behavior for the bulk of the film but is rewarded in the end once Hancock learns to be less destructive in deploying his talents in service of humanity, and Will Smith's signature disarming wit and charm emerges through Hancock's rehabilitation. Will Smith's cool-guy persona is restored and reliably the character does the right thing. Lisa Schwarzbaum reiterates, "there's no way on Hollywood's green earth Will Smith will ever play someone seriously, dangerously unsavory. Charm is the star's armor on either side of the alien-human divide, whether he's a Fresh Prince, a Bad Boy, a Man in Black, the last man alive in New York City, or Muhammad Ali" (Schwarzbaum, 2008).

At first glance, *Hancock* appears to offer a colorblind representation of Smith's racial identity, but the film does highlight his Blackness in one important context—that of the intimation of an interracial romance between Hancock and Charlize Theron's character, Mary—Ray's wife. Mary, who has suppressed her own super powers until she meets Hancock, reveals that she and Hancock were once married, but their union was a always a contentious one. Mary and Hancock were forced to defend their relationship against attack throughout the ages, most recently being eighty years earlier during a racially motivated hate crime that resulted in Hancock's amnesia. The flashback montage of the hate crime stands out as the major moment that draws attention to Will Smith's racial identity. Mary also discloses that paired

immortals lose their powers when they get too close to each other; therefore, it is in the best interest of the world that the two super humans live apart from each other. Hancock eventually relocates to New York while Mary stays on in Los Angeles with her family, and the two remain polar opposites.

Conclusion

Will Smith's body of science fiction cinematic work has made a major contribution to the modest but growing canon of Black science fiction cinema. According to trade publications such as *Variety* and *The Hollywood Reporter*, Smith is said to be in the development stage of producing prequels and/or sequels to several of his blockbuster science fiction films including *Independence Day II and III, Men in Black III, I Am Legend, I, Robot* and *Hancock* (Grossberg, 2010). The expansion of these franchises further solidifies Will Smith's status as a germinal figure of the science fiction film genre in general, but specifically with respect to Black science fiction cinema.

As this chapter has revealed, Will Smith's hyper visibility and indelible mark on the genre skate the line of facilitating a dynamic Black subjectivity as Nalo Hopkinson described, while also promoting a type of colorblindness that has enabled Smith's tremendous crossover appeal. But what are the greater implications of Will Smith's racial fluidity on the constitution of a distinct Black science fiction cinema? Smith unmistakably bears the marks of racial difference as communicated through his physical comportment and socio-political consciousness. His particular brand of Black subjectivity—one richly informed by the savior of the world trope—offers a new archetype in Black cinematic representation. The "racial interchangeability of his movie roles" (Robb, 2000, 114) in combination with Smith's non-threatening cool-guy persona, however, runs the risk of neutralizing the possibilities of producing lasting social changes, thereby potentially maintaining the status quo in Hollywood's representation of Black (male) subjectivity.

Notes

1. By no means is "structured absence and token presence" a novel concept for racialized subjects—W.E.B. Du Bois in the early 1900s articulated similar perspectives regarding the impact of the color line on American society in his germinal work *The Souls of Black Folk*.
2. Will Smith's parents divorced when he was 13 years old. Although he had regular contact with his father, Smith most of the time lived with his mother and maternal relatives.
3. The moniker "Fresh Prince" was based on Smith's childhood nickname.
4. Denzel Washington's science fiction films to date are *Virtuosity* (1995), *Déjà Vu* (2006), and *The Book of Eli* (2010).

5. Some additional examples of black science fiction performers and films include Rosalind Cash in *The Omega Man* (1973), Joe Morton in the role of the mute runaway slave from outer space in *The Brother from Another Planet* (1984), Lou Gossett Jr. in *Enemy Mine* (1985), Robert Townsend in *Meteor Man* (1993), Denzel Washington's work in *Virtuosity* (1995), *Déjà Vu* (2006), and *The Book of Eli* (2010), Angela Bassett in *Strange Days* (1995) and *Supernova* (2000), Wesley Snipes in the *Blade* series (1998, 2002, 2004) and *Demolition Man* (1993) as well as Laurence Fishburne and Jada Pinkett Smith in *The Matrix Trilogy* (1999, 2003, 2003).

REFERENCES

Berenson, J. (1997). *Will power!: A biography of Will Smith*. New York: Simon & Schuster.

Glave, D. D. (2003). An interview with Nalo Hopkinson. *Callaloo, 26*(Winter, 1), 146–159.

Grossberg, J. (2010). Will Smith still jiggy with men in Black—are you? In *E! Online*, Los Angeles. CA.

Kakoudaki, D. (2002). Spectacles of history: Race relations, melodrama, and the science fiction/disaster film. *Camera Obscura, 17*(2), 109–153.

Longsdorf, A. (1999, June 27), Where there's a Will there's a way. *The Record*, Y01.

Marron, M. (2000). *Will Smith: From rap star to mega star*. New York: Warner.

Nama, A. (2008). *Black space: Imagining race in science fiction film*. Austin, TX: University of Texas Press.

Nickson, C. (1999). *Will Smith*. New York: St. Martin's Press.

Rader, D. (2004). 'My Fear Fuels Me'—Film Actor and Rap Artist Will Smith. *Parade*, no. 07/11/2004

Robb, B. J. (2000). *King of cool: Will Smith*. London: Plexus,

Schwarzbaum, L. (2008). Movie review: *Hancock*. *Entertainment Weekly*, 1001.

Taubin, A. (1996). Playing it straight: R.E.M. Meets a post–Rodney King world in *Independence Day*. *Sight and sound, 6*(8), 6–8.

Will Smith "Hancock" interview with Matt Lauer. *The Today Show*. 23 June, 2008, New York: NBC Studio.

FILMOGRAPHY

Schepisi, F. (Director). (1993). *Six Degrees of Separation*. Maiden Movies, Metro-Goldwyn-Mayer, and New Regency Pictures, US.

Bay. M. (Director). 1995. *Bad Boys*. Don Simpson/Jerry Bruckheimer Films, and Columbia Pictures, US.

Emmerich, R. (Director). (1996). *Independence Day*. 20th Century Fox, US.

Sonnenfeld, B. (Director). (1997). *Men in Black*. Columbia Pictures, US.

Sonnenfeld, B. (Director). (1999). *Wild Wild West*. Warner Bros. Pictures, US.

Sonnenfeld, B. (Director). (2002). *Men in Black II*. Columbia Pictures, US.

Proyas, A. (Director). (2004). *I, Robot*. Davis Entertainment and Overbrook Entertainment, US.

Lawrence, F. (Director). (2007). *I Am Legend*. Village Roadshow Pictures, Weed Road, Overbrook Entertainment, and Heyday Films, US.

Berg, P. (Director). (2008). *Hancock*. Relativity Media, US.

Contributors

Alisa K. Braithwaite is an Assistant Professor of Literature at MIT. Her research focuses on contemporary Caribbean Diasporic literature. She is currently working on a manuscript entitled, "Speculative Islands: Reimagining the Past and the Future of Caribbean Science Fiction and Fantasy."

Madhu Dubey is a Professor of English and African American Studies at the University of Illinois, Chicago. She is the author of *Black Women Novelists and the Nationalistic Aesthetic* (1994) and *Signs and Cities: Black Literary Postmodernism* (2003) as well as essays on 20th century African American literature and culture published in journals such as *African American Review, American Literary History, The Black Scholar, differences, New formations, and Signs*. Her areas of research interests include African American literary and cultural studies, feminist theory, postmodernism, and science fiction. She is currently working on a book-length study of the speculative fiction of Octavia Butler.

Shannon Gibney teaches writing, journalism and African American topics at Minneapolis Community Technical College. Her critical and creative work have appeared in numerous publications. She was awarded a 2005 Bush Artist Fellowship and the 2002 Hurston/Wright Award in Fiction. Currently, she is at work on a novel that chronicles the journey of 19th century African Americans who colonized Liberia.

Alexis Pauline Gumbs is a queer Black trouble-maker, an Afro-Antillean grandchild and love embodied. She completed her PhD in English, Africana Studies and Women's Studies from Duke University in 2010. Her dissertation is titled "We can Learn to Mother Ourselves":The Queer Survival of Black Feminism. Alexis is also the founder of BrokenBeautiful Press.

Amie Breeze Harper is a PhD student in Geography, Graduate group, Intersections of Critical Food Geography and Critical Race Theory at the University of California, Davis.

Brandon Kempner is an Assistant Professor of English at New Mexico Highlands University. He is the Director of Undergraduate Studies, English.

Stephanie Larrieux is an Assistant Professor of Screen Studies, Department of Visual and Performing Arts, Clark University. Her research areas include U.S. film and television aesthetics, criticism and theory; cinema history, popular culture, visual imagery and the media; race, gender and identity; race and film of the Americas, including Brazilian cinema. Her current research considers science fiction film and relationships between imagined representations of the future as well as racial discourses in multicultural societies.

Marie-Luise Loeffler earned her MA from the University of Leipzig (Germany) in 2006, majoring in American Studies and Art History. She is currently working on her PhD at the American Studies Department of the University of Leipzig and is a Visiting Scholar at the center for Comparative Studies in Race and Ethnicity at Stanford University, focusing on the construction of interracial relationships in contemporary African American women's fantasy and science fiction writing.

Adilifu Nama, a professor at California State University, Northridge, is a media sociologist and writer. His work examines how race and media intersect in television, film and Hip Hop music. He is the author of *Black Space: Imagining Race in Science Fiction Film*, the first book-length examination on the topic.

Debbie Olson is a PhD candidate at Oaklahoma State University. Her research interests include West African film, images of African/American children in film and popular media, transnationalism, and Hollywood film. She has contributed to such collections as the *African American Biography Project* (2008) and *Writing African American Women* (2006), and articles in *The Tube Has Spoken: Reality TV as Film and History* (2009), *Facts, Fiction, and African Creative Imaginations* (2009). She is the Editor-in-Chief of *Red Feather Journal: An International Journal of Children's Visual Culture*.

Micheal Charles Pounds is the Chair of the Department of Film and Electronic Media Arts at California State University at Long Beach. He is the author of *Race in Space: The Representation of Ethnicity on 'Star Trek' and 'Star Trek: the Next Generation.'* His interests in representation of gender, race, and the alien other across the media and cultures have resulted in numerous articles in a variety of publications.

Index

ROCHELLE BROCK &
RICHARD GREGGORY JOHNSON III,
Executive Editors

Black Studies and Critical Thinking is an inter-
disciplinary series which examines the intellectual traditions of and cultural contribu-
tions made by people of African descent throughout the world. Whether it is in litera-
ture, art, music, science, or academics, these contributions are vast and far-
reaching. As we work to stretch the boundaries of knowledge and understanding of
issues critical to the Black experience, this series offers a unique opportunity to
study the social, economic, and political forces that have shaped the historic experi-
ence of Black America, and that continue to determine our future. Black Studies and
Critical Thinking is positioned at the forefront of research on the Black experience,
and is the source for dynamic, innovative, and creative exploration of the most vital
issues facing African Americans. The series invites contributions from all disciplines
but is specially suited for cultural studies, anthropology, history, sociology, literature,
art, and music.

Subjects of interest include (but are not limited to):

- EDUCATION
- SOCIOLOGY
- HISTORY
- MEDIA/COMMUNICATION
- RELIGION/THEOLOGY
- WOMEN'S STUDIES

- POLICY STUDIES
- ADVERTISING
- AFRICAN AMERICAN STUDIES
- POLITICAL SCIENCE
- LGBT STUDIES

For additional information about this series or for the submission of manuscript
please contact Dr. Brock (Indiana University Northwest) at brock2@iun.edu or
Johnson (University of Vermont) at richard.johnson-III@uvm.edu.

To order other books in this series, please contact our Customer Service Departm

(800) 770-LANG (within the U.S.)
(212) 647-7706 (outside the U.S.)
(212) 647-7707 FAX

Or browse online by series at www.peterlang.com.